VICTORIAN ILLUSTRATED BOOKS

By the same author

Percy Muir

VICTORIAN ILLUSTRATED BOOKS

B. T. BATSFORD LTD LONDON

© Percy Muir 1971
First published 1971
Revised impression 1985

Printed and bound in Great Britain by
Anchor Brendon Ltd, Tiptree, Essex
for the Publishers, B. T. Batsford Ltd,
4 Fitzhardinge Street, London W1H 0AH

ISBN 0 7134 0725 5

Contents

Illustrations

Colour Illustrations (between pages 80, 81 and 104, 105)

Acknowledgments

Acknowledgments are due and gratefully offered to Mr Henry C. Pitz for letting me see the proofs of his book on *The Brandywine Tradition* and for patient and unflagging response to cross-examination on American book illustrators on which he is a leading authority; to Mr Emerson Greenaway, Head Librarian of the Free Library of Philadelphia and Mr Howell J. Heaney of its Rare Book Room, for checking many details of the American iconographic section; to Dr W. H. Bond and the Houghton Library for permission to use the unique Tenniel material (illus. no. 40); to Mr Leslie Shepard for the four chapbooks (illus. no. 2); to Mr Wilbur Smith and the Library of the University of California, Los Angeles, for the use of the Doré woodblock (illus. no. 226); to Miss Virginia Warren, Los Angeles, for help with the London Cries and illus. nos. 3 and 3a; to Mr Frederick Gardner and Mrs M. E. Hutton for dating some of the Walter Crane Toy Books; to Fräulein Christine Roth for bibliographical information on English editions of German books; and to Herr Dr Friedrich Bohne and the Wilhelm-Busch-Gesellschaft, Hanover, for making available to me their records of the English editions of Busch.

This is a book that I have had great pleasure in writing. Much of my working life has been spent poking about in comparatively neglected corners of book collecting, and although book illustration can hardly be said to have been neglected, there has been no full-scale attempt to chart the nineteenth century. Forrest Reid and Gleeson White covered the 1860s, Cohn has dealt exhaustively with Cruikshank, and Martin Hardie, Burch and Courtney Lewis ranged widely over the colour work of the period. Curiously enough nearly all of these admirable and comprehensive studies fell flat on their original appearance, although more attention has been paid to them recently and all have become scarce and difficult to find. Perhaps most remarkable of all has been the neglect of Turner as a book illustrator, especially in view of the detailed studies of his work by his biographers, Thornbury and Hamerton, by Ruskin and by his iconographers – Pye and Roget, Rawlinson and Finberg.

More recently the excellent Art and Technics series covering Doyle, du Maurier, Tenniel and others was discontinued through lack of support. Leech and 'Phiz' were to have been included in this series but adequate monographs on them do not exist. Holbrook Jackson's *The Eighteen-Nineties* takes in some of the illustrators and Sketchley and Thorp have filled in more of the detail of that period. Numerous less important but attractive artists have virtually escaped notice and the great contribution by the engravers on wood and metal has not always been estimated at its true value.

One cannot hope in a single volume to repair all these omissions, but it may be possible, by a reminder of what has already been done and by filling some of the gaps, to provide a broad conspectus of the varied field of achievement in the period. One must be discursive and controversial; some perspective will be lost in drawing attention to unduly neglected artists, and here, as elsewhere, personal taste may sometimes be more evident than critical judgment, due to inadequate equipment in the latter.

The reader may find, in this last connection, a feature that persists throughout – impatience with what may be called 'docketting'. The historical approach to a subject differs from a record of events. The chronicler, for instance, if he treats of Elizabethan England, and takes in Shakespeare, would have to omit nine of his plays, including *Othello*, *Lear* and *The Tempest*. Nearer to our own day, in attempting the delimitation of what constitutes Edwardian England Mr Nowell Smith cites an *obiter dictum* of Mr William Plomer to the effect that the Victorian era petered out in 1918 and recalls that the President of the Royal Academy in that year was born before Victoria's accession. There can be no more truly Victorian artist than Tenniel, who was born 17 years before the period began and survived it by 13 years.

In our terms of reference it will not do to regard the Victorian era as presenting a point of view. This may be true in relation to furniture, or glass, or silver, or furnishings, although even here the general connotation is with the Great Exhibition of 1851. It is certainly not true of architecture or literature, for example; and it is not true of book illustration either. There is no community of outlook between

Cruikshank and Millais, or between Keene and Beardsley.

On the technical side the limits of accommodation must be widely drawn. Throughout the greater part of the period wood-engraving was by far the commonest method of reproducing drawings in black and white and this technique competed on at least equal terms with lithography in the reproduction of colour work. Lithography was invented by Senefelder in the eighteenth century and had been used in England with coloured inks 20 years before Victoria came to the throne. In the long run its development has been much more widespread than wood-engraving, the commercial uses of which have long been abandoned. Yet for our period wood-engraving is of incomparably greater importance than lithography; and no satisfactory account of its remarkable influence in book illustration is possible without reference to the originator of the technique, Thomas Bewick – whose last book appeared in 1818 – and to the work of his pupils whose pervasive activity revolutionised the technique of book illustration not only in England, but on the continent of Europe and across the Atlantic.

Thus, in two different senses, the title of the present work is something of a misnomer. On the one hand it is not a study of a 'school', but rather a chronicle of what went on during Victoria's long reign. On the other hand it includes the work of artists who reached their zenith before the reign began.

It is a misconception to suggest that book illustration entered upon a new era in the year 1837 which came to an end in 1901. George Cruikshank's earliest datable illustration belongs to the year 1806, but he is unquestionably a 'Victorian'. Arthur Rackham's first book work was in 1893 but he is really post-Edwardian. Such considerations make it inadvisable to attempt a study of the period in isolation. Mr McLean, in his seminal account of *Victorian Book Design* (1963), claims a unity for the period in that 'it was the last period of hand-worked printing and illustration processes in commercial book-production', but he is far too well aware of the continuous tradition to which it succeeded to draw a hard and fast date-line.

It has therefore been considered legitimate – indispensable is a better word – to include here books and artists which would have had to be excluded if the terms of reference were based on a rigid date-line; and no excuse is made for doing so.

The point must be further developed within the period itself to correct the favourite and facsimile grouping of illustrators under such headings as 'the Sixties' or 'the Nineties'. Is there really any common denominator that covers John Gilbert, Holman Hunt, Whistler, Keene, du Maurier and Tenniel? The nineties is an even worse case. Holbrook Jackson's illustrations include drawings by Beardsley, Beerbohm, Rothenstein, Nicholson, Crane, Morris, Conder and Sime, artists that show no common idiom except possibly their use of black and white.

The slotting of artists into pigeon-holes has a more serious defect in its tendency to isolate them from the general stream. The one feature common to all 'sixties' books, in the Forrest Reid sense of the

term, is that their drawings were reproduced by the medium of wood-engraving. But on the one hand there is a continuous history of the use of wood-engraving from the time of Bewick until the introduction of mechanical process-work in the late eighties and even beyond; on the other hand the Dalziels and others, before the 'sixties' had elapsed, were photographing drawings on to wood; and metal clichés for process work were in fairly general use in the forties.

There is, nevertheless, one basic principle common to the work of all the artists discussed in these pages – they were all illustrators, which means that they conceived it to be their business to convey to the reader a recognisable graphic representation of scenes and characters in the author's text. Whether concerned with giants or Lilliputians, naiads or dryads, fairy queens or witches, Caliban or Puck, the illustrator's job was representational just as much as with familiar figures in peg-top trousers or crinolines. It is, fortunately, beyond my province to comment on artists of our own day. It is probably *ultra vires* to hint that Lanskoy, Staël, Dubuffet and Fautrier, whatever else they may be, are not book-illustrators. I will just say that I am more at home with Keene, Millais, Doyle and Cruikshank.

This brings me to the final point to be made in this preface. The book is intended mainly as a chronicle: but in selecting particular books or illustrations for special mention there must be a personal element. In that sense and in the relative importance of the artists discussed the intention is more persuasive than didactic – argumentative, perhaps, is even more apt than persuasive. I have indicated what I like and I hope the reader will find that there is something to be said for it even where I have found reason to differ from my betters.

1 *The Background*

Pictures came before letterpress. In a very real sense, they were originally letterpress. Our alphabet derives, through the Phoenicians and the Greeks, from the picture-writing of the ancient Egyptians – hieroglyphics. In that dead end of civilisation which is modern China picture-writing still obtains in some sense for their books are composed of ideographs instead of letters.

Among the earliest printed books to compete in the Western world with handwritten manuscripts – most of which were themselves plentifully provided with pictures – were the block-books which consisted mainly of wood-engravings in which the minimal text was cut on the same wood-blocks as the pictures.

In about 1455 the 42-line Bible was completed, 'the first substantial book to be printed from movable type in the Western world'.[1]

In 1461 Albrecht Pfister who set up the first printing press in Bamberg, produced the first dated book printed from type with illustrations. This was *Der Edelstein*, a compilation of fables made by Ulrich Boner, a German Swiss, in the fourteenth century. It is pleasant to find that the first illustrated book in the Western world, if not a book for children, was a book that they might have read for pleasure.

The high standard of the earliest letterpress printers is universally acknowledged, yet Mr David Bland[2] has recorded the low quality of the illustrations in the cradle books of printing, which may have been due to the reluctance of members of the engravers' guild to participate in the new craft for fear that it might endanger their livelihood. The embargo was breached in the *Hypnerotomachia* of 1499, one of the most glorious picture-books of all time.

But we are concerned with England and the nineteenth century, which was the heyday of book illustration. The reasons for this are simple and clear. A limited reading public entails printing small editions, which means that books are expensive. This sets a further limitation on potential sales, as well as on the actual number of titles published, and the cost of illustrating becomes inhibitive. Throughout the eighteenth century for example it is rare to find the original edition of any of the great novels with illustrations. It is difficult to think of *Gulliver's Travels* or *Robinson Crusoe* without illustrations. Yet the first edition of *Gulliver* has only an imaginary portrait of him and a few maps while *Crusoe* has a portrait and one map. The sixth edition of the first part and the third edition of the second part, both published in 1722, have plates. This is a clear example of the fact that illustrations were used only after a novel had proved a success. Except where a high publication price or a satisfactory subscription list was possible a large and assured public was looked for before a publisher could entertain the possibility of an illustrated edition.

In the nineteenth century that large and assured public was created for the first time. Growth of population and of literacy were the main factors which produced the demand and new possibilities of mass production stepped up the supply. Between the years 1831 and 1901 the population of England and Wales was almost tripled in

[1] *Printing and the Mind of Man*, 1967, p. 1.
[2] *A History of Book Illustration*, 1958, p. 104.

numbers. As to literacy, the government grant for education was £20,000 in 1832. By 1876 it had grown to £1,600,000, catering for 3,000,000 children.

The massive increases in population were largely at the lower end of the social scale and the education grants benefited principally the poorer classes. Their thirst for knowledge is typified by Cobbett's account of villagers clubbing together to buy newspapers which were read to a group by a literate local. This was before the repeal of the 'taxes on knowledge', which included newspaper tax and imports on paper. The gradual abolition of these taxes was a contribution to the cheapening of reading matter which was essential if the newly literate were to be able to take advantage of the lowering of costs made possible by new processes of mechanisation: thus justifying the introduction of the new machinery.

The newspapers that were co-operatively bought by Cobbett's villagers cost 7d each. Something will be said about book prices in relation to earnings at a later stage (see pp. 10–11). Suffice it to say here that when a working man was considered exceptionally prosperous if he earned £2 10s a week – compositors in the period 1836 to 1850 earned up to 48s – and when butcher's meat cost from 4½d to 6d a pound, it is hardly an exaggeration to regard the 7d paid for a newspaper in the 1830s as equal to ten times as much today. When the 4s weekly rent charged for the improved dwellings for the industrial poor sponsored by Prince Albert was regarded as within the reach of only a good mechanic in regular work, one may not be surprised to find an enterprising publisher like Joseph Cundall becoming bankrupt when he charged 5s for quite modest illustrated books for children. As for princely works like Ackermann's *Oxford* and *Cambridge*, published at £16 apiece it is no wonder that nemesis overtook them in the sixties when they were remaindered at one-eighth of the original prices.

A great deal of nonsense has been and still is talked about mechanisation as meaning the death of craftsmanship. Gutenberg's invention was itself an extremely ingenious example of the machine replacing the craftsman. Lowering of standards would have been fatal to the new invention, for as it could not compete initially for price – the early printed books were little, if at all, cheaper than books written by hand – the quality of the work had to be high. Nevertheless Gutenberg's invention was an early example of mass production.

That is not to say that the period with which we are concerned affords no justification for the charge that mechanisation may ruin craftsmanship and debase its cherished standards.

In book production gutta-percha bindings, casing and wiring machines, the half-tone and the oleograph, chemical-wood-pulp paper and an almost total bankruptcy of ideas in the type-foundries, were among the influences which helped to make cheapness synonymous with nastiness. It must be admitted, moreover, that the process is typical of an age when mechanisation was the only means of supplying the needs of the growing population. The new readers were not critical. They could not afford to be.

Nevertheless, this is not the entire story. The advance of technology followed two main streams. On the one hand was the demand for the improvement of techniques. The great inventors of the eighteenth century, men like Smeaton, Boulton, Watt and Samuel Bentham, were frustrated by the lack of machine tools or the men capable of using them. They devised the tools and trained mechanics capable of working to the high degree of accuracy necessary to the efficiency of the new machinery. These mechanics, in their turn, became the inventors and engineers who made possible the great advances in mechanisation in the Victorian era. It makes an interesting gloss on this situation to note that Koenig's first experimental press (*c.* 1803) was made largely of wood because there were no iron-workers in Germany equal to its construction. His first power-driven printing machine (1810) was made in London.

This constant striving for perfectibility, so strong a characteristic of the Victorian outlook, is exemplified in the field of book illustration by the extraordinarily high level of craftsmanship attained, for example by George Baxter, Owen Jones and the Dalziel brothers in the methods of reproduction. These improvements in reproductive processes will form a major element of our story; and although they were nearly all to prove dead ends, although in the long run they were all to be entirely superseded, nevertheless the story of book illustration throughout the major and the more interesting sectors of the present volume will concern the sturdy resistance by handicraft to the inroads of mechanisation.

Mr Ruari McLean was among the first to deploy some of the finer achievements of the Victorians in this sphere[3] and to show that not all the new processes were put to base uses. The faithful records of the sixties by Gleeson White[4] and Forrest Reid,[5] both, alas, long out of print and difficult to find, show that book publishers were recruiting artists like Arthur Hughes, Dickie Doyle, Millais, Houghton and Pinwell and entrusting the reproduction of their work to craftsmen of the highest standing like the Dalziels. It will emerge later in these pages that similar high standards of craftsmanship were observed in less familiar fields, for example, in the wood- and metal-engraving of the first half of the century. Moreover there were still great 'follies' to compare with the Ackermanns, like Baxter's *Cabinet of Paintings* (1837) or the *Victoria Psalter* of Owen Jones of 1861, which failed because they were considered too expensive.

Moreover, with few exceptions, the production of handicraft could seldom be cheap. Thus, although Charles Knight first issued Lane's edition of *The Arabian Nights* illustrated by Harvey in monthly parts at 1s apiece, when bound into three volumes it cost £4 4s – or say £35 to £40 in our money. In 1841 Longmans published an edition of Goldsmith's *Deserted Village* illustrated by members of the Etching Club which, on largest paper, cost £13 13s.

Even more 'modest' publications in the illustrated field were vastly

[3] *Victorian Book Design*, 1963.
[4] *English Illustration 'The Sixties', 1855–70*, 1903.
[5] *Illustrators of the Sixties*, 1928.

expensive compared with productions of our own day, when illustrated books are not thought to be inexpensive. Thus the famous Moxon Tennyson of 1857 cost £1 11s 6d when first issued, but was turned over to Routledge in 1859 who reduced the price by one-third. It was quite usual for Dalziels' illustrated editions, their *Arabian Nights* or their Goldsmith for example, to cost a guinea and special editions like *The Parables of Our Lord* illustrated by Millais, or Birket Foster's *Beauties of English Landscape*, cost much more.

There is, therefore, a clearly marked divergence in publishing. On the one hand there is concern for cheapness and large circulation and on the other hand the aim for a more limited market prepared to pay higher prices for books on grounds of their aesthetic appeal. Between the lower extreme of 'catnachery' and chapbook publishing and the higher echelons where the expensive coffee-table books were produced, many different levels of beauty and ugliness were attained, and although the nadir of ugliness is to be found in the Catnach group it is not always synonymous with low prices and some extremely pretty pieces will be found, for example, among the many low-priced series issued by Thomas Dean and his successors.

It will therefore be profitable to take a closer look at the changes in methods of book production as they affected illustrated books in particular as well as book-production methods in general.

Looking back from the end to the beginning of the period one seems to be not merely in another century, but another world. Life in the civilised world of the West at the end of the eighteenth century was much nearer in its essential features to the Egypt of the Pharaohs than to the England of Edward VII. Had Gutenberg wandered into a printing shop in the year 1800 he would have found little with which he was not immediately familiar. One hundred years later he would have been completely bewildered by the new methods that had been introduced.

Koenig's steam press, rightly described by *The Times* as 'an invention only second to that of Gutenberg himself', introduced the first dramatic reduction in costs. Up to 28 November 1814 *The Times* was printed by hand, 250 copies were produced in an hour. On the following day Koenig's machine was used for the first time and the production rate was quadrupled. In 1891, the year in which Morris issued the first book from the Kelmscott Press, linotype machines came into use in this country for mechanical type-setting. The use of machines for sewing, blocking and casing – as opposed to binding – got into its stride in our period, and the replacement of rag by wood-pulp also made feasible the production of cheap paper.

It is possible that Gutenberg's impressions would not have been limited to bewilderment. He might have shared Morris's disgust with the tawdriness of much that was turned out. It was not until the first quarter of the twentieth century that it became clear that the future of book production lay not in a return to antiquated methods but in making full and proper use of the potentiality of the machine.

In our own field changes in printing and binding methods were accompanied by new methods of reproducing illustrations for books

and some of these processes should now be examined more closely.

Throughout the history of book illustration success is measured by two criteria. The more important of these is the degree of sympathy between the artist and his medium. This entails on the one hand an understanding by the artist of the technical limits of the medium. This understanding was sometimes lacking or ignored in the nineteenth century. In our own day the most successful illustrators are those like Edward Ardizzone, Barnett Freedman and Joan Hassall who have mastered modern process techniques and have supplied the operators of them with material ideal for their purpose.

On the other hand the artist depended greatly on the sympathy and ability of his interpreter and this is found in ample measure until the first crude intrusions of mechanisation.

The second important criterion of success is the degree to which illustrations are integrated into the pattern of the book as a whole. On this ground books like Blake's illustrations to Blair and Young rank very high. The *fermiers généraux* edition of La Fontaine or Ackermann's *Microcosm* come much lower down in the scale. Good and bad examples are to be found in our period, although generally speaking a lack of good type-faces and of the demand for them hindered the book designer.

Metal and wood continued to be used as the basis of reproduction processes, although there were innovations in both media. Copper was found inadequate to the long runs demanded for the part issues of popular novels and steel was substituted. In our own day electrotyping has been used to deposit a thin layer of steel on copper plates, which enables the artist to use the more tractable material and then to strengthen it to make it stand up to long runs. This is an excellent example of arriving at an artistic understanding with mechanical terms.

Engraving on wood was the most widely used medium during the first half of the century. This was the process developed, if not actually invented, by Thomas Bewick in which the design is cut on the end-grain of a section of boxwood with graver and gouge. This is in contrast to wood-cutting, which is done with a knife on the long grain of the wood.

In Chapter 3 the striking influence of Bewick in this field will be emphasised. A very large number of extremely competent wood-engravers grew up in London, most of them either pupils of Bewick or pupils of his pupils. English wood-engravers were also responsible for the revival of the craft in France and in many of the great illustrated works recorded by Brivois[6] and Carteret[7] English engravers were employed. The great colour printers of the period used both wood and metal and some used a mixture of relief and intaglio printing. But the first great advances in colour printing were made by the entirely new invention of lithography, the eventual importance of which can hardly be overestimated. Like wood-engraving, pure lithography as a commercial process is hardly used at all today. But

[6] *Bibliographie des Ouvrages Illustrés du XIXᵉ Siècle*, 1883.
[7] *Le Trésor du Bibliophile*, 1927, vol. III.

in nineteenth-century book illustration it played a great part, if not always an entirely creditable one.

This remarkable invention will be more fully discussed in Chapter 7. Suffice it to say that its earliest use in England was principally in colour work and even here no such great artists as Daumier and Gavarni in the earlier period, or Toulouse-Lautrec and Steinlen later, turned their hand to it. In England the lithographic process was used more extensively for poster-work and commercial illustration than for book work; and for pseudo-facsimiles of illuminated manuscripts. Its potentialities also encouraged a revival of early methods of illumination and decoration in book production which, in the hands of such artist-craftsmen as Owen Jones and H. N. Humphreys, was responsible for some very remarkable *tours-de-force*.

Colour printing at a high standard of perfection remains, and has always been, an expensive business. Long runs were needed to justify it and in the early days long runs were (*a*) difficult to secure and (*b*) infrequently saleable except in certain special fields. Edmund Evans, on his own responsibility, printed 20,000 copies of Kate Greenaway's *Under the Window*, but such a run was considered astronomical and is said to have caused consternation at Routledge's who published the book.

Black-and-white illustrations were far cheaper to produce and as there was an ample supply of drudges capable of cutting acceptable, if usually deplorable, wood-blocks at very low rates, the insatiably increasing demand for, for example, juveniles was met largely from this source where even the shoddiest material found a ready sale.

Fortunately, as will transpire in later chapters (see chaps. 3 and 6) there were those who continued to observe the scrupulous standards set by Thomas Bewick and even in sheer virtuosity to surpass them. Such were William Harvey (1796–1866), himself Bewick's favoured pupil, and his fellows, and the wood-engravers of the 1860s headed by the Dalziel family. Artists and craftsmen such as these nurtured the spirit of good workmanship and a kind of apostolic succession is observable from the Bewicks to the Dalziels until the craftsmen were driven into oblivion by the development of photography and the metal blocks mechanically produced for line and half-tone work.

Our period is so largely dominated by this process, so many of the books to be considered were illustrated by means of it that a summary of the technique may be useful. The wood-block was given a thin coating of Chinese white on which the artist would work with pencil, pen or brush. The engraver then cut away the drawing with a graving-tool that was pushed, the direct opposite of the knife technique, and proofs were then pulled. The proofing was a special job. The block was inked with a special ink and this was applied, not with a roller but with a dabber similar to those used by the early letterpress printers. By a mixture of dabbing and wiping the proofer achieved the depth of inking required. Proofing was then completed, using a special paper with a slightly glossy surface called in France *papier de chine* and here india paper, probably to indicate its relationship to the fine papers used in the Orient.

Impressions were taken, not in a press, but by laying the paper down on the inked block and rubbing the back of it with a burnisher. Proofs were sent to the artist, who frequently retouched them or wrote instructions in the margins for recutting. Forrest Reid reproduces proofs of this kind by Robert Barnes[8] and W. Holman Hunt.[9] When the recutting was completed a proof was sent to the printer to show him how the finished result should appear.

When the illustration was to be printed in colour the procedure was even more elaborate. The drawing was first proofed in black and sent to the artist for colouring. Thereafter the required number of separate blocks, one for each colour, was cut and the whole reproofed for amendment by the artist if necessary.

The ingenuity of the engravers is almost incredible. Boxwood, first used by Bewick, was the favourite material for blocks and as the girth of the box-tree is comparatively small most blocks were composed of several small pieces screwed together. For very large blocks, such as double-page illustrations in the *Graphic* or the *Illustrated London News*, as many as 20 pieces had to be used and as this work had to be done at high pressure it was customary, after the drawing had been made, to unscrew the pieces and distribute them among as many craftsmen so that each one cut only a small portion of the whole. The Dalziels themselves record that it was necessary to do this sort of thing for magazine illustrations, the drawings for which might arrive on Saturday evening; the finished blocks to be with the printers on Monday morning.[10] Forrest Reid declares that John Gilbert would actually unscrew the blocks himself and send parts piecemeal to the engravers.[11] Unsightly white lines can occasionally be detected in illustrations of the period betraying imperfect reassembly of a block.

That this technique was a novel one is borne out by the fact that wood-engravers would include among their apprentices artists who had no intention of becoming engravers themselves but wished only to learn the technique of drawing on wood. Charles Keene, Fred Walker, G. J. Pinwell and J. W. North were among those known to have taken a course of this kind and the Dalziels at one time opened a special school for this purpose.

All this was swept aside and a radical change was effected when photography was adapted to the process. Mr Bland says that a method of photographing drawings on wood was discovered by an engraver called Langdon in about 1851,[12] but it seems to have been made practical only in the sixties when it was taken up by Walter Roberts, a professional photographer in Upper Holloway. Not only did this sweep away the tedious necessity for drawing on the block, it introduced an entirely new mechanical element into the reproduction process. No longer need the drawing be the same size as the reproduc-

[8] Reid, *op. cit.,* p. 258.

[9] *Ibid.,* p. 46. See also my illustration 49.

[10] *The Brothers Dalziel. A record of fifty years' work, 1840–1890,* 1901, p. 158.

[11] Reid, *op. cit.,* p. 20.

[12] Bland, *op. cit.,* p. 270. *The Art Journal* for 1854 gave an account of the process and a specimen illustration produced by it.

tion. It could be enlarged or reduced. This was welcomed at the time, and certainly it permitted the preservation of the original drawings, which was desirable not only for posterity but for the opportunities it gave to compare the reproduction with the original. But it destroyed the vital link between the artist and the finished product. Artists no longer needed to observe the limitations of the process. The limits imposed by the graver were ignored, liberties were taken in the use of wash and gradations were introduced which it was impossible to reproduce on wood. The engraver was **superseded** and the early horrors of half-tones and the three-colour process succeeded him. Wood-engraving was not revived until the early 1900s.

The introduction of photographic methods had on balance an unfortunate influence on book-production standards in the period. The first book illustrated by photography was Fox Talbot's *The Pencil of Nature*, issued in parts between 1844 and 1846 and confusingly given the earlier date on the book title-page. Although several later books were illustrated with original photographs and many with 'Woodbury types', which were actually an early form of photo-mechanical printing, there was very little future in such long-winded and expensive methods. The best-documented account of the advances in photo-mechanical processes is *The History of Photography* by H. and A. Gernsheim, 1955. Briefly, in 1839 the essentials of photo-lithographic process had been stated, in 1856 the first publications of photographs in printers' ink, photo-engraving, were published, in 1860 came the first collotypes and in 1881 the first half-tones. Burch[13] says that at the Philadelphia exhibition at which these earliest half-tones were shown there was also a print worked in three colours by the same process.

Metal-engraving using both copper and steel was widely used in our period. There were artists like Cruikshank, 'Phiz' and Leech who etched their own metal plates in large numbers for the popular part issues of the 1830s and there were professional metal-engravers, working in our period mostly on steel, who reproduced the designs of others; and although Hind[14] tells us that the engraver 'was seldom more than a designer's shadow or a publisher's drudge', some of the exceptions to this harsh generalisation are notable, as we shall see.

The etchers of the 1830s are a famous company. Between them they formed one of the most notable schools of book illustrators in our history. They have been worthily associated with immortality in such great novels as *Oliver Twist* and *Pickwick Papers* and their brilliance has preserved from complete oblivion many effusions that would now be deservedly forgotten were it not that they were illustrated by Cruikshank, Leech or 'Phiz'. Who, for example, could withstand the whimsical fustian, the long-winded phrase-making and the sheer vulgarity of Pierce Egan were it not for a necessary occasional gloss on obscure features of the spirited engravings of the Cruikshanks? Ainsworth and Lever are bores. Fortunately one

[13] *Colour Printing*, p. 232.
[14] *A History of Engraving*, 1923.

does not have to read them to enjoy the etchings that adorn them.

Steel-engraving is a process capable of producing results of great refinement, especially when the original designs are the work of such as Turner, who greatly favoured it as a process. Soon after its inception, in the first quarter of the nineteenth century, it had a wide vogue, and in the 'Keepsakes' and similar annuals the large number of engravers suggests that a chronicler who would chart the process as Reid charted wood-engraving in the sixties would perform a useful service.

Steel is an expensive and a recalcitrant material for engravers and the results were, after all, line-engravings, although an illusion of half-tone was given by cross-hatching and the subtle use of the 'ruler', a device by which lines could be produced very close together on the plate.[15] The great improvements in the engraving of wood-blocks made by the Dalziels and others made serious inroads into the use of steel and it was finally killed off – as was also the use of wood – by the growing use of photo-mechanical processes.

Thus, briefly and inadequately, has been sketched the means by which publishers grasped the opportunities furnished by the enthusiasm of the new generations of the Victorian era. It will be seen how very well, and in some cases, how very badly, they rose to the occasion.

Despite attempts, laudable and otherwise, to bring down the cost of illustrated books there is no doubt that in the first half of the nineteenth century books in general and illustrated books in particular were very much dearer than the productions of the first half of the twentieth century. It was due to the increased use of mass production before the nineteenth century was out that prices came down with a run. But standards also declined. This is unquestionably due in large part to mechanics replacing craftsmen as the interpreters of the artists' designs. But it is also undeniable that the artists themselves contributed to the *débâcle* by their inability to adapt their work to the new media.

The half-tone process was, and largely remains, the principal cause of offence. This medium made possible the reproduction of photographs, and publishers increasingly demanded from artists imitations of photography with deplorable results. Half-tones also have to be printed on heavily coated paper – 'art paper' is the cant term for it – which is an offence to sight and touch and defeats the possibility of treating a book as a unit.

Line drawings were most successful except when the artist was misled into using 'tints' and excessive cross-hatching in an attempt to imitate as closely as possible the half-tone effect.

At almost any time in the nineteenth century the diligent seeker will be rewarded by the discovery of excellent work. It must nevertheless be admitted that at no time, in the nineteenth or any other century, was so much dreariness in evidence as in the early years of mechanical process work.

[15] It will emerge later that pure line-engraving is rarely to be found in this period.

Notes on prices

One of the most difficult things to accomplish is to translate cost of living figures from one age or environment to another. A simple example will suffice to illustrate the difficulty. An English traveller abroad today will find shopping expensive in terms of devalued pounds, but he would be wrong to conclude that the cost of living is correspondingly higher for the inhabitants. For the German who earns as many marks in a day as his British counterpart earns shillings, local prices are correspondingly cheaper.

Contrariwise, when today a Penguin costs anything up to ten times the war-time sixpence, and few decent books for a child can be bought much under a pound, one is apt to regard five shillings as a trifle for an elaborately illustrated book published for the first time. But to arrive at something like true costing and to estimate the likely scale of purchase by any particular class prices must be calculated in terms of wages. The question that has to be answered is how long would a man have to work to pay for a contemplated purchase – in our case a book.

The following figures are largely drawn from J. H. Clapham, *An Economic History of Modern Britain*, 3 vols., 1926–38. They cover average earnings from about 1830 to 1850. A bricklayer averaged 5s a day and his labourer 3s 6d. A Manchester bricklayer's weekly wage averaged 28s and an Edinburgh mason 20s to 26s. Compositors, still among the highest-paid skilled workers, earned in London up to 48s. An iron-moulder got about 30s to 34s. Weavers and spinners were among the lowest paid, for although a first-class fine spinner could earn 42s 3d in 1839, in Blackburn 28 families of weavers averaged 9s 6d *a family* as their weekly earnings, while in Manchester first-class weavers, in high-grade work, with three looms to a family made 16s 4¾d. Hours of work throughout industry were seldom less than 12 hours a day. When the Ten Hours Bill was introduced in 1847 it was opposed as likely to ruin the manufacturers.

As to the changes in wages later in the century, Clapham reproduces a chart devised by G. H. Wood in 1909 which shows that between 1850 and 1890 wages generally rose by 60 per cent, but he points out that 'the "average wage-earner" is not a man of flesh and blood'. 'A man who had worked at the same trade from the Great Exhibition to the eve of Victoria's Jubilee without losing any of his efficiency', Clapham says, could not show a rise of 48 per cent like this 'average wage-earner'. It would have been more like 30 per cent in practice.

Darton's Peter Parley books cost from 1s for *Peter Parley's First Present*, a tiny volume of a few pages, to 6s 6d for *Peter Parley's Keepsake*. The *Annuals*, stoutly and attractively bound and with plenty of pictures, often including a frontispiece, cost 5s.

Thus one of the *Annuals* would cost one of the better-paid workers such as a type-compositor more than half a day's wages,[16] while a

[16] If, as is probable, he worked at least a 60-hour week, this means perhaps six hours' work.

mill-owner who bought one of Cundall's seven-and-sixpenny volumes in the Home Treasury series might have reflected that he could employ an entire Bradford family of weavers for a whole week for very little more.

A compositor today can buy a 5s book for the product of less than half an hour's wages.

Obviously the comparison can be shot full of holes. It is none the less clear that books are incomparably cheaper today than they were 150 years ago; and that their availability to the wage-earner has increased in proportion. Working-class families 100 years ago, if they bought books at all, mostly patronised the Catnachs, the Rushers and the Houlstons – the more studious were catered for by Charles Knight.

The Mechanics' Institutes, to which Samuel Smiles lectured, suggest an encouraging prospect of the horny-handed, earnestly studying to improve their station in life. This is not so. 'Everyone agreed, in early Victorian times, that you saw few mechanics there . . . [the] advantages were "embraced almost exclusively by the middle classes".'[17]

As with the Mechanics' Institutes so it was with the bookshops. These were frequented by the middle and upper classes. Others found their price-range prohibitive. The plentiful supply of cheap books began only very late in the century and illustrated books were certainly no exception to this rule.

[17] J. H. Clapham in *Early-Victorian England*, vol. II, p. 232.

2 Catnachery, Chapbooks and Children's Books

In this chapter we touch the lowest ebb reached by the floods of ink that poured forth in our period. This was the work of the industrious crew of low-class jobbing printers operating in Seven Dials who were among the first to cash in on the new reading public.

James Catnach, the best known among them, began operations in 1813 and although he died in 1842 his business was carried on by his sister and her successors, of whom the last, W. S. Fortey, died in 1890. Their main business was the production of broadsheets and song-sheets costing a penny or less for sale by street-vendors with a speciality in the 'last dying confessions' of murderers and other sensations. But they had regular lines in penny ABC's and stories and rhymes for children. Although Catnach supplied hawkers outside London a similar trade was carried on in Leeds by Andrews and Bassal, in Preston by Harkness, Pratt in Birmingham, and others.

Industrious they certainly were, although their type-faces were mean and old and their wood-blocks were worn to a degree of indecipherability that hid their almost complete irrelevance to the text they were supposed to illustrate. Boxwood blocks seem to be indestructible, but the Seven Dials printers used blocks of less hard-wearing quality cut on the plank, not engraved on the end-grain, thrown out by their former owners because their limited life-span was virtually exhausted. Nevertheless they were not despised by Jemmy Catnach and his rivals. In 1823, when James Weare was murdered at Elstree the Catnach 'Full, True and Particular Account' had to be set up in eight formes on four different presses and, working day and night for a week, 250,000 copies were pulled off and sold. A street-seller told Mayhew[1] that in 1849 he had lived for a month on selling the story of a murderer called Rush. Other excellent lines were the births, marriages and deaths of royalty, divorce cases – known as 'crim. con.' – and seamy life-stories of whorehouse-keepers, thieves and villains of all kinds. There were also regular lines in coarse ballads, fairy stories and pious exhortations.

It is worth noting that although Cruikshank never worked for this low-class trade he constantly augmented his income as a young man by illustrating similar scandal-sheets with such titles as *Crim. Con. £10,000 Damages, Lord Barrington & Sir A. Paget; Retribution; or the Dangers of Adultery;* and *England's Prime Minister Murdered.*

Chapbooks have a much more ancient, though not always more respectable lineage. It has been suggested that their original ancestors were the tracts printed by Wynkyn de Worde in the sixteenth century. It seems more likely that the idea and the earliest titles were imported from France in the sixteenth century.[2]

A. W. Pollard records that at the beginning of the sixteenth century the chapmen sold a ballad or a Christmas carol for a halfpenny and a thin quarto chapbook for fourpence.[3]

That they were resented by the regular book-trade and some idea

[1] *London Labour and the London Poor,* 4 vols.
[2] On the early French chapbooks see C. Nisard, *L'Histoire des Livres Populaires,* 1854. It is extensively illustrated. He includes some fifteenth-century examples.
[3] *Ency. Brit.,* 11th ed., art. 'Book'.

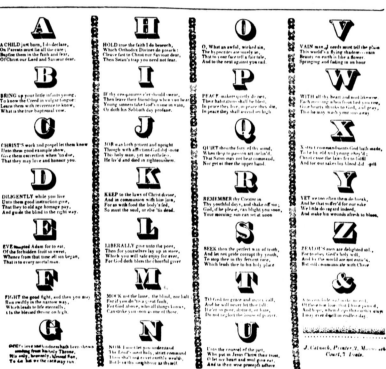

1. A Catnach broadsheet

of their range may be gathered from an extract from a Star Chamber decree of 1627 quoted by Ashton.[4]

This ordered that:

'no Haberdasher of small wares, Ironmonger, Chandler, Shopkeeper, or any other person or persons whatsoever, not having been seven years apprentice to the trade of a Bookseller, Printer or Book-binder shall, within the citie or suburbs of London, or in any other Corpora-

[4] *Chapbooks of the 18th Century*, 1882.

Nursery Songs

BY

SUSAN SILENCE.

Printed and sold by
E. Billing,
86, Bermondsey-street, London·

BIRMINGHAM:
Printed by D. Jones, 53
Edgbaston Street.

The History of

SIMPLE

SIMON.

Simple Simon,
Met a Pyeman,
Going to the fair!
Says Simple Simon,
To the Pyeman,
Let me taste your ware.

tion, Market-towne, or elsewhere, receive, take or buy, to barter, sell againe, change, or do away any Bibles, Testaments, Psalm-books, Primers, Abcees, Almanacks or other booke or books whatsoever, upon pain of forfeiture of all such books. . .'

Just how ineffective this was may be seen in the Pepys Library at Magdalen College, Cambridge, where are several of the larger chapbooks bound and labelled *Vulgaria* and four volumes of smaller ones labelled *Penny Witticisms, Penny Merriments, Penny Compliments and Penny Godlinesses.*

Chapmen carried all sorts of books. *Mother Shipton, Wat Tyler, Joe Miller* and other jest books were favourites, penny dictionaries and cook-books were also carried and books professing to interpret dreams or to foretell the future sold readily. The chapmen also carried small household goods, knives and other tools for men, ribbons and laces and sewing materials for women – in short anything portable that could be sold for a penny or two.

In France they were called *colporteurs*, because they often carried their wares slung round the neck (*col*) on trays or in sacks. This term was also adopted in Germany and when Charles Burney referred to a *Colporteur* in 1796 he made it clear that this was the German word for a book-pedlar. Its adoption as an English word seems to have arisen in the nineteenth century when it was used only to describe agents of religious publishers. George Borrow was one of the earliest, acting for the British and Foreign Bible Society from about 1835 onwards. Sigfred Taubert, in *Bibliopola*[5] illustrates many examples of what he designates *Kolportage* but where these are not Oriental they are most frequently either sellers of prints, ballads or 'catnachery', or streettraders. Herr Taubert also reproduces Reinagle's charming portrait of John Nicholson (1749?–1833) which hangs in the entrance hall of the University Library at Cambridge. Nicholson probably had a shop at the time the portrait was painted. He was formerly a streettrader, but not in books as his nickname 'Maps' Nicholson indicates.

These differentiations are rather important if confusion is to be avoided. The chapman was a very special animal, and a very common and busy one in the Victorian countryside, his wares varying little from those of his predecessors.

Chapbooks were nearly always illustrated and although their publishers often took their blocks where they could find them – witness the widespread distribution of Bewick blocks after his death – and themselves employed distinctly low-grade workmen, there were more honourable members of the trade whose tiny productions were neatly put up and retain a quaint charm of their own that is not to be despised. These had also largely outgrown the rather disreputable reputation of earlier days; and the firm of Rusher, father and son, in Banbury produced an endless stream of attractive penny booklets down to the death of the son in 1877. The respectability of the Rushers is evident from the fact that the father was mayor of the town in 1833. In York there were Killigrew and Kendrew, Richardson and Drew

5 Penguin Press, 1966.

THE

Cries of Banbury

AND LONDON,

AND

Celebrated Stories.

——ooo——

BANBURY:

PRINTED BY J. G. RUSHER.

2. (above and opposite) Four
nineteenth-century chapbooks

in Derby, Lumsden in Glasgow, Mozley in Gainsborough, Davidson in Alnwick, Curry in Dublin and Marsden in Chelmsford. In 1840 an attractive series with coloured cuts, albeit rather crudely printed, was published in Otley.

The chapbook publishers were very adroit in presentation and titling. Kendrew, for example, published a penny alphabet which he called *The Silver Penny*, while Houston called his *The Silver Toy* and Davison's was *Tom Thumb's Play Book*. A chapbook issued by Lumsden in which the cuts seem to have very miscellaneous origins, was called *Fun Upon Fun; or the Humours of the Fair*. Lumsden was a dab at attractive titles, for example, *The History of Little King Pippin* and *The Story of Little Dick and his Playthings*, each of them really a poor man's *Sandford and Merton*; and so was Kendrew's *History of Tommy and Harry*.

Publishers who looked to booksellers and stationers rather than to travelling salesmen for the marketing of their wares also began to cater for a cheaper market.

Thomas Dean founded his business in the eighteenth century, and was in the same class as John Harris, Newbery's successor, whose business was taken over by Grant and Griffith in 1843. When Dean's son joined his father in 1847 the firm had already begun to exploit

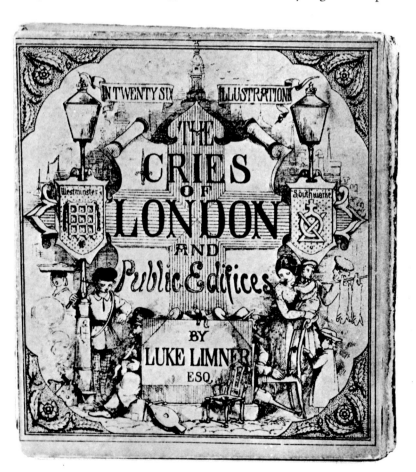

3. Title-page of *The Cries of London*

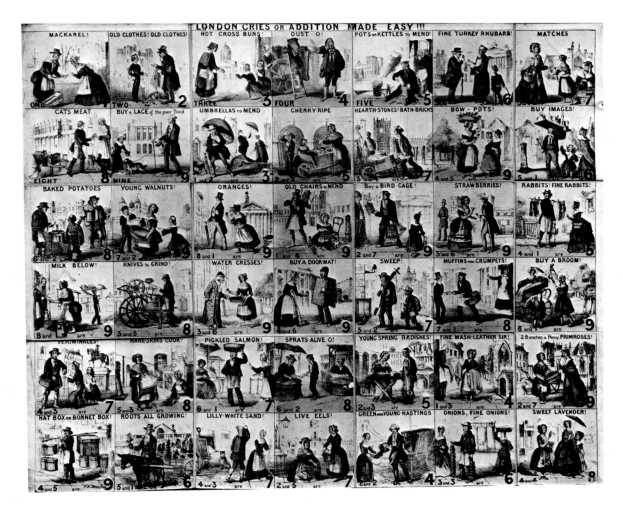

3a. *The Cries of London*

the cheaper market and although they seldom employed recognised artists they produced a great mass of jolly, coloured books at very low prices. Their movable books were highly ingenious, and at 2s each were very reasonable. They were among the first children's publishers to use lithography and to produce untearable books printed or mounted on linen, of which, by 1855, they advertised 52 titles at 1s each.

It may be useful here to clarify a slight mystification about some of the early Dean books. These are occasionally found with the imprint of A. K. Newman, who took over the Minerva Press in 1820 and ran it until 1848. The explanation is simply that Newman had a standing arrangement with Dean by which in return for taking a minimum of 1,000 sets of sheets of any of Dean's publications a special title-page was printed with his name as publisher. Occasionally both names appeared on the title-page and this means that Newman had taken less than 1,000 copies.[6]

In the Newbery succession, when John Harris retired in favour of his son the business rather went downhill; but it is pleasant to be able

[6] Cf. D. Blakeney, *The Minerva Press*, 1939, pp. 45–6.

to record his imprint on an edition of *Puss in Boots* in the year of Victoria's coronation, although it bears all the signs of a reissue. Grant and Griffith, who took over his business and made great play with being the successors of John Newbery, were extremely active in the juvenile field and became even more so when Robert Farran succeeded E. C. Grant in 1856.

Other giants will soon occur. George Routledge began business in 1834 and Ward & Lock in 1854; but their supremacy in the children's market is of a different kind and falls to be dealt with at length in the sixties (see Chap. 6).

William Darton senior founded an honourable and long-lived firm of publishers of children's books in Gracechurch Street in about 1785. His chief glory was the discovery of the Taylor sisters – *Original Poems for Infant Minds* (1804–5), and *Rhymes for the Nursery* (1806).

Although the parent firm continued until 1847, our chief concern is with his son, William junior, who set up on his own account in about 1801 on Holborn Hill, and continued under various changes of denomination until 1928. F. J. Harvey Darton, the author of *Children's Books in England* (1932, 2nd ed., 1958) was the great-grandson of the original Darton. In 1910 the firm commissioned Gordon Browne, the son of 'Phiz', to illustrate John Masefield's *A Book of Discoveries*.

They used coloured frontispieces by George Baxter in 1835, the very same year in which he took out his patent (see p. 151), for books by their favourite author, Mary Elliott, née Belson, and were otherwise adventurous with new processes of reproduction.

One of Darton's most lucrative fields was his exploitation of the name and fame of Peter Parley. The story is not a very creditable one by modern standards and certainly reads strangely when associated so closely with a Quaker firm. But as Harvey Darton himself has pointed out, commercial morality did not observe very high standards at the time. Indeed, it was all mixed up with the lack of copyright protection between America and this country which was not cleared up until the United States finally granted copyright to English authors towards the end of the century.

The original 'Peter Parley' was an American, Samuel Griswold Goodrich (1793–1860) and the first book using his pseudonym, *Peter Parley's Tales About America*, was published in Boston in 1827. The only copy of it that is known to have survived is in the Harvard University Library.

The disgraceful story of his introduction to England is told by Darton.[7] On a visit to England in 1832 Goodrich found that Tegg had published English editions of the *Tales* without the formality of a by-your-leave and had also dug up a Peter Parley of his own. Goodrich himself claimed to have produced about 120 Peter Parley books, of which over 7,000,000 copies were sold. The temptation for English publishers was clear and they took full advantage of it. Darton has identified six 'fake' Peter Parleys, but there were certainly more. Between 1835 and 1862 19 English publishers were using the name.

Darton was the most prolific of these and he had at least two Peter

[7] *Op. cit.*, pp. 231 ff.

Parleys. William Martin edited a *Peter Parley Magazine* which provided the material for an *Annual* which appeared over Darton's imprint until 1862 and was thereafter carried on by various publishers until it ended up with Cassell in the eighties. Another of Darton's Peter Parleys was his brother-in-law, Samuel Clark, afterwards a clerk in holy orders, who also used the reassuring pseudonym of 'the Rev. T. Wilson'.

Darton also published English editions of some of the genuine American Peter Parleys without acknowledgement or payment; but this, in the light of the non-existence of copyright protection, was surely less reprehensible than the filching of the name.

Some of the English Parleys were shoddy, cheap-jack publications. Darton's were at least well produced and, like all his books, gave good value for money. They were profusely illustrated.

Harvey Darton says categorically that Baxter produced a coloured plate for a Parley publication in 1835 and Lewis thinks this may have been a Peter Parley annual. The Peter Parley *Annuals*, however, seem to have been started only in 1840; but the assiduous collector may be able to run the book down because if such a print was used it was entitled 'Modifications of Clouds'. It showed nine different cloud formations and bore Baxter's imprint with his address at 29 King's Square. In later impressions the address was changed to 3 Charterhouse Square to which he moved in March 1835. The print certainly occurs in J. M. Moffat's *Book of Science*, a juvenile publication by Chapman & Hall, 1835.

In 1842 (but see p. 113) Darton published *The Adventures of Dick Boldhero*, edited by Peter Parley, the frontispiece to which is signed by Charles Keene. It was Keene's first commission for a book illustration but the other 38 illustrations are not by him. Incidentally this is a genuine Peter Parley, the work of S. G. Goodrich.

In the 1846 *Annual* the coloured frontispiece and title-page are among the few productions of Gregory, Collins & Reynolds, former apprentices of Baxter, and the 1847 has similar work by Collins and Reynolds alone. Cohn's iconography of Cruikshank lists ten *Annuals* and two other Peter Parley books with illustrations by him from 1838 onwards. Some of these are not original to the work and, although patient searching will unearth illustrations by several worthy artists of the period, many may be clichés.

Most of the publishers who published cheap illustrated books at this time were catering for children. There was at least one publisher, however, who deliberately framed much of his programme to appeal to the earnest artisans who formed the bulk of the audiences for such lecturers as Samuel Smiles and the membership of the Mechanics' Institutes that sprang up all over the country in the thirties and forties. This was Charles Knight, inspired with a reformer's zeal, with *The Penny Magazine* and *The Penny Cyclopaedia*, both excellently illustrated by a staff of wood-engravers presided over by John Jackson (see p. 26).

Knight complained, probably with some justice, that *The Penny Magazine* failed because of the competition of the 'Salisbury Square'

School. This was the creation of Edward Lloyd who began, in 1841, *The People's Police Gazette* and followed it up with *The Weekly Penny Miscellany*. The latter, being unillustrated, does not concern us, and of the former it can only be said that its pictures were as blatant and crude as its text. Lloyd made a fortune, but Knight died in penury.

These were the days, too, of the penny weekly part issues, of which G. W. M. Reynolds, who is accorded the dignity of inclusion in Michael Sadleir's *XIXth Century Fiction*, was a master. They were nearly always crudely illustrated and the nature of their contents may be gauged from their titles. Thus Reynolds wrote *The Loves of the Harem*, *The Parricide, or The Youth's Career of Crime* and *Robert Macaire, or the French Bandit in England*. One W. J. Neale was responsible for *Paul Periwinkle; or the Pressgang*, with excellent illustrations by 'Phiz'; and my own favourite of all, for its authorship, is *Jack Sheppard*, by Obediah Throttle.

This was a genre that was to run through the Hogarth House Jack Harkaway series to the Amalgamated Press with Sexton Blake, Jack, Sam and Pete and Billy Bunter.

Book illustration, in whatsoever form it is used, adds to the cost of production even when, as with Catnach and his fellows, the extra expense is limited to the reworking of old blocks picked up for a song. Quite reputable publishers were not above this practice, although they were usually more selective in their choice of material. It was a very common practice throughout the nineteenth century for publishers to buy up job lots of wood-blocks and to send strikes of a group of them to a complaisant author and commission him to write a story round them.

Bernard Barton, a Quaker versifier and essayist, in his editorial preface to the first volume of the *Juvenile Scrap-Book*, a kind of 'Keepsake' for children, openly admitted that his task had been to produce a text suitable to a collection of secondhand engravings handed to him by the publisher, and this practice was continued throughout the life of this annual (1836–50). Most of the engravings were unsuited to their purpose and the text was frequently not much better. When Sarah Stickney Ellis took over the editorship in 1840 she deplorably confessed that she had quite forgotten that the object of the work was to amuse. 'She consequently found, when it was too late, that the pictures she had selected were but little calculated to exact a smile, or even to produce a jest.' But she comforted herself with the reflection that it is 'quite a pleasure to be prevailed upon to *think*'. She therefore illustrated and wrote about views of Birker Force in Cumberland, camel drivers looking at the town of Sidon, and Worms Cathedral; with variations in a death-bed scene and the practice of infanticide in Bengal. This sort of montrosity cost eight shillings and must have darkened many a Christmas morning.

One of the most extraordinary examples of success in this dubious practice was the Rollo books, originating in America but finding an almost equally large public in this country. These were written by Jacob Abbott, a New England nonconformist minister who has himself recorded the onset of a series that was to continue for nearly 30

THE

LITTLE SCHOLAR

LEARNING TO TALK

A

PICTURE BOOK FOR ROLLO.

BY HIS FATHER.

Rollo reading his Book.

BOSTON:
JOHN ALLEN AND CO.
1835

4. The first appearance of 'Rollo'

years, to be continually reprinted and to comprise nearly 30 titles.

T. H. Carter, a book agent in Boston found in his stock a quantity of wood-engravings that he thought might be made into a book. He took them to Abbot who wrote: 'He gave me the proofs, and I began to see what I could do. In that way I made my first "Rollo Book". I sold the manuscript to Mr. Carter for about one hundred and fifty dollars. . . . The price presently got up to three hundred and fifty dollars.'[8]

The only surviving copy of this curious production in the Library of Congress, *The Little Scholar Learning to Talk, a Picture Book for Rollo* (Boston, 1835), shows on the title-page a very scratchy wood-engraving of a little boy curled up with a book in an armchair, which suggests that Rollo could read before he could talk.

Rollo reached England in 1836 and by the mid-fifties ten or a dozen Rollo titles had been published here. Abbott was a disciple of Maria Edgeworth and Thomas Day and the Rollo books make rather tedious reading today. He was more felicitous, if rather less successful, with his Franconia Tales, of which *Beechnut* is probably the best. His later Rollo books were illustrated by commissioned artists, but it is odd to think of him as the equivalent of Beatrix Potter in his day.

Children were notoriously the victims of this rather cynical attitude of many publishers who thought, and it seems correctly, that anything was good enough for them. It is common to find in their magazines and books blocks 20 or more years old.

They were not the only sufferers. In 1891 Puttick and Simpson sold by auction *An Extensive Collection of attractive old Engraved Copper-Plates and a Quantity of Old Wooden Blocks collected with a view to Republication by the late Mr. H. G. Bohn.* He was the great remainder bookseller and publisher of cheap editions from about 1831 to 1864 when his business was taken over by Bell & Daldy. He had sold a quantity of plates to Chatto & Windus in 1874. Among the coppers listed by Puttick's were 500 for *The Antiquarian* and *Topographical Cabinet* (1807), 15 for *The Book of Waverley Gems* (1862), 8 for *The Festival of Flora* (1819) by 'the other' William Blake, 16 for an edition of Marmontel's *Tales* (1799), 47 out of 65 for Nash's *Views of Paris* (1820) and 10 for Mayhew's *Adventures of Mr. and Mrs. Sandboys* by Cruikshank (1851). The wood-blocks also included a set of 13 by Cruikshank for *The English Spy* and many of earlier date, mostly for children's books. Possibly the most interesting of these was what claimed to be the 17 original blocks for the original edition of *Dame Wiggins of Lee*, 1823, which had been vainly sought, according to the cataloguer, by John Ruskin for his reprint in 1885. But in 1887 Field & Tuer issued a facsimile of the original printed in colour from the original blocks, which had recently been swept into their 'omnivorous drag-net'. In the preface they announced their acquisition of the blocks for *Deborah Dent and Her Donkey* and *Madame Fig's Gala*, sets of which were also in the Puttick sale. Did Bohn's executors – he died in 1884 – lend the blocks to Andrew Tuer, or were there two sets?

[8] Quoted by Rollo Silver, Abbot's bibliographer, in *The Colophon*, New Graphic Series No. 2, New York, 1939.

Publishers' economies were not confined to providing themselves with illustrations for next to nothing. They sometimes paid for the illustrations and got their texts gratis. This was done by reprinting old favourites where texts were out of copyright, and here again children's books were much to the fore. Sometimes the publisher scored both ways as when Nimmo in 1885 illustrated an edition of *The Compleat Angler* with the plates originally commissioned from Stothard by Pickering in 1825 and the wood-engravings used by Bogue in 1844. This book was a great favourite with reprint publishers throughout our period and Peter Oliver[9] lists 146 editions between 1836 and 1901, most of them more or less illustrated. One of the best, possibly the very best, of these was the superb edition edited by Sir Harris Nicolas for Pickering with engravings after Stothard, Inskipp and others. It was printed by Whittingham and in the special edition with the plates as proofs on india paper it makes a very handsome book. It was expensive – £6 6s on ordinary paper and £10 10s on large paper – and it was not one of Pickering's most profitable ventures. He obviously did not bind all the sheets for they were available to booksellers long after his death and were frequently on offer in both forms handsomely bound at less than the original published price. As late as 1897 a set of unbound sheets turned up in the auction room and sold for £12 15s. We shall meet the editor of this edition again in the colour printing period when one of Baxter's masterpieces, the *History of the Orders of Knighthood*, was also published by Pickering with the letterpress printed by Whittingham, and even more recherché in some quarters than the *Angler*.

Thomas Stothard (1755–1834) continued to gain favour with publishers long after his death. The plates for his engravings for *Robinson Crusoe* originally commissioned by Stockdale in 1790 changed hands many times and were still in use 100 years later. His vignettes for two books of poems by Samuel Rogers, with the even better ones by Turner, were reprinted long after the death of Moxon, the original publisher, although in this case remaining in the hands of one firm. But these two handsome and popular volumes will be more fittingly treated with other books illustrated with line-engravings.

Editions of *Robinson Crusoe* abound throughout the century. In 1840 a London edition with Grandville's illustrations appeared, almost before the part publication was completed in Paris. This did not catch on, doubtless because of its high price, 16s, and unfamiliarity with the artist. It was eventually reduced to 5s but does not occur with any frequency in Routledge's list. Cruikshank's edition of 1831 had 38 wood-engravings and was finely printed by W. Nicol, Bulmer's successor, for John Major – a notable publisher of illustrated books. But the duodecimo reprint issued by Thomas in 1838 in 'The Child's Library' is also very charming.

In 1847 there was an edition notable for the illustrations by Charles Keene and so rare that when G. S. Layard wrote his life in 1892, although he reproduced some of the original drawings, he was unable to trace a copy of the book. It was eventually run to earth in 1897 by

9 *A New Chronicle of the Compleat Angler*, New York, 1936.

5. (left) C. Keene. His first book illustrations: for *Robinson Crusoe*, 1847

6. (right) T. Morten. 'The Scientists of Laputa' in *Gulliver's Travels*, 1865

W. H. Chesson and included with a full description in his admirable bibliography at the end of Pennell's rather pointless monograph on Keene.

An edition of 1859, published by Longmans, is a rather special curiosity, less for the quality of its illustrations, which is not very high, than for the fact that they were the work of C. A. Doyle, father of Conan Doyle, and one of the first depictors of Sherlock Holmes. This seems to have hung fire and its price was reduced in 1861. Walter Paget, brother of Sidney Paget, who immortalised the features and figure of Sherlock Holmes, also illustrated a *Robinson Crusoe* for Cassell in 1891, reprinted in 1896; and another curious combination is that 'Phiz' produced one for Routledge in 1861, while Blackie commissioned one from his son, Gordon Browne, in 1885 and reissued it in 1892.

There are are several other editions worthy of notice – in colour by A. F. Lydon in 1862 and by Kronheim at about the same time, both admirable – by Griset in 1869 and by Jack B. Yeats in 1895.

An edition that has eluded me, and no wonder for it eluded Forrest Reid also, is one attributed to Macmillan in 1862 when Millais's son records two drawings made for them by his father. It is certainly not the Golden Treasury edition, as surmised by Reid, for that came out in 1868 and had only a tiny vignette on the title-page.

Gulliver for some reason was less popular than *Crusoe*, although both 'Phiz' (1879) and his son (1886) illustrated it and Grandville's edition, again in 1840, was speedily remaindered to Bohn. More to a modern taste is the edition, first issued in 11 parts and then in volume form by Cassell and illustrated by Thomas Morten (1836–66) which is by far his most important work in book form. He was, in fact, a most uneven and erratic artist and his suicide in 1866 is grievous evidence of his ill-balanced personality. Most of his work was done for magazines, notably for *Once A Week* and *Good Words*. The *Gulliver* shows an occasionally almost eerie originality and one is tempted to describe it as the best of all attempts to interpret the strange stories in that very extraordinary work.

There is no end to the illustrated reprints of favourite authors at this time when the growing appetite for good reading demanded pictures to go with it. *Aesop*, *The Arabian Nights*, both at length and in selection, Cervantes, Cowper, Watts, Goldsmith, Gray, Mrs Gaskell, Grimm, Bunyan, Thomas Moore, Aytoun, Hood, Wordsworth and the Bible all appeared in illustrated editions over and over again. One strange omission is the name of Perrault. There were innumerable editions of the separate stories with Cinderella as the favourite. But throughout the *English Catalogue of Books*, the name of the author occurs only once, in 1888, with Andrew Lang's translation. In fact Cassell, in 1865, used slightly more than half of Gustave Doré's designs from the French edition of 1862 for a translation of five of the eight stories translated and put into verse by Thomas Hood junior, but did not mention the original author. I do not myself consider Doré by any means the ideal illustrator for Perrault. It must be added that the English printer did not make the best of him and when the book was later reprinted as *Fairy Tales Told Again*, still without Perrault's name, the illustrations were massacred.

Books applicable to this chapter

C. Hindley, *The Catnach Press*, 1869; *Life and Times of James Catnach*, 1878; *The History of the Catnach Press*, 1886

The first book consists largely of facsimile reproductions of books and broadsheets printed and published by Catnach. The second book is a rambling and disconnected work, more than half of it scissors and paste, but the best we have. The third book, a rehash of the other two, was published by Hindley's son.

Facts and figures on the economics of Catnachery are in: Henry Mayhew, *London Labour and the London Poor* of which the original edition, 1851–64, is a scarce book but there are reprints. He deals mostly with the vendors.

Children's books

F. J. Harvey Darton, *Children's Books in England*, 1932 (second edition, 1958) The pioneer work in this field – indispensable.

M. F. Thwaite, *From Primer to Pleasure*, 1963
Covers similar ground with many new and refreshing sidelights.
Percy Muir, *English Children's Books*, 1954 (reprinted 1969)
Has been found useful by some for its book-lists, its bibliographical
information and extensive illustrations.

Selected list of illustrated books

The area and period covered in this chapter constitute the morning
twilight of the renaissance of book illustration, when much of it was
the work of hacks.

Hindley's facsimiles are the best guide to sampling Catnach's wares.
It should perhaps be mentioned that Catnach was not the only
producer of such literature: but he is the best known and the only
one written about. Nothing worthy of distinctive mention was
produced by him, and although the best of the chapbooks – those of
Rusher of Banbury, Richardson of Derby and Marsden of Chelms-
ford, for example – were greatly superior to those of the Seven Dials
gang no display of undiscovered genius will be found among them.

In the field of children's books some examples of unusual merit are
mentioned in the text. For the rest the reader may be referred to the
books suggested for further reading. Towards the end of this chapter
it will be observed that specific mention of particular illustrators –
Keene, Cruikshank, Millais and others – is occasionally made; and
from Chapter 3 onwards it will be possible to particularise their work
in greater detail.

3 Two Colossi – Thomas Bewick and George Cruikshank

Bewick (1753–1828) and Cruikshank (1792–1878) were the first British artists to make a living largely by book illustration. The work and influence of the two men were as different as their backgrounds and characters. Bewick, the son of a farmer, lived most of his life on Tyneside. A naturalist, familiar with the birds, animals and fishes of his native land, he wrote about them and illustrated his own work with great charm and accuracy. If he was not the inventor of wood-engraving – the cutting of blocks on the end-grain of the wood with a graver rather than on a plank with a knife – he certainly revived and perfected it. A simple, gentle man of placid temperament, he had many pupils, at least one of whom, William Harvey, gave a new turn to wood-engraving, which would hardly have earned the approval of his mentor, and which, although it gave this technique a leading position in commercial process work, was ultimately responsible for its virtual extinction in that sphere.

Cruikshank, the son of a dissipated, unsuccessful artist who drank himself to death before he was 60, was born and lived all his life in London, friendly with Ainsworth, Dickens, and Thackeray, an irascible, quarrelsome man, a cartoonist of mixed political loyalties, and in later life a rabid campaigner for total abstinence. A complicated and sophisticated character, he had, so far as is known, no pupils. But he was enormously prolific and varied in his output. A. M. Cohn's *Bibliography* describes 863 books illustrated by him and more than 2,000 caricatures and separate prints. His earliest known etching dates from 1804, when he was 12, and his latest from 1875 when he was 83. During those years his name became one to conjure with and much feebler artists owed their livelihood to little more than a claim to share the magic surname.

Bewick died before Victoria came to the throne, and it can hardly be said that he was a man born before his time. A study of the publishing history of his major works[1] shows that his methods were those of the eighteenth century. Several of his pupils fall outside our period also. William Temple, after serving his time as an apprentice, gave up wood-engraving and became a linen-draper; Charlton Nesbitt died in 1830; Luke Clennell lived until 1840, but lost his reason in 1817 and never recovered it. Robert Bewick, Thomas's son, is a disappointing figure. He became his father's partner in 1812, and had a considerable hand in the unsatisfactory *Aesop* of 1818 – his signature appears with his father's on the famous thumb-mark receipt for that book – but the only published work that can certainly be attributed to him are some – Linton says all – of the drawings for a *History of British Fishes*, left unfinished at his father's death. Some of these were printed in the first edition of Thomas Bewick's *Memoir*, 1862, and Robert's sister, Isabella, who lived until 1883, included in her gift of Bewick material to the British Museum 50 drawings of fishes which she expressly described as being Robert's work. They are fine drawings, worthy of comparison with his father's drawings of birds and quadrupeds and it is regrettable that, whether from diffidence or ill-health, he refrained from continuing his father's work. He died in 1849.

[1] S. Roscoe, *Thomas Bewick. A Bibliography Raisonnée*, 1953.

It is nevertheless true that Bewick's pupils, and their pupils, were a major influence on nineteenth-century book illustration. W. J. Linton, a severe critic of Bewick, was none the less aware of his importance for later generations attributing 'to his impulse and direction . . . the best examples of the art'.

Just how quickly that influence came to be felt is evident from the fact that although when Bewick died in 1828 not more than a handful of wood-engravers were at work, most of them his pupils, in the next decade there were more than 50 in London alone, many of them women, and all of them engaged in book illustration.

John Jackson

John Jackson (1801–48) was born, like Bewick, in Ovingham. After serving some time with Bewick – his apprenticeship was cut short by some obscure disagreement which must have been violent for both the Bewicks, father and son, are said to have removed their names from his indentures – he came to London, and after a short stay with William Harvey, another Bewick apprentice, and an important figure later in this story, worked for Charles Knight and the Society for the Diffusion of Useful Knowledge. He was the staff engraver for the countless illustrations in *The Penny Magazine*, 1832–45, *The Penny Cyclopaedia*, 1833–4, the *Gallery of Portraiture*, 1832, and many other publications. This was not very distinguished work, but a selection of engravings from *The Penny Magazine* was published in 1835 and earned the commendation of the Committee of the House of Commons as an example of the progress of wood-engraving as a method of book illustration.[2] Notable are his engravings for Knight's edition of Shakespeare, first published in parts beginning in 1838 and completed in eight volumes in 1843 at the then very considerable price of £7 7s.

Jackson was responsible for the 300 or more wood-engravings in the anonymous *Treatise on Wood Engraving* published by Knight in 1839. This is a handsome book and was for a long time a standard work on the subject. Indeed, in some respects it has not even now been entirely superseded, and is of great value in its account of the immediate post-Bewick period on which so little has been written as yet. How great was Jackson's share in it is difficult to elucidate. On its first appearance he seems to have claimed the authorship, but this claim was speedily disposed of and in later editions W. A. Chatto's name appears on the title-page.

Chatto was a Newcastle man who had set up in London as a tea-merchant in 1830, and who later succeeded Surtees as Editor of *The New Sporting Magazine* in which Jorrocks first appeared, and which inspired Robert Seymour with the notion from which *The Pickwick Papers* eventually emerged.

Dobson[3] scorns Jackson's claim even to full credit for the wood-engravings. The facsimiles of early woodcuts, he says, were chiefly

7. J. Jackson. Initial letter in *A Treatise of Wood Engraving*, 1839

[2] A. Dobson, *Thomas Bewick and his Pupils*, ed. 1899, p. 216.
[3] *Ibid.*, pp. 218–9.

8. J. Jackson. Headpiece in the
Book of Common Prayer, c. 1841

the work of a pupil of Jackson's named Stephen Rimbault, and others
were engraved by J. W. Whymper. In fact what little original work
there is in the book is mainly confined to specimens of new processes
supplied by their inventors – George Baxter and Charles Knight
himself – but Jackson undoubtedly supervised the production and
much of the fine technical work in its later section came from his hand.

Jackson's best work is possibly to be sought in a *Pictorial Edition of
the Book of Common Prayer* published by Knight *c.* 1839–40. This
contains more than 700 engravings, a very remarkable achievement in
addition to the day-to-day work that went on for Knight, and to the
300 high-quality engravings for Chatto's book which must have been
well on the way at this time. We do not know the number of
Jackson's employees, but it is reasonably certain that he cannot have
coped with all this work single-handed. Nevertheless the general
standard of the craftsmanship is very praiseworthy in both of these
books; but where the Prayer Book takes precedence is that much of

it consists of original designs whereas the *Treatise*, by its very nature, is mostly illustrated by copies of engravings by other artists. There is a certain amount of similar work in the early part of the Prayer Book and, despite the ingenuity with which the subjects are adapted, purists will take exception to the miniaturisation of vast canvases by Rembrandt, Rubens, Andrea del Sarto, Reynolds, Correggio and Van Dyck and, when these ran short, to the inclusion of adaptations of pedestrian artists like Westall. But many of the initials are original and so is the masterly series of head- and tailpieces of English cathedrals and churches. The engravers have proved singularly successful with interiors, especially with King's College Chapel (p. 37), Westminster (p. 42), Salisbury (p. 62) and, above all, with Ely, the final tailpiece (p. 711). The sectional titles show great ingenuity, each being in six panels divided by architectural decoration with an impressive representation of a named church in each panel. The most striking series of all is for each of the 30 days of the liturgy. Here, within a compass of six or seven square inches, are some first-class examples of the art and craft of wood-engraving. Nearly all are good, those for Psalms 24, *Domini est terra*, 62 *Nonne Deo*, 79 *Deus venerunt*, and 90 *Domini refugium* supremely so. This, moreover, is pure wood-engraving and not susceptible to the charge of imitating metal-work. The typography, by Clowes, is better than bearable; and as the book seems to have escaped the attention it deserves, it is usually inexpensive.

William Harvey

William Harvey (1796–1866), the longest lived and most important of Bewick's pupils, was a great favourite of his master's. He began his apprenticeship in 1810 and in his last year cut many of the blocks for the *Aesop* of 1818. In 1817 he came to London, where he studied drawing under Haydon and anatomy under Sir Charles Bell. In 1821 he produced a magnificent wood-engraving of Haydon's picture 'The Assassination of Dentatus'. It measured some 15 inches by 11 inches and because it was made before the method of screwing pieces of boxwood together the sections had to be glued on a wooden base so that even the few impressions made of it had to be considerably touched up by Harvey. Linton[4] bemoans the style and purpose of this engraving as the beginning of what he called 'the aftermath' when wood-engravers abandoned the true course of their technique by trying to supplant the metal-engraver. Yet even he is forced to admit that 'This one engraving, even without the *Fables* of 1818, would entitle Harvey to rank, if not among, yet closest to our Greatest', and he devotes one of his full folio pages to a fine reproduction of it.

Although not a book 'illustration' this engraving is of considerable importance to us as being the only major work that can be attributed to Harvey as an engraver. For, apart from a vignette portrait of the printer John Johnson on the title-page of his *Typographia* (1824) and some charming, if rather over-elaborate decoration to Henderson's *Ancient and Modern Wines* (1824), Harvey confined himself to making

[4] *Masterpiece of Wood-Engraving*, 1890, pp. 185–6.

9. W. Harvey. Sectional title in
Book of the Months, 1844

drawings on wood which were cut by other craftsmen.

In 1828 he was fairly launched with the first of a short series of
entrancing books. This was *One Hundred Fables, Original and Selected*
by James Northcote. The writing and editing of these fables was an
occupation greatly enjoyed by the aged painter – he was born in 1746
– in which he was helped and encouraged by Hazlitt. Northcote took
a special interest in the illustrations and in a sketch of his life prefaced
to the second series of the *Fables*, published posthumously in 1833,
there is a short account of the odd way in which they were produced.
Northcote had a large collection of prints in which animals were
included. From these prints he cut out suitable figures for each fable,
arranged them in groups on paper and passed them to Harvey who
adapted them into drawings on the wood which were then engraved
by various craftsmen, John Jackson among them.

The results were brilliant and they had the advantage of being
printed by Charles Whittingham the elder who, if never quite the
equal of his nephew, was unsurpassed in the printing of wood-blocks.
It has been claimed for him that he discovered the 'underlay' process
in which, by means of layers of paper of varying thicknesses beneath
the blocks the impressions obtained from them were enormously
improved. The book was very well received and glowingly praised
both in *The Gentleman's Magazine* and *The Court Register*.

Harvey knew that he had done well with the illustrations for this
book and it must surely have been he who persuaded the rather
obscure bookseller whom Northcote had found to distribute the book
to send a copy to Bewick. This evoked a characteristically generous
acknowledgement couched in a mixture of pride in his pupil and
almost paternal affection. It is given in full in the reprint of the first
series of *Fables* made in 1833 to accompany a second volume.

In 1829 Whittingham printed *The Tower Menagerie* and in 1831
The Gardens and Menagerie of the Zoological Society Delineated, both
extensively illustrated by Harvey's exquisite miniatures, the latter
having for us the added interest that Edward Lear contributed some
drawings for Harvey to transfer to wood. Two of them, the 'Red and
Blue Macaw', and the 'White Fronted Lemur', bear his monogram.
Lear's first book was the *Parrots* issued in parts between November
1830 and the beginning of 1832, so that he must have been working
on the Zoological Gardens drawings at the same time.[5] The *Parrots* is
an impressive work of great beauty with 42 hand-coloured litho-
graphs; the plates within their limited range are fit to be compared
with Audubon and would probably be priced today at over £500.
It was published at £7 7s but was available as a 'remainder' in the
sixties for about half-price. *The Tower Menagerie* is an extremely
modest affair by comparison, yet the craftsmanship is perfect and it
may still be found for a few shillings by the persistent.

Harvey seems to have been indefatigable. In 1839 Chatto[6] credited

[5] Cf. Brian Reade, 'The Birds of Edward Lear' in *Signature*, N.S., No. 4, 1947,
where incidentally it is stated that Harvey received his first puff in an article by
Thomas Wainwright, the poisoner.

[6] *Op. cit.*, p. 625.

him with over 3,000 book illustrations, which is almost one a day, seven days a week since he began in 1828. 'The History of wood-engraving for some years past, is almost a record of the works of Harvey's pencil', said a writer in *The Art Union* for 1839.[7]

Charles Knight, as tireless as Harvey, had scored a great success with his publication in 1836 of E. W. Lane's *Manners and Customs of the Egyptians*. He secured Lane's translations of *The Arabian Nights* and was proposing to issue it in parts. Knight commissioned Harvey to illustrate the work, which entailed making several hundred draw-ings and arranging for them to be engraved on wood. The work was divided between about 40 engravers including the leading prac-titioners of the day; Jackson, Landells, Thompson, S. Williams and his brother and sister, Linton, Whymper and the two Branstons among them. The part publication was begun in 1838 and completed in 1840, with bound volumes keeping pace in 1839, 1840 and 1841.

Lane was not only a considerable Arabic scholar, he had lived in the East for many years, inhabiting Mohammedan quarters, wearing native dress and assuming the name of Mansoor Effendi. His trans-lation has been superseded by Burton and Mardrus, but it was by far the best that had then been made and although it was toned down to comply with the modesty of the age it was not Westernised like Galland's eighteenth-century French version. It reproduced in fact a great deal of the original flavour and it was Lane's version that popularised the stories in the West and made Sindbad and Aladdin, for example, nursery classics and the darlings of Drury Lane pantomimes and Gaiety farces.

There is one ground on which the shortcomings of the text may be seriously criticised and that is that there are not 'a thousand and one nights' but only 580. This entails at least one major casualty, for the story of 'Ali Baba and the Forty Thieves' is omitted. Lane himself says in his preface that he has omitted 'such tales, anecdotes, etc. as are comparatively uninteresting or on any account objectionable', but this will hardly account for the omission of nearly one-half of the original number. From the method and occurrence of their omission it is far more likely that Knight found that the work was running to a length for which he was not prepared and ordered rather wholesale omissions. Thus there are no cuts in the first volume, and it is only towards the end of the second volume that they begin to be extensive, with 43 consecutive nights omitted. The third volume has 340 nights omitted out of the 567 it should have contained; and certainly 'Ali Baba' cannot be called uninteresting or objectionable.

Harvey's illustrations had a considerable share in the popularity of the work. Lane-Poole, the great-nephew of the translator, who edited a definitive selection of the tales in 1893, professed a poor opinion of them, but this was not shared by his great-uncle who, in his summing-up in the final part of the work wrote: 'I must also acknowledge my obligations to Mr Harvey whose admirable designs have procured for my version a much more extensive circulation than it would otherwise have obtained.'

[7] Cited in *D.N.B.*, art. 'Harvey.'

10. W. Harvey. *The Thousand and One Nights*, 1839–41, (above) The Afreet; (below) The Old Man of the Sea
11. (right) S. Williams. Tailpiece for *Forest Trees*, 1842

With this judgement one cannot but agree. Harvey collaborated very closely with Lane in preparing his drawings and drew heavily on his collection of Oriental costumes and household articles for the purpose. For architectural details he studied among other works a book of which there will be more to be said in another chapter, *The Alhambra* of Owen Jones, to the part issue of which he must have subscribed.

Harvey could not exceed the size of the boxwood blocks and in consequence the illustrations are seldom more than vignettes, most of them head- and tailpieces. Very occasionally he made use of eccentrically-shaped pieces of unusual length in one dimension and with these he produced striking effects. One example is the lowering of Sindbad into the burial-pit after his dead wife (vol. III, p. 45). This engraving is 7 inches long but only $1\frac{1}{4}$ inches wide in most of its length. The lower section, however, broadens to nearly $3\frac{1}{2}$ inches. Harvey used this to make a striking frame for the accompanying text which, owing to clumsiness in make-up, is just one page too early.

Among so many hundreds of drawings there is bound to be some unevenness of quality; but Harvey certainly created an atmosphere and if that atmosphere will not always stand sophisticated scrutiny, it must have greatly helped the reader to grasp the Oriental background in which these romantic tales were set.

Harvey's drawings are surpassed in grandeur by the Dalziel series of 1865 which, like Knight's edition, was first published in parts. Harvey was no Houghton, neither does his picturesque cloud of smoke compare with the majestic terror of Tenniel's massive genie. But there are points at which it compares more than favourably with its later great rival. Pinwell's Sindbad looks like a West of England farmer wearing a turban. Harvey's is much more Oriental and his monster who roasted the captain aboard ship in Sindbad's third

voyage is also better than Pinwell's, perhaps because it is much better printed. Finally, Pinwell has nothing to equal the coming forth of the sea-horse, or the old man of the sea. 'Aladdin' is much superior in Dalziel, although the flying couch is well handled, and there is a joyous attempt to depict the polo game, which Lane describes as a kind of horseback hockey played with 'golf-sticks' – polo being unknown in England until 1869.

But the Harvey volumes certainly have something that is lacking in the Dalziel in that they form a unit. The pictures belong to the text, whereas in the Dalziel version the poor cobbled-up text by Dulcken is merely a pretext on which to hang the pictures. The intrusive and irrelevant borders to the Dalziel text are almost an apology. There was never a clearer demonstration of the Dalziel indifference to and ignorance of the principles of good book production, for the book was conceived, designed and printed by themselves.

Harvey's illustrations to *The Thousand and One Nights* have other significance and importance for our story. Here for the first time on a large scale he introduced a method of production of which he had already found the germ in Bewick's shop. In the *Fables* of 1818 he had seen announced and sold as by Bewick a work in which he knew that some – Chatto[8] says most – of the drawings were by his pupil, Robert Johnson, and nearly all of them were cut by apprentices.

This may have been the genesis of an idea that Harvey was one of the first to exploit on a large scale, which entailed a division of labour – and some thought of purpose – between the artist who made the drawings and the craftsman who cut them on the wood. From the credits in the Lane volumes it is clear that there were any number of *ateliers* where wood-engraving was carried on, some fairly large, with a more or less extensive staff of engravers, like Orrin Smith's establishment, or the two brothers and a sister of the Williams family, or another family group consisting of Mary and Elizabeth Clint and their uncle and aunt, John Byfield and his sister Mary, the last-named of whom executed some splendid woodcut borders for the younger Whittingham. The drawings were distributed to these various studios in accordance with their capacity.

This was the onset of the system which came to its height in the sixties, and which Linton so deeply deplored, for as he wrote: 'In the factories of Swain and Dalziel . . . the engraver was degraded, retrograded to the old *Helgen* time, and became again a mere mechanic.'

Linton was only expressing more forcibly a fairly common point of view. Recently Mr David Bland has called attention to the shortcomings of the method, to the use of the medium to reproduce work unworthy of the high standard set by Bewick, and to the fact that the whole movement was a dead end.

Now this is all very well, but if book illustration had been confined to artist-engravers of the Bewick standard we, not to mention the Victorians themselves, would have been deprived of much very fine work. Moreover, occasion will be later taken on to remark that the

[8] 'Bewick most certainly had very little to do with them; for by far the greater number were designed by Robert Johnson' – *Treatise*, p. 594.

modern recurrence of the artist-engraver was greatly helped by the persistence of the craft engravers. Had it not been for them the technique must have given place much earlier to the onslaughts of purely mechanical methods of reproduction.

Harvey continued his successful career, although he never attempted another *tour de force* to match *The Thousand and One Nights*. Prominent in the long list of credits in that work is the name of Ebenezer Landells (1800–60) who, like Harvey, was apprenticed to Bewick. He was not yet out of his time when his master died, and Landells came to London and worked for John Jackson. For a time he worked with Charles Gray, by whom George Dalziel, the eldest of the brothers, was engaged when he came to London in 1835. There is rather more than a hint in the *Record* that through either Landells or Gray, or both, Dalziel may have had a hand in cutting the blocks for the Lane book. Landells does not seem to have been a consistently good engraver, but there will be much more to say of him when we come to the history of *Punch*: and he helped to train some of the best known of the next generation of engravers and illustrators, among them Kate Greenaway's father John, Edmund Evans and Birket Foster.

Other engravers

The great increase in the number of wood-engravers at the onset of our period has already been remarked. There was John Thompson (1785–1866), of whom Linton thought so highly, and his brother Charles, who took his graver to Paris in 1816 and engraved many of those masterpieces of the romantic era like the Deveria La Fontaine of 1826, the Molière of 1835–6 and many other works. Indeed he introduced the technique into France and the French illustrators of the period – Grandville, Johannot, Meissonier and the rest – were as much beholden to the followers of Thompson as were their English counterparts to the followers of Bewick.

This seems as good a point as any at which to mention a book which probably owes more of its success to pictures than to text. This was Edward Lear's *Book of Nonsense* (1846). The first edition was produced by lithography, Lear having made the drawings on specially prepared paper, but the quality of the result was poor. Lear, himself a perfectionist, had seen his drawings of parrots superbly reproduced in lithography, by Hullmandel in 1830–2. He was obviously disappointed with the indifferent results in his Nonsense book as is shown by the following account by the Dalziels:[9]

'Early in the Sixties we made the acquaintance of Edward Lear. . . . He came to us bringing an original chromo-lithographic copy of his "Book of Nonsense". . . . His desire was to publish a new and cheaper edition. With this view he proposed having the entire set of designs redrawn on wood, and he commissioned us to do this, also to engrave the blocks, print and produce the work for him. When the work was nearly completed, he said he would sell his rights in the production

[9] *The Brothers Dalziel. A record of fifty years' work, 1840–1890*, 1901, p. 317.

to us for £100. We did not accept his offer, but proposed to find a publisher who would undertake it. We laid the matter before Messrs. Routledge and Warne. They declined to buy, but were willing to publish it for him on commission, which they did. The first edition sold immediately. Messrs. Routledge then wished to purchase the copyright, but Mr. Lear said "Now it is a success they must pay me more than I asked at first." The price was then fixed at £120. . . .'

One or two emendations are called for here. It was not a 'chromo-lithograph' original that Lear brought to Dalziels, but the black-and-white lithograph edition of 1846. He also added 45 new limericks, which brought the number up to 112 – wonderful value for the 3s 6d that Routledge charged for the new edition. The Dalziels also fail to record that the first printing of the book in colour was made by them for Warne in 1870. An edition of 5,000 copies was printed in three colours and black. It cost 5s and was also available in six parts at 1s each.

Lear's most famous pieces for children appeared in later books, 'The Owl and the Pussy Cat' and 'The Jumblies' in *Nonsense Songs* (1871), and 'The Yonghy-Bonghy-Bo', 'Mr. & Mrs. Discobbolos', 'The Pobble', 'The Quangle-Wangle', 'The Dong' and 'The Akond of Swat' in *Laughable Lyrics* (1877). Both books were illustrated by the author.

We cannot do more than indicate the widespread activity of wood-engravers during the first half of the century. Fortunately in this period publishers frequently pursued the amiable practice of giving the engravers' names as well as those of the artists and one becomes familiar with the work of the better craftsmen.

Furthermore the beautiful craftsmanship of this period is a reminder of the futility of arbitrarily dividing the century into periods, or pretending that wood-engraving was virtually a lost art between the death of Bewick and the publication of the Moxon Tennyson. In fact many of the artists prominent in the sixties period had drawn on the wood long before – Birket Foster, Charles Keene, John Tenniel, John Gilbert among them – and many continued to be active long after 1870. Tenniel, for example, resigned from the *Punch* staff only in 1901.

It is, therefore, misleading to describe certain books as 'forerunners' of the sixties. *The Book of British Ballads* is sometimes so described and, indeed, it would more than pass muster with an 1860s date on its title-page. In fact, it appeared in 1842 with a second series in 1844. The selections were made by S. C. Hall and issued by an unfamiliar publisher, James How. The get-up is almost pure 'sixties' in style with the illustrations fitted into the text, sometimes arbitrarily, but often with great success. It is, nevertheless, a book of its time. The artists, with the exception of Tenniel, whose first commission it was, are not 'sixties' artists and the engravers, while they include George Dalziel then only just out of his time, are mostly craftsmen of the thirties and forties like W. J. Linton, Orrin Smith, Branston, the Williams family and many less familiar names, but mostly showing highly competent work.

There is little to be said for Tenniel's ten drawings illustrating the 'Ballad of King Estmere', engraved by J. Bastin. It is surprising that he should have been given so many, but he was probably cheap. There are better things to be found in the two volumes. There is an excellent series of eight drawings by Kenny Meadows for 'Gil Morrice', engraved by W. J. Linton and Orrin Smith who were then in partnership; a rare, and perhaps not very striking, appearance of W. P. Frith as an illustrator with five drawings for 'The Twa Brothers', engraved by Bastin; a number of drawings by William Bell Scott, some very poor, the four for 'Kempian' by far the best; and eight excellent ones by Alfred Crowquill for 'The Luck of Eden Hall'. Very well worth noting is the unusual appearance of Samuel Williams for once in a way engraving his own drawings, for 'The Nut-Brown Mayd' and they are not at all bad, greatly superior to W. B. Scott's for the same ballad.

Unquestionably the great *trouvaille* is the group of four fanciful drawings for 'Robin Goodfellow' by Richard Dadd – the best in the whole of the two volumes. In short this is a grand book. It was very popular in its day and frequently reprinted.

W. P. Frith tells a capital story[10] of the editor's summoning to his Brompton cottage, the 'Rosery', a group of the artists who illustrated the work to submit their drawings for inspection. They were served with coffee and biscuits, much to their disgust, more especially for Kenny Meadows with whom they later adjourned to a favourite tavern and kept it up till the small hours, with rueful consequences for Meadows who arrived home with the milk, which 'pretty well settled' his wife's query about the time.

S. C. Hall may well have been a figure of fun, who took himself and life too seriously[11]; but he is deserving of great credit for the production of these two volumes. They are now difficult to find in their original format, but the later editions are not to be despised and may be found in quite elaborate contemporary morocco bindings for even less than the three guineas that they cost when originally published.

This is as good a place as any at which to add a word on bindings in general. Mr Ruari McLean has called attention to the ingenuity and the attractions of Victorian publishers' bindings.[12] Before about 1823, with the introduction of cloth binding by Pickering, it is hardly possible to speak with any exactness of 'publishers' bindings'. It would be inappropriate to discuss here the rather dubious preference among collectors for original boards or wrappers – the 'deckle fetishism' displayed in the 'passion for uncut edges in books which were intended to have their edges cut' and to be rebound to individual taste.[13]

Cloth itself was first introduced as an alternative to boards and was also intended as a temporary covering. Until John Murray started gold-blocking it was even duller than boards in appearance. But it was not very long before publishers realised that the blocking could

[10] *John Leech, his Life and Work*, 1891, vol. II, pp. 103–5.
[11] Hall was the model for Mr Pecksniff.
[12] *Victorian Book Design*, 1963.
[13] Cf. John Carter, *A.B.C. for Book Collectors*, 4th ed., 1966.

be used to enhance the outward appearance of a book and thus help to catch the eye of the buyer.

Publishers of gift books were aware of this quite quickly. One of the earliest examples that I have seen is the 1828 issue of *The Amulet*, bound in green watered silk with a pretty spine incorporating a lyre design; and among the most elaborate are the table books produced by William and Edward Finden. *Finden's Tableaux* (1838), has large and elaborate ornamental plaques in gilt on the sides, which were certainly designed by one of the brothers. Such books as these would be displayed for sale flat on their sides. For books that would be stacked on shelves special attention was paid to the spines. Leech, for example, produced a brilliant, eye-catching pictorial design for the two volumes of Albert Smith's *The Wassail Bowl* (1841), and did the same for Smith's *Christopher Tadpole* (1847), and for Gilbert à Beckett's 'Comic Histories' (1847 and 1851). In the forties more elaborate bindings were designed by Owen Jones and his assistant Albert Warren and by John Leighton, who was also 'Luke Limner', book illustrator and designer of greetings cards. The fifties and sixties provide splendid examples in great number, both signed and unsigned. The Dalziels, however, were mostly as oblivious to the attraction of their covers, as to notions of typographical niceties. Their editions of *The Arabian Nights*, Goldsmith and Swift are drab in the extreme. But, on the whole, publishers' bindings of the Victorian period are a happy hunting-ground for the enthusiast and as many of them were designed by book illustrators they make a very acceptable section of a period collection. The amateur should examine the designs very closely in search of the initials of the designer, usually very small and such an integral part of the design as to be easily overlooked.[14]

Quite frequently a few copies of a favoured book were put up in morocco by the publishers: but material of poor quality was often used for this purpose and they are hard to come by in really satisfactory condition. Contemporary rebindings, alas seldom signed, are often very fine examples of the craft and are still considerably undervalued, though interest in them is rising fast.

Returning to the main subject, the course of book illustration in the nineteenth century, at any rate until the rise of mechanical process work in the eighties, should be regarded as a continuous process. Changes of emphasis, broadening of scope and ever increasing variety of effect are unmistakable features of it. One such change has already been mentioned. It was largely due to William Harvey who, as artist, commissioned from engravers the cutting of his drawings on wood. The second major change came in the sixties when engravers like the Dalziels and Edmund Evans commissioned artists to produce work for them to engrave.

The earlier period that we have been considering is unduly neglected and the enthusiast should keep an eye open for the engravers already mentioned and others such as William Hughes and G. W.

[14] Mr McLean's chapter 17 and his numerous illustrations of bindings of the period will be found invaluable to beginners and experts alike.

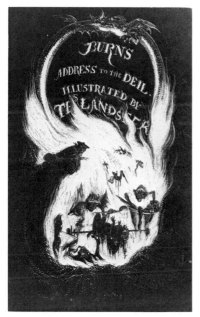

12. (above) T. Landseer. Title-page for *An Address to the Deil*, 1830

13. (below) W. Mulready. Headpiece from *The Vicar of Wakefield*, 1843

Bonner. These and others like them bridged the gap between Bewick and the sixties period and with them the emphasis is on the engraver more than on the artist, even when it was Harvey's designs upon which they were engaged.

There are all kinds of pleasant surprises for the enterprising sleuth in this field. If the name of Thomas Landseer evokes anything at all it is his engravings of the paintings of his more famous brother Edwin – 'Dignity and Impudence', 'Stag at Bay', 'The Monarch of the Glen'. As technical achievements in etching on steel these are very fine. But this Landseer was also an artist in his own right. In 1838 he published an imposing series of *Characteristic Sketches of Animals*, with notes by J. H. Barrow. These were highly thought of in their day and are worth more than a second look today, his Barbary Lion being better than his brother's animals in Trafalgar Square. The book should be sought for with the etchings on india paper in which form it should be found for not more than the original published price of £5.

An edition of Robert Burns's *An Address to the Deil* published by William Kidd in 1830 is a much more elusive, more striking and more modestly esteemed volume. It is described on the wrapper as 'Illustrated with eleven first-rate engravings on wood after designs by Thomas Landseer'. This is no exaggeration. The title-page (pl. 12) is quite staggeringly good and so are the frontispiece, showing the poet and the Deil 'ayong the loch', the terrified wayfarers, the 'rag-weed nag' and the 'water kelpies'. Landseer was no wood-engraver and he is here well served by Slader and Landells and by Whittingham, his printer.

Several of the engravers at this period were themselves more than competent illustrators in their own right and it is well worth running down books in which the engraver was also the artist. Thomas Miller's *Pictures of Country Life* (Bogue, 1847) is illustrated by Samuel Williams with engravings from his own drawings. It is a gem of a book and the head- and tailpieces include some real beauties – the ferryboat (p. 34), sheep-shearing (p. 51) and osier peeling (p. 81). The first headpiece, rural cemeteries, has a macabre charm of its own; and the final tailpiece of a pair of gentlemanly fishermen on a river bank is very jolly.

George Cruikshank

We turn now to work of a different kind – work of infinite charm and variety.

George Cruikshank is without question one of the greatest of all the fine illustrators who come within the scope of these pages. Ruskin thought him the greatest etcher since Rembrandt. Ruskin was rather given to hyperbole but superlatives are called for in face of Cruikshank's best work. He has fallen somewhat out of favour in recent years. Forty years ago Cohn's great iconography was evidence of the widespread interest in the work of this attractive artist. More recently a marked lukewarmness has been shown, like Mr Bland's

reference to a mixture 'of fantasy and horseplay' as his outstanding characteristic. Perhaps if the surrealists or some other faddist cult had taken him up we should hear more of him. In any case it seems high time that we gave him a closer look.

He had no regular teaching, only what he could pick up in his father's studio; and the precocity forced upon him by a mixture of adulation and dire necessity. His father, Isaac Cruikshank (1751–1811), was a hack caricaturist whose work sold easily to the numerous printsellers of the day. There are good hacks as well as bad and Cruikshank senior was good, although on a lower level than his contemporaries Rowlandson and Gillray. But he was an alcoholic, driven to it, perhaps, by a shrewish wife; and despite the charitableness of his son's biographer it seems clear that saleable plates in varying degrees of preparation lay about the workshop while Isaac was drinking in the Ben Jonson Tavern in Shoe Lane.

Austin Dobson extracted from the *Catalogue of the Cruikshank Collection of the Westminster Aquarium* in 1877 the information supplied by the artist himself that a 'children's Lottery Picture' was drawn and etched by him before he was 12 years old. This cannot now be identified unless it be Cohn's No. 883, described as a '(Children's Picture) In four sections . . .', published by W. Belch in Newington Butts but undated. It seems reasonably certain that he etched the folding frontispiece for *The Funeral Car of Admiral Lord Nelson*, published by Fairburn. The funeral took place on 9 January 1806 and young Cruikshank was 14 in the following September. There are signed, but undated prints by him attributed to 1805 and a song-sheet *Mail Coach Guard*, published by Laurie and Whittle on 1 May 1806. The earliest recorded plate with both a date and a signature is a headpiece to some broadside verses on *Cobbett at Court*. This was published by W. Deans on 16 October 1807 and is signed 'G. Cruikshank'.

These and similar efforts were probably undertaken to help his father, or more likely his mother, who had a much better eye to the main chance than her husband, and it was probably due to her efforts that George began to finish plates that his father had left lying about. There are records of a couple of dozen or so of these from 1805 onwards. In this way the son became known to the printsellers for whom his father worked and within the next ten or 15 years he was himself regularly employed by almost all of them from Aldgate to St James's.

These printsellers were important people in Cruikshank's early career and so we will look at some of them and at the sort of round young Cruikshank had to make to call on them. From his father's house in Dorset Street, Salisbury Square, he found almost on his door-step in Fleet Street William Hone and Laurie and Whittle, moving westward he came to West in Exeter Street and Jameson just off Bow Street, then in the Strand were Ackermann and Sidebotham who later moved to St James's Street – and Stockdale in Pall Mall, M'Lean in Haymarket and Fores in Panton Street, after he had moved from Piccadilly, and finally Mother Humphrey in St James's Street.

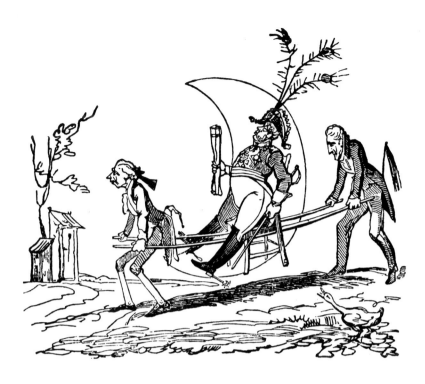

14. G. Cruikshank. George IV.
The Man in the Moon, 1820

Returning by a different route he might visit Clinch in Soho, King in Chancery Lane, Hodgson in Newgate Street, and Wood in the Cloisters near Bart's. In Cheapside were Tegg and Johnson, and further east Knight near the Royal Exchange, the lottery puff people in Cornhill, Harrild in Eastcheap and Chappell in the Minories where had formerly been Fairburn, later off Ludgate Hill.

For all of these Cruikshank worked more or less regularly, supplying juvenile theatre sheets, tinsel prints, and twelfth night characters to West and Hodgson, some 300–400 lottery puff subjects to the various firms in Cornhill to whom the lotteries were farmed out, and political caricatures to all and sundry, but with most pleasure to Mother Humphrey where he was welcomed above the shop by her gin-sodden 'lodger' James Gillray for whom the younger artist would often finish off plates beyond the power of the elder's palsied fingers.

Many of the printsellers were also booksellers and publishers, mostly of catchpenny booklets, wares for street-vendors, song-books and political squibs. The Nelson illustrations for Fairburn were, as already remarked, among his earliest published work, and for Fairburn alone he provided coloured frontispieces for Annual song-books from 1807 to 1824 while doing the same for at least two other publishers; as well as lurid depictions of executions of murderers and of examples of *flagrante delicto* in cases of 'crim. con.', especially among the nobility. In 1807 he started a connection that was to last for 15 years with the newly founded *Caricature Magazine* edited by G. M. Woodward, a friend of his father and of Thomas Rowlandson. Cruikshank contributed to the first volume an engraved title and six plates and continued to contribute to each of the succeeding volumes. The

principal contributor was Rowlandson, but Cruikshank's father was represented in all but the second volume and his brother in the first and second.

Thus far Cruikshank had found enough work to keep him going and the fecundity and indefatigability of the youth, still in his teens, are almost incredible. But he was moving in a rut, one of the many producers of ephemeral wares unlikely to make any permanent mark on the mind or the imagination. Fame, and eventually, fortune, came to him in a way and by a medium that may not have been altogether welcome.

William Hone, a radical and irreligious bookseller in Fleet Street, was looking, in 1815, for 'a young artist with a light purse' to retouch a worn plate for reprinting and was recommended by Neely of the firm of Sherwood, Neely & Jones to try young Cruikshank, who was particularly good at that sort of thing. Cruikshank was given other commissions by Hone – to etch popular subjects for window display, and to draw on wood for illustrations to topical pamphlets. This work was intermittent until, in 1819, Hone sent for Cruikshank to illustrate an anti-government squib that he had written called *The Political House that Jack Built*. Castlereagh, Canning and Sidmouth were among those of whom caricatures were required and their features were so unfamiliar to Cruikshank that much coaching from Hone was required. He tells how he had to pose for Cruikshank, and give him detailed instructions about the features and costumes of the leading personalities.

The pamphlet was an immediate and continuing success. It was reprinted over and over again – 50 times if the later title-pages are to be believed. There are 13 cuts, all by Cruikshank, for which Hone paid him half a guinea apiece. It was the drawings at least as much as the text that did the trick. Hone made a small fortune out of this and the other political squibs that Cruikshank illustrated for him. They did irretrievable damage to the government.

To Cruikshank this was a job like any other and not one altogether to his taste. His biographer writes of these squibs that 'to Cruikshank they were productive of nothing but the fame of their cleverness and the odium of their politics'. Indeed Cruikshank loathed radicals in general and Cobbett and Hunt in particular.

There was one thing he did for Hone that gave him complete satisfaction, and of which he never ceased to boast in later years. This was the *Bank Restriction Barometer*, published in 1819. He saw one morning several bodies hanging from the gibbet opposite Newgate Prison, two of them women hanged for passing forged £1 notes. He went straight home to Dorset Square and 'in ten minutes designed and made a sketch of this "Bank Note not to be imitated"'. Hone saw the possibility of both a large sale and another blow to authority, and indeed it created a sensation. Cruikshank described it in his old age as 'the most important design and etching that I ever made in my life' and claimed that it was responsible for the end of hanging for all minor offences. That it contributed to this great reform is undoubted, that it constrained the Bank of England to

cease the issue of £1 notes is improbable, but Cruikshank was never one to minimise his own importance.

This work for Hone brought him commissions from all sides, and he seems rarely to have declined any of them. Naturally most of the work did not attain the brilliance of *The Political House*, the *Bank Restriction Note*, and *The Matrimonial Ladder*, all of which are worthy of a place among the very best of his designs. But he was gestating at this time two major works, one of which turned out a masterpiece.

George and his brother Robert, who has been unduly over-shadowed by the brilliance of his junior, were great friends, and the third member of their trio was the elder Pierce Egan, a sporting journalist for whose *Boxiana*, 1816, both brothers, but more notably Robert, had provided plates. Egan was senior to both brothers, having been born in 1772, and he was doubtless the leader in the 'Corinthian' exploits which, in 1821, he proceeded to describe in a monthly part publication called *Life in London*, rather unwillingly accepted by Sherwood, Neely and Jones. Nobody has succeeded in allocating between the Cruikshanks the proportion of work on the 36 coloured etchings and the 21 wood-engravings. It may be that Robert's was the lion's share. However the success was as vast as it was unexpected. No fewer than seven dramatic versions were staged, there were parodies, imitations and translations, and reprint followed reprint over the next 20 years. Tom and Jerry, the two leading charac-ters were as familiar as Mr Pickwick and Sam Weller became a few years later. But Egan was no Dickens and the appeal of the text evades a modern eye.[15] Not so the plates showing visits to Vauxhall, the Opera, the docks, the Royal Academy, Tom Cribb's Parlour and the royal throne-room, which are as lively as ever.

Different and more important work was to come in 1823 when a selection of Grimm's *Fairy Tales*, the first to appear in English, was published by Baldwyn with a title-page and 11 superb etchings by Cruikshank. Baldwyn seems to have known what he had for he printed some special copies with the plates pulled as proofs on india paper. Strangely enough in 1826, when Baldwyn had already re-printed the first volume three times, a second volume, uniform in every way with the first, was published by Robins. Was this an early example of Cruikshank's propensity for quarrelling with those with whom he had to do business? We do not know; but Cruik-shank knew that he had produced something quite exceptional and from this time onwards dates his practice of striking off sets of proofs of the plates to his more important books as a source of supplementary income. Cohn does not record proofs from the second volume of Grimm, but they exist.

Although contemporaneously with the Grimm he accepted what must have been a tedious commission from his old friend Fairburn, to reduce to octavo format a selection from the splendid folio plates of Carle Vernet published in folio in 1806 to illustrate Napoleon's

15 Grego quotes from *Every-Night Book*, 1827, that Moncrieff, in dramatising the book 'wrote his piece from Cruikshank's plates' and 'boiled his kettle with Pierce Egan's letterpress'.

campaigns, Cruikshank's stature as an artist was now emerging. The Napoleon plates were fitted to a cobbled-up life by W. H. Ireland, the publication of which dragged on over six years through 64 monthly parts, although Cruikshank prepared only 27 plates for it. This not very thrilling work seems to be very attractive to collectors if the price they are prepared to pay for it is anything to go by. They would be better advised to concentrate on quality rather than rarity. Fortunately there is much to interest the discerning and patient collector in this period. John Wight's two volumes of *Mornings at Bow Street* (1824–7) are full of good things – india paper copies may be found by the persistent. J. A. Paris's *Philosophy in Sport* (3 vols., 1827) has 25 small cuts of indoor pursuits for children one of which, the thaumatrope, is a forerunner of the cinema. Best of all, perhaps, is William Clarke's *Three Courses and a Dessert* (1830). The text gives one a shiver of apprehension when one remembers that Clarke was the first choice for what eventually became *The Pickwick Papers*. But the illustrations are a constant delight.

There is one more book of this period to be mentioned and that is the *John Gilpin* (1828). There are but six vignette illustrations but they are all first class, and when we think of Gilpin it is the Cruikshank figure that comes to mind, for many other illustrators followed his lead very closely. The illustrations to Wight, Clarke and Cowper as well as those to Hood's *Epping Hunt* (1829), were drawn on wood and cut by Thompson, Branston, Wright and Slader. There were india paper proofs of most of them.

This short account of Cruikshank's multifarious pre-Victorian activity is an indispensable prelude to a study of the sustained high quality of the work of his maturity which began with his association with Dickens.

In 1833 Dickens dropped 'into a dark letter-box, in a dark office, up a dark court in Fleet Street' the manuscript of a sketch of London life called *A Dinner at Poplar Walk*. 'A month later he bought a copy of *The Monthly Magazine* . . . and for the first time he saw himself in print.'[16]

He wrote seven more sketches for *The Monthly Magazine* but was not paid for any of them. Several more appeared in the *Evening Chronicle* and in *Bell's Life in London*. In 1836, Macrone, the publisher of *The Monthly Magazine*, gathered several of these pieces into a volume, commissioned Cruikshank to etch eight small plates for them and published *Sketches by Boz*. In 1837 a second series appeared, similarly illustrated.

Meanwhile Dickens had been engaged by Chapman & Hall to write the text to a series of sporting pictures, of which more later, and had also been engaged by Richard Bentley to edit a new magazine – *Bentley's Miscellany*. His contract as editor included an undertaking to provide a novel to be published serially in the *Miscellany*, and in the second number, February 1837, the first instalment of *Oliver Twist* appeared. Cruikshank was commissioned to etch a plate for each instalment.

[16] Arthur Waugh, *The Nonesuch Dickens*, 1937, p. 12.

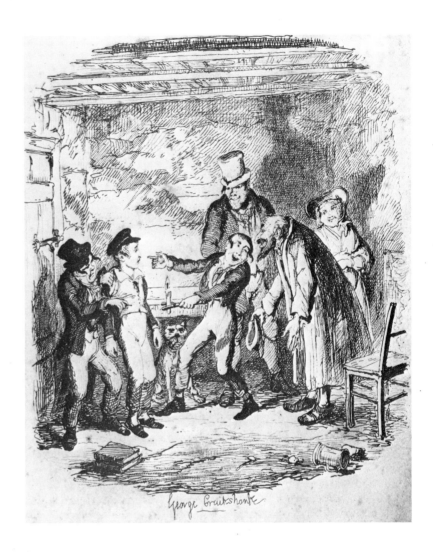

15. G. Cruikshank. 'Oliver's
reception by Fagin and the boys'.
Oliver Twist, 1846

The resounding success of *Pickwick* (see p. 89) encouraged
Macrone to contemplate a reissue of the *Sketches* in parts. This notion
horrified Dickens and eventually the copyright was acquired by
Chapman & Hall, who delayed the part publication until after the
completion of *Pickwick*. There were 20 parts and each was to have two
plates. Cruikshank enlarged 27 of the small plates to fit the large
octavo format of the part issue, etched 13 more to make up the re-
quired number and drew a splendid design on wood for the wrappers,
which was cut by Jackson, whose engraving for Chatto's *Treatise of
Wood Engraving* has already been noted.

It was for *Oliver Twist* that Cruikshank surpassed anything he had
previously done. It is neither appropriate nor necessary to comment
on the text of this great novel, but the illustrations may almost be
said to belong to our folklore. Oliver himself, Mr Bumble, Bill
Sikes, the Artful Dodger and perhaps above all Fagin cannot be
thought of without immediately conjuring up Cruikshank's figura-
tion of them. Film people are notorious for the liberties they take

with hallowed literary figures, but they knew their business well enough to realise that for *Oliver Twist* only Cruikshank's figures would be acceptable on the screen.

Unfortunately Cruikshank quarrelled with Dickens over the last plate for this book. The circumstances were rather peculiar. Bentley had decided to issue the novel as a three-decker before the periodical publication was completed and this entailed delivery of the last three plates in some haste. With two of them, Bill Sikes and his dog, and Fagin in the condemned cell, Dickens had no fault to find, but he took a strong dislike to the third which showed Oliver at Rose Maylie's knee with Harry and old Mrs Maylie, all gathered round the drawing-room fire. He insisted that it be replaced. The original design had to be used in the early copies of the book issue, but was replaced in later copies and in the magazine by one of Rose and Oliver standing before the monumental church plaque to his mother.

Cruikshank undoubtedly resented this and apart from 12 etchings for Dickens's *Memoirs of Joseph Grimaldi* executed almost simultaneously with the *Oliver Twist* plates, the two men never worked together again. The artist cherished his resentment for many years and after the author's death he spread it abroad that the story itself and all the leading characters in it were of his invention and that Dickens had written the book around some drawings that he had seen in Cruikshank's studio. He was very much given to inventions of this kind. We have already seen his extravagant claims about his *Bank Restriction Barometer* and he was also to fall foul of Ainsworth over a similarly unfounded claim about *The Tower of London*. But Ainsworth was still alive when this claim was made and was able to dispose of it very summarily.

After the conclusion of *Oliver Twist* Dickens, dissatisfied with the grossly disproportionate division of the spoils between Bentley and himself, declined to continue his editorship of the *Miscellany*, or to write the second serial called for by his contract. Harrison Ainsworth took over these responsibilities. Cruikshank remained as the principal staff artist and his association with Ainsworth inspired a magnificently sustained peak of achievement. Beginning with the serialisation of *Jack Sheppard* (1839), it continued with *The Tower of London* (1840), for which he is said to have used steel plates for the first time, *Guy Fawkes* (1841) and *Windsor Castle* (1843).

A curious association arose with the last of these. In 1842 Cruikshank had publicised his extravagant claims to part authorship of *The Tower of London*, stating explicitly that Ainsworth 'wrote up to most of my suggestions and designs' and even that the plates were prepared before the letterpress was written in some instances. For *Windsor Castle*, therefore, Ainsworth went to Paris and commissioned plates for the first three parts from Tony Johannot. The arrangement proved too complicated and Dr Thomas Pettigrew bore an olive branch from Ainsworth with the result that the remaining 14 plates were etched by Cruikshank. In later years the storm blew up again when he made a similar claim over *The Miser's Daughter*.

This unfortunate egotism on the part of the artist cannot affect

The Hornsey Gate

16. G. Cruikshank. Turpin's
Ride to York. *Rookwood*, 1846

the enormous advance in both technique and artistic perception
shown in his illustration to the Ainsworth novels. There had been a
foretaste of this in the plates for the fourth edition of *Rookwood*
(1836) – the first with Cruikshank illustrations – with its sensational
etching of Turpin's ride to York. But there is a dramatic tension, a
display of vigour and command of his subject in *Jack Sheppard* that
surpasses even the criminal scenes in *Oliver Twist*. The storm and the
murder on the Thames, Jack Sheppard's visit to his mother in Bed-
lam and the final scenes between Newgate and Tyburn show us an
entirely new Cruikshank, and this was to continue in *The Tower of
London* and *Windsor Castle*.

Cruikshank's association with *Bentley's Miscellany* was a very
fruitful one and, apart from his illustrations for the novels of
Ainsworth and Dickens, he etched many delightful things for this

magazine. Some of his best subjects were nautical and were to texts by W. H. Baker, who wrote under the pseudonym of 'The Old Sailor', for whose *Greenwich Hospital* Cruikshank furnished some agreeable coloured plates in 1826. The text of these sketches is now of interest only to students of nautical slang, but two of Cruikshank's etchings, one for *Jack in Disguise* (May 1837), and one for *The Battle of the Nile* (April 1838), are real beauties. The latter depicts a side-show at Bartholomew Fair. *Minor Bodkins's Cure for Conceit* (September 1842) illustrates an anonymous story of Irish life, the hero of which is of Flurry Knox's calibre. Mrs Gore may have been the author.

Cruikshank eventually quarrelled with Bentley and is said to have got release from his contract by deliberately turning in work of poor quality. Jerrold is fully justified when he describes some of the later plates as 'the poorest that ever proceeded from his etching-needle'.

Cruikshank was succeeded as staff artist by John Leech, as later on *Ainsworth's* by 'Phiz'. For the moment, however, he persuaded Tilt & Bogue to publish a magazine called *George Cruikshank's Omnibus*, to be edited by Laman Blanchard. It was a failure, and after only nine monthly issues had appeared Cruikshank had to swallow his pride, make up his quarrel with Ainsworth, and join the new magazine to be started by him in succession to *Bentley's*. Incidentally, in doing so, Cruikshank gave up etching on copper altogether and used steel exclusively henceforward.

The offer to join *Ainsworth's Magazine* was certainly a tempting one. Jerrold says that Cruikshank was paid £40 a month for his plates. If this is true it was very high pay indeed for only two plates a month and contrasts strongly with Croal Thomson's estimate that Hablot K. Browne ('Phiz') was never paid more than £15 15s for a plate and often less.

Cruikshank's association with Ainsworth, troubled though it was and ending in disaster owing to the irascible nature of the artist, covered one of the most fruitful periods of his career, possibly even more important than the Dickens period. Certainly this was true quantitatively. For *Bentley's* under the editorship of Dickens he made 33 plates, which include 24 for *Oliver Twist*. With the 40 that he made one way or another for *Sketches*, 12 for *Joseph Grimaldi* and a handful of odds and ends the Dickens total hardly exceeds 100.

With Ainsworth he made 113 for *Bentley's* alone and a further 62 for *Ainsworth's Magazine*. If the non-serialised work is added the 200 mark will certainly be passed.

Quality? *De gustibus* notwithstanding, few will dispute the excellence of the plates for *Rookwood* or *The Tower of London* and Cruikshank himself believed that his work for Ainsworth included many of his finest designs.

It might be thought that he would be hard put to it to keep pace with the commissions he received from publishers; but he was always jealous of the lion's share of the proceeds that escaped his own pocket and already in 1826 he had tried out the idea of being his own publisher with a comic squib on Gall and Spurzheim's claim to read character

by bumps. This was followed by *Illustrations of Time* (1827); *Scraps and Sketches* (1828–32); *My Sketch Book* (1834); and in 1835 the first *Comic Almanack* which continued annually until 1853, to which Thackeray was an occasional contributor and for which Cruikshank made nearly 250 etchings.

In 1847, however, this strange man pursued the strangest course of his whole extraordinary career. He had always been a great moraliser and now by a double series of plates on the demon of drink he converted himself to total abstinence, and at the same time wrote his own epitaph as an artist. He came of a hard-drinking family. His father had died a drunkard's death and his beloved brother bid fair to do the same. Gillray, whom he revered, had gone the same way. There is ample evidence that George shared this weakness, but he now issued a warning to himself, as much as to others, in a series of eight drawings entitled *The Bottle*, which he followed up with a sequel called *The Drunkard's Children*. The plates, accompanied by doggerel verses by Charles Mackay, were a cross between Hogarth's *The Rake's Progress* and *Ten Nights in a Bar-Room*. Bogue published

17. G. Cruikshank. 'Sheppard visiting his mother in Bedlam'. *Jack Sheppard*, 1839

them in 1847–8 on Cruikshank's behalf and at his suggestion used a recently invented method of process reproduction called glyptography.[17] The idea was to achieve a cheap price and a large circulation, and this was done. Each set, in folio size, cost only one shilling – with copies on fine paper at half-a-crown and to judge by the frequency with which they turn up today the circulation must have been very large. But the process robbed the drawings of the bite of Cruikshank's needle and the transpontine vigour of the designs is almost washed out in reproduction.

Cruikshank now developed a mania on the subject of alchohol and tobacco, and lost all sense of proportion and humour. The most wretched evidence of the bore that he became is in the four volumes of his Fairy Library in which he turned popular stories into temperance tracts. Dickens called them 'Frauds on the Fairies' in a gently chiding notice of them in *Household Words*. Cruikshank replied good-humouredly, but unrepentantly in the second (and final) number of his own *Magazine*. The best thing in it is a superb tailpiece which scores heavily off Dickens.

Publishers now began to fight shy of him for, apart from the almost overpowering temptation to introduce his moralisings inappropriately into his work, he had become an intolerable bore, lecturing all and sundry without provocation or invitation at great length on the evils of drinking and smoking.

Cuthbert Bede tells a curious story of Cruikshank's endeavour to persuade him, as a young man, to join in a crusade against 'the habit of ladies and gentlemen placing the handles of their sticks, canes, parasols or umbrellas to their mouths. . . .' He spoke very seriously of what he called this 'hideous, abominable and most dangerous custom' and outlined an extensive propaganda campaign to wean Victorians from their addiction.

The etchings to *Frank Fairleigh*, by F. E. Smedley (1856), are well thought of and the illustrations to Henry Mayhew's *The Adventures of Mr and Mrs Sandboys [at] the Great Exhibition* include some very good things. A commission much to Cruikshank's taste at about this time was to provide illustrations for an edition in twopenny parts of *Uncle Tom's Cabin* published by Cassell in 1852 and probably the first English appearance of the story. Cassell could have made no more successful choice for what was in reality a weekly series of anti-slavery tracts, intended to be sold by canvassers from door to door.[18] Unfortunately the cuts were ruined by bad printing on wretched paper.

For Longman he enlivened the part issue of a life of Falstaff in 1857 with some admirable etchings and in 1861 he permitted B. M. Pickering to commission from Whittingham a charming reprint of an anonymous fable in verse by Richard Frankham, *The Bee and The Wasp*. This reprint is considered of only nominal value by Cruikshank's bibliographer, but in fact it is altogether superior to Tilt's

18. G. Cruikshank. *The Bee and the Wasp*, 1861

[17] In *The Adventures of Mr. Obadiah Oldbuck*, Tilk & Bogue, 1841, the cuts are said to have been reproduced by 'gypsography' – possibly the same process.
[18] S. Nowell-Smith, *The House of Cassell*, 1958, p. 38.

original edition of 1832. The plates are printed on india paper and laid down, while the text is printed in Whittingham's favourite Old Face type with several of Mary Byfield's pretty ornaments and initials. What is surprising is that the plot turns on over-indulgence in liquor, which is treated jocularly. Possibly the poor man was glad of any payment, however small, for the time was not far off when he would be dependent on small pensions from the Crown and the Royal Academy. Truly, here was a great man ruined by temperance. Nevertheless the picture of him in his old age by Jerrold is an attractive one.

'He was, to sum up, a light-hearted, merry, and albeit a teetotaller, an essentially "jolly" old gentleman . . . somewhat dogged in assertion and combative in argument; strong-rooted as the oldest of old oaks in old true British prejudices; decidedly eccentric, obstinate, and whimsical; but in every work and deed a God-fearing, Queen-honouring, truth-living, honest man.'

A man, in fact, whom one would like to have known, though perhaps not too well. But as an artist he was supremely good at his job. Perhaps facility was his greatest enemy. Yet even when pot-boiling he was capable of first-class work. Thus in the early days, when he was turning out drawings on wood for half a guinea apiece he preserved his own high standard and produced some drawings that should be included in any selection of his best work.

He was equally good at comedy or drama, he could depict the fantasies of Grimm or Fouqué as well as the sordid realities of London life in the *Sketches by Boz*. His favourite medium was etching, first on copper, later on steel. He also etched on glass, drew hundreds of designs on wood to be engraved by others and for reproduction by lithography and even by autotype. Others occasionally touched the heights that he scaled: none of them was quite as much at home there as he. A nonpareil, indeed!

Robert Cruikshank

Robert Cruikshank was unduly overshadowed by the greatness of his younger brother. Yet nobody has quite certainly been able to allot their respective shares in the *Life in London* plates. In the sequel, *Finish to the Adventures of Tom, Jerry and Logic*, all but one of the plates are Robert's. His most sustained effort was for the 24 monthly parts of Westacott's *London Spy*, in which 68 of the 71 hand-coloured aquatints and all of the 75 wood-engravings are his. Some good early work of his will be found in the ballad-sheets published by Laurie and Whittle from about 1815–16. The earliest of these were by the father and by George, while Robert was at sea helping to conquer Napoleon.

Robert drew 57 of the 84 cuts for *The Universal Songster*, of which 24 were by George. There are not many that would not pass muster if the initial was changed; and Robert was especially good in the earlier numbers. The occasional appearance of another and very

19. G. or R. Cruikshank. Wine
tasting at the London Docks.
*Finish to the Adventures of Tom and
Jerry,* 1830

inferior artist is probably due to Robert's unreliability and indeed
George's cuts may have been called for when Robert was incapable of
observing his date-line. They were not well served by the engraver,
J. R. Marshall, and when he was later discarded for H. White there
was little improvement.

In the late twenties and early thirties Robert Cruikshank illustrated
a number of amusing booklets for Marsh and Miller, Kidd, Griffiths
and others, the most important of which was the light-hearted squib,
attributed on the title-page to 'Professor Porson' but actually by
Coleridge and Southey, *The Devil's Walk,* 1830. One or two of these
are reminiscent of Egan's *Life in London,* such as *Walks About Town by
the Antiquated Trio.* Others make fun of a passing craze – *The March of
Intellect, or the fashions of the day* and *Monsieur Nongtongpaw.* Although
issued by different publishers these have a family likeness. They are
all in paper wrappers and, in size and general get-up, they look like
chapbooks. They are well worth searching for, usually inexpensive,
and although their quality is uneven, they include some delightful
things. They are often found several bound together. The work of
Robert has not been painstakingly chronicled like that of his younger
brother and must be patiently winkled out. It is worth doing.

Books applicable to this chapter

Thomas Bewick Bewick died in 1828, nine years before Victoria's accession, but his
influence on the revival of wood-engraving as a means of book illus-

tration is clear. Moreover, his blocks survived him and were widely used by chapbook publishers. Many of them are still extant and some recent impressions taken from them are superior to the original printings – remarkable evidence of the longevity of boxwood as compared even with steel. A queer use of some of them occurs in an odd collection by one W. Brown, called *Tales, Poetry and Fairy Tales* 1878, 'illustrated with 96 woodcuts, many of which are printed from the original woodblocks by the famous Thomas Bewick'. Linton rightly described this as 'the most tasteful poor printing ever done'.

For an exhaustive account of his most favoured work, the *Quadrupeds*, the *British Birds* and the *Aesop* there is nothing to equal S. Roscoe, *Thomas Bewick. A Bibliography Raisonné*, 1953.

For those who wish to delve further into the astonishing and extensive diversity of his work there is that great rag-bag: T. Hugo, *The Bewick Collector*, 2 vols., 1866–8.

Bewick's own *Memoir* first published in 1862 but frequently reprinted may be supplemented by: M. Weekly, *Thomas Bewick*, 1953.

There are three chapters on his pupils in: A. Dobson, *Thomas Bewick and his Pupils*, 1884 (reprinted 1889 and 1899).

In the post-Bewick era one is generally ill-served. There is no general guide, like Forrest Reid. Indeed, but for a couple of histories of wood-engraving whose authors tacked on a chapter or two on their contemporaries, there is practically nothing. The first of these is: (W. A. Chatto) *A Treatise on Wood Engraving*, 1839. In the penultimate chapter there is a list of the names of many of the engravers and some of Bewick's pupils are discussed. In the last chapter, beginning with a fine initial drawn by R. W. Buss depicting a wood-engraver at work (see illustration 7), a few of the engravers of the time are discussed. In the edition of 1861 this discussion is somewhat extended. Details given of the techniques are important.

W. J. Linton was himself a fine engraver, and a man of very decided opinions. As a historian of wood-engraving he discussed the work of his contemporaries disparagingly, not for their technical shortcomings. Quite the contrary, he chided them for having debased their art by developing it to the point where it imitated line-engraving and was used not for producing original works of art, but for reproducing the work of others. Nevertheless, his great folio volume is indispensable: *The Masters of Wood Engraving*, 1890. He is also unsurpassed in his knowledge of the techniques employed, which he described in: *Practical Hints on Wood Engraving*, 1879 and *Wood Engraving, a Manual of Instruction*, 1884. He was also the first historian of the craft as practised in the United States (see chap. 10 *passim*).

Edward Lear Angus Davidson, *Edward Lear*, 1938, is the best life.

W. B. Osgood Fields, *Edward Lear on my Shelves*, 1933, is the record of an extensive collection sadly devoid of bibliographical information.

Edward Lear. 1812–1881, Arts Council, 1958, is an extremely useful exhibition catalogue.

George Cruikshank Cruikshank's iconography is the subject of: A. M. Cohn, *George*

Cruikshank. A Catalogue Raisonné, 1924. This painstaking and voluminous record of 843 books illustrated by Cruikshank and 2,114 separate prints is indispensable to the collector, even if one does not share the compiler's enthusiasm for part issues and the finikin details associated with them.

Part issues aside his values frequently exceed current prices though not in the lower echelons. For instance one would be very lucky to find a first printing of *The Man in the Moon* for 2s 6d or the *Bank Restriction Barometer* in its envelope for £1.

B. Jerrold, *The Life of George Cruikshank*, 2 vols., 1882 (also reprints). Exceedingly readable, authoritative and extensively illustrated. It occasionally shows the affectionate bias of a friend and admirer.

R. McLean, *George Cruikshank*, 1948
An excellent summary of the modern view of the artist with a good selection of reproductions and a useful list of books illustrated by him.

Cruikshank's Water Colours, with an introduction by Joseph Grego, 1903
Among Grego's vast collection of prints and drawings which were dispersed after his death by Christie & Puttick in 1908 were three suites of water-colours made by Cruikshank based on the original black-and-whites for *Oliver Twist, The Miser's Daughter* and *The History of the Irish Rebellion*. In the above volume Grego reproduced these drawings (66 in all), prefaced by a distinctly tendentious introduction on Cruikshank's claims in regard to the first two titles. The title-page to *Oliver Twist* states that this suite was made for F. W. Cosens in 1866, and all three suites suggest that the artist may have found this sort of thing a welcome addition to his failing revenues. The drawings are very uneven in quality but some of them, in particular the title-page to *Oliver Twist*, suggest unsuspected potentialities as a water-colourist in this master of black-and-white. It is of some interest that the last illustration is in the later form, preferred by the author but originally resented by the artist.

Selected list of illustrated books

John Jackson (W. A. Chatto) *A Treatise on Wood Engraving*, 1839, enlarged edition 1861
Jackson supervised the wood engravings in this extensively illustrated work and some of the finest of those in the last chapter are signed by him. Other engravers of the period are also well represented, notably Harvey, who had not yet given up engraving for drawing and supervising the work of other engravers. The technical quality of the engraving in this volume is extremely high and several of Bewick's designs are better seen than in the originals.

Pictorial Edition of the Book of Common Prayer, 1838–9
This is a landmark in nineteenth-century wood-engraving. It was obviously planned with great care and a considerable sense of the proper relation of ornament to text. Unfortunately the names of

the engravers are not listed, but many can be recognised by comparison with their signed work elsewhere. Of the few that are signed on the block some by Jackson are among the best.

William Shakespeare. Dramatic Works, etc., 1838–43
Published first in 56 parts and on completion in ten volumes. A good second to the 'Common Prayer'. It is worth noting that all the above three works were published by Charles Knight, who also published Harvey's edition of *The Arabian Nights*.

William Harvey

Apart from Harvey's undoubted ability, both as an engraver on wood and as the source of designs to be engraved by others, he is an important figure in the whole history of nineteenth-century wood-engraving and its ultimate dominance in book illustration. He makes his earliest recorded bow as a wood-engraver in:

The Fables of Aesop, and others, with designs on wood, by Thomas Bewick, 1818
Apart from the controversy over who actually designed the head- and tailpieces for this work,[19] it has been stated categorically by Bewick himself in his *Memoir* that Harvey engraved some of them.

It has occurred in the text (p. 28) that as soon as he came to London Harvey began to take drawing lessons. An early sequel is seen in:

Alexander Henderson, *A History of Ancient and Modern Wines*, 1824
For this imposing quarto, published at £2 2s, Harvey designed all eight of the head- and tail-pieces and 24 of the initials and engraved these himself. The rest of his designs were engraved by others. This may well be his earliest venture as an entrepreneur.

There now follows a series of books for which Harvey was commissioned as an illustrator, farming out the text to various engravers and supplying publishers with a package deal. These, described in the text (p. 29) include: J. Northcote, *One Hundred Fables*, 1828; *Fables Original and Selected*, 1833; *The Tower Menagerie*, 1829; and *The Gardens and Menagerie of the Zoological Society Delineated*, 2 vols., 1830–1.

We have already seen him collaborating with Jackson in the illustration of books for Charles Knight. Some time in the late thirties he embarked in this company upon a *magnum opus*: *The Thousand and One Nights commonly called the Arabian Nights' Entertainments*, translated by E. W. Lane, 1839–41. This has already been discussed in the text (pp. 30–32). It is worth noting that this is the first printing of Lane's text.

An exquisite book in which internal harmony is assured by the drawings coming all from one source, Harvey, and the engravings from another, Orrin Smith and Linton in partnership, is:

The Book of the Months, 1844
This has 16 full-page vignettes, one for each of the four seasons and one for each month. The paper and printing are worthy of the ingenious and frequently beautiful designs.

[19] The best statement of the pros and cons will be found in S. Roscoe, *op. cit.*, pp. 154–5.

Harvey and Others Mrs S. C. Hall, *Sketches of Irish Character*, 1842

This book is an excellent example of the unexpected treasures to be found in the pre-Forrest Reid period. Superficially rather un-inviting, with its unsuitable mixture of full-page steel-engraving and vignettes on wood, there are some excellent things in it by J. B. Jackson, including the title-page, an engraving by Thompson after Cruikshank, and a few striking vignettes by Linton. Most exciting for the explorer, however, are half a dozen prentice engravings by Edmund Evans, not yet 17 years old and in his third year in Landells's *atelier*. It is not surprising that he was not given the best subjects or that the execution of them compares unfavourably with the work of more senior hands. But it says much for Landells that he not merely gave Evans his chance but allowed him to sign the blocks. This is the third edition of Mrs Hall's first book – the first to be illustrated.

This leads us on to other artists and craftsmen of the period and Mrs Hall's book is a reminder that attention is divided between the two, although they may often be found wonderfully combined in one individual, and a volume cobbled up by her equally industrious husband is one example (see p. 34).

Samuel Williams A delightful artist-craftsman was Samuel Williams. His name occurs frequently among the credits in much of the good work of the period.

Already mentioned in the text (p. 37) is one book in which he engraved his own drawings. Another is:

P. J. Selby, *A History of British Forest-Trees*, 1842

This is a learned treatise by an authority which may be designated 'popular' only by Victorian standards. It is made a pure delight by the 200 or more engravings drawn and executed by Williams. Each species is accurately delineated with a human or other figure to show the scale, and the instructive vignettes in the text are charming. But it is in the tailpieces that the artist's fancy is allowed to range and the results are delightful (see illustration 11).[20]

William Howitt, *Visits to Remarkable Places*, 1840

This might have been almost as good as the Selby if Williams's designs had been as well treated by the printer.

Kenny Meadows It will already have been evident from the variety of books mentioned here and in the text of this chapter that the investigator is very much on his own and will generally make his own discoveries. Here we can but indicate a few personal favourites that seem to have unjustly been allowed to fall by the wayside. An illustrator whose once considerable reputation deserves to be revived is Kenny Meadows. Some of his work cannot be overlooked, where wood-engraving is considered, notably:

W. Shakespeare. Dramatic & Poetical Works, 3 vols., 1843

This is a book not to be missed! The illustrations are by Kenny Meadows, engraved by Orrin Smith, both of whom were at their best. It is a really astonishing production with more than 1,000

[20] Edward Lear designed all but one of the 30 hand-coloured plates in P. J. Selby's *The Natural History of Pigeons*.

engravings, large and small. Not the least of its attractions is that, in this country at any rate, booksellers hardly give it a second glance. However, the work is highly thought of on the Continent. Arthur Rumann's opinion[21] is an authoritative example. In his view:

'The illustrations have a diversity equal to Shakespeare's. Delicious, witty fancies alternate with scenes of pathos. Orrin Smith was a skilful collaborator. The artist is at his best in illustrating the Comedies. His humour catches the spirit of the author, gracious vignettes within the text, marginal ornaments, decorative, witty initials, form a kind of marginal glossary throughout the work. . . . His Shakespeare illustrations must be considered the best in the whole of the 19th century.'

In the British Museum there is a copy on india paper.

Nothing else by Meadows is in quite the same class as the Shakespeare, but there are some good things in:

D. Jerrold (editor), *Heads of the People*, 2 vols., 1840–1
Originally in parts and then in the volumes. Less interesting than the Shakespeare, but with some very good humorous drawings. The text is by Thackeray, Leigh Hunt, Mrs Gore and others.

Mayhew Brothers, *The Magic of Kindness*, 1841
Cruikshank provided four etchings. The wood-engravings are by Meadows.

William Mulready

An artist of uneven merit but with one or two striking achievements to his credit, notably, in our period:

Oliver Goldsmith, *The Vicar of Wakefield*, 1843 (see illustration 13).
The 32 illustrations are in the form of chapter-headings and their excellence is remarkably brought out by the delicate engraving of John Thompson, who also engraved the design for the Mulready envelope commissioned by Rowland Hill to accommodate the first postage stamps, and the figure of Britannia in the 1852 Bank of England notes.

Mulready's drawings are as good in their way as his drawings for *The Butterfly's Ball*, 1807, and it is evidence of the continuity of wood-engraving as a medium that this artist, born in 1783, contributed to the Moxon Tennyson a drawing for the 'The Deserted House' which Forrest Reid describes as 'the only other illustration that can hold its own for a moment with the Pre-Raphaelite designs'.

W. J. Linton

Best known as a wood-engraver and art historian he is worth looking out for in his rare appearances as an illustrator, mostly for his own writings, for example, a curious novel:

Bob Thin, or the Poorhouse Fugitive, 1845
This includes illustrations by his friend William Bell Scott as well as some of his own. Also, privately printed by Linton at his Appledore Press at New Haven, Connecticut, an anthology: *Golden Apples of Hesperus*, 1882.

[21] *Das Illustrierter Buch des XIX Jahr*, p. 96.

He was responsible for both the drawings, and the engraving of them, in: Harriet Martineau, *Guide to the English Lakes*, 1858, and J. R. Wise, *Shakespeare, his Birthplace*, 1861.[22]

Edward Lear A very special mention should be made in this period of the work of Edward Lear. He has not been treated at any length in the text partly because he has been more adequately treated elsewhere, but mainly because he is difficult to fit into the story. He is one of the very few illustrators who made extensive use of lithography, although his later and more interesting Nonsense books were illustrated by the more usual process of wood-engraving. It is, moreover, difficult to fit him into a period. He was not a 'sixties' man. His earliest book-work was in 1830 (see p. 29), his latest was for the privately printed edition of his illustrations to Tennyson, 1889.

For Lear's splendid ornithological work and his association with Gould the reader is referred to Mr Brian Reade's 'The Birds of Edward Lear'.[23]

We are mainly concerned with his Nonsense books, which are: *The Book of Nonsense*, 1846; *Nonsense Stories*, 1871; *More Nonsense*, 1872; *Laughable Lyrics*, 1877.

His travel books contain many attractive original lithographs: *Illustrated Excursions in Italy*, 2 vols., 1846–56; *Journal of a Landscape Painter in Greece and Albania*, 1851; *Journal of a Landscape Painter in Southern Calabria*, 1852; *Journal of a Landscape Painter in Corsica*, 1870; *Views in Rome and its Environs*, 1841; and *Views in the Seven Ionian Islands*, 1863.

A curiosity that Lear enthusiasts should endeavour to get a sight of is:

Alfred, Lord Tennyson, *Poems*, illustrated by Edward Lear, 1889 Lear had first conceived the idea of an illustrated edition of Tennyson in about 1852. He was obsessed with the idea during the last ten years of his life and made 200 drawings for it, some of which seem to have been lithographed by his young assistant, Frederick Underhill. After Lear's death his life-long friend, Franklin Lushington, selected 23 of the drawings that were in a sufficiently completed state to illustrate three poems by Tennyson, the first of which was one addressed to Lear himself, written in 1852. Only 100 copies of the book were printed, each of which the laureate was induced to sign. The drawings were reproduced in Paris by a process described as 'Goupilgravure', which is not a gravure process but an early form of collotype based on the process invented by A. Poitevin.

Angus Davidson is probably right in saying that the book 'would hardly have pleased Lear', and, indeed, his drawings are greatly reduced and are printed in a process other than that for which they were intended. But, not only for their being a pledge of a great artist's affection for a great poet, but also for their intrinsic beauty and charm we may be grateful for this preservation of the last great work that Lear engaged upon.

[22] This author gave Walter Crane his first commission in 1862 (see p. 158).
[23] *Signature*, N.S., No. 4, 1947.

George Cruikshank *Fairburn's Edition of the Funeral of Lord Nelson*, 1806. The folding etched frontispiece and 'A correct view of the Funeral Car' appear to be the earliest verifiable book illustrations by Cruikshank.
Pierce Egan, *Life in London*, 1821
The Brothers Grimm, *German Popular Stories*, 2 vols., 1823–6
J. Wright, *Mornings at Bow Street*, 1824; *More Mornings at Bow Street*, 1827
J. A. Paris, *Philosophy in Sport*, 3 vols., 1827 (many reprints, later in one volume)
W. Cowper, *The Diverting History of John Gilpin*, 1828
Thomas Hood, *The Epping Hunt*, 1829
W. Clarke, *Three Courses and a Dessert*, 1830

Charles Dickens

Sketches by Boz, 2 vols., 1836. This first edition has 16 plates. The second series, 1837, in one volume, has 10. The part issue, 1837–9, has 40. *Oliver Twist*, 3 vols., 1838. In the part issue, 1846, the plates are inferior. It is worth noting that both these books were originally serialised in magazines, the part issues being subsequent to their publication in hard covers.

Cruikshank's Comic Almanack, 19 annual volumes, 1835–53
F. E. Smedley, *Frank Fairleigh*, 1849–50 (part issue). Hard cover edition, 1850
H. B. Stowe, *Uncle Tom's Cabin*, 1852 (part issue). Hard cover edition, 1852
(R. Frankham) *The Bee and the Wasp*, 1832 (the plates are better printed in the edition of 1861)

W. Harrison Ainsworth

Rookwood, 1836. This is the fourth edition of the book, but the first to have plates.
Jack Sheppard, 3 vols., 1839. Although first serialised, with the plates, in *Bentley's Miscellany* there was a part issue in 1840 in which the plates are inferior.
The Tower of London, 1840 (first in parts)
Guy Fawkes, 3 vols, 1841 (no part issue)
The Miser's Daughter, 3 vols., 1842 (no part issue)
Windsor Castle, 3 vols., 1843
The bibliography of this book badly needs sorting out. The three-decker, which has only frontispieces, was the first to be published in book form – cf. Sadleir, *XIXth Century Fiction*. The part issue, also 1843, has wrappers and four plates by Johannot, 14 by G.C. and wood-engravings by Delamotte, but it had been serialised, with the illustrations, in *Ainsworth's Magazine*, beginning in 1842. Even more mysterious is that whereas the three-decker cost £1 11s 6d the more attractive illustrated edition appeared as a single volume in the same year priced only 14s. The latter is sometimes dated 1844. There are

other publication problems about the book, probably associated with Cruikshank's quarrel with Bentley.

Many of the illustrations for the *Miscellany* which had not previously been published in book form are collected in *Old 'Miscellany' Days*, 1885. Thirty-three etchings by Cruikshank are well printed from the original plates.

The Hone Tracts

These are all fully described in Cohn's *Catalogue* but are rather difficult to run down. The best of them are therefore listed below in chronological order with the dates of original publication. The first printings are extraordinarily difficult to find. Several were issued both plain and coloured. They were all issued unbound and stitched. Hone also issued, in 1827, through Hunt & Clarke, a collected edition with the title *Facetiae & Miscellanies*. This has a title-vignette of Hone and Cruikshank conferring over a table. A useful analysis of the tracts with an account of their political significance is in J. Routledge, *Chapters in the History of Popular Progress chiefly in relation to the Freedom of the Press*, 1876 (Chap. xix) – a volume of absorbing interest.

The Political House that Jack Built, 1819 (3 cuts); *The Man in the Moon*, 1820 (15 cuts); *Non Mi Ricordo*, 1820 (3 cuts); *A Political Christmas Carol*, 1820 (4 cuts); *The Political Showman at Home*, 1821 (24 cuts); *A Slap at Slop*, 1821 (in newspaper form – 26 cuts). Reissued in book form, 1822; *The Queen's Matrimonial Ladder*, 1826 (32 cuts, with a cardboard ladder loosely inserted).

Two other Hone tracts are of value: *The Trial of Lord Cochrane at Guildford*, 1816. Also as: *Lord Cochrane's Reasons for Escaping*, 1816 (fine coloured portrait of Cochrane); *Bank Restriction Barometer*, 1819 (in bank-note form in an envelope).

Robert Cruikshank Pierce Egan, *Life in London*, 1821, issued in parts and volume form. Illustrations partly by George.

The Universal Songster, 3 vols., 1825–6–8
Of the 84 cuts, 24 are by George and 57 by Robert.

S. T. Coleridge, *The Devil's Walk*, 1830
In the earlier copies the pagination is faulty. It jumps from 20 to 23, omitting the intervening numbers, although the book is complete. There was a whole series of booklets in chapbook form following the success of the Coleridge squib. A few of the titles are: Anon, *The Devil's Visit*, 1830; W. T. Moncrieff, *The March of Intellect*, 1830; Anon, *Monsieur Tonson*, 1830, and *Old Booty*, 1830. The cuts are excellent.

Pierce Egan, *Finish to the Adventures of Tom and Jerry*, 1830
This sequel to *Life in London* was also issued in parts and in volume form. Cohn says that no complete set of the parts was then known. All but one of the plates are by Robert.

J. Birch, *Fifty-one Original Fables*, 1833

4 Line-Engraving (with Special Reference to Turner)

Pickwick Papers was published in the year of Victoria's accession.[1] It was, as we have seen in the previous chapter, the forerunner of a whole line of novels by Dickens and others issued in the part format and with illustrations from metal plates. The craze was short-lived. Already in 1840, Chapman & Hall, the publishers of *Pickwick*, were using wood-engravings for *Barnaby Rudge* and *The Old Curiosity Shop* as they appeared serially in *Master Humphrey's Clock* and for their subsequent issue in volume form. The last work by Dickens in which metal plates were used is *The Tale of Two Cities* (1859).

The reproduction on paper of designs engraved on metal plates is older than printing from movable type. Until the nineteenth century the metal was usually copper, although zinc, iron, silver, brass and pewter have also been used. None of these metals could stand up to the long runs called for in book publication. Great improvements in the quality of steel attracted the notice of engravers in the first quarter of the nineteenth century. Heath, in England, and Perkins in America used it quite early in the engraving of bank-notes. In 1822 Thomas Lupton was awarded the Isis Medal of the Society of Arts for his use of steel in a mezzotint portrait of Munden the actor. This is the earliest recorded use of steel for this purpose. It was speedily to take hold.

Before going on to discuss some of the innumerable books in which the new medium was used it will be well to clear away a few misunderstandings. It should be said that there is no fundamental difference between engraving on steel and on any other metal. Exactly the same techniques were involved and in the best work it can be very difficult to decide which metal was used in the production of a particular print. Generally speaking it is true that steel-engravings have a crispness and brightness which is seldom attained with copper, while possibly losing some of its warmth. A discrimination should also be made between the work discussed in the present chapter and the illustrations of Cruikshank, 'Phiz', Leech and others. These, although often referred to as 'engravings' are, in fact, etchings.

On the other hand, at least in our period, pure line-engraving is almost never encountered. It is a laborious process; and since the seventeenth century, if not earlier, engravers have lightened their task by a preliminary etching of the subject, varying from bare outlines to a degree in which the drawing is almost fully developed on the plate before taking up the burin or the dry-point. Some engravers were also artists in their own right and some were masters of the technique of etching. Samuel Middiman was one of these. He was also a very fine engraver and executed some of the best of the early steel plates. But his excellent etching frequently brought him commissions from other engravers to etch the preliminary work in their plates. Turner sometimes did his own etching and John Martin engraved many of his own plates himself. Etching was also occasionally used at a later stage to strengthen lines already cut with the burin or the dry-point.

Details of the various processes used in line-engraving are

[1] The part issue ran from April 1836 to November 1837, but the complete volume bears the later date.

complicated and cannot be extensively discussed here.[2] Very briefly, in etching the line is obtained by biting in with acid a design that has been drawn with a needle through a wax-cum-resin ground covering the plate. In engraving the design is cut directly on the metal surface with the burin or the dry-point. In mezzotint the entire plate is first covered with minute dots by means of a rocker and the engraver then works out his design by scraping away the lighter parts of the design. The deeper the scraping the less ink will be taken up by the plate. Aquatint is really a variant of the etching process in which the ground used to cover the plate is partly porous.

None of these techniques is found in isolation in line-engravings of our period. They are frequently combined to an extent that it defies all but the expert to analyse: and a very high degree of expertise was called for in their execution. The necessary skills were only rarely mastered by the artist and when they were the executant was usually more gifted as engraver than as artist. There are a few notable exceptions. John Martin engraved all the 24 mezzotints for *Paradise Lost*[3] and Turner sometimes used the needle or the scraper in the preliminary stages of his plates.

This interposition of the craftsman is partially responsible for a long-continued sales resistance to line-engraving in general and to steel-engraving in particular. There are other reasons that contribute to this antipathy – the long runs and the undoubted prevalence of hack-work are among them and will be discussed later. Condemnation on the ground of lack of originality, the feeling that one is presented with an interpretation rather than a creation, while it is a common ground of criticism from experts and amateurs alike, really amounts to a sweeping condemnation of book illustration in general.

Restricting the subject to engraving for the moment, are we to despise the 1481 Dante because Botticelli did not engrave the drawings that he designed? Is the entire output of Moreau le jeune, Gravelot, Cochin and Eisen to be cast aside for the same reason? If we go further afield, it is very distinctly the exception rather than the rule that book illustrations, from the *Hypnerotomachia* to Beardsley's *Savoy*, were produced without some intermediate factor.

Objection to long runs is equally indefensible. On the one hand *The Yellow Book* is not despised because 5,000 copies of each volume were printed; and on the other hand the connoisseur of steel-engraving may confine himself to early impressions of the plates by exclusive attention to the proof editions provided by most publishers of the better books in this class.

[2] A. M. Hind, *A History of Engraving and Etching*, 1923, describes them in his introduction. He illustrates 30 tools used in the various processes. J. H. Slater, *Engravings and their Value*, n.d., does the same in his preliminary chapters with useful and informative discussions of matters of interest to collectors of line-engravings. It should be said that he is concerned with prints, rather than books, that his approach is commercial rather than artistic, and that all his valuations are out of date, although for our period they are high rather than low. The best edition is the sixth, edited by F. W. Maxwell-Barbour.

[3] He is said to have composed them directly on the plates, T. Balston, *John Martin*, 1945, p. 99. But Charles Mottram engraved many of Martin's other plates.

What has really prevented much general interest in the subject is the vast quantity of shoddy and uninteresting material with which publishers stuffed the almost insatiable appetites of an undiscriminating public. In fact, meretriciousness indicates a similarity of taste between buyer and seller.

Some of the less offensive examples of the use of unsuitable material may be found in the 'Annuals' and 'Keepsakes' which had such a vogue in the second quarter of the century – coinciding with the prevalence of line-engraving in book illustration. These 'Annuals' had a mixed origin. They combined features of the French '*Almanachs*', the German '*Taschenbücher*' and the English 'Pocket Companions' and 'Polite Repositories'. Much of their content was written round the illustrations and the general approach is expressed by Alaric A. Watts in his editorial preface to the second volume (1825 for 1826) of *The Literary Souvenir*, one of the most popular series. After announcing the satisfactory sale of 6,000 copies of his first effort he recommends 'the embellishments',

'executed, as will be seen, from *original* paintings, and drawings by the first artists of the day, in a style which, as it regards several of them, has certainly never been surpassed, if equalled, on the small scale to which they are necessarily restricted.'

This says it all and unwittingly betrays the inevitable failure of the 'Annuals' on the pictorial side.[4] Most of the subjects chosen for illustration were totally unsuited to the medium. Vast canvases by Haydon and Martin were reduced to an area of a few square inches; and one marvels at the virtuosity of the engravers in the technical excellence and clarity of some of the results. An occasional Turner, or Bonnington, or Prout is refreshing but most of the artists are remembered only by the *Kunsthistoriker*.

The miniature scale of the 'Annuals' does have a charm of its own. When it is transferred to a larger scale it becomes atrocious. A fair specimen of this undesirable practice is *Finden's Tableaux . . . of National Character*, 1838, edited by Miss Mitford, although Mrs S. C. Hall seems to have done the donkey work. The engravings were commissioned first and the text was written round them. That this was an accepted procedure is clear from the preface where the editor describes the poetry and prose supplied by her collaborators as 'no unfit companions to the beautiful Engravings which they are intended to illustrate'. This might have been, but probably was not written tongue-in-cheek. The technical accomplishment of the engravers is extremely good. Mezzotint, aquatint, etching, ruling, as well as expert use of pure engraving are cunningly employed. Unfortunately the originals from which they are taken are insipid and, with the exception of two by Uwins, are the work of hacks. They are matched by the text. Its best feature is the binding, especially attractive in morocco-bound copies.

During the short-lived craze vast sums were spent on many

[4] This is not the place to discuss their literary content which may be studied in A. Boyle, *An Index to the Annuals*, 1967. Only vol. 1 has so far been published.

intrinsically worthless productions in which pains were often not spared to ensure technical excellence. Some engravers, Heath, the two Finden brothers and Virtue, father and son, among them, found it profitable to indulge in mass production by setting up as entrepreneurs, promoting the preparation of picture-books for which they farmed out the work to groups of craftsmen and providing publishers with a finished article.

E. & W. Finden were extremely active in this field, specialising in 'Galleries' of portraits and paintings, a favourite gambit with this kind of production. Almost any book of the period with 'Gallery' in the title is a stumer. The Findens ultimately came to grief with *The Royal Gallery of British Art*, published in parts between 1838 and 1849. In this fantastically elaborate work the brothers risked and finally dissipated the considerable fortune amassed from earlier publications. Some idea of the grandiose scale of this work may be gathered from its price. As 'proofs' the set cost £63 and the ordinary edition cost £20. Failure was total even when reduced to half-price and the work was eventually remaindered at £14 14s for proofs and £6 10s for ordinary copies. It is virtually worthless today.

Mass production found another more lucrative field to exploit in the production of a rather peculiar form of travel-book. The developing taste for European travel is shown by the success of John Murray's handbooks, of which the earliest appeared in 1832. After 1827 the completion of the Corniche obviated the need to brave mountain passes on the road to Rome. By 1855 Thomas Cook was advertising a return trip to Paris for £1 11s. Here was a large and growing public for a series of picture-books with chatty texts to awaken nostalgia for the town and rural scenery of France, Switzerland and Germany. To provide them the line-engraving manufactories found ready to hand Robert Batty, a retired army officer who had fought at Waterloo. He provided excellent drawings to be worked up by the engravers. The success of *European Scenery* (1820–3) was followed by a series of volumes on separate countries during the next ten years or so.

When Batty's energy began to flag he was succeeded by two fellow travellers, William Beattie for texts and W. H. Bartlett for pictures. Bartlett later collaborated with N. P. Willis to produce *American Scenery* (1840), and *Canadian Scenery* (1842).

This once highly favoured type of book was virtually forgotten until the last few years when they have been given a new lease of life by breakers and colourists, who sell the prints separately. Some titles reach three figures in the sale-room. This kind of book-making descended in the hands of unscrupulous publishers to book-faking.

A thoroughly shoddy example of this is a two-volume work on Hindostan, undated, but probably belonging to the second quarter of the century. The text is strung together from the works of Emma Roberts, who died in 1840. The title-page boasts that the illustrations were 'drawn by Turner, Stanfield, Prout, Cattermole, Roberts, Allom, etc.' and so they are, but not a single one of them was made for this work. They are shockingly worn restrikes of plates formerly used in Grindlay's *Views in India* (1826), Elliott's *Views in Hindostan*

(1830–3), and White's *Views in the Himalayan Mountains* (1836–7). Even on their original appearance they were not of much account for none of them was original. All were based on sketches made by the amateur authors. In their later form they are not worth house-room.

The prevalence of such meretricious and dubious material in this period goes a long way towards explaining the present repugnance to it. This is unfortunate because line-engraving on metal was the basis of some of the most brilliant and desirable work in the whole of our period. Most especially because it was used by an artist of outstanding genius in the person of J. M. W. Turner.

Turner's book illustrations in this medium are so immensely superior to all others that, so far as line-engraving is concerned, it is virtually Eclipse first and the rest nowhere. His towering genius is the primary factor, but there are other major considerations that combine to make his contribution so overwhelmingly great. When we come to consider the later period, when metal was so largely superseded by wood, we shall encounter repeated instances of comparative failure due to the unfamiliarity of artists with the medium by which their drawings were reproduced. Turner not merely had a complete grasp of all the techniques of metal-engraving, he was himself an expert in them. In fact he trained a whole school of engravers to his own high standard.

'He educated a whole school of engravers, and a very remarkable school it was; he educated them first by showing them the most subtle and delicate tonality in his pictures, and afterwards by a strict supervision of their work as it proceeded.'[5]

The degree of his supervision is well seen in the fascinating collection of his marked proofs in the Print Room of the British Museum.

From the time of Bewick onwards the execution of many fine designs was bedevilled by the use of inferior paper and inks and by slapdash treatment in printing. Turner and his associates knew all that was to be known in these departments so that the technical execution was worthy of the fine material on which it was used.

One question-mark remains suspended over the whole of Turner's book illustrations. They are almost all topographical, local histories, towns of the English and French countryside – even the illustrations to Rogers, Scott and Campbell are views of places. In this respect they are exceptional. We are largely concerned in this general survey of the Victorian era with the illustration of literary texts. Cruikshank and 'Phiz' with Dickens, Millais with Trollope, du Maurier with Mrs Gaskell, Beardsley with Wilde and Pope, all embrace texts of a different character from those with which Turner was engaged; and it may not be considered sufficient justification of this extensive preoccupation with his work that it was so much better than other work of a similar kind. Yet the justification does emerge quite precisely from that standard of eminence. Paradoxical though it may appear the great interest for us of Turner's work lies in a lack of veracity in his drawings. It was here that argument raged not only

[5] P. G. Hamerton, *The Life of J. M. W. Turner*, 1879 and 1890, p. 211.

over his book illustrations but over his greatest pictures. The simple fact is that he was less interested in producing a faithful representation of a locality than in the creation of an original work of art, and if the natural ingredients of the landscape failed to conform with his requirements he changed them to suit his purpose. Hamerton devotes a large proportion of his third chapter to an analysis of his treatment of Kilchurn Castle which he illustrates with two sketches showing that Turner's drawing bears little relation to the facts beyond the inclusion of mountains and water. He shows that the castle could not be seen from the viewpoint chosen by Turner, that it bears no

20. J. M. W. Turner. *Datur Hora Quieti*. S. Rogers, *Poems*, 1834

resemblance to the original and that the mountain in the background is not Ben Vorich, as it should be, but Ben Cruachan, which is three miles away. He also mentions the glorification of Abbotsford as 'a fairy castle of vast size in a beautiful domain on the side of a noble stream' and his deception on visiting the place.

Ruskin gives several examples of the liberties that Turner indulged in.[6] In one passage he writes: 'Hills are raised and valleys are deepened; spires and castles are placed, not on the exact spots on which they will be found on an ordnance map, but where they will tell most effectively in the composition. . . .' Whatever the view taken of this by those whose principal interest is in topographical veracity, from our point of view it removes all these beautiful drawings from purely utilitarian considerations so that they may be judged as the expression of genius.

Hamerton reminds us of the prevailing attitude to art and artists at the time. He writes:[7]

'The ideas about art and artists which prevailed . . . were simply these. It was believed that painting had a practical use in handing

[6] *Modern Painters*, vol. IV, Chap. II, 'Turnerian Topography' discusses the question at length and gives (pls. 22 and 23) a striking instance of Turner's varied treatment of Nottingham at an interval of 35 years.

[7] *Op. cit.*, p. 9.

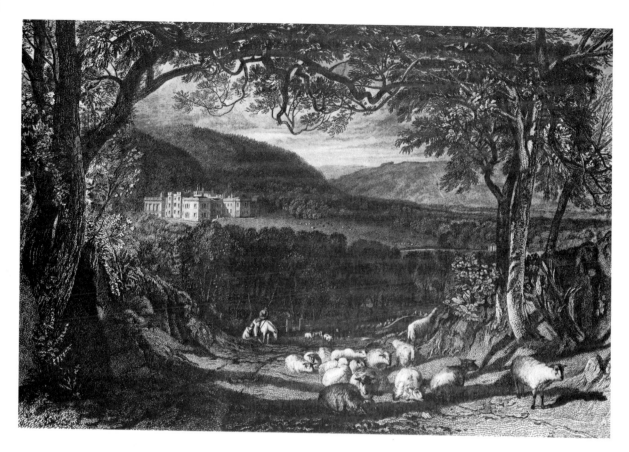

21. J. M. W. Turner. Aske Hall.
History of Richmondshire, 1823

down to posterity the likenesses of important people, and artists were
considered to be clever workmen who gave proof of a certain utility
to society in doing this.'

Ruskin, taking Turner as his text, changed all that.

Turner is said to have been introduced to the Rev. T. D. Whitaker,
Vicar of Whalley and local historian, by Edwards, the Halifax
bookbinder and fore-edge painter. Whitaker commissioned from
Turner illustrations for his histories of his own parish and of Leeds.
The results are not particularly edifying, although it is amusing to
find some of these early plates financed by local gentry with a tribute
to each on the relevant plate. The drawings must have pleased the
author – they seem to have been faithful topographically – for he
gave Turner a much more extensive and lucrative commission to
illustrate his *magnum opus*, the great *History of Richmondshire*. Long-
mans, who were to spend £10,000 on the publication, must have
welcomed the splendid set of 20 drawings that Turner supplied at a
cost of 25 guineas apiece, especially as they recouped the cost of the
drawings by selling them almost as soon as the book was published.
It is doubtful whether they will have been so fortunate with the
architectural drawings by John Buckler.

The book was an immediate success. The large-paper edition of
160 copies was sold out before publication at 48 guineas each and more

than 300 of the ordinary edition at 24 guineas were subscribed for. It was reprinted many times down to 1891. None of the intermediate printings is worth consideration, but in the 1891 edition the plates were skilfully reworked by J. C. Armytage, one of Turner's engravers and interesting notes on the localities depicted were added by Mrs Alfred Hunt. A great tribute to these drawings is that they had a share in inducing Ruskin to write *Modern Painters*. In his Preface to the first volume, to which he had then planned no sequel, Ruskin writes:

'The work now laid before the public originated in indignation at the shallow and false criticisms of the periodicals of the day on the works of the great living artist to whom it principally refers. It was intended to be a short pamphlet. . . . But, as point after point presented itself for demonstration, I found myself compelled to amplify what was at first a letter to the editor of a Review, into something very like a treatise on art. . . .'

Other living artists are referred to in the first volume but only with the object, in Ruskin's own words, that 'he who now places Stanfield and Callcott above Turner, will admire Stanfield and Callcott more than he does now, when he has learned to place Turner far above them both'. The *leit-motiv* of the five volumes to which the work was eventually extended is to demonstrate that Turner was 'the only perfect landscape-painter whom the world has ever seen'. Indeed, he made no secret of his opinion that Turner was 'a being of unequalled intellect and the greatest painter of all time'. Hamerton's confessed object in writing his life of the painter was to adjust this exaggerated perspective.

Whitaker's *Richmondshire* is by no means the only book illustrated by Turner from which Ruskin draws his examples. All the important suites of engravings are referred to and *Modern Painters* is still unsurpassed as a commentary on them.

Ruskin did not 'discover' Turner. By the year 1843, when the first volume of *Modern Painters* was first published, Turner's major work was done. He was a famous and successful painter and a rich man. But the attitude of the general public was clearly expressed in the outraged reception of his three pictures in the Academy exhibition for 1836. Blackwood's was the worst offender, demanding that 'the Hanging Committee should be suspended' and characterising 'Mercury and Argus' as 'perfectly childish . . . all blood and chalk'. This moved Ruskin to reply. He was restrained from sending his letter of protest to Blackwood's by, among others, the painter himself and the sequel has already been indicated.[8]

Richmondshire contains unquestionably Turner's finest work in this field to date; but other and greater things were to follow. Indeed, if strict chronology is observed, he had already begun work on another series of drawings which eclipse the Yorkshire series.[9] The drawings

[8] See D. Leon, *Ruskin*, 1949, Chap. II.

[9] This, too, ignores the *Liber Studiorum*, which came to an end in 1819, four years before *Richmondshire* was completed. Alas! this magnificent series of mezzotints can hardly be called book illustration.

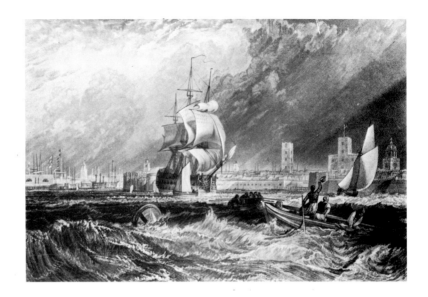

22. J. M. W. Turner. Seascape.
Harbours of England, 1856

for the latter were made in 1817 and 1818. In 1814 Cooke published the first part of the *Picturesque Views of the Southern Coast of England,* publication of which in volume form came in 1826. Despite the long-drawn-out publication and Turner's quarrel with the publishers[10] it seems to have been a success and was several times reprinted.[11]

The illustrations to *Provincial Antiquities of Scotland* (1826) are discussed on p. 73 and we turn now to *River Scenery.*

This fine work, also known as *Rivers of England,* is of major importance for the connoisseur. In 1822 Thomas Lupton was awarded the Isis medal of the Society of Arts for a mezzotint printed from a steel plate. Turner immediately proposed to the brothers Cooke that the process should be tried out for the views of English rivers projected by them. The engravers of the first three plates, Charles Turner and Lupton himself, ran into great trouble, and after printing had started new ones had to be made. Similar troubles may have been responsible for the fact that although 36 plates were projected only 21 were published – 16 by Turner, four by Girtin and one by William Collins, painter of two once popular pictures – 'The Sale of the Pet Lamb' and 'Happy as a King', the latter once a favourite subject with the chromoists, the original now in the national collection.[12]

The *Ports of England* (1826–8), was intended as a sequel to this series, but it was a failure and only six plates were issued, not in book form. In 1856 the plates for these six prints and for a further six that had not been issued, were acquired by Gambart. Ruskin wrote a splendid introduction and notes to the drawings and under his supervision the volume was published with the title *Harbours of England.* This was the only use of Turner's mezzotints in book form.

[10] See Rawlinson, *The Engraved Work of J. M. W. Turner,* 1908–31, vol. I, pp. xxix ff.

[11] See p. 81.

[12] See also p. 82.

Opinions vary on *Picturesque Views in England and Wales* (1827–38). Hamerton gives them only faint praise in an almost passing mention. Rawlinson thought them 'his central and most ambitious work in black-and-white' and 'the most brilliant and finished piece of landscape engraving which up to that time had ever been produced'. He must surely have forgotten the *Liber Studiorum*, not to mention Claude's *Liber Veritatis*, on which it was based. It is true that during the early part of the 12 years over which the publication stretched Turner's drawings have more topographical exactitude than fantasy, which partially justifies Hamerton's dictum that they were 'a continuation of the topographic labours of the artist's youth'. Ruskin would not have agreed with this. The book is not mentioned in the index to *Modern Painters*, but in vol. IV from p. 254 onwards he analyses the drawing of Bolton Abbey as an example of the liberties that Turner took with topography: and he thought that there was 'no more lovely rendering of old English life' than in the drawing of Richmond. Both of these drawings belong to 1827 and are among the earliest made for this work. The drawing of Stoneyhurst, made in 1830, is compared by Rawlinson with a view from virtually the same spot in Whitaker's *Whalley* (1801), expressly to emphasise the

23. J. M. W. Turner. Knaresborough. *Picturesque Views in England and Wales*, 1832–8

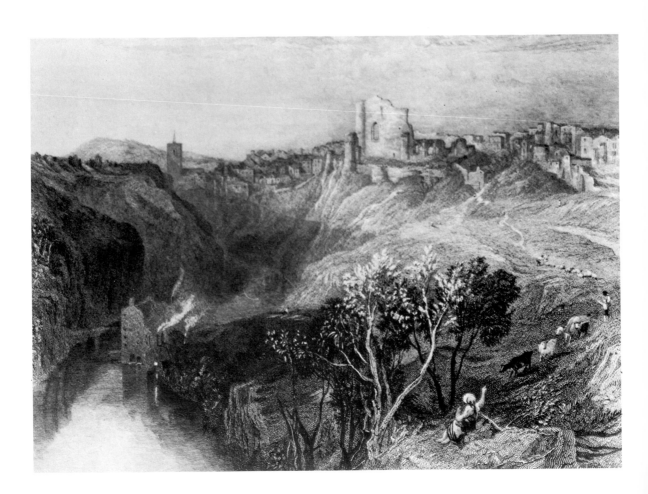

romanticism of the later design. For the broad range of its subjects, the great beauty of many of the drawings and the exquisite finish of the engravings this surely must take first place in all Turner's landscape work in this form; always excluding the *Liber Studiorum* from consideration as a book.[12a]

The checkered career of more than one of Turner's undertakings has already been mentioned. *England and Wales* suffered worse vicissitudes than any of them and ended in disaster. It was conceived on a grandiose scale, to be issued in 30 parts, each with four engravings, and a text by one Hannibal Evans Lloyd. It was offered in five different forms from 'India proofs before letters, Colombier folio, with the etchings' at £96 to 'Prints, Royal Quarto' at £21. Turner was to receive 70 to 80 guineas apiece for the drawings and the engravers £80 to £100. This entailed a total commitment of about £25,000 exclusive of the text and other overhead costs of publishing.

The promoter was Charles Heath, who began his working life as an engraver in his father's *atelier*, where considerable work was done for the 'Annuals'. Charles Heath developed the business into one of the leading 'factories' for line-engravings by promoting, in conjunction with various publishers, large quarto volumes of portraits and views in which he did little if any of the engraving himself but farmed it out to other craftsmen, several of whom may have worked in his own shop. Nothing comparable in magnitude or importance with the Turner had previously been attempted by him. Its onset was accompanied by a disturbing circumstance, for in May 1826 Heath's collection of prints had been sold at auction under circumstances that suggest financial difficulties.

All went well to begin with, however, and, with the imprint of Jennings & Co., printsellers and publishers in Cheapside, the first two parts appeared in the spring and summer of 1827. Henry Graves, whose firm had later taken over publication from Jennings, told Rawlinson that the plates were engraved as fast as Turner supplied the drawings. The first hitch occurred with the third part which was due in the autumn but did not appear until December 1827; and in 1828 only one part was published. If Graves was right the responsibility for delay was Turner's and may well have been due to financial shortcomings on the part of Heath. By the end of 1831, when 19 or 20 parts should have appeared, only 11 had been issued and publication was transferred to Moon, Boys & Graves (from Part XVIII, Hodgson, Boys & Graves). There is more evidence of muddle here as, for example, in Part XIII, published in 1832, where one engraving is dated June 1 1830 and has the imprint of Jennings and Chaplin. In 1832, with the issue of Part XV, the first volume was published, containing 60 plates, although 80 plates should have been issued if the schedule had been observed.

The second volume started badly with only one part in 1833 and two in 1834. At this point publication was transferred to Longmans, limping along with only six parts in four years, after which it came to an end with 96 engravings completed of the 120 projected.

[12a] See also pp. 82–3.

Heath was crippled by the financial burden. His health gave way and his stock was once more put up for sale. Included in the sale were the unsold prints and plates for the *England and Wales* which were bought by Turner himself. They were still in his possession when he died and the prints were included in the sale of his engravings at Christie's in 1873–4. Heath, at least, had gone down in a blaze of glory, not like his rivals, the Findens, in a shower of sparks.

It is reported by Hamerton that Bohn, the 'remainder' king of the period, turned up at the sale. He had failed to buy the stock of the *England and Wales* privately and was to be disappointed again, but Turner told him that he had bought the lot expressly to prevent reprinting. 'No more of my plates shall be worn to shadows', he said.

This was the last book of Turner's in which the plates were engraved[12b] on copper, and indeed there was little more to come in the topographic line. In 1833, 1834 and 1835 three volumes were published as *Turner's Annual Tour – Wanderings by the Loire and the Seine*, with texts by Leitch Ritchie. The title and the association are somewhat misleading for although Ritchie and Turner occasionally met and travelled together the resulting volumes were by no means the product of journeys in common made in three specific years. There is little connection between Ritchie's text and Turner's pictures, the text being thrown together from notes made on a rambling commission from none other than Charles Heath, and the drawings were based partly on earlier visits to France – a further reminder of the error of regarding such work on a purely topographical basis, which is reinforced by Hamerton's sympathetic analysis of its lack of veracity.[13]

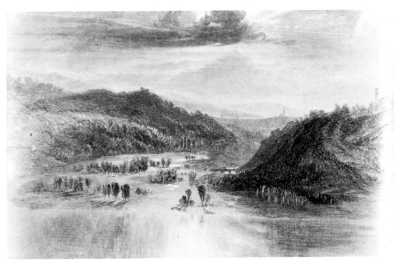

24. J. Ruskin. Lake, Cloud and Land. *Modern Painters*, vol. iii, 1826

Ruskin's extensive and informative comments on this charming series are in the first volume of *Modern Painters* and should be carefully studied with the 'Tours' themselves at hand. He is unfair to what he describes as the 'haggling, blackening, and "making out" of the engravers'.

[12b] See also p. 83
[13] In his Chapter 12.

Turner's contributions to Finden's *Landscape Illustrations of the Bible* (1836), need not detain us as they were all worked up from other people's drawings: and we now cast back to examine his work in a different field – the illustration of literary texts. It has already been said that to suggest a basic differentiation is wrong for these drawings are almost all based on actual places. In the two Rogers volumes, for instance, to which we now turn, it is clear that Stothard was commissioned to design precisely such subjects as would have been unsympathetic to Turner.

Ruskin's enthusiasm for Turner was almost boundless and frequently betrayed him into hyperbole. When he writes of the illustrated editions of Samuel Rogers's two volumes – *Italy* (1830) and *Poems* (1834) – that they contain the 'loveliest engravings ever produced in the pure line' he is thinking of Turner's superb contribution to them. Alas! there was also Stothard, not to mention the incongruous introduction of trimmings after Titian, Vasari and others. While such intrusions were in keeping with the taste of the period one cannot but regret them for their disruption of the homogeneity of the work as a whole. They are nevertheless of outstanding beauty and importance, and of their time and kind they may well stand first among equals.

The two books were published by Edward Moxon, a publisher of considerable standing. He was not in the first league with Longman and Murray, but he was high up in the second. A poet himself, he was pre-eminently the poet's publisher. In his list at one time or another were Browning, Campbell, Hood, Hunt, Lamb, Landor, Rogers, Shelley, Tennyson and Wordsworth, which was a very remarkable achievement for a first-generation publisher.

Every publisher needs a best-seller and Moxon's was Samuel Rogers, the banker-poet, with whose loan of £500 he started in business on his own account. The two books on which most money was made were the illustrated editions of Rogers's *Italy* and *Poems* mentioned above. Rogers financed the publication of these and is said to have spent upwards of £15,000 on the two volumes. Modern French publishers of illustrated books could have taught Rogers little about the possible permutations of limitation. There were copies on large paper and on largest paper and there were india-paper proofs. The volumes were available in boards and in a variety of fine bindings of which the most attractive was in green morocco, extensively gilt-tooled and with the almost invariable use of the handsome Greek vase by Allen which forms the tailpiece to 'The Fountain' in the earlier of the two volumes.

It was the author's express intention that they should be the finest illustrated books ever published. This is a pardonable exaggeration, but it is undoubtedly true that in their period and in their particular kind there is little that can be compared with them. Moreover, those that come nearest, like the Campbell of 1837, were also the work of Turner. They fall short of perfection in Rogers's inexplicable decision to share the illustrations between Turner and Stothard. In the *Italy* there are 25 drawings by Turner and 19 by Stothard. The juxtaposition

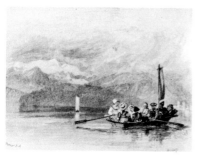

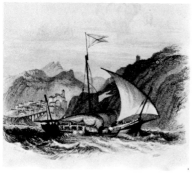

25. J. M. W. Turner. *Italy*, 1830, (above) Lake of Geneva; (below) Amalfi

is hard on Stothard for, while almost every one of the Turners is a miniature masterpiece, the best of the Stothards are *kitsch*. The incongruity is even more striking in the *Poems* where Turner rose to even greater heights, while Rogers sank even lower. His outline of Thomas More and his daughter is a disaster.

26. J. M. W. Turner. Leaving Home. S. Rogers, *Poems*, 1834

Ruskin's opinion seems to have been based on the drawings.[14] Most of the other commentators seem to agree that the engravings greatly surpass the drawings because of the curious vagaries of colouring deliberately introduced by Turner as a guide to the engravers. He nearly always worked very closely with his engravers, supervising and revising the work at every stage, and he doubtless acquainted them with the significance of these strange colour effects in relation to the technique of producing the desired effect in the finished product.

There is conflicting evidence about the terms and conditions on which the work was apportioned. Rogers's biographer[15] says that Turner received only £147 for 25 drawings but suggests that this was partly due to the sketchiness of some of the drawings. The drawings are, in fact, far from sketchy, but Rawlinson clears up the mystery. Turner was to have had £50 a drawing, but was eventually paid £5 apiece for the loan of them. This fact, interesting in itself, also sheds light on an apparently accepted practice at the time, namely that the artist's fees included the surrender of the drawings.[16] There is general agreement that the engravers received 40 to 50 guineas apiece for engravings that seldom exceeded ten square inches. This indicates the length of time taken in this work, and, indeed, the utmost care had to be exercised at every stage. The use of acid in etching the basic design had to be carefully controlled and the miniature scale of the

[14] It occurs in his *Catalogue of Turner Drawings at the National Gallery*, 1881.

[15] P. V. Clayden, *Rogers and his contemporaries*, 2 vols., 1889.

[16] This practice has been changed only comparatively recently. John Lane, for example, retained all the drawings commissioned from Beardsley.

work made retouching and correction a labour of the utmost delicacy.

One other curious feature of the illustrations may be mentioned. Turner's figures were considered to be weak and Stothard, who was rather good at them, is said to have supplied these on occasion. The tiny and totally incongruous stag in the view of Vallombrosa (*Poems*, p. 144) was supplied by Landseer.

Both books were a resounding success and were constantly reprinted throughout the early part of our period, sometimes with changes in the illustrations.

Only one other of Turner's non-topographical books quite stands comparison with the two Rogers books and that is the Campbell of 1837. It was the last important work of Turner's for the booksellers. Many of its 24 vignettes are almost as good as the Rogers and it has the inestimable advantage of homogeneity. There was no rich author to finance its publication. Moxon and Goodall, an engraver, undertook it as a joint risk, but Goodall eventually found that the terms of the agreement were greatly to his disadvantage. He was rescued by Turner who undertook the drawings on similar terms to those he made with Rogers.

The plates in the two Rogers volumes, like those in many other works of the period, were available in portfolio or bound form as proofs printed without the text, and usually on special paper. These were not usually issued by the publisher of the book but by firms of printsellers. The *Italy* suite was published by Jennings & Chaplin and the *Poems* suite by Moon, Boys & Graves, who specialised in this kind of thing and also published a suite of the excellent plates to the Author's edition of Scott (see p. 74). This practice is a reminder that letterpress and engraved plates were rarely printed in the same establishment and first came together in the bookbinder's shop. Textual changes and reworkings of the plates cannot, therefore, be expected to synchronise and are usually devoid of relative significance.

The enormous public for the writings of Sir Walter Scott made him a particular favourite with publishers of illustrated editions. Special mention must be made of *The Provincial Antiquities of Scotland*. Turner was commissioned to supply the drawings and Scott was asked to supply the text. He would have preferred that the illustrations should be made by a protégé of his, John Thomson, for whom he had procured the living of Duddingston in Midlothian. That this was not due to personal favouritism is shown by the high esteem in which Thomson is held today; but the undertaking was expensive and the publishers preferred a name. A compromise was reached, some of the work being given to Thomson. Scott had offered to supply the text without a fee if Thomson were employed and here again there was a compromise. He was given all the Turner drawings, which comprised 12 of the 52 that were made for the book, and some of the others. They were hung in the study at Abbotsford where they remained after Scott's death. Turner went to Scotland to make his drawings but he did not meet Scott, although he was entertained by Thomson.[17]

[17] For details of the publication see p. 82.

He did meet Scott in 1830 when he was engaged on the frontispieces and title-vignettes for an edition of the *Poetical Works* for Cadell, who introduced him to the authors. The three men, with Scott acting as guide, visited many of the locations of the poems, and the frontispiece to vol. VI shows them picknicking on the grass with Melrose Abbey in the background. It is possible, though doubtful, that Scott may have seen drawings or proofs of some of the 24 illustrations but he died in 1832, two years before the edition was published.

The *Poetical Works* were followed by the *Prose Works* (1834–6) in which many of the drawings are of foreign scenes, including some, like Jerusalem, that Turner had never seen, and others, like 'Napoleon on the *Bellerophon*', that were pure imagination. The frontispiece to *Provincial Antiquities* should not be missed. It is 'Norham Castle – Moonrise'. The scene was a favourite with Turner and he drew it more than once but never so attractively as here. It is odd that he did not use the subject in the edition of the *Antiquities* for he was already familiar with it. The publisher was Robert Cadell, formerly in partnership with Archibald Constable, after whose bankruptcy he set up his own account. Scott went over to the new publisher, who assumed responsibility for the huge total of debt, totalling £130,000, incurred by Scott and Constable and bought the Scott copyrights for £8,500. That he was able to accomplish this titanic task was due, in very large part, to his courage in publishing various collected editions of Scott's works, most of them illustrated.

While still with Constable Cadell had experimented with illustrating Scott's novels by native artists. In 1820 he employed Walter Allan, whom Lockhart commissioned after Scott's death to make drawings of Abbotsford, to produce a series of *Illustrations to the Novels and Tales of the Author of Waverley*. In 1821 came a *Series of Sixteen Engravings from Real Scenes Supposed to be Described in the Novels and Tales of the Author of Waverley*. These were mostly by that interesting man Alexander Nasmyth, although at least one was by John Thomson. This was followed by similar groups for individual novels, the text of the relevant passage being engraved on each plate. A selection from them was re-engraved on a slightly smaller scale as vignettes for the title-pages of a 12-volume edition published in 1823.

In 1829, in conjunction with Moon, Boys & Greaves, Cadell embarked on a much more ambitious undertaking, an entirely new edition of the Waverley Novels in 48 volumes, each with two engravings, which was completed in 1834 and reprinted in 1858 and 1862. It is probable that the engravers chose the artists, and one of their choices makes this suite notable. There are several plates after R. P. Bonington, who lived most of his short life in France and whose book illustrations are mostly lithographs made for French publishers, including several for the second volume – *Franche-Comté* – of the massive *Voyages pittoresques et romantiques* of J. Taylor of which only 20 of the projected 30 folio volumes were completed. Bonington's contribution to this *monument lithographique* included the magnificent 'Rue du Gros-Horloge'.[18]

[18] Cf. D. Bland, *A History of Book Illustration*, 1958, p. 281.

Bonington probably received the commission for the Scott drawings in 1827 on one of his rare visits to England and may have delivered them in 1828 shortly before his death in his twenty-eighth year. Apart from the Scott drawings I have encountered only one or two other engraved drawings by him between covers, in 'Annuals', including the enchanting idyll called 'The Lute' which appeared in Allan Cunningham's *The Anniversary*, 1829. This contains several other pretty things, including a view of Beckford's Fonthill specially drawn by Turner, a title-page and a pretty plate of Chillon by Stanfield, some absurd monkeys by Landseer and a portrait of Scott writing at Abbotsford. This volume should be sought in the large-paper format in which the impressions are incomparably superior.

Returning now to Cadell's ventures, all of them were given the full treatment of proofs, before and after letters and published states. Cadell now devoted himself almost exclusively to Scott and in 1842 he began publication of the Abbotsford edition of which 12 volumes appeared down to 1847 in which year, on certain conditions, he paid off the still large remaining debts on the Scott estate. He is said to have expended £40,000 on the Abbotsford edition, which was reissued by A. & C. Black in 1852–7 in 25 volumes, with more plates, and, of course, with the usual portfolio suites issued separately. The original published price of the Cadell edition was £16 16s but it was remaindered by Houlston at £11 11s after his death. Stanfield, Nasmyth, Wilkie, Turner, Martin, Allan and Leitch all contributed to Cadell's edition, but some at least of these were replicas and/or unauthorised.

Editions of plates, though not always texts, from Finden, M'Glashan, Colnaghi, Heath and many other publishers form a great tribute to Scott's enormous and continuing popularity as an author and to the avidity of the public appetite for line-engravings.

Practically all that is known about John Martin is contained in two books published in the present century to which readers may be referred for more detailed information.[19]

Martin was apprenticed to a coach-painter in Newcastle in 1803, but after the first year seized on his master's infringement of a provision in the indentures to free himself from this drudgery. After much uncongenial work in London he had a picture hung in the Academy in 1811 and in 1816 made his first etching. His reputation was made in 1821 with the exhibition of his painting, 'Belshazzar's Feast', one sequel to which was a commission from an obscure publisher called Septimus Prowett to provide mezzotints for Milton's *Paradise Lost*.

Balston[20] gives a quotation from the prospectus which says that Martin 'composed and designed the subjects on the plates themselves'. This is not only extremely interesting in itself, but is also remarkable in that the designs were made specifically for mezzotint, whereas previous use of the medium was mostly confined to the reproduction of paintings and portraits.[21] All the work was done on steel.

[19] M. L. Pendered, *John Martin, Painter*, 1923; Balston, *op. cit.* [20] Balston, p. 99.
[21] Notable exceptions pre-dating Martin are Turner's *Liber Studiorum* (1807–19) and *The Rivers of England* (1823–7), but these were largely the work of professional engravers from Turner's drawings.

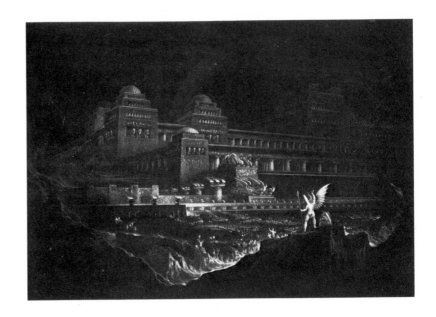

27. J. Martin. Pandemonium.
Milton, *Paradise Lost*, 1827

Publication, which was as usual in part form, and with the usual
suites of proofs with the plates in two forms – large, measuring about
8 inches by 11 inches, and small measuring about 6 inches by 8 inches –
began on 25 March 1825, the first part containing two engravings
and 48 pages of text. The part issue was completed in 1827 when it
appeared in book form in two volumes.

Fired by the success of the Milton, Martin embarked, in 1831,
on another series of mezzotints, *Illustrations of the Bible*. This time he
decided to be his own publisher, with disastrous financial results.
The full story may be found in Balston.[22] Suffice it to say that his
method of procedure was unbusinesslike, that the illustrations were
divorced from the text, that publication of the ten parts dragged on
for nearly five years and was then abandoned with plates to the Old
Testament only. In 1837 Martin sold the plates and the unsold prints,
which greatly outnumbered the sales, to Charles Tilt, who issued
them in book form, with the text, at £3 3s. Copies in this form with
Martin's imprint on the plates are from the original pulls. Later issues
with the same date, but with Tilt's name on the prints, are later and
less desirable.

These two works comprise all that is of importance in Martin's
work for book illustration.[23] They display to the full his highly
idiosyncratic work and they could have been made by nobody else.
His remarkable command of perspective, suggesting vast spaces in a
small area, which lends such majesty to all his work, is evident
throughout. In the Bible plates he relies a little too heavily on his
favourite trick of piling up massive cities as in the 'Destruction of
Sodom and Gomorrah' and the 'Fall of the Walls of Jericho'. It is
interesting to compare the effects he was able to produce in this way

[22] *Op. cit.*, pp. 139 ff.
[23] For a complete list see Balston, *op. cit.*, pp. 285–93.

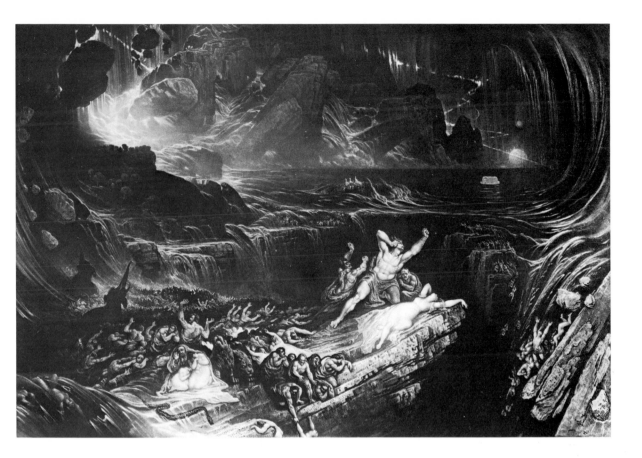

28. J. Martin. The Fall of Man
from *Illustrations of the Bible*,
1831–5

with the fifteenth-century masters, for example with Dürer's '*Das Meerwunder*', or '*Maria mit den vielen Tieren*' and to see how Martin carried it much further and made the most of it.

But the Bible plates do not compare very favourably with the Milton series which is so very much his best work in book illustration. There, for example, in 'Heaven: the Rivers of Bliss' and in 'Adam and Eve driven out of Paradise', Martin's great power of perspective is used much more subtly and with greater effect. He brought off something comparable with these in one or two of the Bible prints, for example in 'Moses breaking the Tablets'. Note, especially, the effect of the tiny figure of the golden calf in the lower right-hand corner.

But one sees the falling off in power, too, by comparing some of the Bible subjects with his earlier treatment of them in mezzotints that he made from his own pictures – 'The Deluge' and 'Joshua commanding the sun to stand still'. In the former subject the treatment is quite different. In the 'Joshua' the elements of the design are very similar, but the earlier engraving puts the later one completely in the shade.[24]

[24] Balston's reproduction of the earlier engraving is confusingly dated 1816 which is the date of the painting. Martin's mezzotint was made in 1827 and there is therefore an interval of only four or five years between it and the Bible version, evidence of Martin's failing powers.

The mystery and melodrama of Martin's brooding spirit imbue the Milton designs with the eerie pessimism that is characteristic of most of his finest productions.[25] Tragedy had a great appeal for him – his earliest success was 'Belshazzar's Feast'[26] and one of his last paintings was 'The Great Day of His Wrath' – and Milton's satanic epic gave him full scope. Selection is difficult in this series, every plate is excellent. It is said that the initial limitation of the large proofs to 50 sets and the long-continued practice of selling the plates separately has made the acquisition of the complete set very difficult.[27]

These, then, are the masters of line-engraving and the reader will be well advised to study their work in depth before proceeding further with the subject. If he does not like them he had best refrain from further investigation.

Even among the non-books an occasional treasure emerges. Such, for example, is *Art & Song* (1867), a pleasant book, issued by the meticulous firm of George Bell & Son, and with a curious history. In the foreword Robert Bell explains that the plates were commissioned by 'an amateur of fortune, with a view to an ultimate object which he did not live to accomplish'. According to Rawlinson[28] this was a Dr Broadley who had planned to use the plates to illustrate a privately printed edition of his own poems in 1844, which was never completed. The six plates by Turner were certainly executed during his lifetime, for stage proofs of them with his comments have survived. Probably most, if not all, of the other 24 were also in existence by 1844, though none was published.

Bell acquired the plates but was without a text to accompany them. The solutions are more ingenious than creditable. Taking the Turners as examples one is attached to a 'poem' by Byron which is given the title 'Lake Nemi'. It is simply one stanza extracted from *Childe Harold*. The picture entitled 'The Old Abbey' is even more curiously treated. Originally engraved from a drawing of St Agatha's Abbey it is now graced with $13\frac{1}{2}$ lines from the first canto of *The White Doe at Rylstone* describing Bolton Priory and given the title 'The Old Abbey'. 'Tynemouth Priory', one of the best of the Turners, is given the new title of 'The Northern Star' with some anonymous doggerel attached. All of which adds up to a rather shabby piece of book-making in the worst sixties style.

Nevertheless, the book is worth looking out for. The Turners are fine, with 'Tynemouth Priory' and 'Folkstone' outstanding, the five Martins by no means despicable. Robert Hills, who specialised in animals[29], especially deer, contributes two pretty groups of these animals for one of which Leitch has provided a background of

[25] They may be compared, favourably, with Turner's interpretations in the Macrone edition of 1835.

[26] Martin issued a sixpenny pamphlet on this picture when it was exhibited in 1821 with an outline etching to accompany his analysis of it (see Balston, *op. cit.*, pp. 260–5, where it is reprinted).

[27] See p. 85 for two books with wood-engravings after Martin.

[28] *Op. cit.*, vol. II, p. 324.

[29] There are said to be 1,240 etchings of them by him in the Print Room at the British Museum.

Windsor Park and for the other Henry Hills, who also contributes two rather melodramatic seascapes, has set a Highland scene. Among the many engravers is Lumb Stocks, who survived most of his colleagues. Born in 1812 he engraved plates for the *Amulet* in 1835, and died in 1892. *Art and Song* is excellently produced, the engravings, all vignettes, are on india paper laid down and they and the text are admirably printed, the text by Whittingham and Wilkins.

There is a pretty and textually important edition of the works of William Cowper edited by Southey and published between 1835 and 1837 that attracts a price in the sale-rooms only as 'furniture' – that is when rebound. In its charming original cloth binding it usually arouses little enthusiasm. It has illustrations that reveal William Harvey in an unusual guise – as a designer for steel-engravings. These are mostly views of Olney and Weston Underwood including an enchanting glimpse of Cowper and Mrs Unwin, arm in arm, walking past the summer-house in the 'Wilderness' belonging to the Throckmortons, the whole of which is still intact and very much as Cowper knew it. There are 'states' of some of the plates.[30]

In 1841 George Tattersall, a member of the famous sporting family[31] published with Ackermann a small quarto with the beguiling title *Sporting Architecture*. An architect himself, he was concerned to illustrate every kind of building associated with horses from race-course grandstands to hound kennels. The book is a delight from the symbolical frontispiece to the splendid view of racehorses passing an imaginary grandstand designed by himself. Some of the tailpieces of coursing greyhounds and mounted jockeys suggest the use of some aquatinting. Curiously enough the tailpiece to the list of illustrations is on wood, engraved by Landells. No engraver's name is given for the steels but they may be by F. W. Topham who engraved George Tattersall's 43 charming drawings for his book on *The Lakes of England* (1836). This is a small volume and the drawings are only in outline. Elusive, it is worth the few shillings for which it can be bought. Topham also worked for the 'factories' – Fisher and Virtue, and drew on wood for several books in the 1840s.

This brings us back to the topographers, but one has to tread very warily here. Stanfield, Prout, Fielding, Callcott and many other contemporaries of Turner were regularly engaged by the 'factories' and some of the publications of Cooke, Finden and Virtue in this field are worth a second glance. Clarkson Stanfield's *English Coast Scenery* (1836) drew qualified praise from Ruskin.[32]

[30] See N. Russell, *A Bibliography of William Cowper*, 1963.

[31] His father was the founder of Tattersall's.

[32] His *Sketches on the Moselle, the Rhine and the Meuse*, 1838, like Callcott's *Italian and English Landscapes*, 1847, was a suite of tinted lithographs, also available with hand colouring. David Roberts's *Views in the Holy Land* and its sequel, *Egypt and Nubia*, in its original form, 1842–6, were the most elaborate of a whole series of books using this technique. It cost £129 in coloured form and is now worth a great deal more. The dates of publication should be carefully observed and the imprint of the publisher should be F. Moon. Louis Haghe and J. D. Harding transferred the drawings to stone. It should not be confused with *Views in Egypt and Nubia*, 1824, published by Murray and lithographed by Harding and Westall.

Owen Jones's *Alhambra* includes many steel-engravings, Birket Foster worked in the medium more than once, and George Baxter's base-plates on steel are wonderful tributes to his craftsmanship. There is, indeed, plenty to choose from and even this long chapter has only scratched the surface of this unduly neglected if overworked field.

Books applicable to this chapter

There is no general guide to the subject like Forrest Reid on the sixties, or Holbrook Jackson on the nineties.

J. M. W. Turner A wealth of information is available on Turner, most of it rewarding, if nowadays neglected. The best guide to his engraved work is: W. G. Rawlinson, *The Engraved Work of J. M. W. Turner*, 2 vols., 1908–31. This is indispensable for its detailed account of all the book-work; and the long introduction to the first volume makes excellent and informative reading. Rawlinson also published the first really comprehensive study of the *Liber Studiorum*, but this has been superseded by: A. J. Finberg, *History of Turner's Liber Studiorum*, 1924.

There can be no better corrective of the current neglect of Turner as a book illustrator than: John Ruskin, *Modern Painters*, 5 vols., 1843–60 (and many later editions).

Enthusiasm that is kindled thereby may be fed with his other writings on Turner: *Catalogue of the Turner Sketches in the National Gallery*, 1857–8, revised edition 1881 and *Notes on his drawings exhibited at the Fine Art Society*, 1878.

A corrective to Ruskin's frequent hyperbole will be found in: P. G. Hamerton, *The Life of J. M. W. Turner*, 1879 and 1890.

Last and very much least, comes: W. Thornbury, *The Life of J. M. W. Turner*, 2 vols., 1862. This inexpressibly bad book is unforgivable because the author had access to those who had known the artist well and to correspondence and other papers. It is grudgingly to be admitted that, confused, repetitive, self-contradictory and generally incompetent though it is, the book contains a few crumbs of information not available elsewhere.

John Martin On John Martin there are two books: Mary L. Pendered, *John Martin, Painter*, 1923. A pioneer work, but largely superseded by: Thomas Balston, *John Martin*, 1947 which has an indispensable check-list and much bibliographical information in the text.

Selected list of illustrated books

J. M. W. Turner Much of Turner's work for the print- and booksellers originated before Victoria came to the throne. To observe rigid limits of date would necessitate the omission of many of the finest drawings,

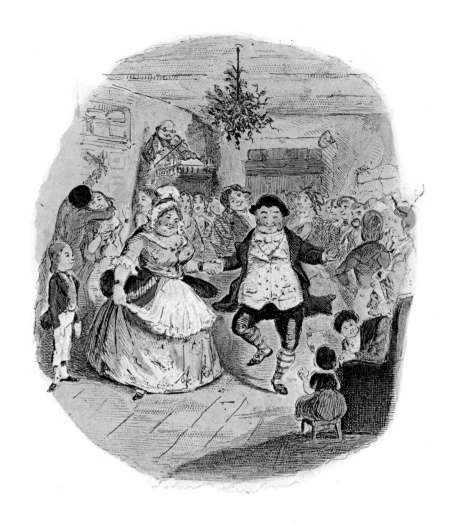

Mr. Fezziwig's Ball.

John Leech. Mr Fezziwig's Ball,
(*A Christmas Carol*, 1843)

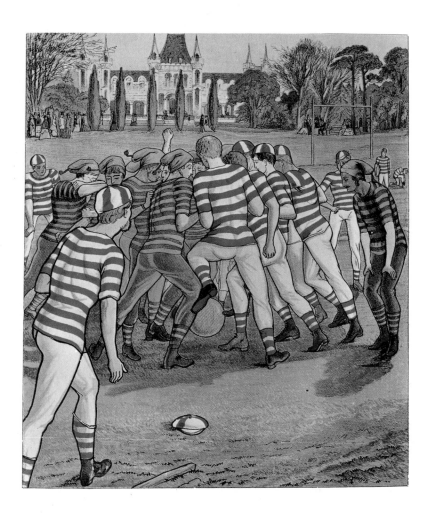

J. M. Kronheim. The Rugger
Match

although *England and Wales* was not completed until 1838, and *Harbours* came only in 1856. Moreover, the height of his popularity was reached quite late. Its onset might almost be said to coincide with and to proceed from the publication of the first volume of *Modern Painters* in 1843. The initial failure and non-completion of several works, although partly due to unbusinesslike behaviour by the entrepreneurs, surely indicates some lack of public enthusiasm, for had the subscriptions been encouraging there would have been sufficient incentive to observe schedules. The frequent reprinting of books that failed on their initial appearance is adequate proof of Victorian enthusiasm. In recent years the enthusiasm has slumbered. A re-awakening is overdue and if this book does nothing else it will be amply rewarded if it contributes to such a desirable result.

For many of the details in the following list I am heavily indebted to W. G. Rawlinson's admirable treatise; but his approach is based on the prints themselves and his information has been redrafted and amplified to treat of Turner's work as a book illustrator.

Turner & Girtin's Picturesque Views Sixty Years Since, 1824
This comes first because it gathers Turner's earliest work from *The Copperplate Magazine*, 1794–8 and elsewhere. The plates are re-touched, but the book is worth having. A reprint of 1873 should be shunned.

T. D. Whitaker, *History of Richmondshire*, 1819–23
Issued in parts and in two volumes on completion. Among the frequent reprints only the edition of 1891 is worth consideration (see also pp. 66–7). Whitaker's earlier histories, *Whalley*, 1800–1, *Craven*, 1812, and *Leeds*, 1816, are of minor importance.

Picturesque Views of the Southern Coast of England. 1814–26
Originally in parts, 1814–26. On completion in two volumes. Reprinted in 1849 as *An Antiquarian and Picturesque Tour round the Southern Coast*, and at various intervals in the *Art Journal*. In both the plates are badly worn. Some of the plates were included in some editions of *The Turner Gallery*, 1859 and 1875, but the plates were almost worn out by then. 'Proofs' were issued at a fancy price; but these seem to have been fabricated by removing the original lettering and are worthless. In 1891 the plates were skilfully reworked by J. C. Armytage who managed to recapture a little of their former glory.

Rawlinson (*op. cit.*, vol. 1, p. 46) reprints the original prospectus in part from which it would appear that in parts the work was available in three forms: proofs at 18s a part; prints at 12s 6d a part; india proofs 'a few . . . for the accommodation of the curious' at £1 10s a part.

Each part contained three large plates and two vignettes, with descriptive letterpress to each part. In volume form ordinary paper proofs cost £14 14s and prints £10 10s.

This would have made 48 plates and 32 vignettes in all and that, in fact, is what it contained as originally published. Eight of the plates and all of the vignettes are by hands other than Turner's.

A feature of this publication, which is common to other books with line-engravings after Turner and others, is that whereas the

prospectus was issued by the engraver, in this case W. B. Cooke, the book publication was in the hands of Arch. In the case of the *England & Wales* (see below) three parties took a share – the engraver, who projected the work, the printseller who took in subscriptions and displayed the parts for sale, and the eventual book publisher. The permutations in that instance are even more complicated, for the first volume was on sale with the printseller Jennings, but on completion was handled by Longmans.

Walter Scott, *The Provincial Antiquities of Scotland*, 1825–6
Originally in parts. On completion in two volumes: india paper proofs £15, prints £8.

River Scenery, 1823–7
No details are available of the part issue, 1823–7; or of its publication in volume form in 1827; but it is probable that the usual variety of proofs was available. There were reprints by Jones and Bohn, but they are quite worthless for, even though made on steel, the life of mezzotint plates is short.

The Ports of England, 1828
Twelve mezzotint plates were prepared for this work by Thomas Lupton, whose personal venture it was. Only six were issued and those in very limited numbers. After Turner's death the plates were secured by Gampart. They were printed under the expert supervision of John Ruskin, who provided a text for them, and published as *Harbours of England*, 1856 at £2 2s.[33]

One of the few useful things in Thornbury[34] is a reprint of the prospectus for the *Ports*, according to which it would appear that at least 48 plates were visualised. These were to be issued serially, two plates to a part, 12 parts to a volume. In part form there was no text, but 'At the completion of each volume will be published in handsome letterpress (detached), an Historical Account of the Rise and Progress of the Ports up to the Present Time. . . .' Subscriptions were invited in three forms – prints, 8s 6d, proofs, 12s 6d, india proofs 14s. These prices were presumably for parts. In addition to Lupton, the engraver, subscriptions were accepted by Ackermann and Colnaghi.

Picturesque Views in England & Wales, 1827–38
The part issue was projected in five different forms:

India proofs before letters. Colombier folio, with the etchings	£96
India proofs (as above) without the etchings	£80
India proofs, lettered. imp. quarto. (30 copies printed)	£48
Proofs on plain paper	£31 10s
Prints – royal quarto	£21

These prices and details are taken from Rawlinson, who gives them as 'the original advertised prices', which would have been for 120 engravings, as first projected. In fact, in its final form (1838) in two volumes, with 48 plates in each, plain-paper proofs and prints were

[33] For later editions see an article by James S. Dearden, 'Wise and Ruskin' in *The Book Collector*, Spring 1969.
[34] *Op. cit.*, vol. I, pp. 411–12.

on sale at £31 10s and £21 respectively. The price of the first volume, as published in 1832, has not been ascertained.

Turner's purchase of the unsold prints was not a good investment. They were split up and sold at Christie's in 1874 and although they made up the better part of a day's sale they realised only a fraction of what he had paid for them. Most of the leading printsellers of the day were among the purchasers.

Samuel Rogers, *Italy*, 1830; *Poems*, 1834
In book form these two works are reasonably straightforward. It is said that in later impressions of *Italy* the vignettes on pages 89 and 91 were transposed, but even if that is so it is of very little consequence. The first editions are preferable, although impressions in the early reprints are often sharp and clear. There were small 'special' editions of both books in which the word 'proof' occurs after the engraver's name and these are the best of all.

In 1838 quarto editions of both works were issued in which unsold sets of the proof suites were cut down and inserted. These cost £2 2s each as against 16s for the original editions. Both editions went to a premium.

As was usual at the time, the engravings were also on sale without the text, and although strictly speaking this is not our concern, points of interest do arise therefrom, at least as far as *Italy* is concerned. The printseller handling the suites was R. Jennings of Cheapside. The prints for *Italy* were prepared in two batches, one dated September 1829 and the other dated 1 January 1830. Most of the first batch have the imprint of Jennings alone, but a few have the imprint of Jennings and Chaplin, which appears on all of the second batch. There is also evidence on some of the pre-publication proofs that they were in hand in 1827. This shows the length of time needed by engravers for the preparation of steel plates. It also disposes of any suggestion that Rogers first commissioned the drawings 'about 1830'.[35] Thornbury[36] prints a letter from Turner to J. Robinson of Hurst and Robinson, who took over Alderman Boydell's art gallery, in which the artist estimates the time required to engrave a steel plate at two years.

J. M. W. Turner and L. Ritchie, *Annual Tours*, 1833, 1834, 1835
These three volumes, devoted to scenes on the Loire and the Seine, do not appear to have been issued in parts. There were proofs of the engravings. The books were published on large and small paper at £2 2s and £1 1s respectively. A reissue by the original publisher, Longman, of the three volumes in one, as *The Rivers of France*, 1837, cost £1 16s on large and £1 15s on small paper. Reissues by another publisher in 1853 and 1857 as *Liber Fluviorum* are not worth considering. In 1886 there was another edition with the plates reworked by J. C. A. Armytage.

Walter Scott, *Poetical Works*, 12 vols., 1834; *Prose Works*, 28 vols., 1834–6
These contain some 65 engravings in all by Turner, including some very attractive drawings, but the bulk of the 40 volumes is

[35] Cf. e.g. Rawlinson, *op. cit.*, vol. I, p. 1.
[36] *Op. cit.*, vol. II, pp. 250–1.

rather tiresome. The sets can be picked up very cheaply: but the proofs can also be bought for very little.

Finden's Landscape Illustrations to the Bible, 1836

Turner contributed 25 of the 100 plates in this edition. Callcott and Roberts also contributed. All of the drawings were worked up from sketches by others, some of them amateurs, which robs them of some interest, although there are beautiful things among them.

John Milton, *Poetical Works*, 1835

This contains seven tiny vignettes by Turner which, although highly thought of by some, do not bear comparison with the Rogers or the Campbell.

T. Campbell, *Poetical Works*, 1837

This contains 24 vignettes by Turner in the style of the two Rogers volumes and in some ways is preferable for its homogeneity. There were three editions costing between 8s and £1 10s for various states of the prints. Rawlinson[37] gives an account of the publishing history of this edition which he had from the son of Goodall, the engraver of the vignettes, who was jointly interested with Moxon in the venture.

John Martin John Milton, *Paradise Lost*, 1825–7

Part issue in various forms. For details see Balston, pages 97 and 286. There is some confusion on the published prices of the four editions and, indeed, on the general arrangements for the publication. Balston writes on page 96 that Martin received £2,000 for 24 mezzotints. On page 98 he says that the artist's 'energy was declining before the forty-eight plates were finished'; and on page 286 he lists 24 plates in the complete work. There were, in fact, only 24 plates, but each had to be engraved twice – once for large- and once for the small-sized plates.

There were numerous reprints of the large and small series between 1837 and 1866 in which the plates show steady deterioration. In 1876 Bickers issued an edition of Milton's *Poetical Works* with small photographic prints of the larger suite.

Illustrations to the Bible, 1831–7

Originally in ten parts, each with two plates and occasionally with minimal text, 1837 – book form, with text (see p. 75). 1839 – reissue in smaller format. An undated edition, with the imprint of Sangster, the Bible publisher, on the prints shows the shameful degree to which plates such as these were exploited by undiscriminating publishers.

Annuals

Two of these are interesting because Martin himself engraved the mezzotint for them. They are: *The Amulet*, 1826, (two mezzotints); *Friendship's Offering*, 1829, (one mezzotint).

The medium is hardly suited to the small size, especially with such detailed subjects as Martin's. It is also unsuitable for long runs and early impressions should be sought.

[37] *Op. cit.*, vol. I, pp. lix–lx.

Several other illustrations in 'Annuals' are listed by Balston, engraved by others, and often taken from unsuitable originals.

Illustrations of the Bible, 1835; *Illustrations of the New Testament*, 1836
These really belong to the wood-engraving section. The two volumes contain respectively, 96 and 24 wood-engravings, in each case half by Martin and half by William Westall. John Jackson was among the numerous engravers employed in these volumes and in the 1861 edition of the *Treatise on Wood Engraving* he includes several of the designs, with interesting notes on some of the engravers.

Sir Walter Scott

Illustrated editions other than those listed under Turner.

Letters on Demonology and Witchcraft, 1830
Simultaneously with the publication of this book by Murray in the Family Library George Cruikshank published, through J. Robins & Co., a suite of 12 etchings illustrating the work. These were in two forms, india paper proofs and prints. They were not published with the Murray edition.

The Family Library was not a success and was eventually remaindered to Tegg. During the last 50 years copies of the first edition sheets of the Scott volume have turned up in suspiciously new condition with the plates in *three* states, one set coloured. No coloured sets were issued by Robins or Cruikshank. These copies are usually bound rather strikingly in red morocco by Wood, with small gilt tools emblematic of witchcraft. They are obviously a sequel to a *trouvaille*. But where did the first edition sheets come from?

Illustrations to Scott's Poetical Works, 1834
In its original form this was a portfolio of 40 plates issued by Tilt without text, but afterwards issued with the text in four volumes. The only set of the latter examined has engraved titles with Tilt's imprint, dated 1838–9, but the printed titles, undated, have the imprint of David Bogue, who took over Tilt's business in 1844, having been in partnership with him from 1841 to 1843.

Three of the plates are by Turner and are identified by Rawlinson as small replicas from the *Provincial Antiquities*. They were probably made without consulting Turner and it is entirely consonant with Tilt's general practice that the other artists' work was also pirated. Bogue was later sued by Bohn for poaching other copyright plates.

Waverley Novels, 48 volumes, 1836–40
This edition was published by the rather dubious firm of Fisher, Son & Co., and it has some curious features. There are 108 plates in all, including 35 etchings by Cruikshank. The rest of the illustrations are steel-engravings, including six by Turner, at least one of which for *The Antiquary*, is a beauty. It makes a mixed bag but the separate issue of proofs, either in 18 parts or two volumes, is worth looking at. They should bear the imprint of the original publisher and be dated between 1837 and 1838. In book form the imprint includes a Paris address[38] – notable not only for the enterprise of the publisher, but

[38] There was a French edition in 36 parts and in two vols. on completion in 1840–1.

also for the great interest in Scott abroad. There is a reissue by Jackson in 1841 and the book edition was remaindered to Houlston in 1846.

The Waverley Gallery, 1840

'Engraved under the direction of Charles Heath', this set of portraits of Scott's female characters is not to be taken seriously, but may be mentioned as one of the best of the 'Gallery' books, of which there were many. There is a jolly Kenny Meadows and three pleasant drawings by John Hayter. The other artists belong to the rank and file, with F. P. Stephanof as their lance-corporal. Nevertheless, meretricious though this kind of book-making was, in fine condition and in the splendid morocco bindings with which they were frequently provided, though we may despise them as books, as Victorian artifacts they have a place. This one is best seen in the excellently hand-coloured copies.

The above is a selection from the numerous illustrated editions of Scott. There was a rather fine series issued by Finden with engravings after Prout, Fielding, Cattermole, Roberts, Daniell and others which has not been encountered in book form, or dated. Richard Westall made some rather insipid drawings which are sometimes found with separate editions of the works, notably in late editions of the quarto poems – *Marmion, Rokeby*, etc.[39]

Lord Byron

Byron was not so great a favourite with the engravers as Scott. The original editions are very difficult to sort out and the effort is less rewarding, for reasons that will emerge in the descriptions of some of them below.

The Findens come top in this field and almost monopolise it with their frequently and variously reprinted engravings for the:

Life & Works of Lord Byron, 17 vols., 1832–4

This edition was a great favourite with Samuel Chew, the American Byron scholar, who remarked especially 'the modesty, sobriety, and restraint of its lovely line engravings'.[40]

There are no fewer than 156 engravings, all vignettes, and the artists include Turner, Stanfield, Prout, W. Westall and Harding. Rawlinson says that many of them appeared in earlier editions, but they 'are now difficult to trace'. Seen in the original 24 parts they make a fine show, especially as india paper proofs. They were also issued in this form in three quarto volumes, without the text, but furnished with descriptions by William Brockedon. The imprint on the early states of the engravings show an unusual variation of normal publishing practice in this genre. It reads: 'Published 1832 [–4] by J. Murray and sold by C. Tilt. . . .' This must mean that Murray commissioned the plates from the Findens and that Tilt purchased a

[39] See Ruff, *Bibl. of the Poetical Works*, 1937.
[40] *Byron in England*, 1924, p. 240.

sufficient number to warrant the inclusion of his name in the imprint. Murray's command over the engravings is further shown by his later use of 62 of them to illustrate a separate edition of *Childe Harold* in 1841.

Murray reduced the price of the original 17-volume edition from £4 5s to £3 3s in 1846. At some later date the plates came into the possession of A. Fullarton, who substituted his own imprint for the original.

Finden also published: *A Gallery of Byron Beauties*, 1838 (?). This is similar in style to the *Waverley* and the *Shakespeare* galleries and similar remarks apply to it. There seems to have been a reissue by Smith & Elder in 1850. *The Illustrated Byron*, 1857, has about 200 engravings after Kenny Meadows, Birket Foster, 'Phiz' and others, but is unimportant.

Thomas Lupton

Lupton, who played a considerable part in the introduction of steel for use in line-engraving, has at least one first-rate book to his credit. Lady Charlotte Bury, *The Three Great Sanctuaries of Tuscany*, 1833, with six engravings in bistre by Lupton.

Clarkson Stanfield

This artist will frequently be found with Turner and others in books of this style and period, chiefly for the seascapes in which he specialised. Ruskin thought highly of his *English Coast Scenery*, 1836. But he is more interesting for us for having illustrated two novels, both by Captain Marryat:

The Pirate and the Three Cutters, 1836 and *Poor Jack*, 1840

Both were issued in parts and afterwards in volume form. For the curious story of the plates in the later work reference should be made to Sadleir, *XIXth Century Fiction*, 1951, vol. 2, p. 240.

W. H. Bartlett

W. H. Bartlett was not a very distinguished artist, but he did prefer to make his drawings on the spot, and occasionally wrote the text himself. An example of this kind is his *Forty days in the Desert on the Track of the Israelites*, 1848.

He collaborated with William Beattie, with whom he made several tours, the most favoured results of which are now *Switzerland,* 1830 and *The Danube*, 1844.

Both of these, however, are inferior, in sale-room terms, to two collaborations with N. P. Willis: *American Scenery*, 1840 and *Canadian Scenery*, 1842. The book-breaker and the colourist probably account for the latter costing three figures at auction.

Bartlett has some pretty drawings in:

Thomas Wright, *The History of Essex*, 2 vols., 1836

The architectural drawings are almost uniformly wooden and uninspired, but when he lets himself go a bit he can produce attractive landscape studies like the bridge over the Chelmer at Little Easton, the Terrace at Southend, or the main street at Dedham. Some of his subjects have changed very little in the interval, though several are now threatened by the march of progress.

E. & W. Finden's Publications

Landscape Illustrations to the Bible, 3 vols., 1835–6. The plates are worked up from sketches by amateurs by Turner, Callcott, Roberts and others.

Landscape and Portrait Illustrations to the Life and Works of Lord Byron, 1836

Ports, Harbours and Watering Places of Great Britain, 2 vols., 1842[41]

The Royal Gallery of British Art, 1838–49. Only for those who are interested in the bravura of the engravers' works. A few excellent examples of their virtuosity will be found in:

The Court Album, 2 vols., 1853–6. Portraits of beauties of the day

The Shakespeare Gallery (*c.* 1842). Look for Tilt's imprint, not Bogue's on the title-page

The Cabinet Gallery of Pictures, 2 vols., 1836. The bindings on these are usually outstanding and seem to cost little more in morocco than in cloth (see also *The Waverley Gallery*, p. 86).

Books illustrated by line-engravings have been given this lengthy treatment because of the general lack of information available about them, which has caused them to be unduly neglected. There is at least as much rubbish in this field as in any other and the amateur will do well to confine his attention initially to Turner and Martin, undisputed masters of the medium, before adventuring with lesser lights – even though this should mean that he finds the latter not worth bothering with.

[41] The Sotheran & Willis Catalogue, 1862, lists 'an original copy' (1840). It was also reissued in 1842.

5 Pickwick, Punch and other Periodicals

An enormous fillip was given to book illustration by the success of the part issues of novels by Charles Dickens. Part publication was nothing new[1] but wildfire success in this medium began with Dickens. The formula for the first of them, *Pickwick*, reads like a ready-made, copper-bottomed recipe for failure.

Robert Seymour, a self-taught and unsuccessful painter, was employed by Chapman & Hall to illustrate a comic annual called *The Squib* (1835–6). His etchings were not particularly brilliant, but he had developed a turn of cockney humour and was particularly successful with sportsmen. He showed Chapman & Hall a number of drawings of this sort and they agreed to find an author to write a kind of picaresque novel around the incidents depicted in the drawings. It was to be called *The Adventures of the Nimrod Club* and to be issued in monthly parts at one shilling each. Thomas Hood, Theodore Hook and Leigh Hunt were among the authors considered, but the choice fell on Dickens, a fledgling author of 23, with a book of London sketches to his credit.[2] One imagines that the publishers had encountered reluctance on the part of established authors to subject themselves to the artist's whims and William Hall, who interviewed Dickens on the subject, may have thought that youth and inexperience would make him more subservient. It became clear almost at once that this was not entirely so. Dickens protested his unfamiliarity with sport and sportsmen, and expressed his strong conviction that the illustrations should arise from the text. He discarded the 'Nimrod' idea altogether and took the name Pickwick from a jobmaster in Bath. He retained the notion of a club out of deference to Seymour's original idea and invented the character of Mr Winkle for his special benefit. Seymour's first sketch of Pickwick was a tall, wiry individual like most of Seymour's sportsmen, but Chapman, who had had a glimpse of Dickens's text, protested that the hero's cheery good nature called for plumpness and took Seymour down to Richmond to see 'a fat old beau who would wear, in spite of the ladies' protests, drab tights and black gaiters'. As a result Seymour's drawing of the club in session was the best he ever made and fixed the likeness of the hero once and for all.

Publication of the parts began in April 1836, and continued until November 1837, but not uninterruptedly. On 20 April 1836 after he had completed seven plates, Seymour committed suicide. The second part was issued with only three plates and a new artist, R. W. Buss, hastily produced two plates for the third number but they were poor efforts. John Leech applied for the succession and so did Thackeray, who had as yet made no great literary mark, and still

[1] See, for example, Graham Pollard, 'Serial Fiction' in *New Paths in Book Collecting*, 1934.

[2] Some apparent overlapping with *Oliver Twist* (see pp. 43 and 91) should be cleared up. The first volume of *Sketches by Boz* appeared in 1836. It is possible that William Hall first approached Dickens on the collaboration with Seymour even before this date, but the *Sketches* were already well known, having begun to appear in 1833. In April 1836 the first number of *Pickwick* appeared. On the eve of the appearance of the sixth number, in August 1836, Dickens signed a contract with Bentley as editor of his new *Miscellany*, of which the first number appeared in January 1837.

29. Phiz. The First Appearance of
Mr Sam Weller. *Pickwick*, 1837

considered himself an artist rather than an author.

Dickens himself now took a hand, deciding that this was his opportunity to assume the dominant share in the partnership. He picked on a young man, not yet 21 and quite unknown, Hablot Knight Browne. There is every sign of the deliberate nature of the changes being made by Dickens himself. Thus, the number of text pages was increased from 24 to 32, while the reduction of plates from four to two, due to necessity in the third part, was regularly adopted. Most important of all, and a major sign that the course of *Pickwick* was now to be directed by the author rather than the artist emerged with the introduction of the character of Sam Weller in the fourth part. One of Browne's first two plates, signed with the pseudonym 'Nemo' which he soon abandoned for 'Phiz' as more compatible with the author's 'Boz' showed Mr Pickwick's first meeting with Sam in the yard of the White Hart Inn.

The plate is preceded in Part 4 by one showing the breakdown of Mr Wardle's coach in the pursuit of Jingle, but the Sam Weller one,

that follows it, was actually etched first. Croal Thompson's account of this makes it clear that Dickens had impressed upon Browne the importance that he attached to the figure of Sam.[3] The artist and his friend Robert Young sat up all night biting-in the steel plate.

The success achieved by these changes was phenomenal. Of the first Part 1,000 copies were printed, and only 400 were subscribed for. The printing order for Part 2 was therefore reduced to 500. Considering that Dickens was paid 14 guineas for each part this was a confession of failure, for even taking into account the revenue from the advertisements that appeared in each part, a heavy loss must have been envisaged if sales did not improve considerably.

Fortunately they did. Before the year was out 40,000 copies of each issue were being sold. The demand for copies of the earlier parts created acute problems for the reprinting of the etchings. Even in the first part it was found that Seymour had used inferior metal which began to break down after 50 impressions had been taken. The quality of the metal was not the only consideration, or even the main one; for the task of producing 40,000 impressions of two etchings every month was prodigious. This was partially solved by Browne producing duplicates of the plates so that they could be worked off at two machines. Even this was sometimes inadequate and lithographic transfers were prepared for some plates to keep up the supply. Haste was also occasionally necessitated by the author's or the artist's failure to produce the material punctually. Dickens makes oblique reference to this in his Preface to the first edition of *Pickwick*. It was not until about 1850 that the perfection of the electrotype process solved this problem and by that time wood had largely replaced metal as the basis of book illustrations.

The reputations of both author and artist were made by *Pickwick* and 'Phiz' remained Dickens's favourite illustrator. Out of 363 steel plates used in the part issues 'Phiz' was responsible for 290; the remaining 73 were divided among four artists. Of the designs for wood-engravings he drew 157 out of 252, the remainder being divided among five artists. He was always at his best with Dickens; although he became very popular with publishers generally and illustrated many books for children.

Before *Pickwick* was much more than half finished Dickens was at work on *Oliver Twist*, which appeared serially in *Bentley's Miscellany* from February 1837, until March 1839. But the writing and illustrating of it had to be completed several months earlier to permit publication in volume form. It came in the nature of a bombshell, therefore, when Macrone, fired by the success of *Pickwick*, announced his intention of reissuing the Boz *Sketches* in part form. Dickens saw at once that this would overload the market, but Chapman & Hall came to the rescue by advancing the fantastically large sum of £2,000 to secure the copyright and the postponement of the part issue, which was begun in November 1837 and continued until June 1839, thus overlapping *Pickwick* at the one end and *Nicholas Nickleby* at the other.

Oliver Twist was thus the only one of the novels to date that

[3] Croal Thomson, *Life and Letters of Hablot Knight Browne, 'Phiz'*, 1884, pp. 88–92.

escaped part publication. It was used, in 1846, in that form to fill a gap between *Chuzzlewit* and *Dombey* and on completion the parts were collected into a single volume. The rarity of this part issue today suggests that it was not a success. Indeed, events were beginning to catch up with Dickens. His own success had brought rivals into the field. Ainsworth has already been mentioned. There were also Mrs Trollope, Marryat, Le Fanu, Lever and Lover, and overlapping *Dombey* the considerable rivalry of Thackeray's *Vanity Fair*. As Dickens's biographer puts it 'the forty and fifty thousand purchasers of *Pickwick* and *Nickleby*, the sixty and seventy thousand of the early numbers of the enterprise in which *The Old Curiosity Shop* and *Barnaby Rudge* appeared, had fallen to little over twenty thousand'. Chapman & Hall, perhaps unduly alarmed by this fall in circulation, tactlessly chose this moment to remind him that his share of the copyright purchases of *Sketches* and *Oliver Twist* had not yet been paid off. Finally *Barnaby Rudge* and *The Old Curiosity Shop* had appeared serially in *Master Humphrey's Clock* the weekly numbers of which cost only threepence, on which the profit must have been small.

This conjunction of circumstances caused Dickens to assume an entire change of policy which included a change of illustrator and eventually of publisher also. Hitherto, since working with Browne on *Pickwick*, Dickens had remained faithful to him. Thus, disregarding booklets like *Sunday Under Three Heads* and *Sketches of Young Gentlemen*, Browne produced 40 etchings each for *Nickleby* and *Chuzzlewit* as well as a wrapper design, and while these added no figures quite comparable to Mr Pickwick or Sam Weller new additions to the personifications of the great Dickens Gallery included

30. Phiz. Sim Tappertit. *Master Humphrey's Clock*, 1841

Wackford Squeers, Vincent Crummles, the Mantalinis, Pecksniff and Mrs Gamp.

The Old Curiosity Shop and *Barnaby Rudge* were illustrated from drawings on wood mostly engraved by Landells or Gray and mostly drawn by Browne, although a few are by Cattermole, including 'The Maypole Inn'. Here were a host of new characters – Little Nell, Dick Swiveller, Quilp, Codlin and Short and Mrs Jarley in the first story; and Barnaby himself, Sim Tappertit, Miss Miggs and the Willetts in the second. There were other cuts in the *Clock*, including scenes with the Wellers and Mr Pickwick.

In an ill-advised and unsuccessful attempt to retrieve what he regarded as his shattered fortunes Dickens now decided to become his own publisher; and although his contract with Chapman & Hall necessitated their handling of two more books after *Chuzzlewit* Dickens took complete charge of the production of *A Christmas Carol* – with disastrous financial results. He engaged John Leech, to produce four etchings to be coloured by hand and four wood-engravings. Leech, who, at the age of 19, had unsuccessfully proposed himself to succeed Robert Seymour as illustrator of *Pickwick*, had not previously worked for Dickens, but was now the principal artist on the staff of *Punch*. He did his work well and his etchings of Mr Fezziwig's Ball and of Marley's Ghost vie with the cuts of Scrooge and Bob Cratchit for a place alongside the best scenes of the beloved text.

The book went off well. Even at the high price of five shillings a first printing of 6,000 copies was sold before Christmas and 2,000 of a second printing went before twelfth night. Dickens expected to make £1,000 on the first printing alone and was disgusted to find that it left him with only £230 to his credit. His displeasure with Chapman & Hall was intensified, quite unjustly for it was his own experiments with various colourings for the end-papers and title-page and the hand-colouring of the plates (£120 for the first and £140 for the second, not yet sold out) that ran away with the money.

He did better with the other three Christmas Books which, apart from an etched frontispiece and title after Maclise for *The Chimes*, are illustrated entirely by wood-engravings. The principal and the best of the artists is always Leech, who has fine things in all four volumes. The other artists include Doyle, Tenniel and Clarkson Stanfield. Each of these artists might be well enough on his own account, while liable to clash with his colleagues if used between the same pair of covers.

Thus, in *The Chimes*, Leech's fine pictures of Trotty Veck contrast most unfortunately with Dickie Doyle's airy-fairy portrayal of the same character, and in *The Battle of Life* Leech's Snitchey and Graggs, Maclise's Secret Interview and Stanfield's Nutmeg Grater, while all of good quality, are hopelessly incongruous together. It was still the pleasant custom at this time to include engravers as well as artists among the credits. Dalziel is mentioned among the engravers in *The Chimes*, but the block is signed by W. J. Linton, who fled to America to escape the need to engrave other men's work – an early example of

And let us not remember
Italy the less regardfully,
because, in every fragment of
her fallen Temples, and
every stone of her deserted
palaces and prisons, she helps
to inculcate the lesson that
the wheel of Time is rolling
for an end, and that the world
is, in all great essentials,
better, gentler, more forbear-
ing, and more hopeful, as it
rolls!

THE END.

the brain drain. In that volume he showed his skill equally in the interpretation of both Leech and Doyle. Gilbert and Edward Dalziel appear in *The Battle of Life*.

After *The Chimes* Dickens broke off relations with Chapman & Hall and was published elsewhere for the next 15 years. For the next couple of years he was travelling and living abroad for most of the time and apart from the Christmas Books produced only *Pictures from Italy*, a minor work but precious for us in being one of the few books with illustrations by Samuel Palmer. There are but four vignettes of Italian scenes by him, but they are exquisite.

In 1846, Dickens resumed his partnership with 'Phiz', who provided the etchings and the wrappers for *Dombey and Son*, and in 1849–50 another masterpiece of text and illustration in *David Copperfield*, perhaps most people's favourite in both spheres. The Peggottys, Mrs Gummidge, Mr Dick, Traddles, Uriah Heep and, best of all, Mr Micawber are among the immortals.

The characters in *Dombey* are less interesting than those in *Copperfield* but it has an importance for us in the record that is available of the pains that Dickens took, whenever he could, to keep his artist in touch with the likely development of the story and the implications of this in relation to the pictures. On 10 March 1847, just back from his long sojourn in Switzerland and France, where he had begun the

31, 32. S. Palmer. (opposite above) Tailpiece from *Pictures from Italy*, 1846; (opposite below) The Dell of Comus. Milton, *Minor Poems*, 1889
33. Phiz. (right) Major Bagstock is delighted. *Dombey and Son*, 1848

writing of *Dombey* he wrote Browne a long letter about one of the plates that would be needed for Part 7 – the April issue.[4] This is the illustration lettered 'Major Bagstock is delighted to have that opportunity'. Browne had not yet seen the text and Dickens summarises the incident to be portrayed and describes the characters that appear in it – the rascally Major, Mr Dombey, Miss Tox and Co. He would like to see Browne's sketch before he starts on the plate itself. Five days later he approves and returns the sketch and Browne had to work quickly to be in time with his two plates for the April part. Delay in the preparation of one design always delayed its companion for it was the custom to etch both on one quarto plate so that they could be printed in one operation, the sheet being divided after printing. Let it be said that if Bagstock is not one of Dickens's major characters he is certainly not the least of Browne's.

Dickens sent equally detailed information for the plate in Part 4 where Paul Dombey is seen walking on the shore in a 'crocodile' under the supervision of Dr Blimber. The letter must have been delayed on its way from Paris for although Dickens expressly states

4 Croal Thomson, *op cit.*, Chap. II.

that Blimber took only ten pupils Browne has shown him with 17. He was often compelled to work with great speed, etching a plate during the day, having it bitten by a friend in the evening and delivering it to the printer on the following morning. Considering that the plates had always to be presented in pairs and that each pair had to be made in duplicate, it is no wonder that things sometimes went wrong.

They seemed to go wrong more often and more grievously than usual with *Dombey*. Dickens was very exacting over the illustrations and it is not too much to say that his tetchiness exceeded all reasonable grounds. He probably realised that after an interval of two years since producing a major work he had now provided an inferior article and what made it worse was that it was the first important book offered to his new publisher.

The situation improved with *Copperfield*, but it seemed that the author had shot his bolt after that. His reputation never stood so high as at the completion of this charming masterpiece – and the same may be said of Browne. He was to illustrate three more books for Dickens, *Bleak House*, *Little Dorrit* and *A Tale of Two Cities*.

A great deal has been made of the so-called dark plates in these books. The fact is that they were neither entirely new nor entirely successful. What Browne tried to do with the dark plates was to produce the effect of mezzotinting on an etched plate. It is usually a mistake to attempt to imitate one medium in a different technique and this was no exception to the rule. The effect was produced by having a background of fine, closely spaced lines mechanically ruled all over the plates, and then, by elaborate methods of burnishing the high-lights and stopping out the shadows, to increase the contrasts. The result when seen at its best, as in 'On The Dark Road' in *Dombey*, is not ineffective, but at its worst, as in 'The Mourning' in *Bleak House*, is a rather nasty mess.

Great Expectations, after serialisation in *All the Year Round*, was published in three volumes without illustrations and *Hard Times*, serialised in *Household Words*, came out in one volume, also un-illustrated.

With *Our Mutual Friend* and *Edwin Drood* part publication was resumed. Browne was deeply hurt at not being invited to work on either. Both were illustrated by wood-engravings, the former after Marcus Stone (21 by Dalziel, 19 by Green) and the latter, which was unfinished, after Luke Fildes. Both sets of illustrations are totally undistinguished.

Browne wrote to his friend Robert Young at the time expressing his fear that Dickens might resent his having accepted a commission to illustrate Trollope. The fact is that the plates for *A Tale of Two Cities* were not very good. The figures look like characters in a masquerade and not very convincing ones at that. As for the Trollope plates they are even worse and Browne was discarded after illustrating the first ten parts in favour of an otherwise virtually unknown Miss Taylor. Salt was rubbed in the wound when the publisher described the illustrations in a later, one-volume edition, as 'by Phiz and Marcus Stone'.

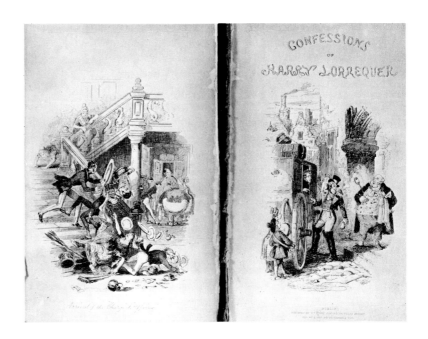

34. Phiz. Frontispiece and title-page for *Confessions of Harry Lorrequer*, 1839

The sad fact is that the poor man's powers were declining and Dickens felt the need of new blood. In 1867 Browne suffered a stroke and Croal Thomson paints a picture of his cruelly painful efforts to continue his work. For he had made no provision for such an eventuality and the last 15 years of his life were spent in penury, slightly relieved by an allowance from the Royal Academy. He confidently anticipated the grant of a Civil List pension by Disraeli but it was withheld.

He had had a great run, and for most of the time he was near the top of the tree. He had leapt into fame with almost his first commission at the age of 24. For nearly 30 years he was eagerly sought after as an illustrator and when his work for Dickens flagged in 1841 he was already busily occupied elsewhere.

He cannot be said to have replaced Cruikshank. Good as he was he was not good enough for that. In truth nobody at this time stood out so unmistakably from his contemporaries as Cruikshank had done and with the increased opportunities available to book illustrators the work was more broadly shared.

Browne's name did replace Cruikshank's on the title-page of *Ainsworth's Magazine* in 1846, but that was due to the older man's incurable pugnacity. Browne had also provided etched plates for several of Ainsworth's novels. He illustrated *Jorrocks's Jaunts and Jollities*, the first of the Jorrocks series – he was especially good at horses – but was not asked to illustrate any of the others except *Mr Facey Romford's Hounds* and then only when Leech, the preferred artist, died halfway through the part publication.

Another author with whom Browne succeeded brilliantly was Charles Lever. Between 1839 and 1865 he etched nearly 500 plates for 15 of Lever's novels, as well as drawing a large number of

vignettes on wood. This work is uneven, and some of it is just plain bad; but the general level of the etched plates is astonishingly high. He started off with a bang with *Harry Lorrequer*, which contains some capital plates. One can see from these what Lever meant when he complained that Browne's plates for his work generally had given the author a not altogether justified reputation for a liking 'for up-roarious people and incidents'. The frontispiece describes a scene in Chapter 52 where a *chargé d'affaires* calls on Lorrequer at his inn. This is merely a passing incident in the text describing how the hero rushed through the hall to meet the official 'pushing aside waiters and overturning chambermaids in my course'. Browne depicts him as running downstairs leaving in his wake an incredible complication of disaster.

The truth is that the novel itself is so boring, so padded with irrelevances and generally dragged out that the artist may well have considered himself as performing an acceptable service to the author precisely by emphasising the few lively incidents. It is astonishing to learn that Lever's novels made the fortune of the *Dublin University Magazine* and earned him the post of editor at £1,200 a year. Today they are virtually unreadable, except possibly in very small doses, whereas the 'Phiz' illustrations are a joy. Rumbustious most of them are, whether depicting the commemoration of the Battle of the Boyne at Father Malachi's Supper, Mr O'Leary clearing the gaming-room in Paris, or the improbable identification of Lorrequer as the composer at the Strasbourg Opera. One or two of the quieter scenes are also well done by Browne. Such, for example, is the incident in which Father Luke and his French Abbé friend are trapped by an Irish sentry in wishing a 'bloody end to the Pope', or the scene at the French Consul's office in London.

Lorrequer is fairly representative of Browne's work for Lever, but the others are well worth close inspection. *Charles O'Malley* has 44 etchings, nearly all of which are excellent. 'The Two Chestnuts', 'A Flying Shot' and 'Charley trying a Charger' show why Leech envied Browne his horses; and 'Jack Hinton' and its companion 'Tom Burke' remind us that he could be as masterly with the pencil as with the needle.

He does not show always to the best advantage with his drawings on wood, however. This, in most cases, is due not to the quality of the drawing but partly to uneven quality in the engraving and mainly to poverty of printing and paper. If the blocks were available for printing nowadays on a good esparto book-paper the results would certainly be astonishing.

There are some very good ones in *Master Humphrey's Clock*, especially for *The Old Curiosity Shop*. 'Grinder's lot' surprising Little Nell with Mr Codlin at the roadside, the fight between Quilp and Dick Swiveller, and Little Nell asleep in the Old Curiosity Shop itself are among those that one longs to see better printed. In *Barnaby Rudge* Browne is less well suited. The best drawing of Barnaby himself is probably the tailpiece to the second volume where he lies at full length with his raven on his knee. Sim Tappertit is very well

done whether strutting in his employer's forge, swearing in a novice, or roistering with his dubious friend Hugh at The Boot. Facing this drawing, which heads Chapter 39 is a superb tailpiece of Hugh and Dennis in a boisterous dance.

John Willett presiding over the company at The Maypole agog at the appearance of the mysterious stranger, Varden attended by his adoring household in volunteer uniform and the artful Miggs waiting at the window for the suspect Tappertit are all excellent and there is an effectively sinister study of Gashford sitting on the roof of Lord George Gordon's house waiting for the promised conflagrations.

It would be kind to ignore his later work as when, for example, out of charity the publishers engaged him to illustrate once more for the Household Edition those adventures of Mr Pickwick with which he had blazed into fame at the very outset of his career. The miserably

Then there were "restaurants" on a scale of the most primitive simplicity, where boiled beef, or "spoleen," was sold from

35. Phiz. *St. Patrick's Eve*, 1845

unskilful results are all too painful a reminder of the wretched artist's plight, with the pencil lashed to his half-paralysed arm striving desperately to keep the wolf from the door.

Punch

In 1890 appeared the one-hundredth volume of *Punch*. It included a suggestion that a set of *Punch* comprised the true 'Hundred Best Books' and if one wanted an 'infallible barometer' of English social life over the period, a guide to its costumes and customs, one would be hard put to find a more inclusive or representative source. It is an essential, a representative feature of what England has stood for not only in the eyes of the natives, but at least as much to the rest of the world. This is as it should be, for *Punch* has represented, to foreigners and natives alike, the peculiar English sense of humour, the stupidity, the misleading indulgence in understatement, the toleration – of muddle and injustice, as well as of eccentricity and heresy – the willingness to rise in wrath if pushed too far. And all this it has done far more effectively in its pictures than in its letterpress. It was, in fact, the first English periodical to make illustration a regular, and in a very real sense, a principal feature, which increased the opportunities open to the illustrator not merely by its own existence but by the great number of its imitators. It has been well said that there has never been a good second to *Punch*; but the ramifications of the illustrated press have spread far beyond the limitations of the humorous journal to which they all owe their origin.

The great success of the Paris *Charivari*, started in 1832, had been remarked in London and the possibility of an English counterpart had been attempted more than once. The short lives of *Figaro in London*, *Punch in London* and several other similar journals had suggested that the project would not survive the Channel crossing. The varied accounts of the origin of *Punch* itself have one thing in common; they all involve Joseph Last, a printer, Ebenezer Landells, a wood-engraver and Henry Mayhew, a journalist. Each looms larger than the other in accordance with the bias of the chronicler. The best summary of the preliminary negotiations is given by Price.[5] Spielmann,[6] however, is more informative on the early vicissitudes of the paper.

Landells and Last were mainly interested in the extra work that such a journal would provide for them. Mayhew was to contribute the editorial know-how which was beyond the capacity of the other two men. Spielmann reproduces in facsimile the first draft of the *Punch* prospectus which, although it is in the handwriting of Mark Lemon, was probably almost entirely the work of Mayhew. The first number appeared on 17 July 1841 and despite the enthusiasm of those connected with its preparation there is really very little to be said for it, especially on the pictorial side.

This is hardly to be wondered at when one considers the circum-

[5] R. G. G. Price, *A History of Punch*, 1957, esp. his App. III.
[6] M. H. Spielmann, *The History of 'Punch'*, 1895.

stances under which it was produced. Respectability is the word that comes to mind when we think of *Punch*. This was far from true of the early years of its existence. Copy-writers did much of their work in pot-houses and debtors' prisons and they were regarded as of incomparably greater importance than the artists. These, in fact, were a grade lower than the wood-engravers and were regarded as a necessary evil.

The staff of artists, headed by A. S. Henning, who designed the first cover,[7] included Brine, John Phillips and William Newman, all now completely and deservedly forgotten.

Feebly written, execrably illustrated and wretchedly produced, it nevertheless achieved the remarkable circulation of 6,000 copies; but sales of 10,000 were needed to break even. Last's printing bills were not being paid and he sold out to Landells. Despite an enormous boost in circulation produced by the *Almanac*, the proprietors were in debt all round. Two printers gave up in a very short time because they were not paid, and by 1842, the fourth printer, Bradbury & Evans, issued an ultimatum.

Spielmann discreetly plays down the intrigue by means of which Bradbury & Evans took over, but it is clearly not a very creditable story. Mark Lemon, already the *de facto* editor, was the villain of the piece. Landells and Mayhew were ousted, the former very discreditably, although his continued influence would undoubtedly have run the paper into the ground.[8]

Lemon's unscrupulous scheming does him little credit; but the result was unquestionably the paper's salvation. 'He was evasive and prepared to pull any string to trip an opponent. . . . But would anyone less tough have kept the paper afloat?'[9] He introduced brilliant writers, notably Thackeray and Jerrold; but he was less successful with artists. This was unquestionably due to the early prejudice which regarded them as a lesser breed. From the beginning the wrapper bore as sub-title 'The London Charivari'. The conspicuous failure to live up to this ambitious level was due to the lack of a London equivalent of Daumier. The wrapper itself gave evidence of this. Henning's pitiful design was replaced at the beginning of 1842 by a much superior effort by 'Phiz'. William Harvey was entrusted with the third volume, John Gilbert with the fourth and Kenny Meadows with the fifth.

Richard Doyle

In January 1844 the first number of the sixth volume presented the figure of Mr Punch seated at the editorial table with his dog Toby opposite him. This was the work of a young artist who had been introduced to Mark Lemon by his uncle, one Conan, dramatic critic on the *Morning Herald*, with the result that the 18-year-old boy was

[7] He has some amusing vignettes on wood and a Grandville-esque frontispiece in J. W. Carleton, *The 'Hawk' Tribe*, 1848.

[8] Spielmann gives some curious details of the accountancy between Landells and Bradbury & Evans, especially in credits and debits for wood-blocks. 'Deduct Collared Beef 4s 6d' or add 'All round my hat 10s' for example.

[9] Price, *op. cit.*, p. 29.

sent to Joseph Swain, who had succeeded Landells as engraver at the take-over, to learn to draw on wood. The young artist was Richard Doyle. In 1843 he joined the staff of *Punch* doing all kinds of odd jobs, and eventually becoming second only to John Leech, whose first drawing had appeared in the third number of the paper and who, by 1844, the year in which Doyle designed his famous wrapper, had become the paper's principal artist.

Doyle was not really a *Punch* man, although many of his best-known humorous works first appeared in its pages, among them *The Foreign Tour of Brown, Jones and Robinson, Mr. Pips hys Diary* and *Bird's Eye View of English Society*, all of which appeared in book form and are treasured.

He was not a 'sixties' man either. Forrest Reid does not even mention him, although what many consider his masterpiece, the illustrations to William Allingham's poem, *In Fairyland*, was published at Christmas 1869, post-dated 1870. Perhaps it is because the illustrations are in colour that Forrest Reid ignored them. This is another example of the difficulties that arise in creating arbitrary subdivisions such as the 1860s, the 1890s and so on.

In Fairyland has 16 colour plates, several of them with more than one subject on a page, and there is not a bad one among them. It was a small folio, with a charming binding, also designed by Doyle, and Edmund Evans surpassed himself in the printing of the blocks. The letterpress, although less horrific than most of the work of the period, is undistinguished. It is now considered to have been a book for children; but it was published at a guinea and a half. Despite this price it was reprinted in 1875.

Less attractive, but astonishing for its precocity, is the posthumous *Jack the Giant Killer* (1888), a facsimile of the manuscript and drawings completed in 1842 and *Dicky Doyle's Journal* (1885), which dates from his fifteenth year.

Diligence was not among Doyle's strongest virtues. He was frequently late with his drawings and his excuses were often feckless. He once coolly explained to Thackeray that his infuriating tardiness was due to his having no pencils.[10]

This possibly accounts for the frequent uneven quality of his drawings within the same pair of covers. Thus for Ruskin's *The King of the Golden River* (1851) he produced a splendid frontispiece of the 'little man' knocking at Gluck's door in the storm, and a satisfactory pictorial title-page, ruined by the 'rustic' lettering that was much favoured at the time. Few of the vignettes will pass muster, however, and most of them are deplorably pedestrian. The first edition has a rather indifferent binding of yellow boards, replaced in later editions by orange-coloured cloth with a jolly design in gilt by Doyle. This is some consolation for the introuvability of the first edition.

Nevertheless there is an elfin character in Doyle's work which brings out the best of him in fairy-tales and best of all when left to his own devices. He undoubtedly chose the Allingham poem himself, and the posthumous works show him bubbling over with inspiration.

[10] *The Brothers Dalziel. A record of fifty years' work, 1840–1890*, 1901, p. 58.

36. R. Doyle. Frontispiece for *The King of the Golden River*, 1851

A curious example of this is *An Old Fairy Tale Told Anew in Pictures and Verse* by Richard Doyle and J. R. Planché (1865). Doyle had shown the Dalziels a series of drawings that he had made for the *Sleeping Beauty*, which they accepted for publication. For reasons unknown they commissioned Planché to run up a doggerel version of the tale to accompany the drawings. The frontispiece, showing the Prince led to Beauty's bedside, is typical Doyle of the best kind, the title-vignette is a little gem. The Wicked Fairy is terrifying; and the roistering at the King's court is gargantuan. Then, through splendid drawings of the huntsmen and the fairy castle, through scenes of the slumbering sentinels and courtiers, we are led to the King and Queen – and then left in the air, for Doyle's fecklessness betrayed him into

37, 38. J. Leech (above) 'Who Wouldn't Keep a Footman?' *Punch*, 1850; (above right) 'Bolted'. *Punch*, 1852

forgetting to depict the dénouement. But otherwise it is a beautifully sustained piece of work.

John Leech

Doyle's enchantments have carried us ahead of our story which must now concentrate on the man who first made people look at the pictures in *Punch* and made them look at them first – John Leech. The extent of Leech's responsibility for creating the *Punch* image of his day may be readily grasped by turning the pages of the three volumes of his *Pictures of Life and Character*, taken from its pages.[11] Price sums it up beautifully:[12]

'When we think of the early *Punches* we think inevitably of a generalised Leech world. Drunken cabbies sit on cobbles, leaning back bemused and bucolic against conduits. Boys, terribly thin, but jerked into vivacity by the edgy derision of the slums, jeer and play japes. Fat parties, with truculent timidity, undertake complicated journies by boat and train, their voluminous baggage often including pets and barrels of oysters. Weary men about town of extreme youth quiz belles at assemblies, pityingly discuss their schoolfellows, and are precocious with churchwardens and brandy-and-water. Sharp-tongued mammas war with sharp-tongued daughters on seaside promenades, whose winds disclose ankles to military men, real and imitation. It is a world of cabs and bathing-machines, chop-houses and seaside lodgings.'

Add the volunteers and the cockney sportsmen and you have a summary of Leech's favourite subjects.

Punch no longer recruited its staff from taverns and sponging-houses. Leech, like Thackeray, his closest friend on the staff, had been educated at Charterhouse.

[11] 1854–8 and 1860. Reissued in 1886–7.
[12] *Op. cit.*, pp. 62–3.

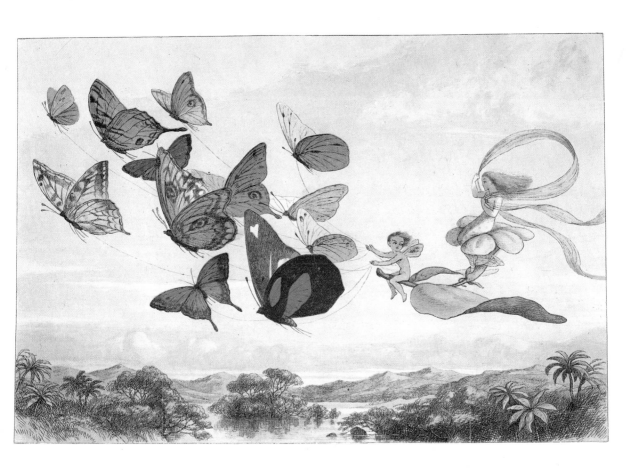

(Above) Richard Doyle. The
Butterflies, (*In Fairyland*, 1870)
(Right) Edmund Evans. Arundel,
Gloucester, Nottingham, Derby
and Warwick before Richard II,
*A Chronicle of England, B.C. 55–
A.D. 1485*, 1864)

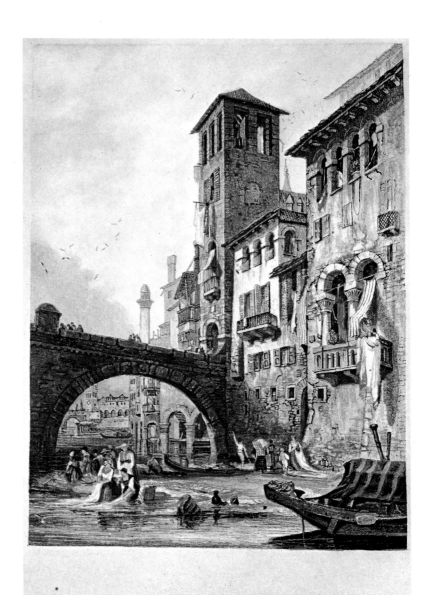

VERONA.

Printed in Oil Colours by G. Baxter (Patentee) from a Painting by S. Prout.

George Baxter. Verona, (*The
Pictorial Album, or Cabinet of Paint-
ings for the Year, 1837*)

He was born in 1817, and had to abandon a medical course at Bart's when his father's fortunes as a coffee-house proprietor on Ludgate Hill collapsed. Among his fellow students at the hospital was Percival Leigh who supplied the text for one of Leech's earliest publications in book form, a *Comic Latin Grammar* (1840). Leigh became a member of the original *Punch* staff and introduced Leech as an artist in its third number. His contribution was an unusually large drawing, 'Foreign Affairs'. The method of making large blocks by joining small pieces together and dividing them among several engravers had not then been devised, and the work of cutting Leech's drawing delayed publication which entailed a serious loss in circulation.[13] It was some time before he was asked to contribute again. By then he had become an established illustrator working regularly, for example, for *Bell's Life in London*. Leech soon fell out with Landells and his fellows over terms of payment. This is, perhaps, little to be wondered at if there were many like William Newman whose regular rate of payment for the tiny silhouettes called 'blackies' was 18s a dozen.

With the change-over to Bradbury & Evans as printer-publisher of *Punch* the journal began to rise in the social scale, swiftly changing from a rather vulgar, street-corner-radical outlook to one more acceptable to what is now called 'the Establishment', and Leech had a major share in the change. He became the principal cartoonist, but, in fact, this was less congenial to him than the inimitable and almost inexhaustible studies of the social life of his day at almost every level that now began to flow regularly from his tireless pencil. The jokes that accompany them have, for the most part, lost their flavour. The drawings are immortal and it is to them that we constantly return as most representative of this talented, warm-hearted artist. He was a 'warm' man in more than one sense, for during his 20 years' association with *Punch* he drew an average of £2,000 a year from that source alone.

Finally, as has been well said by Kitton:[14] 'It should be remembered that if Leech did great things for *Punch*, that periodical gave him a great opportunity, such as no artist before him had enjoyed, and which he alone was able to seize'.[15]

Like Cruikshank and 'Phiz', Leech was almost equally at home whether drawing on wood or etching on copper or steel. He also produced a few lithographs, but these are relatively unimportant.

[13] Leech was not exemplary for promptness in the delivery of his drawings and this again caused an annoying contretemps in the publication of *The Battle of Life* (1846). His three drawings arrived only at the very last moment and it was not noticed before publication that one of the pair on p. 114 suggested that Marion Jeddler's Christmas disappearance was an elopement, which was in complete contrast to the extremely sentimental ending that Dickens had already devised, and caused him much distress, which was not mitigated by the possibility that an elopement was not unlikely at that stage in the story.

[14] F. G. Kitton, *John Leech, a biographical sketch*, 1883. Revised and cheaper edition, 1884, without the useful check-list of titles.

[15] This needs qualification. It is probably true for Britain, but Daumier was contributing a *daily* cartoon to *Charivari* while Leech was still at school.

His metal plates were usually coloured by hand like the *Comic Histories of England* and *Rome* and the Surtees plates. So far as the *Histories* are concerned the plates themselves hardly rise above the level of the text, which is on a par with the knockabout humour of the Christmas pantomime, often vulgar without being funny. Furthermore Leech is not at his best with costume or period work. He was essentially a man of his own day – man-about-town, rider-to-hounds which made him more successful with Surtees than with à Beckett. Yet even here the plates are inferior in quality. The botched colouring may have a lot to do with it. Compare the 'Comic History' volumes with what the French were producing at the same time or with the productions of Ackermann 40 or 50 years earlier to see the appallingly low standard of the Leech colouring. It may be said that he was essentially a black-and-white artist and that the addition of colour to his plates was an error of taste. This is just not true. Leech was frequently in the habit of making a water-colour of a drawing on wood that had especially pleased him and these drawings are quite delicious. They are rarely water-colours in the true sense of the term, but most often pencil drawings with colour added with the utmost delicacy. This was probably the method used in preparing the coloured etchings for publication and it is possible that the master sets produced by Leech himself would be more attractive. That they were immensely popular in this form in their day is proved by the fact that the two early books of Surtees, *Handley Cross* and *Jorrocks's Jaunts and Jollities* had to be supplied with coloured plates when they were reprinted. It is possible that the continued popularity of Surtees is due more to the text than to the plates. The *Histories* are dead ducks on both counts.

The most widely known of all the books illustrated by Leech is Dickens's *Christmas Carol*. The colouring here is much more successful but not entirely so. Despite the jolly things among them it can hardly be said, for example, that the popularity of the *Carol* owes as much to Leech's illustrations as *Alice* owes to Tenniel's.

It is in less generally popular books that his best work will be found. His work for the other Christmas Books of Dickens, *The Chimes*, for example, has already been mentioned (see p. 93) as containing some excellent work. Most of what we have of his was printed from wood-blocks and it may be permitted to wonder how far the fairly frequent crudities in *Punch* illustrations were due to the clumsiness of the engraver. The artist would have been quite safe in the expert hands of such as Orrin Smith, W. J. Linton and any of the Dalziels; but it may have been quite a different matter when a block had to be divided between several members of the *Punch* staff and rushed through to meet the dead-line of the printing shop. Leech may also have to shoulder some of the responsibility, not only because of dilatoriness, but because there is considerable evidence that, like Tenniel, he sometimes handed in the merest outline of his conception leaving the filling in of much of the detail to the engraver.

F. G. Kitton, in the first edition of his booklet on Leech, 1883, gives a striking example of this by reproducing the original drawings

and the finished illustrations for the pair of wood-engravings that caused so much trouble in *The Battle of Life*. In this instance the engraver was Dalziel, and the results show great skill, but there is certainly more Dalziel than Leech in the finished articles. This is yet one more reminder of the importance of the engraver throughout our period from William Harvey onwards, especially on wood but also on steel, and it is rewarding, where names are given or can be

39. J. Leech. Christopher's First Appearance. *Christopher Tadpole*, 1864

deciphered, to observe the deftness and ability of the best of them, the beauty of their craftsmanship and their ingenuity in solving the intricate problems set them by artists.

This was also true of the etchings. There are some capital things by Leech in this medium in *The Ingoldsby Legends*. The ludicrous appearance of the wretched little bird in 'The Jackdaw of Rheims' and the apparition in the 'Legend of Hamilton Tighe' show his great versatility. The etching of 'Little Jack Ingoldsby entering the cellar' in 'A Family Legend', however, is a feeble, botched production and the drawing Leech made for it shows how little material he supplied to the etcher.

He was in top form as an etcher in Albert Smith's *Christopher Tadpole* (1848), for which he designed an attractive binding and provided 26 etchings in which he is as sprightly as ever in 'Christopher's first appearance in public' and in Skittler teaching the

Professor to do the double-shuffle, while such genre studies as Dr Aston repairing a model ship and the capsize of the post-chaise on the road to Arden Court are fully worthy of him. He is equally good in Smith's other novels, *Mr. Ledbury* (1844) and *The Scattergood Family* (1845), and in W. H. Maxwell's *Hector O'Halloran* (1853). These are elusive, whether in parts or in volume form, but excellent copies contemporarily rebound will satisfy all but the purist and are much less expensive.

John Tenniel

When Dickie Doyle left *Punch* abruptly in 1850 in protest against its anti-papist policy, the paper was left without a second string to Leech. On the strength of his illustrations for a version of *Aesop* by Thomas James published by Murray in 1848, John Tenniel was engaged and at once set to work on the *Almanac* that Doyle had left in the lurch. He designed a title-page and a half-title and various initials and decorations. These kind of odd jobs he continued to do for *Punch* itself. Quite soon he was contributing cartoons and 'socials' and when Leech died in 1864 Tenniel succeeded him as principal cartoonist, a position he retained until he retired in 1901. His principal work for *Punch* comprised the 2,000 or more cartoons he drew for the paper.

The cartoon formed the central feature of the paper until its recent somewhat amorphous reorganisation: but it is open to question whether it was the principal selling point. Spielmann thought Tenniel 'the greatest cartoonist the world has produced' – but he must have forgotten Daumier, Gillray and Rowlandson, not to mention Hogarth, Cruikshank or Leech. The truth about Tenniel's cartoons is surely that they were frequently very funny, usually very well drawn, and nearly always in the best of good taste – this final ingredient being inimical if not fatal to greatness. The most widely known of all his cartoons, 'Dropping the Pilot' (March 1890) is an excellent example. The Kaiser leans complacently over the bulwarks as Bismarck, in sea-boots goes down the gangway to board what is surely a rowing-boat. The impression is of sorrow rather than anger. The 'Pas de Deux' (August 1878) – Beaconsfield and Salisbury as Knights of the Garter after the Berlin Conference – is excellent, well-mannered fun; and 'The Quaker and the Bauble' (February 1859), John Bright defending the Constitution against the landed interests, is a good-tempered chuckle.

Very occasionally the cartoons strike a harsher note as in 'The American Juggernaut' (August 1864) indicating British sympathy with the South, or 'The Tempter' (November 1866) with the sinister figure of 'Anarchy' offering employment to the workless. But Tenniel was a fine old English gentleman, lacking the depth of scorn and the fire of indignation essential to the really great cartoonist.

When one considers the traditional method by which the *Punch* cartoons were produced it is surprising that they were so good. The subjects were hammered out at meetings of the *Punch* 'Table' and then written down and handed to the artist for execution. In Leech's

time the artist himself had some say in the choice of subject. Spielmann records that in the three years 1845–7 Leech was allowed to choose 11 of the subjects for his weekly cartoons. Tenniel seems to have been quite content to allow the subjects to be chosen for him. He confessed that he had no political opinions of his own 'at least, if I have my own little politics, I keep them to myself, and profess only those of my paper'.[16] For the rest he was handed his subject on Wednesday evening, presented his drawing on Friday and received his copy of the paper on Monday which he left it to his sister to open, taking no more than a glance at it to 'receive my weekly pang'.[16]

He was nearly always successful with animals. 'The British Lion's Vengeance on the Bengal Tiger' (August 1857), expressing the country's rage at the atrocities after the Indian Mutiny, is brilliant. His Russian bear (July 1853 and elsewhere), his moody German eagle (March 1888) and his 'Dynamite Dragon' (April 1892) are first class.

This brings us to his books and the supremely triumphant *Alice* volumes in which there are such splendid animals. How, one may well ask, did these two totally incompatible individuals – Dodgson and Tenniel – come together? We know that Tom Taylor the dramatist introduced the two men. But was it also the 1848 *Aesop* that persuaded Dodgson that Tenniel was his man? Above all how even Tenniel's infinite patience and good humour must have been tried by one who, while unquestionably a genius, was also a tetchy, fractious, suspicious, childish bore. There are two glimpses behind the scenes, one when Tenniel described Dodgson to Harry Furniss as 'that conceited old Don' with whom Furniss would find himself unable to cope for more than a week. The other, even more revealing, is Tenniel's tenacious refusal to consider the possibility of doing another book for Dodgson after the second *Alice* book was finished. He had tried hard to avoid having to do the second book, but was overborne; but when that was done his determination to have no more to do with Dodgson was unshakeable. This determination is very revealing, for the immediate and continued success of both books must have been flattering to the artist, who surely knew that his drawings had no small part in that success. But then of the 92 illustrations to the two books Dodgson approved of only one – 'Humpty Dumpty'.

Nevertheless it is greatly to Dodgson's credit that, despite the personal expense to himself and the tiresome delay entailed in publication, he made no bones whatever of abandoning the entire first printing of *Alice's Adventures in Wonderland* in deference to Tenniel's dissatisfaction with the printing of the blocks. Dr Bond has pointed out that Dodgson's readiness to inscribe and distribute advance copies of the 1865 printing suggest no dissatisfaction on his part, but he has also criticised drastically the disgraceful printing and lay-out of the letterpress.[17] But how far did Tenniel himself contribute to the problems of reproduction?

[16] Spielmann, *op. cit.*, pp. 463–4.
[17] William H. Bond, 'The Publication of "Alice's Adventurers in Wonderland"' in *Harvard Library Bulletin*, 1956, vol. x, no. 3, Cambridge, Mass.

40. J. Tenniel. Three stages of an illustration for *Alice's Adventures in Wonderland*, 1865–6

The technique of drawing on wood was not easily acquired and artists who could not be bothered to learn it were frequently in trouble. Tenniel seems to have been among them and it may be at least partially due to his own technical shortcomings that the 1865 edition of *Alice* was withdrawn. Far from learning to draw on wood he is on record as never having learned drawing at all. Until about 1892 he always drew in pencil on paper, transferring his drawings to wood by the use of tracing paper and a 6H pencil.

Spielmann[18] records that the result was so faint and delicate that 'it looked as if you could blow it off the wood'. Tenniel constantly complained that Swain's engravings bore little resemblance to the originals. He did not realise that the graver's line was incapable of reproducing the soft effects of his pencil drawings. As Spielmann says:

'Swain has always *interpreted* Sir John Tenniel's work, not simply facsimile'd his exquisite grey drawings. So Swain would thicken his lines . . . and otherwise bring the resources of the engravers's art to bear upon the work of the master of the pencil.'[18]

Four illustrations used by Dr Bond to illustrate the progress of one of the drawings for *Alice* seem to suggest that the Dalziels were spared the pains inflicted on Swain. The illustrations are of the fish-footman delivering a letter to the frog-footman. A tracing of the picture is shown with little more than outlines of the figures and background; but side by side with it is a finished drawing. This drawing, although lighter in texture than the printed impressions from the editions of 1865 and 1866, resembles them very closely in detail, and if it were the drawing given to the Dalziels for reproduction would exonerate them from criticism. But it cannot be so because the drawing would have been made on the wood and cut to pieces by the engraver. It is too early for the drawing to have been photographed on to the wood, moreover it is the wrong way round – that is to say the same as the finished illustration, not reversed as it would have been for the engraver and as it is in the drawing on tracing paper.

The mystery can be resolved from Tenniel's own accounts in an interview with Spielmann of his method of working.[19] 'By means of tracing paper . . . I transfer my design to the wood, and draw on that.' The tracing illustrated by Dr Bond shows distinct signs of the heavy pressure needed to mark the outlines on wood through the paper.

What, then, of the beautifully finished drawing also shown by Dr Bond? This, too, is accounted for in the same interview. 'The first sketch I may, and often do, complete later as a commission. Indeed, at the present time I have a huge undertaking on hand . . . the finishing of scores of my sketches, of which I have many hundreds.'

The risk of labouring the point is worth taking because it is an important one. Leech and Keene are known to have worked in similar fashion and it may be assumed that most of the old hands at drawing on wood habitually provided the engraver with no more than the bare essentials of a picture leaving him to supply the trim-

18 Spielmann, *op. cit.*, pp. 467 ff.
19 *Op. cit.*, pp. 463–4.

41. J. Tenniel. *Aesop's Fables*, 1848

mings. When there was time the artist will have been supplied with a proof on which he suggested improvements. Some of these have survived and are enlightening. Artists who lacked experience of this kind of work, like Rossetti for example, supplied highly finished drawings which often made impossible demands on the engraver, and were disappointed, sometimes vocally, with the results.

These conclusions are to a considerable degree hypothetical. From the very nature of the process much of the evidence has been destroyed, but what has survived suggests that the inferences drawn may not be far wrong. Basically, also, they lend some support to the criticisms of Linton and others that the interposition of the craftsman was its great weakness. We must be thankful that so much splendid work is available to us which we would otherwise have been denied; a reflection that is reinforced by the lamentable deterioration that immediately ensued when the craftsman was replaced by the process worker.

There is not much more to be said about Tenniel, who nevertheless bestrides our period, having been born in 1820 and lived to within three days of his ninety-fourth birthday. He spent 50 years on the *Punch* staff and for more than half of that time he was its principal cartoonist.

As to his book illustrations it is almost a case of *Alice* first and the rest nowhere.[20] His first book illustrations, to Hall's *Book of Ballads*, have already been mentioned. The *Aesop* of 1848 had a very great influence on his career and may be said in a very real sense to have made his fortune and for this reason if for no other we may temper with mercy Forrest Reid's rather harsh, if on the whole just, estimate of it. Some of the illustrations are quite appallingly feeble and even inaccurate, so much so that when Murray reissued it in 1851, many of his drawings were replaced by those of a pedestrian zoological draughtsman, Josef Wolf, and Tenniel himself redrew others. In this later edition, at any rate, a few are outstandingly good, among them 'The Herdsman and the Bull' (Fable 88), 'The Charger and the Ass' (Fable 183), and in 'Hercules and the Waggoner' (Fable 67) the kneeling figure of the peasant and his team and cast are extremely well done. Hercules himself, on the other hand, is a feeble ghost, and the contrast on the title-page between the effective drawing and grouping of the animals and the unconvincing humans below them is marked. Incidentally it was in this book that he first made use of the now familiar decorative initials as a signature.

He has one very powerful drawing in the Dalziel *Arabian Nights*, 'The Sleeping Genie and the Lady' on page 5; but there is little else that would have been remarked as book illustration were it not for the two *Alice* books, than which few books in our period have been better illustrated.

His *Punch* drawings were reissued several times in book form and

[20] The drawings for the first *Alice* book are treated at some length and with invaluable penetration by Dr W. H. Bond in the *Harvard Library Bulletin*, the illustrations to which are very illuminating and consoling to the majority who must deny themselves the 1865 edition.

yet they cannot be regarded as book illustrations. In that connection there can be no disagreement with Forrest Reid's view of Tenniel as virtually a one-book man, considering the two *Alice* volumes as a unit. His frontispiece and title to the last of the Dickens Christmas Books, *The Haunted Man*, 1848, are well enough. He shared the illustration of this book with Leech, Stanfield and Frank Stone, the father of Marcus, and attended with them the 'christening' dinner for the book. His *Lallah Rookh* (1861) has not retained the extravagant esteem with which it was greeted on its first appearance.

Charles Keene

Charles Keene was not only the best of all *Punch* artists; he was very nearly the greatest English black-and-white artist since Hogarth, and a comparable genius. Ruskin ignored him and it is only in quite recent years that his work has begun to be estimated at anything like its true value. His earliest vociferous champion was Joseph Pennell,[21] but this brash American was known to favour such dubious figures as Whistler, and Mr Ruskin had long shown all right-minded folk how little they should think of that mountebank.[22]

Neglect of Keene is excusable to some extent because to all but the very few he was known only as a *Punch* artist, where Mark Lemon and F. C. Burnand thought John Tenniel a greater artist than Keene and where the means and methods used to reproduce his drawings were singularly inappropriate. There will be more to say of this later, but it may be noted at once that Pennell served him well by careful reproductions of his original drawings alongside the *Punch* versions of them and here every picture does indeed tell a story.

Keene's first appearance in *Punch* in 1851 roughly coincided with Tenniel's but under very different circumstances. Keene's drawings were contributed anonymously to help out his friend Henry Silver, who was on the staff but found it entirely beyond him to cope with drawing on wood. These drawings are without intrinsic interest. Even after Keene had become an acknowledged and regular contributor it was nearly six years before he was invited to the 'Table' and when the privilege was granted to him he was unimpressed by it. Nevertheless he made over 2,000 drawings for *Punch*, rivalled in number only by Tenniel who, however, was on the staff for ten years longer. It is, therefore, quite natural that Keene's reputation as an artist should for so long have been allowed to stand or fall on this work.

Indeed, although Chesson's bibliography – an appendix to Pennell's book – identifies more than 63 books illustrated by Keene, with one brilliant and one other possible exception there is little in them to thrill the enthusiast.

It is to his original drawings that one must resort to appreciate the true greatness of this superb draughtsman and it is remarkable that,

[21] *The Work of Charles Keene*, 1897.
[22] Keene declined to give evidence for Whistler in his libel action against Ruskin, although his sympathies were with Whistler.

even today, greatly as they have appreciated in the post-war period, fine examples can still be found at a fraction of the price of drawings by, for example, Menzel or Guys – or, for that matter, by Rackham. But they have recently attracted more attention.

Keene was born in 1823 at Hornsey, then a rural village on the outskirts of London. His father was a reasonably prosperous solicitor and Keene entered the firm on leaving school in 1840, but only for a very short time. His remarkable mother actually removed him from this assured position to send him as pupil to an architect and was bold enough to exchange this for a post with J. W. Whymper, where Keene was taught to draw on wood. Most of the work he did for Whymper is either unidentified or uninteresting but about his first identified book illustration, undistinguished though it is, there is something of a mystery.

The book is called *The Adventures of Dick Boldhero*, 'edited by Peter Parley', and published by Darton & Co. with a frontispiece and 38 other illustrations. The frontispiece is signed 'Charles Keene' but the other illustrations are signed only by the engraver, James Cooper. Chesson says that it was published in 1842 and reprinted in 1845 and 1864. But the earliest dated copy that Forrest Reid could find 'even in the British Museum' is dated 1846, and that is the date of entry in the *English Catalogue of Books*.

In 1842 Keene was in the second year of his time with Whymper and it seems much more likely that signed work of his executed by another engraver should appear in 1846 when he would be out of his time.[23] No other book illustration by Keene is traceable until a *Robinson Crusoe* of 1847, published by James Burns and also with Cooper as an engraver. The illustrations in this book are rather messy but the sketches are full of promise (see illustration 5, p. 22).

After setting up on his own account he acted for some time as a man on the spot for the *Illustrated London News* and the *Illustrated Times*, and in 1847 he contributed to two other Darton publications and one of Hatchard's, always with Cooper as engraver. In 1852 he first worked for an engraver called Smyth who is not mentioned by either Linton or Chatto but has his name on the title-page of one of these two books in preference to Keene's. This is a collection of short stories by Shirley Brooks and Angus B. Reach entitled *A Story with a Vengeance* 'with a steel engraving by John Leech and ten cuts by Smyth'. Leech's frontispiece is in fact an etching and some of the cuts are by Keene. They are not bad. The illustrations to the other book, *The White Slave*, are not so good, but the book has a special interest for Keene collectors in that he designed a charming pictorial brass for use on the spine.

There is no need to pursue Chesson's list, or the two additions to it made by Forrest Reid. In 1854 Keene made his first signed contribution to *Punch* and before being given a seat at the 'Table' in 1860

[23] It is significant that Cooper's apprenticeship to Whymper overlapped Keene's which would explain an association between the two men after they were both out of their time. He should not be confused with James Davis Cooper who engraved some of the early Caldecotts (see p. 165).

he began his most fruitful association with book illustration in a new venture of the *Punch* office, the magazine *Once A Week*, begun in 1859 in rivalry to Dickens who, on the completion of *Household Words*, had left Bradbury & Evans to return to Chapman & Hall with *All the Year Round*.

Samuel Lucas, the first editor of *Once A Week*, collected around him a galaxy of talent – Leech, 'Phiz', Keene, Millais, Sandys, Whistler, Lawless, Fred Walker, Pinwell, Houghton and Tenniel, were among the illustrators. The reproduction standards for *Once A Week*, although executed by the same engravers, are generally much above *Punch* standards.

Keene's first commission here was to illustrate a serial story by Charles Reade, *A Good Fight*, which began in the first number on 2 July 1859, but proved unpopular and the author wound it up in October. Keene made 15 illustrations for it but when Reade greatly extended it for publication in book form in 1861 with the new title of *The Cloister and the Hearth* the illustrations were omitted and were not used until 1890 when seven of them were included in a single-volume reprint. The illustrations therefore were not responsible for the continued success of this rather heavy-going historical novel. Neither can one pretend that they show signs of the genius that was to come. Keene was to prove himself essentially an artist of his own time and medieval life and costume were not very congenial to his pen. Nevertheless these drawings show great progress and were easily the best he had produced so far.

The serial that replaced *The Good Fight* was much more to his taste. This was George Meredith's *Evan Harrington* which ran from February to October 1860. Keene made 40 drawings for this novel only one of which was used in book form, as a frontispiece to a one-volume edition in 1866. There are few occasions to regret more deeply the destruction of the drawings by the engraver. Forrest Reid thought them 'equal to any that had ever been made for a novel' and did not exclude the Millais drawings for Trollope. Yet neither he nor Gleeson White reproduces a single one of them. Pennell reproduces the frontispiece to the book edition and remarks how well Keene was served by Swain, the *Punch* staff engraver. In fairness to his excellent work on these and many other drawings of Keene's for *Once A Week* it should be said that at this period the artist was more observant of the limitations of the technique than he was later on, especially after 1872 when photography spared him the necessity of drawing on the wood. But the series of preliminary drawings shown by Pennell for the 'Old Shepherd' made for *Once A Week* are examples of the virtuosity that Keene by that time (1867) was beginning to demand from Swain and his staff.

In 1863 Bradbury & Evans published Mrs Henry Wood's *Verner's Pride*; alas, without any of the 17 splendid illustrations made by Keene for the serial version. These may not be quite up to the standard of the Meredith drawings but they are certainly better worth preserving than the novel itself.

Of Keene's work for *Punch* there is a representative selection be-

Brushing Pa's New Hat.

Edith. "Now, Tommy, you keep turning slowly, till we've done it all round."

42, 43. C. Keene. A *Punch* illustration. (above) The original drawing; (right) The finished article

tween one pair of covers in *Our People* (1881). This includes just over 400 of his best 'socials', and it is a treasure. There are also two books illustrated by him reprinted from *Punch* – F. C. Burnand *Tracks for Tourists* (1864) and (J. T. Bedford) *Robert, or Notes from the Diary of a City Waiter*, 1885, with a second series in 1888, where the heavy-handed, contrived humour of the text contrasts painfully with the exquisite characterisation of the 31 drawings, nearly all of which are by Keene.

Why did nobody think it worth while to collect his serious work into a volume? The *Once A Week* drawings alone would have made it well worth while. For, apart from their great intrinsic merit, it was surely these, rather than his early *Punch* work, that mark the great turning-point in his career and ensured him, in 1864, the major share of the work hitherto undertaken by Leech. It is grotesque to think of Keene playing second fiddle to Tenniel, but in fact the division of labour between them was apt. Keene would not have been well suited as a cartoonist as is clear from the few occasions on which he filled in for Tenniel; while the latter's equally rare 'socials' are lifeless and amateurish by comparison with Keene's. It is nevertheless clear that his editors and publishers had not a very high opinion of him as an artist. Even the enlightened editors of the 'Black & White' series, published by the lamented Art and Technics, did not think of Keene as the subject of a volume. Is it too late to redress the balance? Many of his drawings have survived, and burnished proofs survive in sufficient quantity to make a volume worthy of him.

He was essentially an English artist. His outlook is hardly conceivable in any other environment and nowhere is this plainer than in the inimitable illustrations for Douglas Jerrold's *Mrs Caudle's Curtain Lectures* (Bradbury & Evans, 1866). Hen-pecking is universal

44. C. Keene. Mr Caudle from
Mrs Caudle's Curtain Lectures, 1866

but Mr Caudle, who suffers it, and Mrs Caudle, who inflicts it,
are as English as Stilton cheese (and I mean English, for there is no
good cheese to be had in Scotland). Jerrold's text is not so amusing as
it was; but Keene's pictures are as funny as ever and what is more
almost every one of the whole 61 of them is a masterpiece. They
rank, for example, with Daumier's 'Robert Macaire' series. But
whereas that great work in its original form may cost £1,000 or
more, *Mrs Caudle* may still be bought for £10 or less.[24] The publisher
turned the book out well, giving it an attractive binding and decent
paper so that Keene was for once well printed. Oddly enough he
had had no part in the original *Punch* series of Caudle lectures or with
the first book publication in 1846.

Keene was a great artist and one who showed that choice of subject

[24] The comparison is tendentious. Daumier's subjects were drawn on the litho-
graphic stones by his own hand, whereas Keene's were interpreted by another.
Daumier's editor and publisher were bolder and more perceptive than Keene's.
Let us not cry too much small potatoes, however, for while Keene earned a pros-
perous living and died a rich man, Daumier, half blind and virtually starving, was
finally rescued from eviction only by the loving kindness of Corot.

is immaterial to genius. His period was not an inspiring one for artists. Ruskin and Morris spent most of their lives in denouncing the crass materialism of the age. In *Our People* there is a *Punch* drawing called 'The Way We Live Now' and that is what most of Keene's drawings were concerned with. It had no romantic preoccupation with a mythical golden age of the past, or with impractical dreams of idyllic futures. He took life as he found it and worked his magic on it, so that when we now study his work it is not a state of society remote and strange to us that we remark, but the certainty of touch that could make of such drab material unquestioned works of art.

For drab it surely was. The smugness of a nation that ruled the roost with a complacency that never experienced a doubt of the inevitability and propriety of it all, or of the propriety of the respect to be demanded from and unfailingly conferred by inferiors. Political agitation was virtually synonymous with treason; and the Queen and her Court maintained a respectably bourgeois outlook. Both in Parliament and in every other phase of social activity control was passing from the old nobility and the landed gentry to the magnates of industry. The Great Exhibition of 1851 was a focal point in this development with royalty, in the person of Prince Albert, handing on the torch.

In 1861 Mrs Beeton, in her first edition, gave the following 'scale of servants suited to various incomes':

'About £1,000 a year – a cook, upper housemaid, nursemaid, under housemaid and a manservant.
About £750 a year – a cook, housemaid, and footboy'

and so on down to:

'About £200 or £150 a year – a maid-of-all work (and girl occasionally).'

The masters and mistresses and their servants, the cabbies who drove them to the station or the theatre, the tradesmen who served them and the delivery and messenger boys who called at their back doors, the policemen who preserved law and order for them, and the Volunteers of which, like Keene himself, they were members – all these were his subjects with a special line in Scots who came south protestingly to bang their saxpences or who jeered at the discomfiture of Sassenachs north of the border. These were the people with whom he had to deal, not, be it said, as a satirical commentator, but as a good-tempered sympathiser with their weaknesses and a partaker of many of their prejudices.

In truth his subject-matter was his least concern. He is not alone among humorous artists in accepting jokes from all and sundry, but Keene went to unusual lengths in this regard. He borrowed sketchbooks of his friend Crawhall and kept them by him as a continual source of ideas for *Punch* 'socials'. Over a period of nearly 20 years Layard[25] identified about 200 examples of this. He illustrates one Crawhall original alongside what Keene made of it; which only

25 G. S. Layard, *The Life and Letters of Charles Keene*, 1892, pp. 446–52.

serves to show more clearly than ever what a great artist he was. As with Shakespeare or Mozart the basic material is incidental, it is the transformation produced by the artist that excites our wonder. As Keene himself said, an artist should be able to draw anything. It is part of his charm that he should convince us that however strange we find his people we should instantly recognise them if we met them. But the grace and verve, the sureness and delicacy of his art are entirely independent of subject.

Keene was a *numéro*, an odd-ball, a character. He collected everything from clay pipes found in Thames mud at high tide (he smoked them, too) to prehistoric flint tools and weapons, through books, prints, armour and musical instruments, among which he included the bagpipes which he would play indoors and out. All such things, with drawings and artists' materials, lay about in great disorder in his bachelor establishment where he would cook bacon to a cinder and eat it with apple-tart for his breakfast.

But he lived for drawing. He ground his own inks in a variety of tints and carried small quantities of them around with him in unspillable inkwells of the kind used by customs officers and insurance agents before fountain-pens came into common use. He used a variety of pens and even sharpened bits of wood to draw with on any scrap of paper – a discarded sugar bag or the back of a used envelope. He would dash off a sketch in a few moments, but this was little more than a shorthand note from which to make a series of careful studies of individual features eventually to be built into the final composition.

Increasingly his style bothered the engravers; and increasingly he strove for the perfection of his drawing with reproduction of it a very secondary matter. With his variously tinted inks, his unusual drawing instruments and his preference for coloured papers with rough surfaces he was producing results which even his own skilled hand could not transfer to wood, and by the end of 1872 it was decided that photography was the only means of doing so. This was a revolution in the *Punch* office where Tenniel, for example, clung to the earlier methods for another 20 years.

But it only egged Keene on to more and greater complications; with the saving grace that the originals were spared. Pennell gives an informative example of what this meant by reproducing both the original drawing and the engraving of 'During the Cattle Show' (1882). The first thing that emerges from the comparison is how much the drawing has suffered by reproduction; but in addition, while admitting the cleverness of the 'translation', the effect of the original is lost. Even the much vaunted half-tone process cannot reproduce in black and white the wonderful subtlety of Keene's mixture of inks and pencil work.

Let it be repeated, therefore, that of all the artists under present consideration there is none for whose proper appreciation the original drawings are more necessary. But while lamenting the losses caused by the engraver's burin let us not forget that without it there might very well have been no Keene illustrations at all, or none to speak of. His remarkable etchings suggest that he might have done much

more in that medium had not *Once A Week* and *Punch* offered an easier way. The good man had his living to earn and the products of the burin provided him with an estate worth £30,000 when he died in 1891. Not all great artists die in garrets.

The best of the etchings that are readily available are the folding frontispieces to the *Punch Pocket Books* between 1865 and 1875. Unfortunately they were coloured by hand. If the plates have survived two world wars uncoloured impressions of them would be a bonus for the suggested Album. Keene also did the frontispiece from 1876 to 1881, but these were not etchings. Two other etchings by him were included in publications of the Junior Etching Club, one in a selection from Hood's poems in 1858, the other in an anthology of contemporary verse in 1862. Like the books containing them neither etching calls for special remark.

The 30 or so etchings that Keene made for his own amusement, to which attention was first called by Beraldi,[26] and which are discussed in Pennell with a full iconography in Chesson's appendix, are tantalising for their great rarity. As to their excellence, if so partisan a commentator as Pennell could describe them as only slightly, if at all, inferior to the 'Thames' set, no higher praise need be sought – unless you happen to dislike Whistler. Pennell's comments date from 1897, when he was amazed that they had been so long ignored: but no furore of excitement about them is noticeable in 1970.

They have not become any easier to find even as restrikes from the original plates of 21 of them issued in 1903 by the Astolat Press with a foreword by Malcolm Salaman. These were issued loose in a portfolio and are sometimes offered separately as original impressions.

Now, reluctantly, we must leave this great artist. One must regret that his *Punch* commitments left him so little opportunity for more serious work; and one must beware of over-compensation for neglect of him in the past, of which there is little or no sign so far. There can be small doubt, withal, that he should be among the higher echelons in any artistic company.

George du Maurier

Ruskin's absurdly extravagant comparison of du Maurier with Holbein[27] and Henry James's copious laudations[28] have done him a disservice. They not only appraised him too highly, they praised him for the wrong reasons. Forrest Reid and Mr Pepys Whiteley[29] have redressed the balance, the former rather harshly, the latter more gently and justly.

Those for whom du Maurier's work begins and ends with *Trilby* and *Punch* – 'that insatiable little mouth that gaped every Wednesday' (James) – miss much of his best work. One must penetrate beyond the pictorial journalism of his later years which he found it so fatally

[26] *Les Graveurs du XIXᵉ Siècle*, 12 vols., 1885–92.
[27] In *The Art of England*, 1884.
[28] In *The Century Magazine*, 1883 and *Partial Portraits*, 1888.
[29] *George du Maurier, his life and work*, 1948.

45. G. du Maurier. From *A Legend of Camelot*, 1898, (left) '*Ver nonsensique*'; (right) 'Behold the wild growth from her nape'

easy to produce, week after week, year after year. A collection of his own drawings, *Society Pictures* (1888), concentrated largely on this kind of work, and make one wonder why his reputation has remained so high. For there is little evidence in it of the sensitive talent displayed in his work of the sixties and seventies, now in some danger of being passed over, if only because of its comparative inaccessibility. Forrest Reid sums it up admirably when he writes: 'Those who associate his name with the *Punch* drawings of the eighties and nineties, the smart studies of smart society, can form no conception of the combined delicacy and richness of many of his early designs.'

Du Maurier did not think of himself as a 'funny' man, but as a social satirist. Late in his life he lectured on *Social Pictorial Satire*[30] in which he included, not immodestly, his own contributions to the subject. Even before he had begun an artistic career he had lost the sight of one eye[31] and had developed an almost morbid preoccupation with insecurity. Thus every sympathy is aroused for his acceptance of the easy, assured livelihood offered by the continuous enlargement of a *dramatis personae* that the more it changed the more it was the same thing. Yet the fact is that in his early days he was an extremely funny man. His jape on the Pre-Raphaelites, *Legend of Camelot*, which ran through five issues of *Punch* in 1866 and was published in book form after his death[32] is still funny to read and uproariously successful in its illustrations which parody the Brotherhood beautifully. Sometimes what started as fun took another turn, as with du Maurier's contribution to Burnand's *Mokeanna!* This was a series of parodies in *Punch* of the sensational stories in popular journals of the day. Each was illustrated by a drawing intended to guy the

[30] Published by Harper, 1898.
[31] The cause was a detached retina, then irremediable.
[32] Harper, 1898. A fuller account of this book will be found on p. 128.

melodramatic illustrations of John Gilbert. Du Maurier's drawing[33] is much more terrifying, as well as infinitely more beautiful, than anything produced by Gilbert. Millais also did a fine drawing and both were included when the series was issued in book form.

This brings us to the consideration of du Maurier as a serious artist and to what concerns us most, his book illustrations. His drawings for his own novel, *Trilby*, have already been referred to. Unfortunately in this, as in his other two novels, *Peter Ibbetson* and *The Martian*, his later mannerisms are indulged to the full, although Gleeson White thought that *Trilby* could easily be proved to be 'the most popular illustrated book ever issued'. Trilby herself is just one more variant of du Maurier's 'My pretty woman', the standard formula for which is one of the illustrations to an article by him in *The Magazine of Art* (1891). The 'Three Musketeers of the Brush' – very much *la vie de Bohème à la gentilhomme* – are caricatures of his *Punch* swells, and Svengali would have been a suitable victim for another 'Mokeanna' series. It is instructive to compare to its disadvantage the carriage in which the demoralised trio rode about Paris with the illustration to Locker's poem 'Berkeley Square' in *Punch* (24 August 1867).

But there are hints of better things. One feels that if only one could see the detail in the drawing of Carrel's funeral it might be worthy of Steinlen – which is intended as a compliment. It is also a reminder of how badly du Maurier suffered in the reproduction of his drawings. His delicate pencil drawings defied the greatest skill of the engraver. When *Punch* at last went over to photographic process methods du Maurier wrote to thank Swain for his good work over 30 years or more. Whenever the opportunity occurs to compare an engraving with a drawing one's immediate reaction is of regret for what was lost. When such as du Maurier fell into the hands of incompetents like Robinson or Harral the sacrifice is brutal. As with so many others, however, mechanical processes inflicted even greater wounds. His own novels are printed on glossy paper to give the clichés every chance. The results are almost uniformly disastrous, an effect to which the artist, like so many others, contributed because of his unfamiliarity with the process. Knowing that the camera could capture details that would elude the engraver there was seemingly no longer any need to observe what had hitherto been essential economies in drawing. It was thought to be a positive virtue of the new process that limits of size could also be ignored. This was particularly welcome to du Maurier, whose one good eye was beginning to fail him. But whereas in earlier days his fussy mannerisms were tempered to some extent by the 'tyranny of the burin' the photographic plate absorbed every detail. Unfortunately the metal cliché was less responsive and printer's ink less sensitive than silver nitrate and the final result is often lamentable. One of the worst examples is the plate of the three friends riding in a hansom 'A-smoking their poipes and cigyars'.[34]

[33] Punch, 28 Feb. 1863.

[34] Mr Pepys-Whiteley gives some striking examples of original studies for illustrations in the three novels which may be gloomily compared with the printed books. He also exemplifies the autobiographical nature of all three of the novels.

46. G. du Maurier. *Sylvia's Lovers*, 1863

Let us now turn to pleasanter things and to some of the more memorable examples of du Maurier's work as a book illustrator, nearly all of it before 1870. His first book[35] need not detain us, for he had not yet found himself. In 1873, with *Sylvia's Lovers*, he began to illustrate some of Mrs Gaskell's novels. These illustrations rank with his best work and it is maddening for the enthusiast that several of the titles are actual first editions of the books and therefore very expensive. Those that are not first editions are *Sylvia's Lovers* (1863), although this is also the date of the three-decker first edition, *Cranford, A Dark Night's Work* (1864), *Lizzie Leigh* (1865) and *North and South* (1867). All of these were issued as single volumes in uniform red morocco cloth and although difficult to find should not cost very much. They are well worth having, with *Sylvia's Lovers* perhaps just a shade ahead of the others. Unfortunately, although engraved by Swain, the engravings are rather poorly printed. One of the two remaining Gaskells that are first editions belong to this series, *Cousin Phillis*, (1865, reprinted 1866). The really tiresome one is *Wives and Daughters* (2 vols., 1866), Mrs Gaskell's last and unfinished work, which is a really rare and expensive book. It was included in the series in 1867 but with the illustrations reduced in number from 18 to five. There is a way round this dilemma which permits the enthusiast to get this fine series of illustrations and that is to hunt down the volumes of *The Cornhill Magazine* for 1864 and 1865 in which the novel was serialised, with even more illustrations than were included in the first book edition.

Du Maurier became for many years the principal illustrator of the *Cornhill*, but did nothing to equal the Gaskell drawings. Meredith's *Harry Richmond* (1870–1) has few memorable illustrations and for Hardy's *The Hand of Ethelberta* (1875–6) the designs are even more of a let down than the novel itself. It is curious that when so much better work by du Maurier and others was dropped in book publication this unsatisfactory series should have been retained.

There is one more important du Maurier volume that may prove something of a teaser. This is Douglas Jerrold's *The Story of a Feather* reprinted from *Punch* in 1867. It is a quarry worth tracking down for its 30 illustrations are among his very best and some of the initial letters are exquisite. Opinions are divided on the illustrations to Thackeray's *Henry Esmond* (1868) – not, be it noted with relief, the first edition of the book, though difficult to find with the right date. Forrest Reid calls it 'a masterpiece'; Pepys Whiteley finds that the drawings 'hardly attain the high standard that might be expected'. A personal opinion is that the drawings are uneven in quality but the best, and possibly the most of them, are exceedingly good.

Other Punch artists

With du Maurier we exhaust the list of *Punch* artists of real importance for our purpose. There was one more to come who approached genius. This was Phil May, a really great master in the economy of

[35] H. Dalton, *The Book of Drawing-Room Plays*, Cassell, 1861.

line. But apart from *The Parson and the Painter* (1891) and Burnand's *Zig Zag Guide* (1897), unless one counts the 15 *Phil May Annuals* between 1892 and 1903, he published in book form only collections of drawings of which the most striking may be *Guttersnipes* (1896).

Linley Sambourne is notable for the illustrated edition of Kingsley's *The Water Babies* (1886) and Burnand's *New History of Sandford and Merton* (1872) which did not appear in *Punch*; and Harry Furniss for the two *Sylvie and Bruno* volumes (1889 and 1893) and for G. E. Farrow's *The Wallypug of Why* (1895). Stacy Marks and Fred Barnard arouse little enthusiasm. The latter was once thought the king of Dickens's illustrators. Such *lèse-majesté* cannot be allowed to pass even in the *Household Edition* against Charles Green's *Old Curiosity Shop*, A. B. Frost's *American Notes* and Mahoney's *Our Mutual Friend*.

C. H. Bennett and Ernest Griset both deserve much more extensive consideration than the passing mention afforded here. But when it comes to the nineties people – Partridge, Shepherd and J. F. Sullivan – they suffer in the light of the brilliance emerging from quite a different quarter.

Punch had moved with the times. There is a community of idiom between Keene and Leech, but du Maurier belongs to the same school as Millais, to which we now turn.

But before doing so let us sum up what *Punch* and its in some ways more influential, if more ephemeral, sister-journal *Once A Week* did for book illustration. They gave for the first time in England an opportunity for the illustrator to earn a regular income. *Once A Week* began in 1859. Before that Dickens had started a new fashion, to be widely imitated, with his illustrated novels in monthly parts. *The Illustrated London News* was started in 1842; and the *Cornhill* overlapped *Once A Week* from 1860. Others followed thick and fast: *Good Words* (1860), *London Society* (1862), *The Sunday Magazine* (1865), *Argosy* (1866), *The Quiver* (1867) and many others.

All of these published serials, the magazine illustrations to which were frequently retained when book publication ensued. This set a fashion for book illustration which has not persisted into our own day when the fiction magazine has virtually ceased to exist and we no longer illustrate novels.

Book illustration in Britain, moreover, would not have taken the form it did had it not been for Thomas Bewick's demonstration of the potentialities of the end-grain of boxwood. It might have been just as prolific: it would certainly have been very different.

Books applicable to this chapter

Charles Dickens

Dickens's bibliographers, Eckel and Hatton and Cleaver, discuss his illustrations only in relation to the kind of triviality that bedevils the

lives of collectors of part issues. Of more general interest in surveying the whole field is: F. G. Kitton, *Dickens and his Illustrators*, second edition 1899, which has much out-of-the-way information.

The illustrations for the Household Edition (1871–9) of his works, (all 866 of them) by a variety of artists, are reproduced, rather unsatisfactorily, albeit 'from the original wood blocks' in: *Scenes and Characters from the Works of Charles Dickens*, 1908.

An informative study of the subject is Arthur Waugh's 'Charles Dickens and his Illustrators' with an extremely useful list of the original illustrations, the artists and their media, by Thomas Hatton in: *The Nonesuch Dickens*, 1937. Well illustrated and with considerable information on many of the books he illustrated.

The best source for 'Phiz' is: D. C. Thomson, *Life and Labours of Hablot Knight Browne. 'Phiz'*, 1884. Cruikshank has already been dealt with in the Appendix to Chapter 3.

There is nothing very satisfactory on Leech except: W. P. Frith, *Leech's Life and Work*, 2 vols., 1891 and F. G. Kitton, *John Leech*, 1883 (reprinted 1884, but without the list of works). Kitton's larger work on the Dickens illustrators mentioned above is more informative in that special connection.

On the *Punch* artists in general two essential books are: M. H. Spielmann, *The History of 'Punch'*, 1895 and R. G. G. Price, *A History of 'Punch'* 1957.

On the individual artists there is very little. Most of them are dealt with in Forrest Reid and Gleeson White. The latter has a few references to Richard Doyle, the former has none. The only book devoted exclusively to him is: D. Hambourg, *Richard Doyle*, 1948. The text is short, but adequate, the illustrations are well chosen and there is a useful check-list of books.

In the same series (Art and Technics) as the Doyle, the du Maurier and the Leech monographs is one on Tenniel: F. Sargano, *Sir John Tenniel*, 1940. Text, illustrations and check-list all good and useful. There is also: W. C. Monkhouse, *The Life and Work of Sir John Tenniel*.

With Keene we are well served by: Joseph Pennell, *The Work of Charles Keene*, 1897. This massive folio (published at three and a half guineas) is valuable for its many well-reproduced illustrations and for the extensive iconography and bibliography by W. H. Chesson. G. S. Layard, *The Life and Letters of Charles Keene*, 1892. Much useful information on his work and good illustrations.

George du Maurier D. Pepys Whiteley, *George du Maurier*, 1948

The text does him justice and the illustrations and lists of his illustrated books fill out the lengthy account of him in Forrest Reid and the factual references in Gleeson White.

F. Moscheles, *In Bohemia with du Maurier*, 1896

A revealing and affectionate account of their student friendship in Belgium and reproduces many early sketches and drawings.

L. Ormond, *George du Maurier*, 1969

A full-length, extensively illustrated biography with much new

information. Pepys Whiteley (*above*) has a much more complete bibliography.

Selected list of illustrated books

Charles Dickens

As is shown in the text of this chapter Dickens's association with 'Phiz', Hablot K. Browne, was extensive and fruitful. Illustrated by other artists were: *Oliver Twist*, 3 vols., 1838 (plates by Cruikshank); *A Christmas Carol*, 1843 (four coloured etchings and four wood-engravings by Leech); *The Chimes*, 1845; *The Cricket on the Hearth*, 1846; *The Battle of Life*, 1846 (all three with illustrations by Leech, Doyle and others); *Pictures from Italy*, 1846 (four vignettes by Palmer).

'Phiz' The following have etchings by 'Phiz': *Pickwick Papers*, 1837; *Nicholas Nickleby*, 1839; *Martin Chuzzlewit*, 1844; *Dombey & Son*, 1848; *David Copperfield*, 1850; *Bleak House*, 1853; *Little Dorrit*, 1857; *The Tale of Two Cities*, 1859.

Master Humphrey's Clock, 1840–1, contains the first appearances of *Barnaby Rudge* and *The Old Curiosity Shop*. Separate editions of both books appeared, apparently made up from the relevant sections of the periodical. They are rather difficult to find in this form but, like the *Clock* itself, inexpensive. In either form they are well worth having for the wood-engravings by 'Phiz'. Those by Cattermole are less interesting.

Among other books illustrated by 'Phiz' worthy of special attention are: Charles Lever, *The Confessions of Harry Lorrequer*, 1839; *Charles O'Malley*, 1841; *Our Mess*, 3 vols., 1843–4; *The Daltons*, 2 vols., 1852, and several of Lever's other novels.

'Phiz' also illustrated several of Ainsworth's novels, notably *Mervyn Clitheroe*, 1852, originally issued in parts, and *Auriol*, 1850.

This was first published serially in *Ainsworth's Magazine*, 1844–5, with the illustrations under the title 'Revelations of London', and again in the *New Monthly Magazine*, 1845–6, as *Auriol*. In book form it first appeared as volume 12 of the collected edition. Sadleir, from whom this information is culled, points out that one of the stories had already appeared in book form with the 'Phiz' illustrations, in The *Pic Nic Papers*, 3 vols., 1841. The illustrations to *Auriol* are very fine.

His brief and not very successful association with the Surtees novels has been mentioned on page 97. He was prolific and his work was very uneven. At his best with Dickens, Lever and Ainsworth – he is a grand artist, redolent of the period and a true illustrator.

John Leech As already stated in the text, Leech was primarily a *Punch* man and for that reason we may take those drawings first in so far as they were issued in book form.

Mr Briggs and his Doings, 1860

Mr Briggs was a creation of Leech's who had appeared in *Punch* at frequent intervals since 1849. In this oblong folio with the drawings

in colour it is less successful. Most of Mr Briggs's exploits, with a splendid and extensive selection of Leech's work for *Punch*, is in *Pictures of Life & Character,* 5 vols., 1854–9.

The 'Comic' series, guying grammar, law, railways and history, some of which appeared in *Punch*, are a mixture of slapstick and facetiousness which has now lost whatever point it may have had at the time.

One of Leech's more successful efforts was his contribution to:

R. H. Barham, *The Ingoldsby Legends*, 3 vols., 1840–7.

Leech contributed nine plates and Cruikshank eight. To the edition in one volume, 1864, Tenniel also contributed and the edition of 1870 includes a famous frontispiece by Cruikshank in which all the leading characters are depicted.

Leech's illustrations for the Christmas Books of Dickens have already been mentioned on pages 93–4. Apart from these his best known and most lasting work in book illustration is probably the sporting series for:

R. S. Surtees, *Ask Mamma*, 1888; *Mr Sponge's Sporting Tour*, 1853; *Plain or Ringlets*, 1860; *Handley Cross*, 1864 (the first edition in three volumes, 1843, was not illustrated) and *Mr Facey Romford's Hounds*, 1865.

All were first issued in parts and in single volumes on completion. The plates were steel etchings coloured by hand and there are wood-engravings in the text. Leech died before *Mr Facey Romford's Hounds* was completed. The first 13 plates are his, the last ten are by 'Phiz'. Leech also illustrated other novels, for example:

Albert Smith, *Christopher Tadpole*, 1848

Issued in parts 1846–8, but especially attractive in cloth, for the Leech-designed cover.

Frances Trollope, *Jessie Phillips*, 1842–3

Issued in parts and in three volumes on completion.

W. H. Maxwell, *The Fortunes of Hector O'Halloran*, 1842–3

In parts and in volume form on completion.

After his death his sister issued in fascimile a series of drawings of slum children that he made in 1841 entitled *Children of the Mobility*, 1875.

Richard Doyle It is difficult to omit any of his books, for there is hardly a bad one among them. Fortunately there is a complete list in Hambourg.[36] Special favourites are listed here:

Mr Pips His Diary, Manners and Customs of ye Englishe, 1849
John Ruskin, *The King of the Golden River*, 1851
The Story of Jack and the Giants, 1851
Bird's Eye View of Society, 1864
J. R. Planche, *An Old Fairy Tale Told Anew*, 1865
William Allingham, *In Fairyland*, 1870
Dicky Doyle's Journal, 1885 (written 1840)
Jack the Giant Killer, 1888 (written 1842)

[36] *Richard Doyle*, 1948, with a broad selection of illustrations.

Sir John Tenniel It is tempting to consider Tenniel exclusively as the illustrator of *Alice*, but although there is certainly nothing comparable in the rest of his book-work, there are a few interesting points that are worth noting. For the record, therefore, the two *Alice* books are:

Alice's Adventures in Wonderland, 1865 (second and first published edition 1866)

The first edition was withdrawn at Tenniel's request (see p. 109). One thousand sets of sheets were sold to Appleton & Co., New York, who issued them with their own title-page, dated 1866. Note that the manuscript that was sold at Sotheby's in 1928 for £15,400 is now in the British Museum, and is not of this book but of the shorter, original version, as told to the Liddell children on the river expedition in 1862. The illustrations are by the author. A facsimile of this was published in 1886.

Through the Looking Glass, 1872

From the illustration point of view this is at least as attractive as *Alice*. In it are introduced the White Knight, Jabberwock, the Walrus and the Carpenter and Tweedledum and Tweedledee.

As for other books by Tenniel, there is a complete list in Sarzano, *Sir John Tenniel*, 1948, from which for extrinsic, if not always intrinsic importance, his first appearance in book form seems to have been, not very notably, in: S. C. Hall, *A Book of Ballads*, 1842 (on which see p. 34), and his first commission to illustrate an entire book was Fouqué, *Undine*, 1846 (published 1845 and post-dated). For its reputed influence on his future career see his edition of:

Aesop's Fables, 1848

In fact the edition of 1881 is superior, but some of Tenniel's illustrations are replaced by drawings of J. Wolf, himself a popular but rather pedestrian artist specialising in animals.

A Juvenile Verse and Picture Book, 1848

This is interesting because the engraver was Charles Gray to whom Gilbert Dalziel was apprenticed.

Charles Keene Peter Parley, *The Adventures of Dick Boldhero*, 1842

The date is given by Chesson and must therefore be respected, but see page 113 for notes on the earliest dated copy extant. The book is a curiosity as Keene's first known appearance as an illustrator, but otherwise without significance.

D. Jerrold, *Mrs Caudle's Curtain Lectures*, 1866

The first edition illustrated by Keene and a masterpiece.

C. Reade, *The Cloister and the Hearth*, 1890

In its original abbreviated form, with the title *A Good Fight*, this was serialised in *Once a Week*, 1859, with 15 illustrations by Keene. In the book publication seven of these, with a new one, were included.

The fact that only three books are here listed over a period of more than 40 years and that only *Mrs. Caudle* is worthy of consideration indicates that his best work must be sought in periodicals, notably *Punch* and *Once a Week*. Chesson's bibliography includes most, though not quite all, of his book illustrations and his list of the etchings, including those for *Punch's Pocket Book*, should be consulted.

In his prefatory note he discusses and lists some of the periodical work – over 2,000 drawings appeared in *Punch* and 134 in *Once a Week*, but these are most effectively listed by Forrest Reid and Gleeson White. A representative selection of some 400 or 500 of the *Punch* 'socials' was gathered in *Our People*, 1881.

George du Maurier Elizabeth Gaskell, *Sylvia's Lovers*, 1863; *Cranford*, 1864; *A Dark Night's Work*, 1864, *Cousin Phillis*, 1865, *The Grey Woman*, 1865; *Lizzie Leigh*, 1865; *Wives and Daughters*, 2 vols., 1866; and *North and South*, 1867.

The above, which include du Maurier's best work as a book illustrator, are discussed on page 122. They were all serialised in the *Cornhill* before being published in book form. Also used in book form, although reduced in size and in number (from 27 to 13), were the drawings, of which Forrest Reid thought highly, for the *Leisure Hour* serial: G. E. Sargent, *Hurlock Chase*, 1876.

For du Maurier's contributions to *Once a Week*, not used in book form, but including some excellent vignettes in Miss Braddon's *Eleanor's Victory* and *The Notting Hill Mystery*, an anonymous thriller, see Reid and White.

G. du Maurier, *Peter Ibbetson*, New York, 1891; London, 2 vols., 1892; *Trilby*, 3 vols., 1894; *The Martian*, 1898
There was a large-paper edition of the last of these three autobiographical novels with six illustrations of sketches not included in the ordinary edition. *Trilby* is especially interesting in its serialised form in *Harper's Magazine* for a long passage and a drawing introducing a character called Joe Sibley, unflatteringly representing Whistler. Both were omitted in book publication.

A Legend of Camelot, Pictures and Poems, 1898
The title poem was more topical when it first appeared in *Punch* in 1866. The other pieces, such as the parody of Swinburne, probably dated a little already in 1898. One is none the less glad to have them now. There is a capital send-up of Ouida – 'A Lost Illusion':

> I may mention at once that she dabbled in vice
> From her cradle – and found it exceedingly nice.
> That she doated on sin – that her only delight
> Was in breaking commandments from morning till night.

He has another crack at the 'anti-prae-Raphaelites' in an excellent piece of fun 'The Rise and Fall of the Jack Spratts'. Incomparably the best thing in the book however, is the brilliant series of 32 limericks in French, the drawings for which are as good as the verses.[37] The book is elaborately produced as an oblong quarto printed on one side of the thick calendered paper only and cost 12s 6d. Unfortunately the reproductions are not of very high quality.

His work for *Punch* is conveniently seen in: *English Society at Home*, 1880; *Society Pictures Selected from 'Punch'*, 1888. The former of these is preferable, although it contains only 63 drawings as against several hundred in the latter. The earlier drawings are greatly superior and are carefully reproduced as india-paper proofs.

[37] 'Vers Nonsensiques à l'usage des familles Anglaises', *Punch*, 1868.

6 The Dalziel Era

Gleeson White began the treatment of the years 1855 to 1870 as a significant period in the history of modern book illustration and Forrest Reid followed. White is very explicit in regarding its significance as being the period in which the wood-engraver took over. Forrest Reid's point of view is not quite so clear cut.

'This' [he writes] 'was the really great period, during which the output of first-rate work was remarkable. It would have been more remarkable still had not drawing on wood been regarded by several of our artists as only an experiment, and by others as a method of keeping the pot boiling when the more serious work of painting failed to do so'.

Gleeson White seems to me to come nearer to the truth of the matter, but both points of view are lacking in perspective. Better service is done to the period and its artists by treating it not in isolation but as part of the evolution that began with Bewick and ended with the invention of the zinco.

The danger of permitting oneself to be beguiled by dates on title-pages may be shown by two attractive anachronisms. In 1888 Strahan issued an edition of *The Poetical Works of Oliver Goldsmith* well printed on hand-made paper by Ballantyne & Hanson – who were later to print the Vale Press books for Ricketts – and with wood-engraved illustrations on india paper laid down. The illustrations, however, were certainly pulled from blocks made in the 1840s by Creswick, Horsley & Redgrave.

Art & Song was published in 1867 by Bell and Daldy. It is a fascinating and highly accomplished example of steel-engraving. But Martin, Turner and Stothard, who illustrated it, were all dead when the book was published (but see p. 78).

One cannot exclude from the study of a period every artist who produced work beyond its limits at either end. But an artist may still overlap a period, or even straddle it without sharing its idiom. Keene, Doyle and Tenniel at the earlier end and Fildes, Green, Marcus Stone, Hopkins and Dicksie at the later end belong to different schools and different environments from Millais, Houghton and Pinwell. To mix them all up together not only clips the wings of the artists but impedes the perspective that is essential to the evolutionary study of the whole era.

There is no doubt – and it is important to observe – that high-pressure developments in wood-engraving brought about vast changes. White says that 'a more ample supply provoked a larger demand'. This seems to put the cart before the horse. In fact the demand had been there all the time. The great interest in illustrated books recorded in previous chapters proves it. And as usual, means of increasing supply were found to meet the demand.

William Harvey was one of the first to grasp the situation and to offer publishers a package-deal in the illustrating of their books. This he was able to do by making the necessary drawings on wood himself and distributing them among existing studios in proportion to the staff of engravers employed by each of them.

Charles Knight approached the problem differently. He employed Harvey for special jobs, but for the day-to-day tasks of his extensive programme of illustrated books and periodicals he employed a staff of engravers under the supervision of John Jackson.

His example was followed from the very outset by the founders of new illustrated journals like *Punch* and the *Illustrated London News*, who saw clearly that publication dead-lines could be observed only if a staff of engravers was at hand on the premises. Swain, on *Punch*, and Landells on the *Illustrated London News* probably did little of the actual engraving. They acted more probably as art editors, although *Punch* never explicitly admitted the existence of such a post until 1905 when the proprietors appointed F. H. Townsend – but without letting on to the editor.[1]

Already by the 1840s publishers were accustomed to ask wood-engravers to provide them with illustrations for books and the basic material was often supplied by pupils who were learning to draw on wood – Keene at Whymper's and Birket Foster at Landells's for example. It is as true of the thirties and forties as of the sixties that 'but for the enterprise of the engraver, the drawings themselves would in all probability never have been called into existence. . . .'[2] True, there was much more of it in the sixties, and many new artists of importance were unearthed; but it is a difference of degree rather than of kind.

Furthermore, it is advisable to remark that many books of earlier date, unregarded by White or Reid, have all the characteristics supposedly exclusive to their period; and that two books that both of them regard as belonging to the period – Allingham's *The Music Master*, 1855, and the Moxon Tennyson, 1857 – cannot be made to fit any formula by which a sixties book can be recognised. These, however, are the dates to begin with and they are important as a link with the forties.

Let us examine the two books more closely, for they have come to be regarded as indispensable to a collection of sixties books and as both of them are elusive and expensive this is rather tiresome. If a criterion of a sixties book is that the selection of the illustrators is left to the engraver then neither book qualifies. Routledge – for the Allingham, and Moxon – for the Tennyson – commissioned the artists direct and conducted all the negotiations with them. Even Rossetti's trenchant protests at the effect of Dalziel's cutting was not made direct but through the publisher.

The Music Master is a memorable book because all the three artists may be regarded as essentially belonging to the sixties, and each of them was making his bow as an illustrator. There were eight full-page illustrations and two vignettes, all engraved by the Dalziels. Rossetti and Millais contributed one full page apiece. The rest were by Arthur Hughes, but with little evidence of his later brilliance. Rossetti's drawing 'The Maids of Elfen-Mere' is unforgettable and, despite his protests, one can see that Dalziels' engraver worked miracles with it.

47. D. G. Rossetti. The Maids of Elfen-mere. *The Music Master*, 1855

[1] R. G. G. Price, *A History of Punch*, 1957.

[2] Gleeson White, *English Illustration 'The Sixties', 1855–70*, 1903, p. 13.

The drawing by Millais, 'Fireside Story' is masterly and intrinsic with promise of greatness to come, already proving how much finer a draughtsman he was than a painter. The Allingham therefore has many points in its favour.

The attractions of the Tennyson I find much more exaggerated. It perpetuated the unfortunate fashion of employing a variety of artists in one volume – always dangerous and here disastrous. The chosen artists divide sharply into two groups and their dates of birth alone show the incongruity of including them within one pair of covers. The older group consisted of Creswick (b. 1811), Mulready (b. 1786), Stanfield (b. 1793) and Maclise (b. 1806). The younger artists were Millais (b. 1829), Holman Hunt (b. 1827) and Rossetti (b. 1828). Mulready was an R.A. before either of the younger two was born. Horsley (b. 1817) was an odd man out.

The volume opens with an appalling pretty-prettiness by Creswick in the worst Birket Foster style, and follows this up with a pretty fair Millais and two effective Holman Hunts. Then we are back with Creswick and Mulready, two each, before we come to two really striking Hunts, for *Oriana*. And so it goes on throughout the volume, the younger men scoring heavily all the time. Again and again one remarks how splendid they are – and how shoddy are their companions. Moxon observed the earlier practice of distributing the engravings to various *ateliers* and not always giving all the work of one artist to the same engraver. Thus the Millais drawings were shared by five engravers, the Hunts by four and the Rossettis by two. The book is thus in no sense a unit but it has some outstanding drawings. Rossetti's drawing for 'The Palace of Art' and Millais's for 'The Death of the Old Year' are perhaps the best of all, although Forrest Reid believes the latter was made for another poem. There are 18 by Millais, seven by Holman Hunt and five by Rossetti, and there is hardly a bad one among the lot, although the printing occasionally leaves much to be desired. 'Mariana' (p. 7) and 'Cleopatra' (p. 149) and Rossetti's drawing for 'The Lady of Shalott' must have called for the Dalziels' highest accomplishment.

Apart from these two books Rossetti made illustrations only for two other books – his sister's *Goblin Market*, 1862, and *The Prince's Progress*, 1866, two for each and all admirable. Holman Hunt, too, is a very rare illustrator, which is also regrettable on the basis of his work in the Tennyson.

The contribution of Millais to the Tennyson is a marvel of accomplishment and variety. He may well be considered as possibly the best illustrator of his day and at least half a dozen of the drawings in this book rank with his best.

There can be no doubt, in fact, and there is here no intention to suggest otherwise, that both the Allingham of 1855 and the Tennyson of 1857 contain some very fine drawings and are desirable on that account. But they set a bad example which was all too frequently followed in the years to come. Routledge was too timorous with *The Music Master*. It almost looks as though he had originally decided to have all drawings made by one artist. Allingham, the author of

the book, wrote to Arthur Hughes on 11 July 1854 saying that there would be only six illustrations in the book and that Routledge would pay the artist three guineas apiece for them.[3]

Hughes did, in fact, supply the required number. Possibly Routledge commissioned the two extra drawings to boost what he feared might prove an unsaleable book. After all, most of the poems in it had already been published only a year earlier in *Day and Night Songs*, and Hughes's illustrations were rather feeble. Whether this is the true explanation or not there seems to be little reason for endowing this book with pioneer significance because of its eight illustrations.

As for the Tennyson, it has already transpired that the unfortunate practice of combining incongruous artists in the illustration of a book was a commonplace in the forties – the later Dickens Christmas Books, Hall's *Book of Ballads*, for example. This disrupted the unifying methods of Bewick and his pupil Harvey and is therefore to be deplored.

The Moxon Tennyson is a distinguished example of this unfortunate aberration, but not a pioneer. It was, in fact, much later in what would be better called the Dalziel period that the lesson began to be learned. Meanwhile the tradition was kept alive by artists and publishers largely outside, or perhaps alongside, the main stream. Both its chroniclers extend the period at either end – 1855 to 1870 – and both record work published earlier and later than these dates. It was indeed in some respects a golden age of book illustration and although it had major shortcomings it was precisely and exactly due to improvements in craftsmanship that existing artists were persuaded to join the ranks and that a new school of illustrators was attracted to the new field.

If we concentrate almost exclusively on the Dalziels in this connection this is not because there were not other able engravers in the field, like Swain, the Whympers, Landells and others. It is because the scale and the comprehensive nature of their activities make them the exemplars of the movement. They were artists, engravers, printers and publishers. They discovered and encouraged young artists to work in the medium, and by the excellence of their results they attracted artists already famous in other spheres to join them. It was significant that they were engaged in the two books already discussed in this chapter, Allingham's *Music Master* (1855) and the Moxon Tennyson (1857), and that Moxon entrusted to them the supervision of the printing of the latter work, although it was in the hands of Bradbury & Evans.

The Dalziel family came from Newcastle. George, the eldest brother, born in 1815, came to London in 1835 as an apprentice to Charles Gray, a wood-engraver. In 1839 he set up on his own account and was shortly joined by his brother, Edward, born in 1817. In 1851 came sister Margaret, and in 1852 and 1860, other brothers, John and Thomas, joined them. At first they took whatever work came their way, and although their names do not appear in the long list of engravers in Harvey's edition of *The Arabian Nights*, they were

[3] Quoted by Forrest Reid, *Illustrators of the Sixties*, 1928, p. 30.

48. R. Doyle. *The Story of Jack and the Giants*, 1851

already employed by him in 1839 while that book was in the course of publication in parts. Harvey was also responsible for the first book in which all the engravings were executed by them. This was an edition of *The Pilgrim's Progress* illustrated by Harvey and published by Boyce in 1850. This was not a success, possibly because of its high price (12s) and it was remaindered by Griffin in 1857 at 7s. Willis and Sotheran evidently took sheets of it for it appears, with the later date, in their vast catalogue of 'Fifty-Thousand Volumes' in 1862 – antique calf 12s 6d, antique morocco 16s. There is more than a hint in the Dalziel *Record*[4] that they commissioned the illustrations from Harvey and engaged Boyce to publish it for them. In the same year they engraved illustrations for Cundall, *Home for the Holidays*, which was also taken over by another publisher. But it is pleasant to record that both their earliest solo efforts fall within our field. *Home for the Holidays*, was one of the few children's books illustrated by Kenny Meadows – 'Iron Jack' as he was known on account of his robust health and his imperviousness to the effects of alcohol. He was 84 when he died and had been living on a Civil List pension of £80.

Meadows was a delightful illustrator who has always been more highly esteemed on the Continent than at home, mainly for *Heads of the People* (2 vols., 1840–1), and his Shakespeare (3 vols., 1843); (see pp. 54–5). He should have a very special place among illustrators of children's books for his drawings for the first edition of a nursery classic, Frances Browne's *Granny's Wonderful Chair* (1856) published first by Griffith and Farran, the successors to Newbery and Harris, plagiarised by Mrs Hodgson Burnett in 1887, and ensured of what likelihood of immortality may arise from its inclusion in the Everyman Library.

In 1851 the Dalziels were associated with a minor masterpiece – *The Story of Jack and the Giants*,[5] with 35 drawings by Richard Doyle, engraved by G. and E. Dalziel. The Dalziels themselves claim to have commissioned the book from Doyle, employing Cundall and Addey as publishers.[6] This may well have been so, for Cundall's firm was certainly in low water at the time. Some colour is lent to the Dalziel claim by the appearance of their names on the title-page. This must have been a great moment for them and it may be truly said that they never thereafter looked back. The little book was excellently turned out by Robson, Levey & Franklyn for Cundall & Addey at 2s 6d plain, 4s 6d coloured. Incidentally, the book was intended to be the first of a series of fairy-stories illustrated by Doyle but he was so slow in delivering those for the second volume, *The Sleeping Beauty*, that the series was abandoned. The drawings that Doyle did make were used for a text supplied by J. R. Planché in 1865: *An Old Fairy Tale Told Anew*, published by Routledge (see p. 103). The habit of

[4] p. 17.
[5] Not *Jack the Giant Killer* as confusingly recorded by Dalziel, p. 352, that was published only in 1888 in facsimile of Doyle's manuscript and drawings of 1842 (aet. 18).
[6] *Op. cit.*, pp. 61–2.

dilatoriness plagued Doyle all his life and we regret it the more for the great illustrator that he was.

This was certainly not the Dalziels' first contact with Doyle, for in 1848 they had persuaded the *Illustrated London News* to commission from him the monthly calendar headings for their Almanack and had had some argument with them over payment.

Neither was it the earliest children's book illustrated by Doyle, which was a version of a Grimms' fairy-tale – *The Fairy Ring* (1846). But he has been dealt with elsewhere, however inadequately, along with Keene, Tenniel and others (see pp. 101–4), which serves as a reminder that none of these is truly a 'sixties' man.

Possibly the most fruitful contact made by the Dalziels was with George Routledge, the Quaker publisher. They themselves have stated that they first met him in Cundall's office. This may well be true, but when they suggest that their first contract with him was for engraving John Gilbert's illustrations for a selection from Longfellow's poems (1856) they have forgotten the Allingham which appeared one year before it. Gilbert cannot be considered a sixties artist either. He was active long before and long after the period, neither was he an especially brilliant artist. But the Longfellow is an important book. Gilbert excelled himself in the designs and the Dalziels made something quite unusually attractive of the pictures. There is more than a hint that they rather than Routledge commissioned them, for they were paid £1,000 for the job, which included Gilbert's share.[7]

The success of this book, which was considerable, caused the brothers to raise their sights and they now began to prepare books for publication at their own risk, paying Routledge a commission, or giving him a share in the profits in return for his imprint and distributional services.

The first of these was *Poets of the Nineteenth Century* (1857) selected by the Rev. R. A. Willmott, an indefatigable litterateur of the period. Rossetti entertained, but eventually declined an invitation to contribute. But Ford Madox Brown did and it was the first and certainly not the worst of his rare book illustrations, of which he made only nine in all according to Forrest Reid. But these do not include the two that he made for the first book of his nephew Ford Madox Hueffer – *The Brown Owl* (1892). If one has to think in terms of delimitation of a period Willmott's book has a very good claim to be considered a true forerunner of the 1860s. It was commissioned by the engraver and executed by him, which is the real hall-mark of period practice. Every artist engaged in it was a true sixties man, with the possible exception of Gilbert,[8] and Hanby. Millais added greatly to his reputation with two lovely drawings, one of which, to illustrate Coleridge's poem 'Love', Forrest Reid thinks 'the most moving and impassioned he ever made'. The Dalziels squeezed in drawings by their brothers, Thomas and Edward, the latter pseudonymously.

[7] Dalziel, *op. cit.*, pp. 29–30.

[8] I once owned a letter by Gilbert pricing a drawing of his illustration to 'Hohenlinden' (on p. 173 of this book) at £150.

Lalla Rookh, for which drawings were commissioned from Tenniel in 1861, used to be thought his best work, but he was not, in fact, the right artist for it.

Birket Foster is an artist for whose black and whites, at least, enthusiasm has waned. Yet he was one of the most prolific and most popular illustrators of the day. He learned to draw on wood in Landells's *atelier* where he founded a lifelong friendship with a fellow apprentice, Edmund Evans. Foster was one of those who was never quite satisfied with what could be got out of a wood-engraving and constantly pushed the engravers to the limits. He tried his hand at etching on steel. While with Landells he made designs for *Punch* and the *Illustrated London News*. His first book commission came from Henry Vizetelly in 1847 for the four parts of Thomas Miller's *The Country Boy's Book*.

Oddly enough, for one whose name is considered synonymous with the sixties, Foster illustrated only one book originating within that decade. Fortunately it is the best of them all – *Pictures of English Landscape* (1863) – of which Forrest Reid truly remarks that 'the whole of Foster can be found in it'. Here his elaborate ultra-sentimental rural landscapes are more finished, more painstaking, than usual and there is not a pin to choose between them. The binding of the book was designed by Owen Jones. Perversely, however, this is one book which is preferable in the special edition of india-paper proofs, which falls outside the period in 1881.[9] I am in some doubt, however, as to whether this can strictly be called an illustrated book at all, for the text consists of verses written round the pictures by Tom Taylor. Yet it cannot be said that the pictures are not relevant to the text.

But we cannot range over the whole school. Its members were numerous, prolific and able and have not lacked chroniclers. White and Reid cast their nets wide and their catch included some that might have been thrown back, not on grounds of inadequacy but because the environment was alien to them. We shall be most profitably employed in concentrating on the giants.

Millais was probably the best of them all and as versatile as he was able. He illustrated five of Trollope's novels – *Framley Parsonage* (1861), *Orley Farm* (1862), *The Small House at Allington* (1864), *Phineas Finn* (1869), *Kept in the Dark* (1882), in which the illustrations used in periodical or part publication were retained in volume form. An author is often his illustrator's harshest critic. But Trollope was entranced by Millais and thought the drawings for *Orley Farm* the best he had ever seen 'in any novel in any language'.[10] Trollope was no flatterer. He took away from 'Phiz' the completion of the illustrations for *Can You Forgive Her?* after half of them were completed, writing to his publisher that he was handing the rest over to 'a lady' for he thought there could be no worse illustrator than Browne for his books. Certainly he was never as well served again as by Millais.

[9] It may nevertheless be useful to confirm Forrest Reid's impression that copies of the first edition dated 1863 are the earliest, although the book was issued in the 1862 Christmas season.

[10] Quoted from Trollope's *Autobiography* by Reid, *op. cit.*, p. 68.

49. J. E. Millais. 'Guilty'. *Orley Farm*, 1862. Proof with artist's comments

It is, of course, a great bore for the Millais enthusiast that the Trollope illustrations have mostly to be sought either in the expensive first editions of the books or in periodicals. But there is consolation at hand in the shape of the *Cornhill Gallery* (Smith, Elder, 1864), a handsome folio put out by the publishers of *The Cornhill Magazine*. It includes the Millais illustrations for *Framley Parsonage* and *The Small House*, 27 drawings for Thackeray novels by Fred Walker, 25 by Frederick Leighton, all but one of those for George Eliot's *Romola* and others by du Maurier and Thackeray – 100 drawings in all. It is, strictly speaking, more a collection of pictures than an illustrated book, but it has the enormous advantage of being printed from the wood-blocks, whereas electros were used in the magazine.

50. J. E. Millais. The Parable of the Marriage Feast. Frontispiece from *Catalogue of Prints*

Alas, it is by no means a common book, probably because of the depredations of the 'breakers'.

There could hardly be anything further removed from Trollope's Victorian domestic comedies than the New Testament Parables. Millais's illustrations to *The Parables of Our Lord* (Routledge, 1864) are a series of masterpieces in black and white. This fine work was originally commissioned by the Dalziels in 1857 and the letter of acceptance from Millais is worth quoting in full.[11]

'Bowerswell, Perth,

13 August, '57

Dear Sirs,

I shall be very glad to accept your offer, but you must give me time. One great inducement for me to undertake these illustrations is the fact that the book will be entirely illustrated by me alone. The subject is quite to my liking; you could not have chosen anything more congenial to my desire. I would set about them immediately if you will send me some blocks. Will you send me a list of the Parables, or leave it to me? I would prefer the former. There is so much labour in these drawings that I trust you will give me my own time, otherwise I could not undertake the commission. I should make it a labour of love like yourselves.

Yours very truly,

John Everett Millais'

He seems to have set to work almost at once and one of the first drawings he sent was 'The Pearl of Great Price'. In 1859, in commenting to the engravers on the proof of 'The Unjust Judge', which he called 'The Unfortunate Widow', he wrote that nothing could have been more exquisitely rendered and added that he was charmed with their work. But he did not keep it up and later letters instead of accompanying drawings were more frequently excuses for failing to keep promises.

In 1862 12 of the engravings were printed in *Good Words*, and in the following year the Dalziels decided to publish through Routledge the 20 drawings they had in book form, although they were still ten short of the number Millais had contracted for. It was not a success and some copies may have been pulped, which would explain its extreme scarcity nowadays. There was a superb folio edition of 50 copies containing proofs on india paper each in a sunk mount. The engravings were reissued in greatly inferior style by the S.P.C.K. It has been well said that these illustrations were enough by themselves to make any man's reputation.

There are plenty of other book and magazine illustrations by Millais – some are listed at the end of this chapter.

We turn now to a much less prolific, but hardly less gifted master – Frederick Sandys. If D.G.R. instead of F.S. had composed the monogram in some of his drawings the attribution could be accepted without question. He died at the age of 72 in 1904, but Reid identifies only 25 wood-engravings as his work, and all but half a dozen of

[11] Dalziel, *op. cit.*, p. 94.

51. F. Sandys. Harold Harfargo.
Once a Week, 1863

these were for periodicals. Yet he was greatly in demand. We are told that for his very first illustration – for George Macdonald's *The Portent* in *The Cornhill Magazine* for 1860 – he was paid 40 guineas. Robert Ross[12] has summed up the sad cause of the intermittance of his work. 'Intemperate and bohemian modes of life seem to have atrophied his powers. He was a constant borrower and a difficult if delightful friend. His relations with most of his associates were chequered.' He was none the less a very great black-and-white artist.

The two books for which he produced commissioned work were Willmott's *English Sacred Poetry*, 1862 and Dalziel's *Bible Gallery*, 1881. The former contains two designs by him, 'The Little Mourner' and 'Life's Journey', both of children and both lovely. It is a very desirable book. Its chief contributor was J. D. Watson, whose 28 drawings include some of his very best; there are three excellent contributions by Fred Walker, two by Keene and others by a great variety of lesser people which, while it does not make for the unity that we regard as so desirable but to which the Dalziels were almost completely oblivious, is as good a way as any of taking in artists like Armstead, Pickersgill and Wolf.

One cannot but regard the *Bible Gallery* with mixed feelings. Forrest Reid warns the amateur that the book should be collated with great care because of the frequency with which individual favourites were removed for framing and, while this reprehensible practice has slaughtered many a fine book, if ever it might conceivably be justified it is here. For it is not really a book at all but the gathering together of the remnants of a project for an illustrated Bible on which the firm had been engaged for almost 20 years, and which they had abandoned in 1863.[13] Moreover it had no text and was issued as a sort of sumptuous coffee-table book as a folio priced at five guineas. Reid[14] says that only about one-fifth of the 1,000 copies printed were sold, an additional reason for its rarity. He adds that 28 of the drawings were first used in *Art Pictures from the Old Testament* (S.P.C.K., 1894) of which Simeon Solomon made 14.

Gleeson White,[15] by no means a harsh critic, puts it very well:

'Turning over the pages after a long interval, there is a distinct sense of disillusion. At the time they all seemed masterpieces; sixteen years after they stand confessed as a very mixed group, some conscientious pot-boilers, others absolutely powerful and intensely individual'.

The one by Sandys, 'Jacob', is certainly in the latter category and so are those of Holman Hunt and Burne-Jones. There are three by G. F. Watts – a rare illustrator – and 12 by E. J. Poynter, possibly the best of his drawings on wood.

There is one book that contains more illustrations by Sandys than any other. This is Thornbury's *Legendary Ballads* (Chatto, 1876), which contains 82 of the finest drawings from *Once A Week*, nine of

12 *D.N.B.*, art. 'Sandys'.
13 Dalziel, *op. cit.*, p. 260.
14 *Op. cit.*, p. 49.
15 *Op. cit.*, p. 146.

52. (above) J. McN. Whistler. The Morning before the Massacre of St Bartholomew. *Once a Week*, 1862
53. (below) J. E. Millais. Polly. *Lilliput Levée*, 1864

them by Sandys. It is a shameful book in that many of the drawings were made for poems by other people. They were intended to show off Thornbury's own verses, but they only show them up. Nevertheless the pictures are excellent and the range is wide. There are 20 drawings by M. J. Lawless – not to be despised – ten by J. Lawson, eight by Pinwell and the rest by Morten, Small, Tenniel and others. Perhaps an even greater treasure than the Sandys are the four Whistlers – two-thirds of his work for the wood-engraver, for he made only two more, both of which appeared in *Good Words*. The four drawings in Thornbury remind us what a black-and-white artist was sacrificed to the broader sweep of the canvas. A personal favourite is 'The Morning Before the Massacre of St. Bartholomew', but 'The Relief Fund in Lancashire' runs it very close. I use the legitimate titles as given in the magazine, not the fictitious retitling in Thornbury.

Beautiful though its pictorial contents are the Thornbury volume is a disgraceful piece of book-cobbling, which helps to show once again that throughout the period and beyond it the conception of a book as a unit was virtually non-existent. We have to await the advent of Horne and Image, Hacon and Ricketts in the eighties and of Walker and Morris in the nineties for the full revival of such a notion. Nevertheless, although the Dalziels knew little and cared less about the elementary principles of book production, in the middle sixties they at least began to experiment with the revolutionary notion of one book, one illustrator. Moreover they were generous and daring in their encouragement of new and comparatively unknown artists.

Experiments of this kind began with their association with the up-and-coming publishing firm of Ward, Lock in 1863.

'In that year we entered into a contract with them to produce a new series of popular standard works, fully illustrated, to be under the able [?] editorship of Dr H. W. Dulcken, and to be published with the general title of "Dalziel's Illustrated Edition[s]". We were to share equally in the cost of production, and participate equally in the profits, if there were any.'[16]

It becomes clear in the sequel that the choice of artists was left to the Dalziels. Their method of working in these publications is enlightening and an analysis of it will be attempted here. The first venture was an edition of *The Arabian Nights* and, like others in the series, this was issued in weekly parts, each consisting of eight pages with two large engravings in the text. In the first 18 parts of the *Nights* seven artists were employed, including Millais, Pinwell and Tenniel. A. B. Houghton appears first in Part 7 and in all these 18 parts has only seven pictures in a total of 37.[17] In the remaining 86 parts there are seven drawings by Tenniel – probably commissioned earlier, but late in delivery – otherwise the illustrations are almost equally divided between Houghton and Thomas Dalziel, a younger brother of George and Edward, with six by Edward himself, one or two of which cause regret that his preoccupation as an entrepreneur left him little time for drawing.

16 Dalziel, *op. cit.*, p. 226.
17 The Introduction has three cuts.

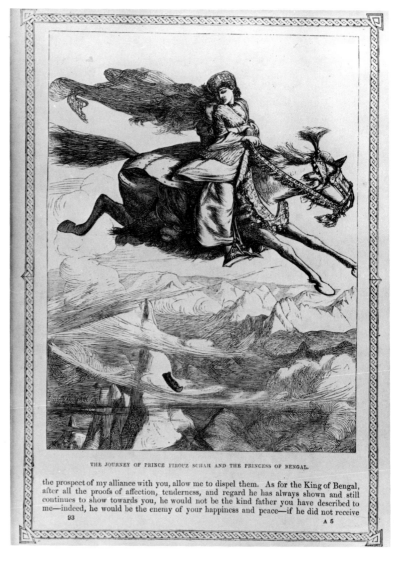

THE JOURNEY OF PRINCE FIROUZ SCHAH AND THE PRINCESS OF BENGAL.

the prospect of my alliance with you, allow me to dispel them. As for the King of Bengal, after all the proofs of affection, tenderness, and regard he has always shown and still continues to show towards you, he would not be the kind father you have described to me—indeed, he would be the enemy of your happiness and peace—if he did not receive

93 A 5

54. A. B. Houghton. From *The Arabian Nights*, 1865

The pattern seems clearly defined. Subscribers were secured by the splashing of familiar names in the early numbers, the remainder of the work being turned over to artists who could be more economically employed either because of a name still to be made or because of establishment ties. Thomas Dalziel occasionally, with, for example, 'Bedridden Hassan and the Pastrycook' (p. 161) or 'The Genie brings the Hatchet and Cord' (p. 65), is rather good, but he cannot keep it up. A. B. Houghton, on the other hand, is in his element, providing a most masterly series of drawings from which the eerie enchantment of these Oriental tales is never lacking – which is the more remarkable because Dulcken managed to lose most of it in his flabby and contorted version of the text. When it comes to choosing favourites one is seriously embarrassed by riches. White reproduces the drawing on page 149 and a very good drawing it is except that it is much more like Balaam on his ass than Nureddin on his mule. Reid chooses the very

fine design of Aladdin's despair on page 637.[18] But there are 19 other remarkable Aladdin drawings, all by Houghton, from the first meeting with the African magician on page 577 to the attempt on Aladdin's life on page 649. Personal favourites are the merchant being locked in the box on page 201 – alas not so well engraved as some – and the Prince handing over the ring on page 313. But for reproduction here these have had to give way to the exciting and mysterious elopement of Prince Firouz Schah and the Princess of Bengal on page 737. There is a Tenniel drawing on page 5 that would have made the reputation of a lesser man.

Quite early in the serial publication of *The Arabian Nights* the practice was observed of giving the whole of a story to one artist, thus ensuring some degree of unity.

For the next book on the Ward, Lock contract, an edition of Goldsmith, Dalziels commissioned the illustrations, all 100 of them, from G. J. Pinwell – and paid him, it would seem, 30s apiece for them. This is a bitch of a book to have to comment on. It is the only considerable work illustrated by Pinwell alone and one would like to give credit to Dalziel for taking the plunge. But then he ought to have done better by his artist. Reid may be right when he says that Goldsmith's period was not sympathetic to the artist. Nevertheless he seems to have made some very pretty drawings – for the haymaking scene on page 25, and the fairy-tale on page 53, for example. But rarely indeed did the craftsmen in Dalziels' workshop descend to such botched workmanship. Those appalling sheep on page 193, or the mixture of Hugh Thomson and Birket Foster on page 237. It is typical of Dulcken's slapdash editorship that the 'Elegy on the Death of a Mad Dog' is printed twice. Not, in fact, a book about which one can be enthusiastic, despite a handful of pretty things. Certainly not, as White thought, Pinwell's 'masterpiece'.

With Pinwell, as with Birket Foster, Sandys, Millais and other artists of the period, owing to the perverseness of publishers, it is necessary to cheat a little if one is to have the best of him without too much hedging and ditching. This may be found in another flagrant piece of book-making by Dalziels called *English Rustic Pictures* and published for them by Routledge in 1882. Here are 17 drawings by Pinwell and they do not always illustrate the poems for which they were originally made: but they are beautifully printed by hand as india-paper proofs and they include several favourites: 'Shadow and Substance', 'The Swallows', for which Pinwell's beautiful wife was a model, 'The Dovecot' and 'The Goose' among others. The same volume contains 15 pictures by Fred Walker treated in the same way, from similar sources and with nearly as many goodies.

Walker's drawings remind us of the origin of this volume. It was intended as a companion to Birket Foster's *English Landscape* and all the drawings were to have been by Walker. He seems to have completed only 11 drawings at the time and with the Dalziels' invariable canniness these were therefore used for other books, *A Round of Days*

[18] Reid's reproduction follows a stunning picture from the American series in *The Graphic*, 1870–1, not, alas, available in book form.

55. From *English Rustic Pictures*,
1882 (left) G. J. Pinwell. Shadow
and Substance; (right) F. Walker.
Spring Days

(1866) and *Wayside Posies* (1867). It would not have concerned the
Dalziels if the verses they were used to illustrate there were not those
for which they had originally been made. Seventeen of the illustra-
tions in *A Round of Days* were by Pinwell and some of these are
included in *English Rustic Pictures*; but both it and *Wayside Posies*
have a further glory for the 24 beautiful drawings by J. W. North,
five in the first and 19 in the second. These include some of his best
work. From *A Round of Days* Reid's choice, 'The Home Pond', is
enchanting, and as good as any; but 'Reaping' from *Wayside Posies*
is exceeded in charm by 'Glen Oona' or 'The Nutting', at least in
reproduced form. 'Rain', 'Summer Days' and 'Summer Words' are
all beautiful, and perhaps 'Out among the Wild Flowers' is best of all.
Reid saw the original drawings 'all of which were drawn with a
brush', so no wonder if they far excel the engravings.

It is curious in view of the great friendship between North and
Walker that none of the former's drawings was included in *English
Rustic Pictures* when it was eventually published as a companion to
the large paper *English Landscape*.[19]

There are two other artists who cannot be overlooked in even such a
brief survey as this. One of them, Thomas Morten, is virtually a one-

[19] There is another example of canniness here for the publishers used the same
blocks for the covers of both volumes, even forgetting to remove Birket Foster's
large monogram from the back cover of the sequel, in which he had no part.

56. J. W. North. Out Among the Wild Flowers from *Wayside Posies*, 1867

book man, so I will take him first. The edition of *Gulliver* that he illustrated for Cassell is among the best, in some of its drawings the very best picturisation of Swift that I know. It is a very tricky book bibliographically and one of which it is especially important to secure the earliest printing. It is undated, but published in 1865. Ideally one would seek the part publication but it was published in parts twice. In book form[20] it is important that the title-page should not describe Morten as 'the late' and the frontispiece should not be in colour. Reid also suggests consulting the publisher's list at the end and checking to see that none of the books mentioned post-date the *Gulliver*. But there is an easier way to reassure oneself. This is by carefully opening the book at the signature divisions where should be found, lengthwise, the publisher's imprint and the part number.

There is no more uneven artist in this, or perhaps any other period,

[20] Reid, *op. cit.*, p. 215.

than Arthur Hughes. His unsatisfactory drawings for *The Music Master* have already been mentioned (pp. 131–2). They are by no means his worst. His three drawings for *Christmas Carols*, 1871, for example, certainly qualify him for the wooden spoon. But how good he could be! And how excellent he almost consistently was in illustrating George Macdonald's books.[21]

These are the despair of the collector for they are exceedingly scarce and collectors of George Macdonald are exceedingly keen. True, the best of them were for serials in the first two volumes of *Good Words for the Young*, but these are even harder to find than the books although likely to be less expensive; but there are other good things in the magazine, too. There are the 150 jolly vignettes by W. S. Gilbert for his father's yarn, *King George's Middy*, occasional pleasant glimpses of Houghton, Mahoney and Pinwell and the chance to sample the wares of less important, but occasionally rewarding artists such as F. A. Fraser, Herkomer, Zwecker and Wolf. But Hughes is the principal quarry and also the most frequently employed artist with 221 drawings, though not all are in these two volumes of 1869–70. These do, however, contain *At the Back of the North Wind* and *Ranald Bannerman's Boyhood* as well as *The Boy in Grey* by Henry Kingsley, all illustrated by Hughes. In the third volume of *Good Words for the Young* is *The Princess and the Goblin* with 30 drawings and another 16 for other contributions.

Hughes was not unknown when George Macdonald chose him in 1868 as illustrator of *At the Back of the North Wind*; but nothing of his had hitherto suggested the possibility of such a brilliant success. It must be said for the editors of *Good Words for the Young* – Norman Macleod, shortly succeeded by George Macdonald himself – and the engravers – the Dalziels – that the standard of reproduction is very high throughout. There can be no doubt, however, that there was a very close and very special kind of sympathy between Macdonald and Hughes, especially in the fairy-tales.[22]

At the Back of the North Wind is at once Hughes's most delightful undertaking and one of the most charming books of the period so that special attention should be paid to it. Forrest Reid is in no doubt that Hughes's contribution is more interesting than Macdonald's. Without entire concurrence with that point of view it may be admitted that the story itself is a very strange one indeed and for more than one reason. The serialisation began in the first number of the magazine

[21] Which again raises the question 'What is a "sixties" artist?', for Hughes illustrated a posthumous edition of *Phantastes* in 1905! He died in 1915.

[22] This rapport was strikingly endorsed by Macdonald's son who, after the author's death, bought back the copyright of the original edition of *Phantastes* and pulped the remaining copies in order to replace it with an edition illustrated by Arthur Hughes. In the preface to this edition (1905) Greville Macdonald writes: 'I know of no other living artist who is capable of portraying the spirit of *Phantastes*; and every reader of this edition will, I believe, feel that the illustrations are a part of the romance, and will gain through them some perception of the brotherhood between George Macdonald and Arthur Hughes.' Hughes was then 73, but he rose to the occasion and his 33 drawings include many delightful and characteristic examples of his work.

and halfway through the first instalment we are already plunged into a dream world the incidents of which alternate with the everyday life of the infant hero. It is not fairy-tale so much as fantasy and the strange mixture continues throughout the intermittent publication of the story, down to the abrupt brevity of the final instalment of Part 1. There is some internal evidence that Macdonald did not intend the story to extend to any length and only eight instalments appeared in the 12 issues of the first volume. But he had not rounded off the story and he proceeded to add one more instalment in the first number of the second volume, of which he was editor, and in which he began the serialisation of *Ranald Bannerman's Boyhood*. This instalment of the *North Wind* story is very clearly the end of this exercise of a very strange imagination which seems to be concerned with expressing the fantasies, sleeping and waking, of a young boy's mind. There are some extremely odd conversations between the boy, Diamond, and the beauteous protean female who personifies the North Wind. One wonders what children make of a great deal of it, although its continued popularity – recently with Frank Papé to supplement Hughes – suggests that Macdonald may mean more to children than one might suspect.

57. A. Hughes. At the Back of the North Wind from *Good Words for the Young*, 1869

After finishing off the original story in November 1869 Macdonald began an entirely new one, albeit using the same title and characters and calling it Chapter II of Part 2. This comprises 29 chapters and is a rather pedestrian tear-jerker concerning the lives of Diamond and his family living in London on the borderline of poverty with the North Wind theme dragged in at the very end to provide a suitably sentimental, unhappy ending. In the course of this story young Diamond blossoms out as a poet, one of his creations being the now familiar poem beginning

> Where did you come from, baby dear?
> Out of the everywhere into here.

Treatment at such length of the nature of this story might be considered out of place in the present context. It may be excused because it serves to introduce Hughes's success in completely identifying himself with every twist and turn of the story, every vagary of the author's pen.

One cannot fail to agree with Forrest Reid that, at any rate in the first, and incomparably the better of the two stories combined under the one title, Hughes has entered successfully into the mind of the small hero and that 'he sees all things just as Diamond saw them, and his wisdom is no wiser than the child's'. With great respect for the authority of a critic who was himself a considerable novelist this does not justify the conclusion that the 'new form of literature' created by Macdonald 'comes most vividly to life' in Hughes's drawings. This Hughes does not in fact attempt, and he could not have done it if he had tried. The texture of words is indispensable to the atmosphere of not entirely amiable fantasy which the author aimed at and largely succeeded in creating. The artist hardly penetrates the shadows of the author's mind and when he attempts it, although taste

should not be disputed, it is hard to agree that the two cathedral drawings constitute 'the highest form of poetry'. They seem to me among the least successful in the first volume. But the 28 drawings in that volume are incomparably finer than all but the last four of the 48 in the second.

There is one Macdonald fairy-story illustrated by Hughes for which I can trace no serialisation – *Dealings with the Fairies* (1867). It is a little beauty. Two books of verse by Christina Rossetti – *Sing Song* (1872) and *Speaking Likenesses* (1874) – almost complete the toll of his best work: but a word should be said about his illustrations for *Tom Brown's Schooldays*, if only because, due to its constant reprinting, it is possibly the most widely known of all his works. The first edition, 1857, was not illustrated. It found immediate popularity and was in its fifth edition before the year was out. Continually reprinted and with the price reduced from 10s 6d to 5s it was rather a bold stroke to prepare a library edition with illustrations at 12s[23] for the Christmas season of 1868. This edition, with the Arthur Hughes illustrations, was also extremely popular, but some of the best of the 58 illustrations were omitted from later reprints and by the nineties were adulterated with an admixture of drawings by Sydney Prior Hall.

One feels that in general Hughes found this commission unsympathetic. There are good things in the book. The remarkably impressive drawing of White Horse Hill, with the exactly right placing of the tiny group of the ploughman and his team, balanced by the sheep, the shepherd and his dog;[24] and the excellently grouped drawings of the country fair. Unfortunately all Hughes's young people had to look like angels, which, in the present context, means effeminate and one feels that Dr Arnold would have expelled both Tom and Arthur instantly at sight of the picture of their first meeting.

Nevertheless Hughes was remarkably fortunate in his commissions; or perhaps he realised that it was inadvisable to contribute too frequently to the sort of *mélanges* popularised by the Dalziels. Whichever way it may have been, nearly all his best work was done when he had a book to himself. And no wonder! In illustrated books from the *Hypnerotomachia* to Sherlock Holmes the principle of one man one book – or rather, one book one man – has been amply vindicated; especially in fiction, where the job of the illustrator is to bring before the physical eye the character and scenes that the author has presented to the mind's eye, uniformity of presentation is vital. Fortunate it is that this was clear to publishers from the very outset of the nineteenth-century upsurge of fiction. Fortunate, also, the fact that periodical publication, whether in parts or in magazines, gave the opportunity to try out new artists – Hablot K. Browne with *Pickwick*, George du Maurier with Mrs Gaskell and so on.

Good Words for the Young continued under Macdonald's editorship only until 1872, after which its name was changed to *Good Things for*

[23] Macmillan's retrospective catalogue, 1891, says 10s 6d, but the book was announced and entered in the *English Catalogue of Books* at 12s.

[24] Comparison with Doyle's treatment of the same subject in *The Scouring of the White Horse* is interesting.

the Young of all Ages, but it nevertheless declined in interest for either young or old and died in 1877.

The rich field of illustration that must be sought in periodicals has already been indicated – *Ainsworth's*, *Once A Week*, *Cornhill*, etc. The nineteenth century was indeed a heyday for magazines. The Times' Handlist from 1620 to 1837 occupies 49 pages; from 1837 to 1901 it covers 145 pages. It has also been shown that much of the best work is not available in book form. This is not strictly our province. The best guide is in White, occasionally needing to be checked with Reid.

Here we conclude the main survey of wood-engraving as a medium of book illustration, although there will be occasion to refer to it at length in another connection in the next chapter. Beginning with the pupils of Bewick it did not long survive commercially the adaptations of photography to process work but it lingered on in quite unexpected places.

We have already noted the retention of the old methods by *Punch* for Tenniel's benefit. It is even more surprising to find William Morris employing professional engravers to reproduce drawings by himself, Burne-Jones and others for the Kelmscott Press books.[25]

Despite this the process had served its purpose, and served it admirably. Greater speed, accuracy and economy were probably justly claimed for the new mechanical processes. The immediate effect was a considerable, albeit almost completely unremarked, loss of quality. Not until the 1930s did commercial users begin to grasp the full requirements and potentialities of the media: but it is still not difficult to find some of the worst monstrosities in common use.

Books applicable to this chapter

Two of the commentators are so well known that they need no introduction.

Gleeson White, *English Illustration. 'The Sixties'. 1855–70*, 1903, reprinted 1970

Forrest Reid, *Illustrators of the Sixties*, 1928

The third is not quite so well known, but, despite its gossipy character, its irregular arrangement and its inadequate index, it contains much information supplementary to the work of the two masters – *The Brothers Dalziel. A Record – 1840–1890*, 1901.

W. E. Fredemann, *Pre-Raphaelitism. A Bibliographical Study*, 1965 Has a most useful section on the Bibliography of Pre-Raphaelite Illustrations.

[25] Sydney Cockerell records even more surprising lapses by the great antitechnologist. 'All the initials and ornaments that recur were printed from electrotypes', he writes. And Burne-Jones's illustrations for *The Water of the Wondrous Isles* were redrawn by R. Catterson-Smith and C. Fairfax Murray and transferred to wood by photography. Worst horror of all – Gaskin's drawings for Spenser's *Shepheardes Calendar* and the illustrations in *Some German Woodcuts* were printed from process blocks. See Sparling, *The Kelmscott Press and William Morris*, 1924, p. 144.

Selected list of illustrated books

Forrest Reid and Gleeson White have covered this period so exten-
sively that the following list is confined to personal favourites with
an occasional bow where their enthusiasm is not always fully shared,
as may be seen in the text. Comment on individual books has been
spared for similar reasons, and these reasons apply also to the arrange-
ment of the list, which is roughly chronological and without listing
the artists involved.

William Allingham, *The Music Master*, 1855
H. W. Longfellow, *Poems*, 1856
Alfred Tennyson, *Poems*, 1857
R. A. Willmott (editor), *Poets of the Nineteenth Century*, 1857
Anthony Trollope, *Framley Parsonage*, 1861; *Orley Farm*, 1862; *The
Small House at Allington*, 1864; *Phineas Finn*, 1869; and *Kept in the
Dark*, 1882
C. G. Rossetti, *Goblin Market*, 1862 and *The Prince's Progress*, 1866;
Sing Song, 1872; and *Speaking Likenesses*, 1874
Anon, *Home for the Holidays*, 1862
Birket Foster, *Pictures of English Landscape*, 1862 (better in the edition-
de-luxe of 1881)
The Cornhill Gallery, 1864
The Parables of Our Lord, 1864
Dalziel's *Bible Gallery*, 1881
Thornbury, *Legendary Ballads*, 1876
Dalziel's *Arabian Knights*; *English Rustic Pictures*, 1882; *Wayside Posies*,
1867; *A Round of Days*, 1866
George Macdonald, *Dealing with the Fairies*, 1867; *At the Back of the
North Wind*, 1871, *Ranald Bannerman's Boyhood*, 1871; and *The
Princess and the Goblin*, 1872; *Phantastes*, 1905

7 The Advent of Colour

Not the least among the technical advances in nineteenth-century book production was the achievement of commercial feasibility in colour printing.

This technique is as old as the first major example of printing from movable type, the 42-line Bible, in which one page of a copy in the British Museum is printed in red. Despite varied and elaborate experiments in the ensuing five centuries, however, only sporadic examples of colour printing were effected, comparatively few of them in books.

One reason for this is indicated in the following description of the laborious necessities involved in printing the beautiful Mainz Psalter of 1457:[1]

'The inking was extremely laborious: the red and blue letters were picked out of the forme before each impression and separately inked; in the case of the two-colour initials, the block for the letter was pulled out of the closely fitting block for background ornament, given its colouring and put back (properly fastened in also) before each printing.'

Such a time-consuming process was probably justified because the early printers had to compete with the elaborately hand-illuminated productions of scribes. But the accounts that we have of the processes used by J. C. le Blon[2] and J. B. Jackson[3] make it very clear that book illustration in their media was far from a commercial proposition.

There were two apparently insurmountable obstacles – accuracy of registration and the preparation of coloured printing ink. The best account of the ink problem is given by Mr Bloy in a wonderfully documented study sponsored by the Wynkyn de Worde Society.[4]

Alois Senefelder

The first real break-through was made by Alois Senefelder in connection with his invention of lithography – *c.* 1796. It is essentially based on the fact that oil and water do not mix; but this was not so in the first instance. Senefelder, the son of a Bavarian actor, was seeking a medium for printing his own unpublishable plays. He actually etched some of them on copper and printed them himself. He apparently used Solenhofen Kelheim stone, calcareous and of consistent quality, on which to grind his inks, and thinking that this might prove cheaper than metal he etched a script on it and printed it. This may have been his mother's washing list, although some regard that as an old wives' tale. However that may be it is certain that his first experiments with stone were by the relief method, for he etched on the surrounding

[1] *Printing and The Mind of Man* (catalogue), p. 32.

[2] The process is not described in his own *Coloritto* (*c.* 1722) but in G. de Mondorze, *L'Art d'Imprimer les Tableaux*, 1756.

[3] *Essay on Engraving and Printing in Chiaroscuro*, 1754. In fact Jackson was more concerned with wall-paper printing; but he did claim that his was the first book published in England with coloured plates.

[4] *A History of Printing Ink*, 1967.

stone by using an ink that was impervious to the acid. Eventually he discovered that by damping the stone it would fail to take up the ink so that he could produce an image planographically. He also used a metal base to print from and lithographic transfer paper, almost a primitive version of offset.

Failing to obtain a patent for the process Senefelder kept the details of it a secret, although he appointed licencees to work it, among them Philipp André in London who produced, in 1803, an elaborate portfolio of *Specimens of Polyautography*, which he seems to have used mainly as a publicity brochure – without, it is to be feared, very great success, for in 1806 the imprint was changed to G. I. Vollweiller, who was not very successful either. This is symptomatic of the slow advance in the use of the process and it is not until the very eve of Victoria's reign that it came to its full glory in this country.

The process was outstandingly important for the opportunity it gave artists to draw their own pictures direct on the stone and thus obviate its interpretation by incompetent craftsmen. Recently a large number of original drawings made for John Harris's juveniles came to light, and, although he set himself high standards, comparison of the drawings with their reproduction shows how much of their charm and beauty perished at the hands of the engraver. Even in the sixties, despite the almost miraculous facility shown by the Dalziels and others in transferring to wood-blocks highly intricate drawings the loss is clearly discernible where the originals have survived. This, in fact, was often due less to the shortcomings of the engravers than to the artists' ignorance of the medium of reproduction. It is, therefore, surprising that the opportunity given by lithography to reproduce direct from the artist's own drawings was so seldom used in book illustration, at least in England, although the practice was fairly common in France and Germany. In more recent times, with the invention of lithographic transfer paper and the development of photographic processes, this situation has changed quite dramatically, but most of that is outside our period.

It was not until 1818 that Senefelder published the details of his invention.[5] His hand had been forced[6] and the process was already quite widely known and practised without benefit to the inventor. His book contained instructions for the use of coloured inks; but already in 1808 J. N. Strixner, working in partnership with Senefelder, had reproduced Dürer's marginal decorations to a Prayer Book belonging to the Emperor Maximilian with some pages printed in colour. These must have proved very difficult because most pages are printed in black, a few are in single colours and the number of colour pages varies, while some have no colour at all. At most three coloured inks were used, green, red and heliotrope.

In 1817 Ackermann issued an English edition with all the 44 pages

[5] *Vollständiges Lehrbuch der Steindruckerei* (English translation, 1819). He had published a *Musterbuch* in 1808.

[6] By, for example, Heinrich von Rapp's *Das Geheimniss des Steindrucks*, 1810, which contains no mention of Senefelder; and possibly by F. Mairet, *Notice sur la lithographie*, 1818.

in colour and a title-page, omitted from the Munich edition, in two colours. This was the first, and for nearly 20 years the only lithographic colour printing in England.

William Savage

In 1815 William Savage invited subscriptions to his *Practical Hints on Decorative Printing* which was to contain specimens of letterpress work in colour with recipes for making 18 printing inks of different colours, which promised to make colour printing a commercial possibility. Even so it was another three years before he was able to issue the first part of the work and 1823 before it was completed. In 1832 Savage produced a more extensive account of his experiments in his book *On the Preparation of Printing Ink* in which he gave recipes for coloured inks[7] prepared by substituting Balsam of Capivi for linseed oil as a base. *Decorative Printing* contains several strikingly successful examples of printing in colours from wood-blocks, including some of the successive stages showing how the final result was built up.

No other colour printing by Savage is on record, perhaps because his recipes proved unreliable. They are characterised as 'incorrect' by the compiler of the *Reports of the Juries* on the Great Exhibition of 1851.

George Baxter

Whether or not George Baxter was aware of Savage's work is not known. It appears reasonably certain that by about 1830 he had produced a print of three butterflies in seven colours.[8] He used water inks in this print and is not known to have completed any other colour printing until 1834, when two coloured vignettes of birds appeared on the title-pages of Robert Mudie's *Feathered Tribes of the British Isles*. These were probably also from water inks, although in the second edition of 1835 they appear to be from oil-based inks.

Baxter did a great deal of work for Mudie and curiously enough, although they are mostly quite early, some of them are among the easiest to find – like the four little volumes on *The Earth, The Air, The Sea* and *The Heavens*, all 1835, the last of which includes some interesting references to his process. *The Heavens* has another and very special significance because it may well contain one of the first prints made by the process that Baxter patented, in which he used a metal plate as a key to print the whole design in a neutral tint, adding the colours by means of a series of wood-blocks.[9] It was among the specimen works that he enrolled with his specification. Some discrimination is necessary, for the frontispiece exists in two forms. In the first Baxter's address is given as '29, King Square' and on the second as '3, Charterhouse Square'. He made the move on 23 March 1835.[10] Further, on

[7] Bloy, *op. cit.*, gives three of them.

[8] C. T. Courtney Lewis, *George Baxter, the Picture Printer*, 1924, pp. 55 and 250.

[9] This would have added to the complications and expense of the process because different inks would be needed for working from metal and wood.

[10] Lewis, *op. cit.*, p. 62.

the later version he describes himself as 'Patentee' and the date of his specification is 23 April 1836.

Not at all easy to find, however, is a small pocket-sized volume, also by Mudie, called *Natural History of Birds*[11] (1834). This contains a frontispiece,[12] described in the underline as 'from a painting by T. Landseer', and is the earliest attempt at the soon to become fashionable endeavour to imitate oil painting in print. More importantly it is probably the first Baxter print made with oil-based colours,[13] although no metal plate was yet in use by him.

Lewis records more than 100 books containing illustrations by Baxter. Most of them have only the frontispiece in colour, with, occasionally, a title vignette. Nearly 40 of them are diaries or pocket-books: and some prints were used more than once for different volumes.

There are two books that need very special consideration, although the grander of the two – Sir Nicholas Harris Nicolas's *History of the Order of Knighthood* (1842) – is more interesting technically than pictorially. It is an impressive folio in four volumes. It contains a frontispiece of Queen Victoria as Sovereign of the Order of the Garter and 21 other plates mostly of heraldic accoutrements associated with the various orders of knighthood. It is doubtful whether the technical quality of these prints could be surpassed today and in their illuminated form, using gold leaf instead of yellow ink, they are truly magnificent. For once the general production of the book is worthy of the plates. It was printed by Whittingham and published by Pickering in conjunction with John Rodwell.

Lewis is rather confused as to the publication date of the book, which is due to his unfamiliarity with its chequered history. It was originally published in parts beginning in 1839 and completed in 1842. In volume form it cost £7 7s or £16 10s according to whether it was illuminated or not. In 1846 it was remaindered to Bohn at roughly half-price, but was available in the secondhand market at an even lower figure. One hundred years after publication it had not risen above its original price which, translated into real purchasing power, represents a considerable fall in value. Curiously enough, during the Baxter mania in the twenties, when the book could be bought complete for three or four pounds, a set of the prints extracted from it might have cost as much as £20.

The publisher and the colour printer of these volumes eventually became bankrupts, and the author had to end his days abroad to escape the attentions of his creditors.

The frontispiece to Nicolas's book is an original drawing by Baxter. It was the earliest of his numerous portraits of the Queen and it was apparently made from life. For the heraldic ornaments he relied on drawings by Hunter, the Queen's robe-maker. Very frequently he

[11] Published in the same year as *Feathered Tribes* it might be thought a poor man's version of it; but it has the imprint of a different publisher.

[12] Not a title-vignette as stated by Lewis, *ibid.*, p. 252.

[13] A possible rival is the frontispiece to Fisher's *Drawing Room Scrap Book* (but Lewis thinks otherwise, *op. cit.*, pp. 252–3).

was his own draughtsman and in the most highly favoured of his separate prints – the 'Four Ladies',[14] which includes 'Lover's Letter Box', 'Copper Your Honour' and 'News from Home' for example – there is only one word to describe the artistic taste – *Kitsch*.[15]

The Pictorial Album, or Cabinet of Paintings (1837), contains among its 11 plates no original work by Baxter; but the pictures to be copied for the book were evidently chosen by him and *Kitsch* is the word for most of them, too. Technically they are superb: artistically only Prout's drawing of Verona is worth a second glance, but the tribute to the reproductions in the Preface is hardly exaggerated – 'it is questionable whether even the painter himself could with his pencils produce a more exact copy'.

The illustration on which the Preface[16] really goes to town is by F. Corbaux, and this was probably Baxter's favourite also, precisely because it was chosen as the frontispiece.

'The subject itself is indeed inspiring', writes Carpmael.

'A Persian girl, lovely as a Houri in Mahomet's Paradise, is about to despatch a message to her lover – to the youth whose image is impressed on her heart, and on whom her mind dwells. She writes not her thoughts upon paper, after the manner of European maidens; but addresses the loved one in the symbolical language of flowers, which speak at once to the heart; and her messenger is a dove! A subject more fraught with the very poetry of love was never painted; and a lady only was capable of conceiving and expressing the idea in all its tenderness and beauty.'

Lucky Miss Corbaux, 'painter and biblical critic' (*pace D.N.B.*), who so impressed her contemporaries with such coyness. Yet it is almost a virtue of the book that the originals of the reproductions are so insipid. For this gives full weight to Baxter's masterly technique. Alas, alas! for purists, this was also a favourite with Baxter buffs in the twenties when up to £10 was paid for this print alone,[17] which makes complete copies of the book very hard to find.

Baxter ground his own inks, made his own drawings, engraved his own plates and blocks and did his own printing. He took on apprentices,[18] but he must have kept a very close eye on them for never were inferior materials allowed to enter or shoddy workmanship to leave his workshop. It must be regretfully admitted that this

[14] In the twenties this set of four prints was valued by Lewis at £100.

[15] This virtually untranslatable German word means roughly banality beautified. 'Bubbles' (Millais) is *Kitsch*, 'Dignity and Impudence' (Landseer) is *Kitsch*. All of Alma Tadema and 99·9 per cent of Hollywood films are *Kitsch*. Perhaps this last is an overstatement, most Hollywood films being too bad to qualify.

[16] Written by Carpmael, Baxter's patent agent.

[17] The total value of the prints sold separately was about £30; but the average was lowered by 'The Destruction of Sodom', made virtually unsaleable by its title. This is tactfully glossed over in the list of plates where it is called 'Destruction of the Cities', although the artist's own title is used on the plate itself.

[18] We know the names of four of them. Harrison Weir, later better known for his drawings of animals, was the first of them, to be joined later by Gregory, Collins and G. C. Leighton, the man who successfully commercialised – and debased – the Baxter process.

insistence on the finest materials and the most conscientious crafts-manship made it hard to survive in a keenly competitive market. There was, moreover, a fecklessness in Baxter's character that denied him business success.

Baxter made virtually no contribution to book illustration in the sense that concerns us. Nevertheless he was the first to show that colour printing was not only possible but commercially viable, and for that we owe him a great debt of gratitude. On the debit side is his obstructive attitude, which held up the wider use of the technique. He was extremely fortunate to secure a patent in 1836 and even more fortunate to have it renewed in 1849 in face of the determined opposi-tion of his former apprentice, G. C. Leighton, for there was nothing in his process that was novel or patentable in the true sense of the word.

Owen Jones

Owen Jones brought lithography back on to the scene in 1836 when he issued the first of 12 parts of his colossal work on the Spanish Alhambra. These were not completed until 1842 after Jones had made a second visit to the Alhambra and had sold some land to pay for the cost of production. The complete work cost £36 10s on large paper or £24 on small paper. It was a financial failure and only in the last few years has it come back to anything approaching its original price.[19]

Jones's earliest attempt at book decoration, at which he later greatly excelled, was in 1841 when he was commissioned by Murray to ornament a new edition of J. G. Lockhart's *Ancient Spanish Ballads*. The book is a hotch-potch and yet in a curiously unexpected way it undoubtedly comes off. Jones contributed a very ornate title-page with very much gold – very Moorish in fact – and four sectional titles, the best of which is the last and the simplest. These are in chromolithography and were probably printed by Jones. He also designed a great variety of decorated text borders which were cut on wood and printed by Vizetelly, mostly in one colour but occasionally in two. There are numerous wood-engravings – in one of which Jones also had a hand and several of which were designed by Harvey. These harmonise well with the coloured ornamentation. A jarring note is struck by a handful of wood-engravings on ochreish back-grounds. It is the tint that spoils them, those printed on green succeed quite well. Mr Ruari McLean thinks it likely that Jones also designed the binding and the Mauresque design on the back supports this. But in my view the book is better sought in one of the handsome morocco bindings to which it was treated at the time.

In many ways the second printing of 1842 is superior to that of 1841. Not in all – the pleasant green of some cuts has been replaced by the horrid yellow. It is pleasantly surprising to see the extent to which a conscientious publisher would go to improve the appearance of a book which had already received the seal of public approval by selling more than 2,000 copies at £2 2s each inside a year.[20] There

[19] For further details of this great work and its second part, see p. 175.
[20] R. McLean, *Victorian Book Design*, 1963, p. 58.

are many entirely new borders and illustrations – best perhaps to have both editions and the 1856 one as well for completeness.

The Lockhart qualifies as an illustrated book because of its engravings. Most of the books in which Jones had a major hand are either technical – like the *Alhambra* and the sumptuous and frequently reprinted *Grammar of Ornament* (1856) – or ornamental. The most ornate and the most representative of the latter class is his edition of the Psalms (1861), known, from its dedication, as the Victoria Psalter. This huge volume, handsome though it undoubtedly is, and costly although it certainly was, is a pseudo-book. From its imitation *cuir ciselé* binding to its pastiches of medieval illumination it is really completely bogus. Yet one has a strong, if sneaking affection for the sheer ingenuity of it all. Nevertheless, as Mr McLean has said, there are much better examples of this sort of thing and some, perhaps most, of them were the result of an association between H. Noel Humphreys and Owen Jones.

H. Noel Humphreys

H. N. Humphreys is a considerable figure in this period. He was in one sense a forerunner of Morris in his enthusiasm for the art of the Middle Ages and his attempts to reproduce and imitate it. Unfortunately he sometimes adulterated the former with the latter. *The Illuminated Book of the Middle Ages* (1844, £16 16s) is a magnificently successful attempt to convey the flavour of some of the masterpieces in this genre; but there are unforgivable interpolations of Humphreys's own invention almost throughout and Owen Jones's title-page is a monstrosity. Nevertheless chromolithography achieves more admirable ends when it is devoted to such books as this or Pugin's *Glossary of Ecclesiastical Ornament* (1846) – less so when used to concoct elaborate modern pastiches of medieval illumination. Humphreys himself produced an elaborate although comparatively modestly priced do-it-yourself manual on the subject called *The Art of Illumination and Missal Painting. A Guide to Modern Illuminators* (1849), and W. R. Tymms and M. Digby Wyatt produced another in 1860. There were many others, which indicates how popular it had become.

The most attractive of the modern imitations were contained in a series of small annual volumes produced by Humphreys, or under his supervision, for Longmans. The earliest of these, *The Illuminated Calendar* (1845), had floral borders based on a Book of Hours made for Anne of Brittany. Others in the series – *The Good Shunamite* (1847), *Maxims and Precepts of the Saviour* (1848), *The Song of Songs* (1849) and *The Book of Ruth* (1850) – varied in quality, but all have a perverse charm which is enhanced by the newly invented, pseudo-medieval papier-maché bindings intended to simulate carved wood and showing almost unbelievable ingenuity. Some of them had letterpress text: but a feature of these illuminated books was their creators' awareness of the poverty and unsuitability of the type-faces available to them. Perhaps they thought that script was more suited to their decoration than letterpress. However that may be the text

was often supplied in the artist's own calligraphy. This was generally not of very high quality. Worst of all was the frequent combination of poor calligraphy with a mean type-face as for example, in Owen Jones's *Winged Thoughts* (1851). This is a very mixed production indeed. To begin with the binding is imitation *cuir ciselé*. The front cover is spoiled by bizarre lettering, but the back is excellent, with a large design based on a peacock's tail. This motive is used again on the title, but with little success. The unnaturally coloured tail swamps the lettering and unbalances the whole page. Some of the birds are handsome, including the parrots, the swan and the swallow, though a naturalist might fault the colouring of the swallow. Others, like the nightingale, are pedestrian. Ornate gilt titling faces letterpress text in which the type is as unfortunate as the verse. Technically the virtuosity of the production is striking.

An unfortunate innovation was introduced by a penchant for printing on thin card instead of paper. This could not be folded for binding and therefore could not be sewn. Instead the gutta-percha method of binding was used in which the backs of the sheets were dipped in a gutta-percha or rubber solution and applied to a piece of lining cloth which acted as the mull and was pasted on to the boards to hold the book together. When the solution dried out the book fell to pieces, which accounts for the distressing condition in which many such books have survived.

As we have seen, Baxter seldom made much more than frontispieces for books and when he did his plates were infrequent and the familiar technique of pasting them in at intervals between the sewn quires of the book was a simple matter. Later methods, when the Baxter process was more extensively developed, will transpire at a later stage.

J. M. Kronheim

Lithography in England was eventually debased to a level of cheap nastiness that touched possibly the lowest point in book illustration in the whole of our period. The firm of Kronheim was the most prolific source of this wretched process, which is unfortunate because the early history of the firm is honourable and worthy of mention.

J. M. Kronheim, a native of Magdeburg, set up in London as an engraver and printer in the 1840s. More than one of Baxter's apprentices joined him and Lewis thinks that it was at the suggestion of one of them, Charles Gregory, that Kronheim, in about 1850, took out a licence to work the Baxter process.

The firm soon became a serious rival to Baxter. From 1852 onwards, for example, Kronheim supplied the frontispieces to two of the annuals which Baxter had formerly produced. More important from our point of view, Kronheim was evidently able to cheapen the process to a point where it became feasible to provide several illustrations printed in colour in comparatively inexpensive books. He was probably prepared to leave much more to his assistants than Baxter was; and they were not highly paid. At the hearing of Baxter's

claim for the renewal of his patent in 1849 Charles Gregory testified that he was now with Kronheim and earning two and a half guineas a week. That this would not be considered a low rate of wage, even for a senior operative, as Gregory must have been, is borne out by Alfred Crewe's testimony on the same occasion that when working for Baxter he was given notice when earning 35s a week, and was now with Vizetelly at 34s a week, where he superintended the elaborately colour-printed Prayer Book published by Murray in 1845.[21]

Be that as it may the quality of Kronheim's work is very high and he was among the first to make it possible for publishers to consider colour on almost a level footing with black and white as a medium for illustrations.

For the Christmas season of 1852 the Religious Tract Society published a small gift-book called *The Rose-Bud* which contained excellently produced coloured views of Windsor, Killarney, Hampton Court and the West Indies that would pass for Baxters almost anywhere. The book cost four shillings. In the following year *The Christian Wreath*, with eight coloured views, including one of New York, cost five shillings. There were also editions of *The Pilgrim's Progress* and *Robinson Crusoe* with Kronheim plates.

Kronheim sold his interest in the firm in 1855 and although his successors continued to produce good work from time to time they eventually concentrated almost exclusively on the cheapest market with the fall in quality that was inevitable.

Edmund Evans

There is no doubt of the eminence of Edmund Evans as a colour printer. At his best he is comparable with Baxter. But he was something much more significant than that. He had an eye for the making of a book and he raised the standards of book production at a time when they were very markedly in need of improvement. Pre-eminently, for our purpose, he was fully aware of the fact that it is not enough simply to combine illustrations and printed text within the same pair of covers. There must be a unity, a marriage between them. Evans possessed a full measure of the ability to produce this desirable result. He formed part of the apostolic succession from Bewick, having been apprenticed to Landells, a Bewick pupil. ·

We are not, therefore, concerned with his early efforts at book-making, often in collaboration with his fellow apprentice and life-long friend Birket Foster. Attractive though many of his early books were they merely added colour to the black-and-white *mélanges* produced by the Dalziels and others. The only significant difference in the style of Birket Foster books produced by the Dalziels and by Evans is the introduction of colour by the latter.[22]

[21] Lewis's figures do not add up. In his *George Baxter*, p. 101, he says that Crewe was given notice by Baxter after 14 years. In *The Story of Picture Printing*, p. 63, he adds that in 1849 Crewe had been six years with Vizetelly. This would push the beginning of his time with Baxter to 1829, which is highly unlikely.

[22] This and other aspects of the development of colour printing will be treated at length in a later volume in this Series.

Evans made his first striking contribution to book illustration with James Doyle's *A Chronicle of England, B.C. 55 – A.D. 1485* (1864). The author, elder brother of Richard Doyle, had provided 80 water-colour drawings to illustrate his work and his insistence on their being reproduced in facsimile hindered the publication for several years. In the words of the Preface it was 'an improvement in the process of printing in colour, and its effect upon the cost of production [that] caused the question of publication to be revived'. Fortunately Longmans decided to entrust the entire production to Evans and it is a measure of the growth of his business that he was able to undertake the composition and printing of a quarto volume of some 460 pages in addition to the 80 engravings, some of which required as many as ten printings from separate colour blocks.[23] Evans decided to insert the pictures within the text at appropriate points and this greatly increased the labour of production. Pages on which an illustration was to be printed were not included in or printed with the regular quires, but had to be worked separately and were pasted in when the sheets were sewn for binding.[24]

James Doyle shared to only a limited extent the artistic ability of his father and brother.[25] His drawings are often wooden. But he was an expert in heraldry and, as will be seen from the period covered by his *Chronicle*, there are plenty of battles and scenes of pageantry of which Evans took full advantage in the opportunities afforded by the picturesque costumes.

The result makes a very pleasant volume in its attractive armorial binding by Edmonds and Remnants;[26] and it forms a landmark as the first book with original work printed in colour expressly designed for the original text.

Walter Crane

Evans had bolder and more far-reaching ideas, the execution of which would be possible only if he could find an artist competent to design a complete book to be printed in full colour throughout and to be sold at a low price. He found the man he sought in Walter Crane, a young artist who had completed an apprenticeship with W. J. Linton in 1862 and had been rewarded by his former master with his first commission in the following year. This was to supply a number of vignette drawings on wood to illustrate a book on the New Forest by J. R. Wise. These pleasant, and naturally largely sylvan landscapes are very well done but they are reminiscent of 30 years earlier and there is nothing about them that suggests any other work that Crane ever did. It is a very agreeable book and has the distinction of a binding by John Leighton. Linton designed and engraved the illustrations

[23] R. M. Burch, *Colour Printing and Colour Printers*, 1910, p. 157.

[24] This causes disconcertingly eccentric collation. Only the comparatively few gatherings containing no illustrations consist of four leaves. Others may consist of any number of leaves from five to ten according to the number of paste-ins.

[25] He wrote well, and was an able historian. In 1886 he supplied the text for his brother Richard's posthumous *Scenes from English History*.

[26] This firm also supplied splendid full morocco bindings for this book.

for Wise's *Shakespeare, his Birthplace and his Neighbourhood* (1861)
and may have suggested his young apprentice as a suitable illustrator
for the New Forest book.

Crane's work as a designer and illustrator of books played an
important part in the development of a new field, as will emerge
later. It is therefore instructive and very material to our purpose to
cross with him the threshold of the world as he entered it in the late
fifties, when conditions and methods must have differed little from
those observed in Bewick's workshop – if not in Dürer's – and in
which there was little change until near the end of the nineteenth
century, when the professional engraver was eclipsed by the develop-
ment of photo-process methods.

An Artist's Reminiscences (1907), Crane's lively and amusing auto-
biography, although frequently careless with dates and names, gives
one or two rare glances into the period that are worth quoting at some
length.

His first employer, W. J. Linton, was a figure of some importance
in his day, not only as one of the ablest of wood-engravers, and as an
historian of the subject, but also in his repeated exhortations on the
high traditions of the craft and the danger of abandoning them.
Crane writes of him:

'W. J. Linton was in appearance small of stature, but a very remarkable
looking man. His fair hair, rather fine and thin, fell in actual locks
to his shoulders, and he wore a long flowing beard and moustache. . . .
He wore an unusually broad-brimmed 'wideawake' [hat] . . . turn-
down collars when the rest of the world mostly turned them up – a
loose, continental-looking necktie, black velvet waistcoat, trousers of
an antique pattern belonging to the forties, rather tight at the knees
and falling over Wellington boots with small slits at the sides.'

Linton, in fact, was an individualist of a very pronounced kind. In
1866, leaving behind his wife, Eliza Lynn Linton, he went to the
United States to escape the growth of mechanisation in England!

The *atelier* in which he worked out his apprenticeship Crane des-
cribes as follows:

'It was a typical wood-engraver's office of that time, a row of en-
gravers at work at a fixed bench covered with green baize running
the whole length of the room under the windows with eyeglass
stands and rows of gravers. And for night-work, a round table with
a gaslamp in the centre, surrounded with a circle of large clear glass
globes filled with water to magnify the light and concentrate it on the
blocks upon which the engravers (or 'peckers' or 'wood-peckers',
as they were commonly called) worked, resting them upon small
circular leather bags or cushions filled with sand, upon which they
could easily be held and turned about by the left hand while being
worked upon with the tool in the right.'

Crane seems to have been apprenticed not so much as a wood-
engraver as to learn to make drawings on wood for others to engrave.
In this he came under the superintendence of Linton's partner Orrin

Smith, whose father had been a pupil of Bewick.

'He set me at his table to draw one of my own pen-and-ink sketches on a small block of boxwood, showing me the way to prepare it with a little zinc-white powder (oxide of bismuth was generally used) mixed with water and rubbed backwards and forwards on the smooth surface of the boxwood until dry. On this the design was traced in outline, and then drawn with a hard pencil to get the lines as clear and sharp as possible for the engravers. . . .

My chief work at first was to make little drawings, on fragments of boxwood, for the apprentices to practise upon. The outside edges of the boxwood, after the square block had been sawn out of a cross section of the tree, were used up in this way. . .

It was usual in a block containing figures and faces for the heads to be cut by the master hand, and what was called 'facsimile' work by the apprentices. In the vignetted drawings then popular there was a good deal of more or less meaningless scribble and cross-hatching to fill up, or to balance, or to give a little relief and colour to the subject.'

This information added to what is known to have been the habit of Tenniel and Leech, among others, may account for many shortcomings in periodical illustrations from *Once A Week* downwards.

'I was put to all sorts of work, sometimes even as improver of other artists' original drawings or to restore some parts of a drawing which had got rubbed out in process of engraving. . . The least enjoyable work I can remember was certainly the drawing of an incredible number of iron bedsteads for a certain catalogue for Mr Heal.'

The New Forest book was published by Smith, Elder, and it was a member of that firm who introduced Crane to Edmund Evans – with extremely fruitful results. Between them they worked out a basic plan by which an octavo of eight pages designed from cover to cover and printed in colour throughout could be sold for sixpence. There were in fact nine pages in colour, for the front cover was pictorial, while the back cover carried advertisements.

When Crane and Evans first met the latter was producing some of the first yellow-backs[27] and Crane's first job for him was to design some of these.[28]

It is the Toy-Books that are of special interest to us. They have become rare in their original form, and none of them was dated, which makes it virtually impossible to compile a list of them with certainty of its inclusiveness, or to achieve chronological accuracy. This would be bad enough as it is but the difficulties have been multiplied by almost every commentator. Crane himself is not the least offender. On page 75 of the *Reminiscences* he gives a reproduction of one page of *Cock Robin and Jenny Wren* with the note Ward & Locke, 1865. On page 76 he includes this with two others as the first that he did and

[27] According to Sadler, *XIXth Century Fiction*, vol. II, p. 3, 56, Evans's first was either *The Lamplighter*, 1854, or *Letters at the Pastry Cook's*, 1853.

[28] Thus Crane himself in his *Reminiscences*. The earliest of his yellow-backs that I have been able to identify is a late reissue of Bulwer Lytton's novels in Routledge's Railway Library, *c.* 1878.

gives Warne as the publisher. It is probable that none of these was among the very first, and virtually certain that they were published by Routledge. ..

There is good reason to suppose that the first of all was *The Railroad Alphabet* and that it was published in 1865, followed by, or simultaneous with *The Farmyard Alphabet*.[29]

The numerous problems associated with producing a specially designed cheap series in colour were almost entirely technical and there can be little doubt that Evans was in complete charge of the operation with Crane receiving guidance from him at every stage. It is probable, for example, that Evans provided him with an exact dummy in shape and extent of each book and that the artist worked closely to this pattern in making the eventual drawings on the wood.

It should be remembered that Evans was cutting into a market that was already well supplied by the cheap chromos of such as Kronheim. Routledge had issued at least 36 sixpenny Toy-Books by other printers before Evans and Crane produced their first. A tinted paper was used to provide a background colour and, apart from the key block, only two colours were used. Ten thousand had to be printed to make it a commercial proposition and even then the return to all concerned was exceedingly small.

Excessive show-through could be avoided only by printing on one side of the paper, leaving the reverse blank. The covers consisted of a thicker sheet of paper which was pasted up on both sides, the whole being stitched through the middle in a single gathering. As the series caught on and the printer's experience developed, the range of colours and the numbers printed were generously enlarged.

The most successful were those with a minimum of text, such as ABCs or multiplication tables. It was fairly easy to accommodate the short rhyming couplets that these called for. Fairy-tales were more of a problem. Even when the text was ruthlessly tailored and cast into doggerel to fit the pictures the tablets of letterpress threw Crane's designs out of kilter. Sometimes he wrote the text also – with unfortunate results in *Sing A Song of Sixpence*, with more success in *Mrs Mundi at Home*, which is the best of a later series designed for Marcus Ward. This is really great fun and shows Crane in his best form. In it gods, goddesses, the sun, the moon and many other personages attend a party given by and on Earth – the sub-title is *The Terrestrial Ball*. The arrival of Lord Sol in his twenty-four-in-hand is a remarkable *tour de force*; and another illustration shows Jove arriving clad mostly in *The Times* newspaper, Mercury with an overcoat of thermometers and Urania attended by a group of poets among which are discoverable playful caricatures of Morris, Rossetti, Swinburne and Tennyson.

This is a reminder that the real trouble with Crane was that he came to take himself too seriously. It is not surprising that this happened because his contemporaries took him very seriously indeed. Out of this series of Toy-Books arose a clamorous demand for his services as a designer. He designed wall-papers, tapestries, plaster friezes

[29] See further notes and the list on pp. 176–7.

and ceilings, pottery, tablecloths, textiles, stained glass and ceramic tiles. A famous piece was an encaustic inlaid chessboard for Wedgwood, who exhibited it in Paris in 1867.

Konody,[30] discussing what he styles the English Renaissance, finds that the two conspicuously outstanding names responsible for it 'like isolated high peaks above the minor summits' are those of Morris and Crane. International honours were richly bestowed upon him, culminating in the great Budapest exhibition of his work in 1901 when the Minister of Art and Education introduced him as 'The great master [who] has opened a double school for us' by bringing art into the workshop and ennobling 'popular art to the conquest of Olympus and the drawing-room'. One can hardly wonder at the soulful look of the portraits of him by Watts and Rothenstein.

This is a great pity and a great loss. For Crane was really a very funny man. Konody reproduces some comic sketches from a note-book that he carried on his travels abroad. Specimens are given from visits to America, France and Italy and the artist makes excellent fun of himself as well as of the natives. He gets his effect with striking economy which suggests that the more he left out of his drawings the better he was.

He is more highly esteemed today in other countries than in his own and now that he has fallen a victim to the *Schwärmerei* of the Art Nouveau enthusiasts discrimination is once more thrown to the winds. The reaction in England has been too severe and has lasted too long. His early work, most of it prior to 1890, is especially worthy of more sympathetic consideration. The indifference to, one might say the distaste for his work is probably due to the fact that it is so rarely seen whereas the later work is all too much with us.

He was not a great artist, but he was a more than competent illustrator and, within his limits, could produce what was demanded of him. For that precise reason he is at his best in these early Toy-Books which may have been precisely because he did not have an entirely free hand but had to produce what Evans wanted. He had two distinct styles at this time. In one – exemplified in *Song of Sixpence* and *This Little Pig Went to Market* – he is natural and realistic even when treating fantastic subjects like pigs dressed as humans. His other style was more fanciful and derivative. He was easily influenced. He saved up his pocket-money to buy the Moxon Tennyson and the aura cast by the Pre-Raphaelites never left him. In about 1865 he begged from the captain of a merchantman a sheaf of Japanese prints and proceeded immediately to introduce motifs from them into the Toy-Books. Thus it is startling to find, in *One, Two, Buckle My Shoe*, a middle-class Victorian matron with a fire-screen apparently designed by Hiroshige; or Ann Taylor's 'My Mother' being dressed in a kimono.

He succumbed easily to temptations of this kind and as time went on he developed other tiresome mannerisms. He was a great one for 'Golden Ages', whether medieval English or ancient Greek. This he seldom entirely got away with and sometimes came a sad cropper.

[30] *The Art of Walter Crane*, 1902.

The hero of *Jack and the Beanstalk* contemplating his final victory is a model Caspar Milquetoast.

Nevertheless, insipid and tiresome though many of his later books are, the earlier ones are gay, lively, imaginative and novel. It is pleasant to add that they were a great success.

From 1875 to 1889 Crane illustrated in black and white the storybooks for children that Mrs Molesworth faithfully produced each Christmastide. These vary enormously in quality and attraction. Many of them exemplify Edmund Evans's observation that 'the only subjects I found he could not draw were figure subjects of everyday life'. This is not invariably so. For example in *Little Miss Peggy*, 1887, not only do the characters mostly appear to be real people, but Crane produced a very ingenious title-page, which is adapted, not quite so successfully, on the front cover. He must have liked this book very much to judge by the pains that he took with it. All the illustrations are full-page and with the exception of the frontispiece each has a long descriptive passage from the text in his own special script.

The Tapestry Room, 1879, is a fairy-tale. Crane's illustrations are very pleasant. They suggest that he was not unfamiliar with the work of Arthur Hughes. It is indicative of Mrs Molesworth's deservedly wide popularity that this book is dedicated to Victor Emmanuel, Crown Prince of Italy, 'one of the kindliest of my young readers'. He was then ten years old.

Mrs Molesworth wrote nearly 100 books, most of them not illustrated by Crane. Those that were are worth looking into. First editions should be sought where possible. For the reprints a dowdy binding was used and the large runs caused wear of the clichés so that later impressions from them are sometimes very inferior.

In 1881 Crane had an opportunity to repay the generosity of J. R. Wise, who had commissioned drawings when Crane was only 16. The artist responded generously by his treatment of a dramatic fantasy by his old friend called *The Fairy Masque*. He made 52 drawings for this and also wrote out the entire text in his own script, the whole of which was admirably reproduced in facsimile. The edition was limited, expensive and a commercial failure.

Two books that should not be missed are *The Bases of Design*, 1898 and *Line and Form*, 1900. They are based on lectures given at the Manchester School of Art in which Crane expounded what he regarded as the basic principles of design. The numerous illustrations are even more illuminating than the text. They show how easily Crane could produce his desired effects with the minimum of fuss. They also show just where he so easily went wrong; in *Line and Form*, for example, the deft and graceful studies of flowers alongside the tortured and disfigured adaptations of them for decoration.

This, alas, was the sort of thing that his contemporaries admired in his work: and his nudes were 'so pure and chaste in conception, that they almost became sexless' and this, too, was considered exemplary. Crane himself divided art into two classes, one which he called imitative, which sprang directly from nature – the other, imaginative, which he preached and practised. 'I feel convinced', he writes in

Line and Form, 'that in all designs of a decorative character, an artist works most freely and best without any direct reference to nature, and should have learned by heart the forms he makes use of.' By the time those words were printed their author was providing plentiful evidence of how far astray such principles could lead.

Crane was one of the most prolific book illustrators of this, or any other period and he could produce almost any kind of illustration to order, from pastoral headpieces for William Morris's socialist tracts to an elaborate suite of decorations for an edition of Spenser's *Faerie Queene* edited by, of all people, Thomas J. Wise. This pretentious publication was issued in parts, and afterwards in six volumes printed by the Chiswick Press on hand-made paper with 28 copies on jap vellum. It is a hideous publication in either form – a pseudo-Kelmscott lacking any vestige of the Morris inspiration. In this book Crane even ventured to add an additional stanza of his own verse treating of 'faithfull squyre' and 'Una fayre'. Crane did illustrate a Kelmscott book, Morris's own *Story of the Glittering Plain*. The drawings are a little better than for the Spenser, but not much. They show Crane at his worst – muddled, overcrowded and derivative.

Nevertheless, despite his constant failure to resist over-elaboration, Crane was a better artist in black and white than in colour. Paradoxically his colour work is the more important, because under the guidance of Edmund Evans Crane's early Toy-Books made the first break-through of colour into the cheap book market.

It is difficult for us, for whom coloured book illustration is a commonplace, to grasp what a tremendously important development this was at the time. The eagerness with which the process was taken up by publishers in the very early stages is sufficient evidence of the demand. Baxter's earliest commissions were for book illustrations, the first successful lithographs in colour were in book form. Routledge, who collaborated with Evans's earliest colour printing, and who published the first Crane Toy-Books, also commissioned colour work from Kronheim, Leighton, Brooks and the Dalziels. The amazing suddenness and extent of the riot of colour that ensued is extensively charted by Courtney Lewis. The special significance of the Crane-Evans collaboration was the production of a series of charming books, each one a complete unit, designed from cover to cover, which could be bought for a few pence. Comparison of the worst of the Crane Toy-Books with the best of others in the Routledge list produced elsewhere makes the point clearly and succinctly.

Before we pass on to Evans's later triumphs mention must be made of three more elaborate books by Crane that he printed. These are *The Baby's Opera* (1877), *The Baby's Bouquet* (1878) and *The Baby's Own Aesop* (1887), later issued together under the title *Triplets*.[31] These are among the best things he did – the settings of the songs with music is especially successful – and they are still beloved by children.

[31] Crane had a full share of the Victorian enthusiasm for puns. He usually signed his designs with a rebus incorporating a crane. One of his more excruciating efforts was to name the young hero of *Pothooks and Perseverance*, 'Sir Percy Vere'.

Randolph Caldecott

Some measure of the contemporary success of the Crane Toy-Books is gained from the fact that the almost overwhelming triumphs of his early career were based on them. His earliest wall-paper designs – he made dozens of them – were adapted from the Toy-Books, and by 1876 the pressure of all kinds of commissions for ceramics, stained glass, plaster ceilings and all kinds of interior decoration, not to mention pictures, including portraits, had become so great that he had to give up the annual output of three or more Toy-Books. Evans and Routledge had done so well with them that a new designer of equal quality had to be found as soon as possible.

In 1874 a wood-engraver called James Davis Cooper[32] thought there was room for an illustrated edition of Washington Irving's *Sketch Book*. In what we have seen to be common practice at the time he commissioned the illustrations at his own risk, hoping to sell the idea to a publisher on sharing terms. As an artist he settled on a young man who had given up a job in a provincial bank in 1872 to try his hand as an illustrator. This was Randolph Caldecott who, without any artistic training to speak of, had been taken up by Henry Blackburn, a civil servant, who was also the editor of *London Society*[33] and who employed Caldecott as a humorous artist on that magazine. He also took the young man on a family holiday in Germany and used a number of his drawings to illustrate a book which came out of the tour – *The Hartz Mountains*, 1872.

Cooper was employed to do much of the engraving for *London Society*; and Blackburn[34] gives an extract from Caldecott's diary on 23 January 1874: 'J. Cooper, engraver, came and proposed to illustrate with seventy or eighty sketches, Washington Irving's *Sketch Book*. Went all through it and left me to consider. I like the idea.'

It was decided to illustrate the book in sketch-book form with most of the illustrations interspersed with the text. Macmillan agreed to publish a selection from the work. They wanted it as a Christmas book. Therefore, overlooking the claims of the two sure-fire favourites, *Rip Van Winkle* and *The Legend of Sleepy Hollow*, they chose the sections describing an old English Christmas spent with a latter-day Sir Roger de Coverley – Squire Bracebridge.

Caldecott designed a striking cover design, which was blocked in gilt on dark green, showing a Christmas party in full swing presided over by the Squire at one end and a fiddler at the other with a border of holly and mistletoe incorporating a Christmas cake. The spine lettering was wreathed in holly and ivy.

There were 102 text illustrations and, perhaps called for by the publisher, seven full-page as well as a double spread for a frontispiece and title-page. These larger illustrations are mostly not very successful,

58. R. Caldecott. *Old Christmas*, 1876

[32] He may have been the son of the James Cooper who gave Charles Keene his first commissions for book illustration.

[33] He describes himself in *Who's Who* as 'Instructor in Drawing for the Press by new processes'. Curiously enough Caldecott, his protégé, disclaimed all the new processes and, wherever possible, had his drawings cut on wood.

[34] *Randolph Caldecott*, p. 68.

and they are not helped by being printed on rather drably tinted backgrounds.[35] They are also inserted, which weakens the unity of the book. The subjects chosen for them seldom gave the artist much scope. Two exceptions are the Squire's reception (p. 54) and the church choir at page 97. But the text illustrations are a revelation. Blackburn says that Caldecott spent hours in deciding what to leave out of a drawing and page after page shows an almost faultless economy of means without any sacrifice of effect. The shrewdness with which the decay of baronial grandeur is suggested on page 12, the minimum of detail needed to show the village street as the country maid returns to complete her Christmas shopping on page 32 and the isolation of one corner of the inn kitchen on page 37 are no more outstanding than the perfect miniature of the post chaise as it 'whirls rapidly over the frozen ground' on page 43. Put a powerful glass on the tiny vignette on page 35 to see with what minimal effort the artist conveys the scene where the author 'could just distinguish the forms of a lady and two young girls in the portico, and I saw very little comrades . . . trooping along the carriage road'.

One should remember, too, that Caldecott was here asked to undertake in almost his first book one of the most testing assignments that an artist can be given – to cope with a period nearly 50 years before he was born. This he does with hardly a trace of parody or pastiche. He set an entirely new fashion in illustration, one that was to be widely copied until after the turn of the century, but seldom if ever with the brilliant success achieved by this young man at his first attempt.

The book was published in October 1875 – post-dated 1876 – and had to be reprinted before Christmas in the same year. The demand remained constant for at least 20 years, and in 1882 there was a six-penny edition of it. Little wonder that it caught Edmund Evans's sharp eye or that he decided at once that Caldecott was the man to take up where Crane had left off, albeit at a very marked tangent.

In the sketchy autobiographical notes that Evans jotted down late in life[36] he gave 1876 as the date of production of the first two Caldecott Toy-Books – *The House That Jack Built* and *John Gilpin*. The date is not a feasible one. In 1876 he was called upon for 117 drawings to illustrate a sequel to *Old Christmas – Bracebridge Hall*. In 1876 also Blackburn commissioned several pen-and-ink drawings of pictures of the year for reproduction in his *Academy Notes*. He finished the *Bracebridge Hall* drawings in August 1876 and very shortly afterwards he had a breakdown in health after which he went to Buxton to recover, but as he did not greatly improve he wintered on the Riviera and spent some time in northern Italy.[37]

It was, in fact, only in 1878 that Evans approached Caldecott about the Toy-Books. His own account of this first visit to the artist in his Bloomsbury lodgings is informative:

[35] These backgrounds were abandoned in later editions.
[36] *Reminiscences*, edited by Ruari MacLean.
[37] Sketches that he made there were used in Mrs Comyns Carr's *North Italian Folk*, 1878.

'He liked the idea of doing them as I proposed, and fell in with me very pleasantly, but he would not agree to doing them for any fixed sum, feeling sure of his own powers in doing them, he wished to share in the speculation, he said he would make the drawings, if they sold and paid, he would be paid, but was content to bear the loss if they did not sell and [he would] not be paid;[38] so I agreed to run all the risk of engraving the key blocks which he drew on wood; after he had coloured a proof [that] I would furnish him on drawing paper, I would engrave the blocks to be printed in as few colours as necessary. This was settled, the key block in *dark brown*, then a *flesh tint* for the faces, hands and wherever it would bring the other colours as nearly as possible to his painted copy, a *red*, a *blue*, a *yellow* and a *grey*. (I was to supply paper and print 10,000 copies which George Routledge and Sons published for me).'

The price of the Toy-Books had been doubled so that the first two Caldecotts were sold for one shilling each. Even so and with a large edition of 10,000, when discounts, production costs and overheads are taken into account there would have been precious little to divide three ways on the first printings.

Evans, moreover, had designed a new and much more elaborate lay-out for the Caldecott series. He used a rather more substantial paper and avoided the need for back-to-back colour printing. Including the pictorial cover there were nine coloured pictures to each, but also a minimum of 20 line drawings to be printed on text pages. For these, and the text itself, he used the dark brown ink in which the key blocks for the coloured designs were printed.

Of the first two, despite some splendid animals in *The House that Jack Built*, this is greatly surpassed by *John Gilpin* if only for the two superb double-spreads of colour, one showing Gilpin careering through a toll-gate to the consternation of a flock of geese and the wonder of the onlookers, the other of the six mounted gentlemen raising the hue and cry. But in these, as in all the series, the gaiety and freshness of the colour does not detract one whit from the admirable consistency of the line drawings. Here, even more than in the two Washington Irving volumes, the economy with which he secures his effects is astonishing, more especially for its novelty. For whereas the aim of the Dalziel artists was to cram the picture with detail Caldecott leaves out every inessential feature and thus, almost for the first time, shows a grasp of the proper use of the wood-engraver's craft. Not quite for the first time, for Crane had seen it almost as clearly in, for example, *Mrs Mundi*, but allowed himself to be seduced into less effective trickiness and mannerism. Crane, moreover, in even his simple drawings, was essentially a decorator, whereas Caldecott is a true illustrator.

And so for the Christmas season of 1878 the first two titles in the

[38] It is known that Caldecott's payment for the books by Mrs Ewing that he illustrated for the S.P.C.K. was a royalty of one penny a copy and he may have made a similar arrangement with Evans for the Toy-Books. If so this would be among the earliest examples of the payment of book royalties.

new series triumphantly appeared and, as Evans says, 'sold before I could get another edition printed'. They, and their successors, two each year until 1885, went on selling, the numbers of the first printings constantly being increased until they reached 100,000 for each book. They were issued collected in cloth-bound volumes – four in a volume for five shillings, or eight for half a guinea. In one form or another they were issued as an edition-de-luxe, if Evans's recollections are to be trusted. 'After the sixteen books were completed', he writes, 'I printed 1,000 copies on larger sized paper, each copy was numbered and signed by the publisher and printer.' They are still kept constantly in print, in both separate and volume form; and until quite recently they were still printed from the original wood-blocks. This practice has now been abandoned, not because the blocks are worn out but to save labour.

Caldecott had a strong sense of humour, and an even stronger sense of good humour. Thus, although the drawings are not primarily funny, they are extremely good fun. Consider how elegantly he emphasises Goldsmith's gentle humour in *Mrs Blaize* by causing the reader to turn the page before the point is made. Quite early in the series, in number four (1879) Caldecott had chosen another of Gold-

59. R. Caldecott. An Elegy on the Death of a Mad Dog from *The Vicar of Wakefield*

smith's parodies of funereal poetry taken from *The Vicar of Wakefield – An Elergy on the Death of a Mad Dog*. This is one of the most brilliant of the series. The drawing of the dog posed against wooden palings on waste land is one of the best things he ever did in colour. Facing it is a page of snippets of text illustrated with dogs of many kinds that no other artist of his day could have done.

John Gilpin has already been mentioned. The excellence of the monochrome drawings should be especially remarked. The three customers placidly arriving at the Cheapside draper's shop, with boys in the background cutting capers on hitching posts while others exhort the coachman to 'whip behind' at the two youngsters hanging on the back axle, the leg and tail denoting the scampering horse with the mud-spattered pedestrians: are all full of life and movement, every one a triumph.

It would be tedious to continue a catalogue of choice pieces with which the reader is already familiar or can readily become so. Caldecott's invention never flagged. For the second series he changed to an oblong format and varied his style accordingly. The last of them, *The Great Panjandrum*, a jumble of nonsense originally strung together by Samuel Foote to test the mnemonic powers of a boastful friend, is as lively and inventive as any of them; and if any one doubts it let him try improving on the scenes where 'gunpowder ran out of the heels of their boots'.

Caldecott died in 1886; but he had already decided to do no more of the Toy-Books. Outside of them there is comparatively little of great consequence: but the facsimile sketch-book that Evans produced for Routledge in 1883 is a treasure. Many of the drawings have Caldecott's notes about them.

He illustrated three books by Mrs Ewing, all printed by Evans and published by the S.P.C.K. and all containing some capital things. These were *Jackanapes* (1883), but dated 1884, *Daddy Darwin's Dovecot* (1884), and a new edition of *Lob-Lie-By-The-Fire*, possibly in 1885.[39] Mrs Ewing had rather a poor taste in illustrators. Many of her S.P.C.K. books were execrably decorated by one R. André. She was better served by Gordon Browne, but never so well as in the three Caldecott volumes.

His work for *London Society* has already been mentioned. He also had drawings accepted for *The Pictorial World* including 'Coursing', one of his best, and for *Punch* – as early as 1872, although in the obituary poem no reference was made to this. But most of his periodical work was done for *The Graphic*, much of it in colour. Between 1883 and 1889 Routledge issued four volumes of selections from these drawings. They were handsomely got up in coloured picture boards with cloth backs and reasonably priced at either 6s or 7s 6d. The oblong folio format is rather clumsy but was dictated by the nature of the contents.[40]

Caldecott's specialities on *The Graphic* were sharply divided into

[39] The first edition of this, with other stories, was illustrated by George Cruikshank (1873).

[40] For the titles see p. 177.

two quite different categories. In one of them he provided a highly facetious illustrated reportage on holidays at home and abroad or on luckless adventures such as taking a country house. In the other he indulged the perennial nostalgia for 'ye goode olde tymes' that was called for in the Christmas supplements. The character of the former may be gauged from the opening sentences of one of them. 'Mr. Chumley's Holidays'. 'Come ye passers-by', it begins, 'and look at these sketches. Full often the hardy Briton requires no permission or invitation to look over the shoulder of the busy open-air limner . . .' It is fair to say that the sketches are much, much better than the text. The earliest ones are by far the best, like those he made at Buxton in 1877 when recovering from rheumatic fever (no text), or at Trouville in 1879, in which the lively scene of bathers on the rope forms the cover design.

The same is true of his Christmas scenes, of which one of the best is 'Christmas Visitors' (December 1876). All of these are in the last of the four volumes *Gleanings from the Graphic* (1889), which was a very happy afterthought. None of the four volumes was printed by Evans, but at *The Graphic*'s own printing works and the colour work is generally inferior to his. But it must also be said that, good as Evans was, it is a revelation to see Caldecott's originals or the coloured proofs that he prepared for the printer. He was incomparably the most rewarding artist that Evans ever worked with.

Kate Greenaway

The previous sentence will not be read without protest by admirers of Kate Greenaway, and they are legion. With all due deference to the charm and felicity of her inimitable powers of decoration, her range is limited and even her 'pretty maids all in a row' are not to be compared with Caldecott's. Taste is said to be indisputable. Never was there a more disputable pronouncement. 'I know nothing about art', said Zuleika, 'but I know what I like.' But 'the top of the pops' is almost a ready-made criterion of bad taste.

The argument must not be allowed to run away with us. The very last thing that could be said about Kate Greenaway's work is that it is in bad taste. But let us get our priorities right. She was not, let it be admitted, a great artist. Her target was a modest one; but she created a small world of her own, a dream-world, a never-never-land, above all a world at least as remote from the one in which she lived as from our own. Yet it was a world familiar to her audience, the world of nursery-rhyme and make-believe. What did she do with it? She peopled it with beings, idealised maybe, but dressed in the clothes of everyday folk – even if always their best clothes – and behaving as they might behave – even if it was always their best behaviour.

Her prim children, starry-eyed and innocent, betray little sign of life. They play their decorative and ornamental games with unnatural decorum, their nimble fingers weaving natty posies and garlands with an assuredness and neatness equalled only by the grace and regularity with which their feet weave the patterns of simple country

dance measures. Quite literally they never put a foot wrong. Their elders are grave and beautiful even in extreme old age: never a minx nor a larrikin defaces her immaculate pages. All is maypoles and smock frocks, beauty and tranquillity, simplicity and charm. Her drawings are dainty and her colours have that pale and limpid fascination now fashionable in 'pastel shades'.

It will not do to say, with certain critics, that she has survived because her work enshrines the Victorian age. It is not true. Her dimity-clad damsels and demure little boys are not representative of an age which, although it had its points, was essentially an age of dirt and ugliness. The illustrated catalogues of the Great Exhibitions of 1851 and 1862 are complete answers to the suggestion that Kate Greenaway was representative of her age. On the other hand, if it were true, it would mean that her work dates, and, despite the fact that her pictures represent things of the past, they definitely do not date. They are as fresh and beguiling to us as ever they were to her contemporaries; and that begins to point to immortality.

The acid test of success in illustrating nursery literature is realism. The more romantic and implausible the nursery hero, the more factual his picture should be. Children will believe anything if it is stated with sufficient emphasis and conviction, and the pictures in their story-books are the maps and charts by which they steer themselves through the maze of incident and adventure. The quality of Kate Greenaway as an artist for children lies in her ability to provide pictures which are really illustrations. They help to tell the story, and they helped the young readers to project themselves into the company of the children she depicted.

One relevant criticism of nearly all early books for children is that the authors and artists saw a child as a small adult. The tendency persists in some modern illustrations intended for children, which are all too fanciful and modernistic. Kate created no single outstanding character, but she knew that children wanted something they could recognise. 'I often notice that children don't at all care for what grown-up people think they will', she wrote on one occasion, and again: 'I think they often like grown-up books – at any rate I did'. Perhaps to solve the difficulty she designed books to please both children and adults. Thus she drew a nursery-rhyme land, raised to the *n*th degree of sublimation if you like, a mortality that had taken on immortality, a corruption clothed in incorruptibility, and her pictures fitted the words like a glove.

Why does she still enchant us? If we are children, because we find her children still real enough to convince us, yet fanciful enough to be true denizens of fairyland, who obviously have wonderful opportunities of dressing-up. If we are adults the appeal is more subtly explained. First there is what might be called a second childhood, if there were no offensive connotation with that term – let us call it a perpetuation of youth. They appeal to us in direct proportion to our ability to look at them with the eyes of a child.

There is also a nostalgia for the past which lends an added glamour to an attractive object because it is old. This is the attraction of the

period-piece and is one element in the make-up of the collector. It is significant that Kate Greenaway's work attracts collectors. Carry this a little further and you have the yearning for a Golden Age when arts and crafts flourished, when the sturdy yeoman of England were all Cobbetts in miniature, and jerry-building was unknown – another dream-world.

But there is more in Kate than that. Even the single-minded, logical Camille Pissarro, who could easily resist the charm of K.G., could, nevertheless, warn his son Lucien to stear clear of Caldecott and Greenaway, '. . . so skilful, and alas so weak, and often too truthful'. There is more in Kate, too, for all those interested in typographical practice and history. In 1878, when Edmund Evans was first entrusted with Kate's dainty water-colours, the foundation of her modern fame was laid. That this foundation was laid in a most satisfactory and substantial manner is also worth recalling. Against expert publishing advice Edmund Evans printed a first edition of 20,000 copies of *Under the Window*, which was immediately sold out. He continued to reprint to a total of 70,000 copies for the English market, and 30,000 additional copies were sold in French and German editions. Until the other day Kate Greenaway book illustrations were still printed from wood-blocks by the firm that Evans founded and which still bears his name. Such printing was originally a rare example of perfect co-operation between artist and craftsman, and, because it is by book illustration that we know and love our Greenaway, it should be remembered that without Evans we should have been robbed of half its charm. But let Evans – that 'surpassingly excellent' character, as Kate termed him – speak for himself.

'I photographed these original drawings on to wood and engraved them as nearly "facsimile" as possible then transferred wet impressions to plain blocks of wood – "transfers" to engrave the several colour blocks on, red, flesh tint, blue, yellow. This was a costly matter, but it reproduced the character very well indeed of the original drawings. The publishers "chaffed" me considerably for printing 20,000 first editions of a book to sell at six shillings, but we soon found that we had not printed nearly enough to supply the first demand: I know booksellers sold copies at a premium, getting ten shillings each for them; it was, of course, long out of print for I could not print fast enough to keep up the sale.'

Henry Blackburn's comment in 1894 that Kate owed 'much of her prestige and success to the colour-printer' was intended as an example of 'how intimately the arts of reproduction affect reputations'.[41] Her debt to Evans is incalculable and nothing that she did elsewhere can compare with anything that he did for her.

He followed *Under the Window* with *A Day in a Child's Life* (1881) and in 1882 they started together the dainty series of almanacks which continued their unbroken annual appearance until 1893 (for 1894). For the year 1895, against her better judgement, the monochrome drawings she had made for Mavor's *English Spelling Book*

[41] *The Art of Illustration*, p. 218.

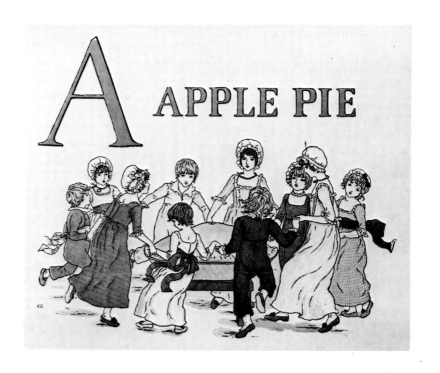

60. K. Greenaway. *A Apple Pie*,
1886

ten years before were used in colour. It was a failure. She made only
one more almanack, for 1897, and this was published not by Rout-
ledge, like the others, but by Dent. The edition must have been small,
or perhaps the change of format from picture-boards to gilt cloth
was unpopular. In either event it is one of the rarest of the series.

Marigold Garden (1885), despite, as even Spielmann admits, 'halting
verse or summary perspective' is one of her most attractive books,
perhaps the best of all, although *A Apple Pie* (1886) runs it close. If
Spielmann's figures are accepted[42] the edition was much smaller than
for *Under the Window*, 6,500 for England, 7,500 for America and
3,500 in French.[43] It is certainly a noticeably difficult book to come by.

Edmund Evans has been prominently featured in this chapter and
from all the wide range of his activities attention has been largely
concentrated on his collaboration with three artists – Crane, Caldecott
and Greenaway. This course has been deliberately followed not only
for his technical supremacy – others unmentioned such as Benjamin
Fawcett could match this – but because with the collaboration of
these three artists he was able to produce and to make almost common-
place something novel in his generation and something of great
significance – not merely a book with illustrations, but an illustrated
book, a book of which the illustrations were an integral part – and
to do it in colour.

He already outdoes his competitiors with the Crane Toy-Books.
He nearly pulled it off with *The Baby's Opera* (1877), the beautiful
text pages of which are only occasionally jarred by such misfortunes

[42] p. 130.
[43] Several of her books were very successful in France.

as the pregnant dwarf on p. 45, attained a high level of consistency with the Caldecott series from 1878 onwards and was finally triumphant with *Under the Window* and *Marigold Garden*.

Books applicable to this chapter

The advent and phenomenal growth of colour printing have been treated by several writers, generally rather discursively and not always in accurate detail. The earliest of these is:

M. Hardie, *English Coloured Books*, 1906

This is an admirable pioneer work and in many respects is still unsurpassed. It takes in hand-coloured as well as colour-printed illustrations. The author was himself a competent artist and for many years was on the staff of the Victoria and Albert Museum.

Less detailed, but comprehensive and reliable is: R. M. Burch, *Colour Printing and Colour Printers*, 1910

A mine of information, sometimes needing caution as to dates and publishers is: C. T. Courtney Lewis, *The Story of Picture Printing in England during the Nineteenth Century*, 1928

An indispensable supplement to these three books, containing much new information is: Ruari McLean, *Victorian Book Design*, 1963

Studies of individual colour-printers are:

C. T. Courtney Lewis, *George Baxter, the Picture Printer*, 1924, which supersedes his earlier books on Baxter

A. Docker, *The Colour Prints of William Dickes*, n.d.

Rev. M. F. C. Morris, *Benjamin Fawcett*, 1925

Edmund Evans, *Reminiscences*, edited by R. McLean, 1967

All of these works discuss books illustrated by the various colour printers, which makes it superfluous to attempt an extensive list here.

On the three principal artists treated in this chapter the following should be consulted:

P. G. Konody, *The Art of Walter Crane*, 1902

W. Crane, *An Artist's Reminiscences*, 1907

G. C. E. Massé, *Bibliography of The First Edition of Books by Walter Crane*, 1923

Dates, publishers and titles given in these should be checked.

H. Blackburn, *Randolph Caldecott; a personal memoir of his early art career*, 1886

This is very little concerned with his book-work, although it includes a dated list of the Picture Books.

M. H. Spielmann and G. S. Layard, *Kate Greenaway*, 1905

Highly informative, though not always quite accurate, and the extensive check-list at the end needs supplementing.

Selected list of illustrated books

William Savage, *Practical Hints on Decorative Printing*, 1823

While Savage's methods proved not to be commercially viable he

laid down the basic principles which Baxter, Evans and other chromo-xylographers used in their processes. It also contains some striking examples of colour printing.

Baxter's process, although brought to a high degree of perfection, was too costly both in time and money for book-work.

The two books described at some length in the text are landmarks in the history of colour printing. They also exemplify Baxter's great virtuosity and scrupulousness as a craftsman.

The Pictorial Album, or Cabinet of Paintings For the Year, 1837
Sir Harris Nicolas, *History of the Orders of Knighthood*, 1842

Baxter was at his best in some of the separate prints: 'The Four Ladies' for example.

Owen Jones and Jules Goury, *Plans, Elevations Sections and Details of the Alhambra*, 1836–45
There is some confusion about the dates and methods of publication of this huge work, which is due to its long-drawn-out part issue and the interval between the two series of parts. The first series, comprising ten parts with 50 plates, was begun in 1836 and completed in 1842 and then issued in volume form. In 1845, after a second visit to Spain, Jones completed the second volume, which he issued in two parts containing 25 plates each.

This is not, within our terms of reference, a book, neither have its illustrations any pictorial quality; but as the earliest example of chromolithography at least in this country,[44] it is astonishing as a technical accomplishment. Jones himself prepared and printed many of the stones at a workshop that he set up for the purpose. Some were produced for him by Day and Haghe. Longman eventually took over the distribution.

J. G. Lockhart (editor), *Ancient Spanish Ballads*, 1841, second edition, 1842, third edition, 1856
The Psalms of David, illuminated by Owen Jones, 1861
The Illuminated Book of the Middle Ages, 1844. Edited by H. Noel Humphreys, the plates lithographed and printed by Owen Jones
A. W. Pugin, *Glossary of Ecclesiastical Ornaments*, 1846

The series edited by Humphreys for Longmans began with two illuminated calendars, 1845 and 1846, and comprised some quaintly charming volumes, now difficult to find, including: *The Good Shunamite*, 1847; *Maxims and Precepts of the Saviour*, 1848; *A Record of the Black Prince*, 1849; *The Song of Songs*, 1849; and *The Book of Ruth*, 1850.

One of Humphrey's finest books is: *The Origin and Progress of the Art of Writing*, 1853.

J. B. Kronheim's early work is well worth noting, especially during his association with the Religious Tract Society, where his work can also be compared with Baxter's as in *The Child's Companion*. This was an annual, cloth-covered booklet costing 1s 6d. From 1846 to 1851 Baxter supplied a coloured frontispiece, thereafter being replaced by Kronheim. Most of the R.T.S. books are undated, but dated inscriptions are sometimes helpful. *Flowers from Many Lands*, 1855 and *The*

[44] The publication date of the first part precedes Engelmann's French Patent.

Christian Garland, new edition, 1854 both have charming plates of natural history subjects.

Edmund Evans is one of the most important figures in the development of colour printing. His rare combination of skill, enthusiasm and business acumen enabled him to produce work of high quality at prices that were commercially acceptable even for books published at sixpence. He engaged suitable artists and demonstrated exactly what was required of them, and with Crane, Caldecott and Greenaway he improved the quality of cheap colour printing out of all knowledge. Moreover, unlike the early colour lithographers, his productions were really illustrated books and not merely picture-books.

His first major effort in this field is also among his best: J. Doyle, *A Chronicle of England*, 1864. But he will be treated at greater length in Mr Ruari McLean's forthcoming volume in the present series and our principal concern will be to list the Toy-Books produced with Walter Crane as designer, not only because of their importance in this history, but because the necessary information seems to be lacking elsewhere.

The Walter Crane Toy-Books The following list is believed to be complete and in chronological order of publication. All are undated but an attempt has been made to date some of them from various sources, which are indicated as follows:

E.E. Edmund Evans's *Autobiographical Notes*.
C.R. Walter Crane *Reminiscences*.
S.C. Catalogue of the Spencer Collection.
O.C. Osborne Collection.

The numbering, where given, is from lists on the back covers of the Toy-Books themselves. The gaps arise from the employment of other artists.

The first two titles have not been found in any of these lists, but are believed to have been the earliest of all and to have been published by Routledge. They are: *Cock Robin and Jenny Wren*; *The House that Jack Built*.

The first series was published at sixpence a volume and the earliest designed by Crane was Number 37.

37. *The Railroad Alphabet* ⎫ (E.E. 1865)
40. *The Farm Yard Alphabet* ⎭
59. *Old Dame Trot*
60. *Sing a Song of Sixpence*
61. *A Gaping-wide-mouth Waddling Frog* ⎫
62. *The Old Courtier* ⎬ (E.E. 1867)
63. *The Multiplication Table in Verse* ⎭
64. *Chattering Jack* ⎫
69. *How Jessie Was Lost* ⎪
70. *Grammar in Rhyme* ⎬ (E.E. 1869)
77. *Annie & Jack in London* ⎪
78. *One, Two, Buckle My Shoe* ⎭
95. *The Fairy Ship* (C.R. 'designed in 1869')

96. *Adventures of Puffy* (wrongly numbered 98 on cover)
97. *This Little Pig Went to Market* (C.R. 'designed in 1869')
98. *King Luckieboy's Party* (C.R. 'published 1870')
100. *The Noah's Ark Alphabet*
103. *My Mother*
104. *Ali Baba and the Forty Thieves* (S.C. 1873?)
105. *The Three Bears*
106. *Cinderella* (O.C. 1873?)
107. *Valentine and Orson* (S.C. 1873?)
108. *Puss in Boots*
109. *Old Mother Hubbard* (C.R. '*c.* 1872')
110. *The Absurd A.B.C*
111. *Little Red Riding Hood* (O.C. 1873?)
112. *Jack and the Beanstalk* (O.C. 1874? a dated inscription Xmas 1875 has been seen)
113. *Blue Beard* (O.C. 1873?)
114. *Baby's Own Alphabet* (O.C. 1874?)
116. *The Sleeping Beauty* (O.C. 1876?)

The Shilling Series overlapped the sixpennies and eventually replaced them, extending into the eighties when Caldecott eclipsed both. Crane contributed only eight titles: *The Frog Prince* (S.C. *c.* 1875?); *Goody Two Shoes*; *Beauty and the Beast* (O.C. 1875?); *Alphabet of Old Friends* (S.C. *c.* 1875); *The Yellow Dwarf*; *Aladdin; or the Wonderful Lamp*; *The Hind in the Wood*; *Princess Belle Etoile* (S.C. 1875?).

The more popular titles were later – between 1873 and 1879 – reissued in composite volumes containing four or more titles each – *The Blue Beard Picture Book, King Luckieboy's Picture Book,* etc.

Remarkable evidence of the long life of boxwood blocks is afforded by Evans's being able to reprint many of these Toy-Books in the 1890s from the original blocks. They were marketed by John Lane, separately and in composite volumes. The separate titles cost 9d each and the composite volumes 3s, later advanced to 1s and 4s 6d respectively.

In addition to the Toy-Books his association with Evans produced three books in which the combination is seen at its very best: *The Baby's Opera,* 1877; *The Baby's Bouquet,* 1878; *The Baby's Own Aesop,* 1887.

Some of his work in black and white is described in the text.

Randolph Caldecott The Picture Books were published in pairs as follows:
1878 *The House That Jack Built; John Gilpin*
1879 *Elegy on a Mad Dog; The Babes in the Wood*
1880 *Sing a Song for Sixpence; The Three Jovial Huntsmen*
1881 *The Farmer's Boy; The Queen of Hearts*
1882 *The Milkmaid; Hey Diddle Diddle and Baby Bunting*
1883 *A Frog He Would A-Wooing Go; The Fox Jumps over the Farmer's Gate*
1884 *Come Lasses and Lads; Ride a Cock Horse* and *A Farmer Went Trotting*
1885 *The Great Panjandrum; Mrs Mary Blaize*

All were first published by Routledge. In the first printings the list of other Caldecott Picture Books advertised – usually on the back cover – includes only those published to date. Thus the first pair should advertise only two books, the second pair four, and so on.

Simultaneously with the completion of each group of four they were collected in one volume, cloth bound, costing 5s. The first two of these were entitled: *R. Caldecott's Picture Books*, vol. 1 (–2). In 1883 the first eight titles were published together at 10s 6d with the title: *R. Caldecott's Collection of Pictures and Songs*. The remaining eight books were in oblong format and were also issued in cloth-bound form as: *The Hey Diddle Diddle Picture Book*, 1883 and *The Panjandrum Picture Book*, 1885; and finally in one volume at 10s 6d as *R. Caldecott's Second Collection of Pictures and Songs*, 1885.

Advertisements of these collected volumes also appear on the separate issues of the Picture Books and should be checked for dates with the titles on which they are advertised.

Caldecott's 'Graphic' volumes are: *'Graphic' Pictures*, 1883; *More 'Graphic' Pictures*, 1887; *Last 'Graphic' Pictures*, 1888; and *Gleanings from the 'Graphic'*, 1889.

His splendid black–and–white work is best seen in the two Washington Irving volumes: *Old Christmas*, 1876 and *Bracebridge Hall*, 1877.

Kate Greenaway Her three best books, all printed by Evans are: *Under the Window*, 1878; *Marigold Garden*, 1885; and *A Apple Pie*, 1886.

8 *Fin-de-Siècle*

To refer to the subject of the present chapter as 'The Nineties' is to fall a victim to precisely the artificiality that seemed undesirable in delineating 'The Sixties'. It is all very well to say that everyone knows perfectly well what is meant by 'The Eighteen-Nineties' but this will hardly bear a moment's examination.

Holbrook Jackson's book, first published in 1913, is considered the standard work on the subject. A glance through the index discloses the inclusion of a great many names that would have been excluded by A. J. A. Symons or Osbert Burdett. In his preface to the catalogue of Symons's library, for example, Jackson complained of the omission of William Morris and Bernard Shaw.

Defining the nineties, in fact, is almost as controversial as defining Bloomsbury. One popular suggestion has been to regard the nineties group as representing not so much a period as a point of view. Whose point of view? Certainly Wilde's and Beardsley's one would say. Yet their kinship with French decadence and symbolism is alien to the Zolaesque realism of George Moore. Yeats, too, was a nineties man. His celtic mysticism is not easily reconciled with the outlook of either Moore or Wilde: neither does he or they find much in common with the Catholic mysticism of Francis Thompson.

Ricketts found his inspiration in the Renaissance, and Morris – for we must get him in – thought nothing of the Renaissance and Beardsley was one of his favourite hates.

Symons, in his *Fleuron* article, has attempted to summarise the position.

What is loosely called 'the Eighteen-Nineties' was the demonstration, by a group of writers and artists, of a belief in art, and not religion or truth, as the special consolation of the human spirit . . . the 'Men of the Nineties' were those who avowed a common creed . . .

Now the first part of this is more succinctly expressed as 'art for art's sake' and the second part is just not true.

Burdett evades the difficulties of definition by calling it 'The Beardsley Period'. This it most certainly was not, for while his work in one sense is possibly the most significant and unmistakable feature of the period it can never have formed a focal point. His influence on other artists was immediate and has been lasting, but at the time nothing really centred on him except for the very brief period when he was art editor of *The Yellow Book*. Whereas Lane's dismissal of Beardsley from the post at the behest of William Watson seems ludicrous from this distance, it does show how much that was alien and even hostile to Beardsley was encompassed within a circle that to A. J. A. Symons comprised the expression of 'a common creed'.

Despite this, when the book illustration of the period is considered, the singularity and significance of Beardsley's genius demand priority.

The leap from Kate Greenaway and Edmund Evans to Aubrey Beardsley, John Lane and Leonard Smithers is prodigious – but not in time. *The Yellow Book* was born and *The Savoy* had died before the Greenaway Almanack series was completed; and Kate

Greenaway, herself only 55 when she died, outlived Beardsley by three years.[1]

This does not mean that there is any evolutionary link discernible between them. The arbiters of the new mystique labelled Art Nouveau or Jugendstil – there is no English equivalent – have contrived a kind of ju-ju that pretends to observe a common style in Greenaway and Steinlen, Crane and Toulouse-Lautrec. This is nonsense; and we may be thankful that it is so. Let them be satisfied with Alfons Mucha and the Wiener Werkstätte and they are welcome to them. Beardsley and Nicholson were contemporaries and compatriots. Their work could not be more dissimilar if they had been born at opposite ends of the earth and at opposite ends of a century. What is much more significant than the Art Nouveau flapdoodle is the dramatic effect of the development of photographic process work and its blighting effect on book illustration in both colour and monochrome. 'Bad cheap process work has been responsible in this country for more vile work than in all the rest of the world put together', wrote Joseph Pennell.[2]

Henry Blackburn's hopes for the future implied the regrettable present, when he wrote, in 1894[3]

'In the "book of the future" we hope to see less of the "lath and plaster" style of illustration, produced from careless wash drawings by the cheap processes; fewer of the blots upon the page, which the modern reader seems to take as a matter of course . . . neither the artists nor the writers have mastered the subject [and] few of our best illustrators have the time or the inclination to take to the new methods. . .'

If these new methods on their inception were responsible for much shoddy work, as they undoubtedly were, those who inveighed most loudly against them erred in the opposite direction by vainly insisting that the evils were implicit in the media themselves and that salvation lay in a flight from the present into the past.

Beardsley had his share of that, also; but in a very special and personal sense. He came to terms with the new processes very quickly and, far from resenting them, he was one of the first to grasp both the advantages they offered to an artist and their limitations. If this was not the greatest it was also not the least of his achievements. In the short five or six years of his activity as an artist he developed marked changes in style; but he was never the slave of the period or mood he was working in. He did not attempt, as Crane for example did, an

[1] The juxtaposition of the two names is less bizarre than might appear. In 1883, when Beardsley was 11 years old 'he became attracted by Miss Kate Greenaway's picture books, and started illuminating menus and invitation cards with coloured chalks, making by this means quite considerable sums for a child'. (Robert Ross, *Aubrey Beardsley*, 1909, pp. 11–12.) In the Lessing Rosenwald Collection in the National Gallery of Art in Washington are two drawings by Beardsley after illustrations by Kate Greenaway made when he was eight years of age.

[2] Quoted by D. Bland, *A History of Book Illustration*, 1958, p. 272.

[3] *The Art of Reproduction*, p. 219. The illustrations to this book include excellent examples of what should and should not be attempted by 'process'.

imitation. On the contrary, whether treating a medieval or an eighteenth-century subject, whether under the influence of Burne-Jones or Hokusai, what emerges is an unmistakable Beardsley design, something that nobody else could have done, something, as they say, that is 'signed all over'. You may not like it, but you cannot fail to recognise it. He escaped completely the 'inflexible regard for descriptive realism' observed by most of his contemporaries. His brief, brilliant illumination of the Victorian scene and his sudden rise to fame are in contrast with the unpromising background from which he sprang.

He entered the office of an insurance company in London in 1889. Near at hand was the bookshop of Jones & Evans and Beardsley frequently spent part of his lunchtime there. He had very little money to spend on books but F. H. Evans, one of the partners, took an interest in him. He sometimes bought drawings from Beardsley and sometimes gave him books in exchange.

On 12 July 1891, with his sister Mabel, and taking with him a portfolio of his drawings, Beardsley went to visit Burne-Jones's studio, having heard that the artist kept open house at weekends. This was no longer true, but as they were turning away from the closed door Burne-Jones came after them and invited them in. Beardsley's mother told R. A. Walker many years later that this may have been due to his having caught sight of Mabel's beautiful red hair[4] or it may have been Beardsley's portfolio that caught his eye. In any case he was much impressed by the boy's drawings and arranged for him to attend evening classes conducted by Frederick Brown, then the best life-school in England. One wonders what he showed to impress Burne-Jones so greatly. It must have been something far better than the sort of drawings he had made at school, which Robert Ross charitably described as 'more a presage than a precedent'.

The twelve months during which he attended Brown's classes did him a great deal of good[5] and Brown thought so highly of Beardsley's work that he arranged for a selection of his drawings to be exhibited at the New English Art Club in 1892.

Oscar Wilde, his wife and two sons were visiting Burne-Jones on the fateful Sunday and took the Beardsleys back with them to Chelsea for tea.

In 1892 J. M. Dent, the publisher, asked Frederick Evans if he knew of a young artist capable of illustrating Malory's *Morte D'Arthur*. Evans suggested Beardsley and produced some of his drawings. Dent was very taken by one of them, 'Hail Mary';[6] and while he was looking at it Beardsley himself came in. Dent asked him to submit specimen drawings, liked them and commissioned the young man to make some 350 drawings as decorations and illustrations for the Malory.

[4] King, *An Aubrey Beardsley Lecture*, 1924, p. 32, footnote.

[5] Ross says only three months, but the *V. and A. Catalogue* is quite categoric that the period was from August 1891 to August 1892.

[6] Now at Princeton University with the A. E. Gallatin Collection.

Beardsley abandoned the insurance office and attendance at Brown's classes; for another piece of good fortune came his way at about the same time. He had been invited to visit Alice Meynell who wanted to see his drawings. A fellow guest was Lewis Hind, editor presumptive of a projected art magazine – *The Studio*. Hind was impressed by Beardsley's drawings and made a selection for reproduction in his first number to be accompanied by an article by Joseph Pennell. He also commissioned Beardsley to design a wrapper for the new journal. Hind did not in fact take up this editorial post. He accepted the editorship of the *Pall Mall Budget* instead, and gave Beardsley fairly regular employment there. But Gleeson White, who replaced him on *The Studio*, carried through the arrangements he had made for the first number.

Beardsley's natural jubilation at all this comes out well in a letter that he wrote to his friend, G. F. Scotson-Clark.

'Behold me then the coming man, the rage of artistic London, the admired of all schools, the besought of publishers. . . . One of them (Dent & Co.) (lucky dog) saw his chance and put me on to a large edition de luxe of Malory's *Morte D'Arthur*. . . . The work I have already done for Dent has simply made my name. William Morris has sworn a terrible oath against me for daring to bring out a book in his manner. The truth is that while his work is mere imitation of old stuff, mine is fresh and original. . . .

Dent is giving me £250 for the *Morte*. Joseph Pennell had just written a grand article on me in the forthcoming number of *The Studio*. . . . I should blush to quote the article: . . .

Clark my dear boy I have Fortune at my foot. . . . I have seven distinct styles and have won success in all of them. . . .'[7]

It was all very wonderful for a boy not yet 21: but enthusiasm for the Malory has waned. Ross's summing up is judicious. It was, he wrote in 1909, 'his most popular and least satisfactory performance. The popularity of the book was due to its lack of originality, not its individuality. Medievalism for the middle classes always ensures an appreciative audience.' Gothic was all the rage. There had been Gilbert Scott and G. E. Street, there was Morris and there was Walter Crane with his *Faerie Queene*. It is not without significance that a French critic wrote that Beardsley's *Morte D'Arthur* reminded him of H. Granville Fell.[8]

The Malory appeared in monthly parts, beginning in June 1893, in two forms – on ordinary paper at 2s 6d and on hand-made paper at 6s 6d a part.[9] When it was completed in 1894 the ordinary paper copies were offered in two volumes at £2 2s. No price was given for the special paper copies, probably because they had all been taken up on subscription, but the publisher offered to bind them in full vellum elaborately ornamented in gilt for 8s a volume. These copies

[7] Dulau Catalogue 1965, item 1308.

[8] *V. and A. Catalogue*, No. 170.

[9] The *V. and A. Catalogue* says 25s 6d and 65s 6d, a rare error in an admirably authoritative work.

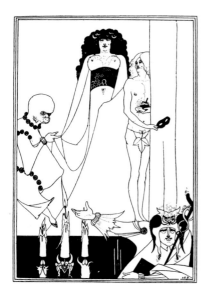

61. A. Beardsley. Enter Herodias.
Salome, 1894

were bound in three volumes because of the extra weight of the paper.

R. A. Walker, an enthusiastic and authoritative commentator on Beardsley, has called attention to the development of his style in the later sections of this work. This is probably just, but there was a far more significant development in the offing.

One of the drawings reproduced with Pennell's *Studio* article was based on a phrase in Wilde's play *Salome* which, with some help from Marcel Schwob and Pierre Louÿs, he had written in French,[10] and had printed at his own expense in Paris. Elkin Mathews and John Lane, his London publishers, were contemplating an edition in English, translated by Lord Alfred Douglas, and on the strength of this drawing asked Beardsley to illustrate it. In this book, despite the fact that the publishers were obviously terrified by it and seem to have done what they could to ruin its appearance, Beardsley's genius was given full play for the first time.

He obviously went to work on the book with great enthusiasm and designed a striking cover for it. This was rejected in favour of a nondescript canvas covering, reminiscent in texture and colour of sackcloth and ashes. His title-page design was emasculated, one drawing – a new version of the *Studio* design that had got him the job – was suppressed and another had to be entirely redrawn. Beardsley had his revenge. To replace the suppressed drawing, 'John and Salome', he put in a design, 'The Black Cape', which had nothing whatsoever to do with the book, looking for all the world like a Beardsley version of Yum-Yum.[11] He dealt with an offending member in the 'Entry of Herodias' by very ostentatiously tying on a fig-leaf and in the redrawn 'Toilette of Salome' he introduced a row of books under her dressing-table by Zola, de Sade, Apuleius and similar authors. The offending member was permitted to appear in the frontispiece but this may have been allowed to pass because it was only a little one. In 1907 Lane repented of his folly and produced an edition such as Beardsley had intended, with his original cover design and all the suppressions made good. Thus justice was done to him; the only thing that jars is the date on the title-page, for this is essentially a book of the Beardsley period.

Wilde is said to have disliked the pictures, saying that they were Japonesque whereas his play was Byzantine. But that was later, in his pettish reaction against not being invited to contribute to *The Yellow Book*.

Holbrook Jackson did not like the book very much. He said the 'drawings seem to sneer at Oscar Wilde rather than interpret the play' and that is almost all he does say about them. But then he did not like Beardsley at all, and has hardly a good word to say for him. He thought him 'a diabolonian incident in British art' and 'none of the books he illustrated are illustrated or decorated in the best sense.

[10] *The Times* critic nevertheless thought that the opening scene read 'very like a page from one of Ollendorf's exercises'.

[11] The drawing by which this was replaced had already been cut on wood and printed. It is equal to almost any other of the series and surely cannot have been thought too improper. It was included in the 1907 edition.

His designs overpower the text . . . because they are inappropriate, sometimes even impertinent'. One can see his point, but it is vitiated by the fact that he uses the term 'decadence' in a pejorative sense throughout. And yet he quotes Whistler's admission when he saw the drawings for *The Rape of the Lock*: '"Aubrey, I have made a very great mistake – you are a very great artist"' and adds his own comment that he 'passed on to the decorations for *Salome*, which consummate magnificently his first period, and to those of *The Rape of the Lock*, which gave formal art a new meaning and Beardsley immortality'.

If the *Salome* drawings are sometimes irrelevant the fault lay with the publisher. If they overpower the text the fault was the author's for Wilde's play is a feeble thing and Beardsley's drawings are masterly. They are certainly not Byzantine. They have an idiom that is entirely their own and is new and striking. 'The Peacock Dress' may be inappropriate but it is nevertheless a masterpiece in black and white, and this is true also of 'The Eyes of Herod', 'The Stomach Dance' and the brilliant tailpiece.

Possibly because of mistrust in mechanical process the drawings were engraved on wood by Carl Hentschel, but in the 1907 reprint the reproductions were by photographic process from metal blocks. A comparison of these reproductions with what was being done elsewhere at this time shows how well Beardsley had grasped the potentialities of the new media. If it be objected that he knew that the *Salome* drawings were to be engraved by hand then reference should be made to *The Yellow Book* drawings where the vignette on the title-page of the first volume is already adapted to mechanical reproduction.

In 1894, before he reached the age of 22, Beardsley was appointed Art Editor of *The Yellow Book*, and continued as such until the eve of publication of the fifth volume in April 1895 when, on receipt of an ultimatum by Mrs Humphrey Ward and William Watson, Lane dismissed him and suppressed the six drawings he had prepared for the new volume. By an oversight his designs for the spine and the back cover were retained.[12] Strictly speaking we are not concerned with any of *The Yellow Book* drawings, not so much because it may be considered to be a periodical as because they did not really illustrate anything. They include some fine things, in yet another new style, like 'The Wagnerites' (vol. III) and the wonderful profile drawing of Mrs Patrick Campbell (vol. I), with an occasional casting back to the *Morte D'Arthur* and *Salome* styles which are curiously and effectively combined in 'The Mysterious Rose Garden' (vol. IV).

The Savoy, which Leonard Smithers started in January 1896, to rival the enfeebled *Yellow Book*, is rather a different matter. It was as much a periodical as its rival, but in its earlier, and for Beardsley more

[12] This is by no means the only instance of Beardsley's survival in the Bodley Head lists after he had been dismissed by Lane and had joined Smithers. In 1895 Lane had announced a new edition of Wharton's *Sappho* with three illustrations and a cover design by Beardsley. When the book appeared in 1896 the illustrations had been scrapped but the cover design was retained. Similarly his designs for the cover and end-papers of the Pierrot Library were used in 1896.

fruitful period, most of his drawings were made to illustrate a text, frequently a text written by himself. With Smithers, too, he felt more at home than with Lane. Smithers was a rascal and is known to have commissioned and sold forgeries of Beardsley's drawings during the artist's lifetime. He was no prude – part of his income was derived from the sale of pornography – but he had to keep a very wary eye on Beardsley. The prospectus for *The Savoy*, the design for the first cover and the first of the illustrations had to be withdrawn: but the artist was off on a new tack and much of his work in the early numbers was great fun. The rakish cupid that forms a tailpiece to Beardsley's own poem *The Three Musicians*, the preposterous group of women bathers to illustrate Arthur Symons's travelogue on Dieppe and the figure of Puck on Pegasus used on several title-pages display a light-heartedness completely devoid of the 'diabolonian' streak that Holbrook Jackson was by no means alone in identifying with the name of Beardsley.

The superb series of drawings illustrating Beardsley's own fantasy *Under the Hill* are highly exotic. They are the sort of drawings that earned him a reputation for depravity. Perhaps deservedly because *Under the Hill* was the title chosen for the publishable version of a much more full-blooded piece called *Venus and Tannhäuser* which was first published surreptitiously and rather disgracefully after his death, almost certainly by Smithers himself.[13]

The first drawing for *Under the Hill* introduces the Abbé Fanfreluche, a figure more representative of his patronymic than of his title. He stands in a grove the partial description of which reads: 'The place waved drowsily with strange flowers, heavy with perfume, dripping with odours. Gloomy and nameless weeds not to be found in Mentzelius. . . .'[14] Huge moths, so richly winged they must have banquetted upon tapestries and royal stuffs', their eyes 'burning and bursting with a mesh of veins', all of which and more is crowded into the drawing.

The second drawing, of Helen at her toilet, includes the sinister figure of Cosine, the coiffeur, and some 'dwarfs and doubtful creatures' behaving rather curiously. The second instalment has a drawing of unpleasant creatures entitled without discernable reason 'For the third tableau of "Das Rheingold"'.

Doubtless indulgence in extravaganzas of this sort, text and pictures, were taken entirely seriously by his detractors, and have done his reputation no good. Much more probably the whole thing was an elaborate, though perhaps not very successful joke. If so it was a joke in very poor taste, the sort of thing that could be tolerated in Peter Breughel or Jerome Bosch because, after all, they were foreigners, who lived a long way away, a long time ago. Whereas this fellow Beardsley was alive and presumably British despite his rather unusual name.

[13] This was in John Lane's list of 1895 as 'In preparation' but Beardsley was dismissed before it was finished.

[14] This typical affectation probably refers to Albert Menzel, who published a Flora of Ingolstadt in 1618.

62. A. Beardsley. *The Rape of the Lock*, 1896

Going back to *The Yellow Book* for a moment, 'The Wagnerites' is very impressive: but, let us face it, they are not the sort of people one would invite to tea. But then I have always felt that if La Mona Lisa opened the door of a house where I was enquiring for lodgings I should have taken to my heels in a panic.

This was the sort of thing that made people feel uncomfortable with Beardsley's work, but there is nothing indecent or obscene about it. This was quite otherwise with the suite of eight drawings that he made to illustrate the *Lysistrata* of Aristophanes, which was issued privately by Smithers in 1896. Regarded as drawings they are supremely accomplished. Moreover there is nothing unwholesome or suggestive about them: although the portfolio was certainly not to be left lying about on the coffee table. Neither is the play, which is concerned with copulation and war and the women's threat to discon-

tinue the former during the continuance of the latter. This Beardsley illustrated with Gargantuan emphases. Aristophanes would probably have thought them uproarious. The Victorians were not amused. The drawings are shocking but not depraving.

There are many other fine things in *The Savoy* including one of Beardsley's best, 'The Coiffing', illustrating his own 'Ballad of a Barber'. This appeared in No. 3 and thereafter, until the eighth and last number, his appearances are rare, for he was already a dying man. 'The Death of Pierrot' in No. 6 is a pathetic realisation of the fact.

No. 2, April 1896, contained a foretaste of a book that Smithers was about to publish in the shape of an illustration to Pope's *The Rape of the Lock*. The nine drawings for this book constitute for some the best of all Beardsley's work. They are in his 'eighteenth-century' style and Whistler's high praise and Holbrook Jackson's grudging admission of their excellence have already been mentioned. The style can be called eighteenth century only because the characters wear the costume of the period. The drawings are pure Beardsley, and, as Ross says, Beardsley did not 'burden himself with chronology'. They are surely 'the testament of his genius, and sober judgement suggests that he will rank with the greatest as a black-and-white artist.'

Not the least astonishing feature of this young artist's brief career was the immediate and continuing influence of his work on other artists. This was well brought out in the Exhibition at the Victoria and Albert Museum in 1966 where the first 82 exhibits showed a range of the work of artists influenced by him. English, French and American designs as early as 1894–5 were already in the Beardsley manner and from Will Bradley to Eric Gill and from Gordon Craig to Arthur Rackham his influence is plain.

Above all, in Germany his work was acclaimed and absorbed freely. The early volumes of *Pan*, from 1895 onwards, with artists like T. T. Heine and E. R. Weiss, abound in Beardsleyesque drawings. Emil Preetorius, Heinrich Vogeler-Worpswede, Melchior Lechter, Heinrich Lefler, Bayros and dozens of other German artists of the period would not have been the men they were but for Beardsley. They might have produced work in different styles that was just as interesting; and most of them eventually developed unmistakable personalities of their own – Paul Klee is an outstanding example of this. Nevertheless the quite staggering fact is that Beardsley, working mostly for small publishers who issued his books mostly in very limited editions, within the five or six years of his active life changed the course of book illustration throughout the Western world.

This is very strikingly seen in a book not shown at the Victoria and Albert, the first German edition of Oscar Wilde's *Salome*. This was published by the Insel-Verlag in 1903. Oddly enough they did not use the Beardsley illustrations;[15] but instead gave his first book com- sion to Marcus Behmer a young protégé of O. J. Birnbaum's. At first sight the effect of the illustrations is startling. It is as though

[15] They used them in an edition of 1907.

Beardsley had suffered a Teutonic reincarnation. The design for 'The Peacock Skirt' is hardly more than a pastiche and strengthens the impression that Behmer must have abandoned the unequal contest when faced with the Beardsley designs. It would seem in fact that he was very pleased with his drawings for he issued 25 sets of signed proofs on very large japon paper. Behmer eventually shook off Beardsley's commanding influence, in, for instance, a selection from Buddhist scripture in 1922, but it lasted for a long time and it is quite grotesque to find him using it to illustrate a dialect fairy-tale by P. O. Runge in 1914. There is an even more remarkable example of Beardsley influence in Vogeler-Worpswede's double-spread title-page to Hofmannsthal's *Der Kaiser und die Hexe*, 1900, which is cribbed from a marginal decoration in Beardsley's Malory.

Behmer, in fact, was only one of many and perhaps in view of such evidence of Beardsley inspiration foregoing remarks on his relation to the Art Nouveau school should be somewhat qualified. Beardsley, in fact, owed nothing to Art Nouveau but its debt to him was considerable.

William Morris

We may appear to have overshot the mark in taking Beardsley before Morris. The fact is that Beardsley was first in the field. The *Morte D'Arthur* illustrations were admittedly made under the direct influence of Burne-Jones: but although the first Kelmscott book was issued in 1891 no publication of the Press can be called an illustrated book before 1894 when Morris's *The Story of the Glittering Plain* had 23 illustrations by Walter Crane, by which time the drawings for Beardsley's Malory must have been virtually completed. So far as book illustration is concerned, or the advancement of the art of the book, Morris's influence was more by precept than example. Some day, perhaps, someone will write a treatise about his work in general from a standpoint this side of idolatry.

He performed a great service by insisting on the use of first-class materials and workmanship, in contrast to the shoddy production that was common in his day. As a designer of books he was a complete amateur and, for all his worship of the early printers, singularly failed to observe the principles that made their work so splendid. It is also true that he almost invariably ignored the canon that he himself laid down that books should be 'easy to read, not dazzling to the eye, or troublesome to the reader by eccentricities of letter form'. These words of Morris's might well serve as a general criticism of the Kelmscott Press books.

An editorial comment in *Alphabet and Image* (December 1946) supports this view:

'Morris, with his medieval museum pieces (for they are certainly not books to read) would have put commercial printing almost back to Caxton if he could have had his aggressive way. He was as anachronistic as Pugin. . . . It is interesting to hear again and again the legend that Morris established the contemporary book. . . . Any six

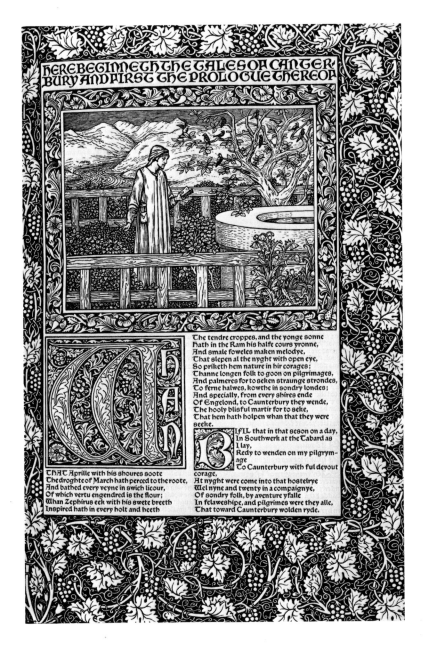

63. E. Burne-Jones and W. Morris. Opening page for *The Works of Geoffrey Chaucer*, 1896. Engraving by Burne-Jones; border and initials by Morris

pages from any six Kelmscott books disprove the claim. . .'

Mr David Bland sums up his comments on the Press as follows:

'Even if we accept the lack of depth, the crowded appearance of the Kelmscott page, heavy type, heavy border and heavy cut all in the same plane run counter to our notion of what the book page should be.'[16]

Morris, in fact, looked always backward, never forward. He was right

[16] Bland, *op. cit.*, p. 275.

to do so to show that standards had fallen too low; what he almost entirely failed to see, and this was temperamental and characteristic, was that the new methods and materials coming to hand could be made to produce excellent results.

'The specially manufactured inks, the imperishable Batchelor paper, the pure vellum bindings, of Kelmscott books, were all things good in themselves; but they were remote from the possibilities open to an ordinary publisher, and tended, indeed, to enlarge rather than diminish the gap between the beautiful but costly, and the commercial and ugly.'[17, 18]

Charles Ricketts

Oscar Wilde's downfall had wide repercussions. Beardsley, whose fruitful adaptation to the line-block has already been remarked, suffered more than most. To be associated with Smithers instead of Lane was in itself a change for the worse. It reduced his audience largely to 'admirers of the dubious and pathological'.

Charles Ricketts, who had been more consistently associated with Wilde than Beardsley – he designed or illustrated no fewer than eight books of Wilde's – escaped condemnation. This was probably because he and his house-mate, Charles Shannon, kept themselves very much to themselves. As Will Rothenstein said of them, 'They knew very few people, and prided themselves on going nowhere.'

Although a lesser artist than Beardsley, Ricketts made a greater contribution to book design. Apart from some agreeable initial letters made towards the end of his life, Beardsley showed almost complete indifference to typography. That the careful and attractive use of Caslon Old Face in *The Yellow Book* was none of his doing is evident from the shoddy and pedestrian setting of *The Savoy* and *The Rape of the Lock*.

Ricketts, on the other hand, from the very beginning saw that a book must be treated as an entity, and he was eventually driven to design type-faces himself in order to make it so. In this he was less successful than in other ways, but at least his types are not fussy and they harmonise well with his own fine illustrations and border designs.

Ricketts, unlike Morris, was a professional. He had been apprenticed to Roberts, the wood-engraver at the City and Guilds Technical Art School. There he had met Shannon. They became great friends and eventually set up house together in Chelsea. Ricketts had a minute private income. Shannon had no money at all. C. J. Holmes[19] gives a hint of Ricketts's prosaic early commission to illustrate a trade catalogue, when he relates how shocked the artist was when the shopkeeper suggested that a drawing of ladies' stockings might be more successful if they were filled.

[17] A. J. A. Symons, *Fleuron*, vol. VII, pp. 89–90.
[18] The Kelmscott, Vale and Eragny Press books will be treated at length in a forthcoming volume in this series on English Private Presses by Mr L. E. Deval.
[19] *Self and Partners*, 1936.

In 1893 Mathews and Lane published at £2 2s an edition of Longus's *Daphnis and Chloe* illustrated by Ricketts and Shannon. Holmes[20] says that one of the engravings, 'The Wedding Feast of Daphnis and Chloe' includes a portrait group of Ricketts, Shannon, Sturge Moore, Lucien Pissarro, Reginald Savage and Holmes himself. Whether this book was a venture of the two artists themselves is not clear; but their next book, the *Hero and Leander* by Marlowe and Chapman bore an imprint that was to become better known, The Vale, which was the name of the house in which they were then living. Mathews and Lane doubtless marketed the book for them, but it was clearly their own venture, and a magnificent book it is.

Thomas Lowinsky[21] describes the unity of purpose and method of the two men. 'Each artist designed illustrations, which, for unity, were redrawn by Ricketts upon the blocks, and then cut by both.'

Prior to this they had started an occasional publication called *The Dial*[22] on the strength of which Wilde took them up and they worked severally or jointly on several of his books for different publishers. In 1891, for Ward, Lock, Ricketts made strikingly successful designs for the cover and prelims of *The Picture of Dorian Gray*. In the same year, for Osgood, McIlvaine, Ricketts again designed the cover, title-page and end-papers for *The House of Pomegranates* and also supplied some textual ornaments. Shannon drew four full-page illustrations. Ricketts's part came off very successfully. The spine is of apple-green linen with very good gilt lettering by Ricketts. The sides of beige coloured boards have an all-over design of a peacock, a fountain and a basket of pomegranates printed in brick red. It is not a binding that has worn very well and loses much of its effect when not in pristine condition. The title-page is rather too elaborate. The pomegranate hedge rather overpowers the figures of the young girl drooping over a not very convincing embroidery frame and of Pan piping in the background, while the mask lying in the left-hand corner seems irrelevant. But nobody but Ricketts could have made it. Shannon's drawings, unfortunately, are almost indecipherable because of the mysterious and disastrous process by which they were reproduced in Paris.

In 1894 Ricketts produced a masterpiece for Mathews and Lane with *The Sphinx*. This, like the *Hero and Leander*, was printed by the Ballantyne Press and Ricketts was evidently given a free hand not merely to illustrate the book but to design it from cover to cover, directing the printer on the number of words to the line and the number of lines to a page. He shows here already the beginnings of an idiosyncrasy which he was to pursue regularly in later books – an aversion to the conventional title-page. Later, when he became a publisher, designing all his own books, he dispensed with title-pages almost completely, giving only the title and the author on a half-title and resuming such information as he thought fit to give in a colophon at the end of the book. In *The Rime of the Ancient Mariner*

[20] *Ibid.*, p. 169.
[21] *D.N.B.*, art. 'Ricketts'.
[22] Five issues appeared between 1889 and 1896.

64. C. Ricketts. Title-page for
The Sphinx, 1894

(1899) not even the author's name appears at the beginning of the
book; but on the last leaf there is a title-page. In Landor's *Epicurus,
Leontion and Temissa* (1896) both author and title are given briefly
facing the first page of text, other information, but no date, is given
in a colophon. This shows Ricketts looking back to his beloved
Renaissance, but it is disconcerting and therefore undesirable.

In *The Sphinx* he has obviously compromised with the natural
desire of the author and publisher that their names and the date of
publication should be readily available to the reader. He seems to
have done so grudgingly and the result is not completely successful.
The lettering is cramped and dismissed to the margins. It appears
almost totally irrelevant to the elaborate arabesque design which
occupies the whole of the page. Deliberately to emphasise this irrele-
vance Ricketts places it on a left–hand page facing the first page of
the text. It is all very well for Symons[23] to say, 'To the unspoken
question "why should the traditional, accepted arrangement of the
[23] *Op. cit.*

[title-] page be thus disordered?'' *The Sphinx* seems to answer blandly "Why not?"' The obvious retort to which is, 'Because it does not come off.'

There is one other criticism of the book for which Ricketts may not have been entirely responsible. This is the use of thin boards for the beautifully designed vellum binding, which causes an irritating and incurable tendency to curl outwards. Otherwise the book is brilliantly successful. The use of brick red for the illustrations and the bright green for the decorative initials and catchwords and the black-printed text in large and small capitals throughout, provides an ideal setting for the artificiality of Wilde's text. There were 25 copies on large paper – which was, as in most illustrated, or for that matter unillustrated, books, a mistake.

It is worth quoting Ricketts's own account of his aims and methods used in designing *The Sphinx*:

'This is the first book of the modern revival printed in three colours, red, black, and green: the small bulk of the text and unusual length of the lines necessitated quite a peculiar arrangement of the text; here I made an effort away from the Renaissance towards a book marked by surviving classical traits, printing it in Capitals. In the pictures I have striven to combine affinities in line work broadcast in all epochs. My attempt . . . was to evolve what one might imagine as possible in one charmed moment or place.'[24]

Implicit in this passage and throughout the short treatise in which it occurs is the extremely personal standpoint observed by Ricketts in designing a whole series of books in which it found expression. Illustrations were not something to be added to books to give them a specious attraction. They should be used only when the text demanded their inclusion. They should arise as a natural and essential feature of the physical evolution of the book in the mind of the designer, and generally speaking should be used sparingly.

In the 43 books that Ricketts designed and issued from the Vale Press, which he founded in 1896, illustration plays a minor part. There are frequent and varied border decorations which he cut on wood whenever they seemed to be called for, and occasionally another artist was entrusted with illustrations like the five beautiful miniatures designed by Sturge Moore for his translation of two pieces by Maurice de Guérin.

These productions in particular and Ricketts's place in the revival of good printing in general will be fully treated elsewhere.[25]

G. S. Tomkinson[26] exaggerates when he 'is doubtful if, in the history of printing, books have been made which reflect the invention and work of one man more than do the Vale books'. Yet an ambitious claim can be substantiated not only for the beauty and appositeness of his book illustrations, but for his remarkable anticipation of modern practice.

[24] *Defence of the Revival of Printing*, 1899.
[25] See note on p. 190.
[26] *A Select Bibliography of Modern Presses*, 1928.

Other Nineties people

Lucien Pissarro, although he was allowed to use Ricketts's Vale type for his Eragny Press books, and marketed the early ones through Ricketts, made illustration an essential feature of most of his books, and very dainty and charming they are. They have only recently begun to attract the attention they merit: but as the editions rarely much exceed 200 copies – and of one book only 27 were printed – they have become very difficult to find. Pissarro did not settle in England until 1894, but on a previous visit, his second, in 1890, he had met Ricketts and Shannon. They published wood-engravings of his in *The Dial* and issued a group of them separately in a portfolio.

In 1894 he went to live at Epping where he produced 16 wood-engravings to illustrate an English version of a French fairy-tale called *The Queen of the Fishes*. Finding no type that would harmonise with his designs, he provided a calligraphic text from which line-blocks were made and 160 copies printed on hand-made paper, four of the engravings in colours. This was the first of the Eragny Press books and actually anticipated the Vale series by two years. The almost complete lack of stimulus in type design between Caslon and Morris probably had much to do with the interval of two years before Pissarro printed another book. Ricketts now permitted him to use his own Vale type, a typically generous offer by a notably unselfish man. It is said that Ricketts made it a condition that the books be sold 'at the sign of the Dial' in Warwick Street where the Vale books were published. It is more likely that he offered this as an inducement to Pissarro to go ahead. However that may be, the first 16 of the Eragny books were published there; and the arrangement ended only when Ricketts closed down in 1903.

The entire series of 32 books is utterly charming. The books are usually on the small side, between six and eight inches in height, occasionally in an oblong format, with specially designed paper-board covers and, unlike those of Ricketts, which were commercially produced, albeit under his supervision, Pissarro's books, with the exception of the first, were 'printed with his own hand'.

The second production, *The Book of Ruth and The Book of Esther* is printed in red and black, it has five jolly little wood-engravings and one does not mind in the least that Ruth and Naomi are clearly Norman peasants. Ahasuerus and his court are thoroughly Oriental.

But it is in his use of colour, both bold and gentle, that Pissarro excels. In such books as Binyon's *Dream-Come-True* (1905) with coloured floral borders embracing and even flowing over into the text, Judith Gautier's *Poèmes Tirés du Livre de Jade* (1911) with a discreet use of gold with colour that pleased Pissarro so much that he issued the engravings also in a separate portfolio, or in Moselly's *La Charrue D'Erable* (1912) successfully reviving the chiaroscuro method, he charms us most. Of several of the books some copies were printed on vellum, a medium with which Pissarro was neither more nor less successful than other printers.

Printing pictures from wood-blocks was developed in quite a

65. W. Nicholson. The Coster
Girl from *London Types*, 1898

different way by William Nicholson. He and his wife's brother,
James Pryde, calling themselves the Beggarstaff Brothers, had struck
out a new, bold line in poster design, comparable in importance with
Toulouse-Lautrec's work in the same medium, though far less
extensively employed. They used a woodcut technique, although
the posters were printed by lithography.

In 1897 Nicholson began to adapt this technique to book illustra-
tion, cutting his own designs on wood. Using a large page, usually
about 12½ inches by 10 inches, the design was picked out in black against
a tinted background. Colouring was mostly in low tones of yellow,
brown or grey with the occasional effective emphasis of a red coat
or hat or a formalised patch of blue cloud. The powerful massing of
the blacks with an unerring sense of exactly where and how to use
colour gave them an individuality which was immediately recog-
nised in their own day; but was subsequently overlooked until the
last year or so. Ultimately they derive from the crude cuts of the ballad
sheets of Catnach and his like, with the crudity refined by the per-
sonality of the most fastidious of artists and adapted to another age.
It had been done before by Joseph Crawhall the younger in the archaic
productions of the Leadenhall Press and was to be done again by
Lovat Fraser. The individuality and refinement of Nicholson's work
is not the less striking for that.

66. L. Housman. Border design for *Goblin market*, 1893

Nicholson, like Crane, Ricketts, Pissarro and others, found no type to match his pictures and therefore cut the text on wood. He even designed a device for his publisher in the same idiom as the rest of the book and the Heinemann windmill thus made its first appearance, in one of its most decorative forms. The occasional publisher's announcement shows the feebleness of the available type-faces, contrasting strongly with the vigour of Nicholson's letter-forms.

It was a godsend for the young and recently married artist that Heinemann took to the idea so readily, and that his enthusiasm was shared by the public. In 1897 two volumes were produced; in October came *An Alphabet* and in December an *Almanack* for 1898, with verses by Kipling. In November 1898 came *London Types*, with quatorzains by W. E. Henley, in 1899 *Twelve Portraits*, which had appeared in Henley's *New Review*, and *The Square Book of Animals*.[27]

That was all! Just those five titles and no more. They probably made his reputation and brought him commissions that were at once more lucrative and more to his taste, although this early and unique series abounds with the artist's enjoyment in their production.

Forrest Reid paid Laurence Housman the compliment of having continued the Pre-Raphaelite tradition in his book illustrations. One can see what he meant. Comparing Housman's illustrations for Christina Rossetti's *Goblin Market* with her brother's he found Housman a not unworthy successor. It is indeed a very pretty book but the praise is too high. As for R. E. D. Sketchley's[28] assertion that he hardly ever surpassed his designs for George Meredith's *Jump to Glory Jane*, no more unfortunate judgement could be passed on the unfortunate artist. For this was a disastrous piece of book-making and failure is by no means entirely to be laid at the artist's door. Two more experienced illustrators, Linley Sambourne and Bernard Partridge had already declined to attempt this monstrously difficult poem. It is full of typically appalling Meredithian lapses:

> Occasionally coughers cast
> A leg aloft and *coughed* their last.
> In jumps that said, Beware the pit!
> More eloquent than speaking it –
> That said, Avoid the boiled, the roast,
> The heated nose on face of ghost.

How on earth the wretched artist's pencil was to express the eloquence of these rural feet only Harry Quilter, who commissioned the drawings, could explain. As drawings some of them are very good – Jane jumping at her first convert or 'Directing jumps at Daddy Green', which is said to have been a particular favourite of Meredith's. The author called it a satire. It is in fact a joke that does not come off. The mixture of spindly letterpress and calligraphy in the text is extremely unfortunate, and Housman had not yet acquired the ability that he showed a couple of years later in his successful marriage of text and

[27] Most of these were published for the Christmas season and post-dated. See the list on p. 210.
[28] *English Book-Illustration of To-Day*, 1903, pp. 15–16.

drawing in Jane Barlow's *The End of Elfin Town*.[29] This and *Goblin Market* are incomparably the most successful examples of his work as an illustrator. Eventually he found drawing too great a strain on his weak eyes and by the end of the century he had given it up altogether.

We now approach the point where the edge of the circle is less well defined. A new school appeared, mostly less individual than Beardsley or Ricketts, but achieving a popularity to which they were complete strangers.

The 'Cranford' school

Hugh Thomson followed a tradition that side-stepped the nineties people, having no point of contact with them. When he was apprenticed to Marcus Ward & Co., the Belfast chromolithographers, they had already printed and published work by Walter Crane and Kate Greenaway. When he came to London and was made a staff artist on *The English Illustrated Magazine* in 1884 he found Caldecott already employed by the journal. He had bought and enjoyed the early Caldecott Toy-Books while still in Ireland: and whereas he had no artistic training beyond what he picked up at Ward's, he clearly made Caldecott his master. This is evident in his earliest characteristic published work, the Roger de Coverley series, which began to appear in the magazine in 1885, while Caldecott was still alive.[30] An even closer relationship between master and pupil came in 1890 when Macmillan decided to revive the format that had succeeded so brilliantly with Caldecott's two Washington Irving volumes in 1876–7. Thomson was commissioned to provide drawings for *The Vicar of Wakefield* in the same style. The covers were of green cloth decorated in gilt with designs by the artist. There are distinct differences between Thomson's approach and Caldecott's, notably in the fact that Thomson's only full-page drawing is for the frontispiece. Balston points out that he was never a good draughtsman and that as late as 1903 he shrank from a full-page drawing. Spielman[31] quotes several examples of self-acknowledged shortcomings – 'I wish I had had training and could use the model'. Comparing Thomson's Goldsmith with Caldecott's Irving it is clear that Thomson had not the same command of the medium. Not only does he compare unfavourably with Caldecott as a draughtsman, he has not the same grasp of *mise-en-page* so that his drawings tend to interrupt the text rather than to blend with it. Nevertheless it was Thomson who founded the 'Cranford' school of illustration. Where Caldecott had made only two such books Thomson illustrated a whole series and attracted a number of other artists to the medium, some of whom surpassed him.

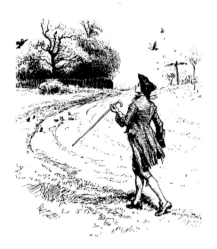

67. H. Thomson. 'Be cheerful as the birds that carolled by the road'. *Vicar of Wakefield*, 1890

[29] There was an edition of this on very large paper which should be shunned.

[30] There is another link with the past here. The first of the de Coverley drawings in the magazine was reproduced by wood-engraving. Thereafter most of Thomson's drawings were printed from metal blocks. Balston, in 'English Illustrated Books', 1880–90, which forms a chapter in *New Paths in Book Collecting*, 1934, says 'all', but in 1891 his drawings for Scott's *The Antiquary* were engraved on wood by Hooper, who also engraved for William Morris.

[31] M. H. Spielmann and W. Jerrold, *Hugh Thomson*, 1931.

The *Vicar* was an immediate success and the first edition – 5,000 copies and 300 on large paper – was sold out within a week. Speculators were soon putting copies aside in the hope of a rise and after *Cranford* appeared in 1891 a 'Thomson' book became a feature of the Christmas market.

68. H. Thomson. 'We sedulously talked together'. *Cranford*, 1891

When Comyns Carr, the first editor of *The English Illustrated Magazine*, appointed Thomson to its staff in 1884 this bound him to its publisher Macmillan. In 1889 Comyns Carr left owing to pressure of other engagements and Thomson became a free-lance at the same time, while retaining a close association with the firm which was then in course of publishing in parts his illustrations with Herbert Railton's to W. O. Tristram's *Coaching Days and Coaching Ways* – one of his best and still one of his most popular books.

All that is known about his financial position at that time is that Macmillan paid him £5 a week to do exclusively work commissioned by Comyns Carr. The first fruit of free-lancing was a commission from Kegan Paul to illustrate some poems by Austin Dobson – *The Ballad of Beau Brocade* – planned for 1891 but actually published in 1892. For these he was paid about £3 a drawing. But he had already

been approached by Scribner of New York to supply 22 drawings for a fee of £175 and in 1894, when he illustrated *Pride and Prejudice* for George Allen he received £500 down and a royalty of sevenpence a copy above 10,000. These were probably his minimum terms thereafter.

Thomson obviously enjoyed himself with *Cranford* – he said that it almost illustrated itself – and the result is a delight. *Beau Brocade*, on the other hand, the first of the derivatives, although most of the illustrations are good, is a shocking example of book production, overloaded with blank pages and with vignette designs masquerading as full-page illustrations. *Cranford* was printed by Clark of Edinburgh and *Beau Brocade* by Whittingham. There is good reason to suppose that the latter was acting on instructions, for in 1895, with another Dobson-Thomson book, *The Story of Rosina*, Kegan Paul switched to Ballantyne Hanson, who printed for Ricketts, with a similar result, whereas Whittingham produced *Pride and Prejudice* for George Allen in impeccable style.

We cannot follow Thomson into other spheres of his work as an illustrator – his immensely successful collaborations in the Highways and Byways Series, or his less successful experiments in colour. One must avoid loading the Thomson school with a significance disproportionate to its performance. Yet it is, in its way, as significant of Victorian escapism as the Morris movement. Thomson arrived on the scene just when the consciousness of the squalor and shoddiness of the mechanical age awakened a nostalgia for 'the good old days' when life was simpler, more decorative; when the countryside was peopled by benevolent squires, served by a retinue of loyal and picturesque rustics, and when such rural retreats were reached by horse-drawn transport, rather than stinking locomotives; when male costume was not confined to stove-pipe hats and drain-pipe trousers, and England was a pastoral paradise.

Thomson began to cater for these masochistic delusions in October 1885 when the first Sir Roger de Coverley paper appeared in *The English Illustrated Magazine*. In the same year appeared Kate Greenaway's *Marigold Garden* and William Morris's *Useful Work v. Useless Toil*. *Days With Sir Roger de Coverley* (1886) and *Coaching Days and Coaching Ways* (1888) were both clothed in the green and gold of the two Caldecott-Irving volumes of 1876–7, although much larger in size. In 1892 and 1893 respectively they were reduced to 'Cranford' size as numbers 5 and 6 in the series, following *The Vicar of Wakefield* and *Cranford* itself. As we have seen, Thomson was soon tempted to extend the style to other publishers and as he was drawn back to Macmillan these other publishers recruited other artists. Thus Chris Hammond worked for George Allen, F. H. Townsend and Fred Pegram for Service & Paton and the two Brock brothers for a variety of publishers.

When Macmillan found Thomson too much engaged by another publisher to undertake a commission for them they in their turn began to recruit other artists. Crane's version of Grimms' *Fairy Tales* was adapted to the series and was followed by *Humorous Poems* by Thomas

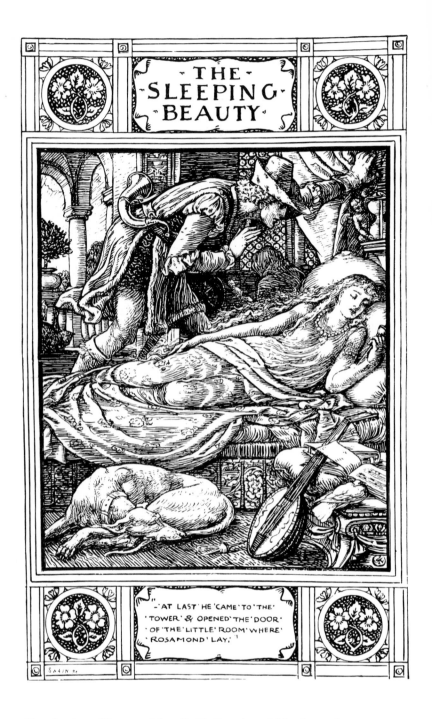

69. W. Crane. The Sleeping
Beauty. *Household Stories*, 1882

Hood, 1893, illustrated by C. E. Brock, which the artist was accus-
tomed to describe in his *Who's Who* entry as his first work of any
importance. There are 130 drawings mostly in Hugh Thomson style.

Very different is Brock's other volume in the series, a *Gulliver* with
100 illustrations, published in 1894. The cover of this volume is one
of the most striking in the series. It is an adaptation of Brock's
drawing of Gulliver walking 'with the utmost circumspection'

70. E. J. Sullivan. Herr Diogenes.
Sartor Resartus, 1898

through the streets of Mildendo, the capital of Lilliput. It is even more effective in gold and green than in black and white. Other brilliant impressions of contrasts in size are the hero's peering through a middle-storey window to kiss the Queen's hand and his perusal of a Brobdingnagian book from the steps of a ladder. The more difficult assignments of Laputa and the Houyhnhnms are less brilliantly, though competently handled. It is doubtful whether Brock ever surpassed the level of these illustrations. The work of his brother, H. M. Brock, is well seen in an edition of Thackeray's *Ballads & Songs* (Cassell, 1896) and in two Marryat volumes (1895) and two by Fenimore Cooper (1900–1) done for another Macmillan series. Both brothers survived prolifically beyond our period.

Possibly the finest of the illustrators to emerge from this school was E. J. Sullivan, whose name is inexplicably absent from the *Dictionary of National Biography*. (When will a supplement of omissions be started?) He was employed on periodicals from the age of 19 and was given his first book commission five or six years later by Macmillan who published three books illustrated by him in 1896. They are very different in style and the first of them, Borrow's *Lavengro*, published in February in their Illustrated Standard Novels, was the finest of the three. The drawings are uneven in merit and style, but the best of them are outstanding – the child Leonora weeping, the traveller casting himself before Stonehenge and the halt at The Silent Woman. Sheridan's two plays, *The School for Scandal* and *The Rivals*, made up the second volume in November. It is very conventional eighteenth-centuryesque and, like so many similar efforts of the period, gives the impression, as James Thorpe has said, 'that the characters are actors in theatrical costume'. *Tom Brown's Schooldays*, which appeared in December, was like Sheridan, a volume in the 'Cranford' series. It is bearable but more important things were to come. Let it be added in passing that in the same year George Bell published an edition of Walton's *Compleat Angler* with 88 drawings by Sullivan, which are by no means the worst illustrations made for that frequently illustrated work. They are quite different from the other three books and include some minor enchantments.[32]

In 1898 he produced his masterpiece – Carlyle's *Sartor Resartus*, also published by Bell.[33] There are 79 illustrations in all, including head- and tailpieces. Sullivan's admirers mostly prefer his illustrations to Carlyle's *The French Revolution*. That was not published until 1910 and so no decision on its merits is relevant here: but Tennyson's *A Dream of Fair Women and other Poems* (Grant Richards, 1900) and the Bunyan of 1901 published in two volumes by Newnes, both claim comparison with the *Sartor*.

James Thorpe goes rather far in claiming that Sullivan is 'the greatest book-illustrator in line that this country has produced'. That at his best he is at home in any company is unquestionable and that

[32] The drawings for the Borrow and the Walton are dated 1895 and the latter may have been published in that year, and post-dated.

[33] The reproductions in this volume are of varying quality. All the original drawings are in the Victoria and Albert Museum.

with Bewick, Cruikshank, Keene and Beardsley he is entitled to tap on the doors of eternity.

A new era

The last quarter of the nineteenth century is interesting for the revival and extension of the practice of illustrating the works of current authors which had been common in the first quarter of the century but had been allowed to languish somewhat with the rise of the coffee-table book, the 'Keepsakes' and the reluctance of Routledge, Ward, Lock, the Dalziels and others to pay authors as well as artists, especially when artists were, generally speaking, cheaper than authors.

There were exceptions and the eagerness with which they are sought causes collectors at any rate to pay heavily for the artist-author combination. It will be noticed that the imprint in this kind of book is usually of a publisher not to the forefront in Gleeson White or Forrest Reid. Thus George Macdonald (illustrator Arthur Hughes) was published by Strahan and afterwards by King; Trollope (illustrator Millais); and Mrs Gaskell (illustrator du Maurier) by Smith, Elder.

In the eighties and nineties the output of every publisher with a general market included a high proportion of illustrated books and this included not only gift books, children's books and travel and technical works but new fiction, poetry and all kinds of *belles-lettres* including essays. Thus a host of contemporary authors had their new books illustrated, among them such as Barrie, Henty, Conan Doyle, Dobson, Lang, Meredith, Jacobs, Wilde, Jerome, Bret Harte, Ian Maclaren, Max Pemberton, Cutcliffe Hyne, Stevenson, Crockett, John Davidson, E. V. Lucas, Anstey and Weyman.

Vast increases in mechanisation had greatly reduced costs of production; and the lack of retail price maintenance before the gradual adoption of the net book system introduced by Macmillan's in the nineties, but not generally observed until the rigours of wartime enforced it after 1914, meant that most books were sold to the public at 25 per cent below the marked prices. This was a bonanza for the book buyer when the ordinary novel plainly marked at 6s on the dust-wrapper was sold for 4s 6d and the huge annual volumes of *The Boy's Own Paper* and *Chums* cost only 6s net while *Little Folks* cost only 3s 9d. Booksellers' windows were plastered with bargain prices similar to those of linen-drapers, where books priced 3s 6d were sold for 2s 7½d and those at 2s 6d for 1s 10d. It created a disastrous situation for the retail bookseller, where the return to the bookseller on a 6s book was 6d and on one at 2s 6d only 2d, and created a situation where he had to supplement his income by the sale of Berlin wool and all kinds of stationery. The retail trade in England took a long time to recover and the after-effects are still notable in the sparse number of bookshops in English towns compared with the Continent, where even Norway is superior.

The immediate effect from our point of view of the intense competition caused by these cut prices was, as already noted, a vast

increase in the output of illustrated books. Examples of the cheapness and also of the nastiness of the majority of illustrated books produced at the time are the Sherlock Holmes books. The first of these, *The Adventures*, 1892, is a large octavo, similar in appearance to *The Strand Magazine* in which the stories first appeared. With over 300 pages of text and more than 100 illustrations, on thick gilt-edged paper it was sold to the public at 4s 6d. The standard of production is as low as that of the magazine itself and the illustrations are even more repulsive as the clichés show considerable signs of wear.

Most of the high-spots that have been mentioned in this period are in a completely different category as regards both quality and price. The limitation of the editions was low and the published prices were high. The list is headed by the Kelmscott Chaucer – 425 copies on paper at £20 and 13 on vellum at £126. The Froissart, had it have been completed, would surely have cost more. Vale Press books cost up to £10 each for vellum copies and the Eragny books were proportionately even more expensive. Milton's *Areopagitica*, comprising less than 40 pages, cost £7 7s on vellum and £1 11s 6d on paper.

Commercial publishers were not slow to perceive that there was money in limited editions. Of them all John Lane was the earliest, the most consistent and the most successful. He and Elkin Mathews began their partnership in 1889[34] – Richard le Galliene's *Volumes in Folio*, published at half a crown with a certificate of limitation to 250 copies was their first publication. It is a trumpery little plaquette, maximum commercial price sixpence. Without the statement of limitation the total circulation might not have struggled above 100 copies. Lane used to carry copies about in his pocket, hawking them on social visits and assuring purchasers of a speedy rise in value. He built his business on this sort of thing. The first book issued by the partnership in which Lane's name was included in the imprint was an exceedingly smart stroke of business, also based by Lane on the irresistible attraction of a certificate of limitation. David Bogue published at the author's expense the first book by Oscar Wilde to be issued in the ordinary way of business – *Poems* (1881). When Bogue went bankrupt in 1882 there were on hand 230 copies of a so-called fifth edition of the book, which had actually been printed at the same time as the 'fourth edition'. These unsold copies, probably in unbound quires, reverted to the author, Chatto & Windus, who acquired Bogue's assets, apparently showing no interest in the young author.

In 1892 Lane heard of these sheets. He offered to market them as an 'author's edition', numbered and signed by Wilde and in a new binding and title-page, designed by Ricketts. This otherwise unsaleable remainder was thus speedily disposed of at the enhanced price of 15s. He and Mathews made only £30 or £40 in the transaction: but they had secured a new and important author for their list.

A postscript to this chapter on p. 213 shows that price-cutting on books of this character was forestalled by the extremely short trade discounts allowed by the publishers, which for all that gave the retailer a better margin than the more popular lines.

[34] Although Lane's name did not appear in the imprint until later.

Cut prices or not the tide was irresistible, and the competency of many of the artists was superior to the reproduction possibilities of the time. Not unexpectedly publishers of children's books were leaders in this field. One of their major discoveries, perhaps the major discovery, was Arthur Rackham. His first few books are undistinguished and uncharacteristic of the individual character that he later developed and retained for over 40 years. The first book in which his unmistakable, neo-Gothic style of illustration appeared was in a fairy-story by S. J. Adair Fitzgerald – *The Zankiwank and the Bletherwich* (1896). The publisher was Dent, who had commissioned Beardsley to illustrate Malory four years earlier. Rackham continued other styles of drawing for other publishers, illustrating new editions of old favourites and new publications, but in 1898 he produced the Rackham touch once more for Dent in *The Ingoldsby Legends*.

His first real success was with a selection from Grimms' *Fairy Tales* in 1900 and this came from another publisher. It was not until 1905, and therefore outside our period, that he produced the first of those non-books, the editions-de-luxe, that brought him fame and fortune and extended his appeal beyond the limit of youthfulness in terms of age but, fortunately for him, not in terms of enthusiasm.

H. J. Ford, H. R. Millar, F. D. Bedford, Gordon Browne and Leslie Brooke probably made a more direct appeal than Rackham to the eyes of children. Ford was the principal illustrator of the Lang Fairy Books. Millar illustrated some imitations of these but is perhaps most endearing for his two E. Nesbit books, *The Book of Dragons* (1900) with decorations by H. Granville Fell and, just getting past the gate, *Nine Unlikely Tales for Children* (1901).[35]

F. D. Bedford illustrated a number of books of which his *Book of Shops* (1899), with text by E. V. Lucas, has been unduly neglected.

Gordon Browne was the son of 'Phiz', and almost as prolific as his father, if not so distinguished. He illustrated authors as diverse as Mrs Ewing, G. A. Henty, Ascott Hope, John Masefield, Talbot Baines Reed, S. R. Crockett and Mrs Molesworth.

A graceful artist now beginning to attract belated attention is Leslie Brooke. He suffers by comparison with the bizarre style of the original in two selections from Edward Lear, published in 1900. One of his most extensive series of drawings, containing some of his best work, was for *The Nursery Rhyme Book*, edited by Andrew Lang (1897).

J. D. Batten's illustrations to the seven volumes of fairy-tales collected by Joseph Jacobs, like the books in which they appear, seem more suited to adults than to children. They are also rather too elaborate, but show great competence.

The three Robinson brothers produced some attractive books. They appear together in a selection from Hans Andersen's *Fairy Tales*, published by Dent in 1899, and there is a strong family likeness in their work. At this period Charles was the most individual of the

71. G. Browne. Title page for *Nonsense for Somebody*, 1895

[35] Outside our period Millar is noteworthy for his illustrations to Kipling's *Puck of Pook's Hill*, 1906, the American edition of which was illustrated by Rackham.

three and his illustrations for Lane in an edition of Stevenson's *A Child's Garden of Verses* (1895) are charming. Incidentally this is the first illustrated edition of the book. At least equally attractive are his drawings for a selection from the poems for children by the American author Eugene Field, chosen by Kenneth Grahame – *Lullaby Land* – also published by Lane (1898).

T. H. and W. H. Robinson illustrated many books for children in colour and black and white. T. H. also illustrated reprints of classical favourites, among them an edition of Thackeray's *Henry Esmond* which was included in a series published by George Allen in imitation of Macmillan's 'Cranford' series. In later life W. H. Robinson specialised in comic drawings depicting elaborately crazy machines, which evoked the expression 'Heath Robinson' to describe any unpractical device. In our period, however, he was in some demand as an illustrator of new editions of old favourites of which a representative example is a *Don Quixote* (1897). All three of the brothers showed a grasp of the new possibilities in black and white, whereas in colour they were victims of the fascination of art paper and the multi-colour process work of their day.

The enormous increase in the number and the output of book illustrators requires a volume of its own. There is in fact such a volume[36] which makes very clear the large share played by the use of illustrations in periodicals – more than 60 magazines are recorded in it. Their significance in this period is even greater than in the sixties in that many artists were employed whose work hardly ever appeared in book form. Others were commissioned by book publishers but failed to make the grade.

In the former category S. H. Sime is a notable example. This brilliant and highly individual artist was employed by *The Illustrated London News*, *The Sporting and Dramatic News*, *Black and White*, *The Sketch*, *The Unicorn*, *Pick-Me-Up*, *The Boy's Own Paper*, *The Ludgate Monthly*, *The Idler*, *The Butterfly*, *The Pall Mall Magazine*, *The Windsor Magazine*, *The Minster* and *The Eureka*, yet until 1905, when Lord Dunsany commissioned eight drawings for his first book, *The Gods of Pegana*, Sime seems to have been entirely neglected by book publishers.

L. Raven-Hill is another fine black-and-white man whose work must be almost exclusively sought in periodicals mainly in *Punch* and in *Pick-Me-Up*, of which he was art editor and recruited a brilliant coterie of illustrators including Steinlen and 'Max'. There is one curious exception with Raven-Hill. In 1898–9 he illustrated some of Kipling's 'Stalky' stories for *Pearson's* and *The Windsor*. The American publishers used these in the book, but the English edition was not illustrated. Apart from some amusing sketches for *The Promenaders* taken from *Pick-Me-Up* in 1894, guying Mrs Ormiston Chant's puritanical campaign, I have found no other book illustrated by Raven-Hill.

Bernard Partridge is best known as a *Punch* artist. His colleague on that journal, F. Anstey, had several books illustrated by him but none

[36] J. Thorpe, *English Illustration: The Nineties*, 1935.

of them compares with his *Punch* work. His best book-work is in Jerome K. Jerome's *Stage-Land* (1889), but he was not really at home as a book illustrator.

There are many unexpected finds to be made in the pages of these periodicals. Thus, in *The English Illustrated Magazine* Gunning King, now completely forgotten, illustrated five stories by Gissing. R. Caton Woodville made 32 drawings to illustrate the serial version of Rider Haggard's *Nada the Lily* (1892) in *The Illustrated London News*, but the book version had 23 illustrations by Charles Kerr. In the same journal Maurice Greiffenhagen was chosen to illustrate George Moore, and Wal Paget to illustrate Thomas Hardy, who was also illustrated by Hubert Herkomer, who illustrated *Tess* in the *Graphic*, 1891; by George Lambert (*A Tragedy of Two Ambitions*, in the *Universal Review*, 1888); by A. J. Goodman (*An Imaginative Woman* in the *Pall Mall Magazine*, 1893) and elsewhere by others whose drawings were not used by the book publishers.

This is not strictly our province, but those who are interested, and sufficient indication of its interest has already been given, may pursue it at length in Mr Thorpe's pages.

R. A. Bell is an attractive artist too long neglected. He was trained as an architect, and, like Morris, Crane and others, was fairly prominent in the Arts and Crafts movement of the time, witness his mosaic panels in the House of Commons and Westminster Cathedral. As a book illustrator he has close affinities with the Art Nouveau school which means, among other things, that sympathy between letterpress and illustration was a prime consideration with him.

His most successful books were the three volumes that he illustrated

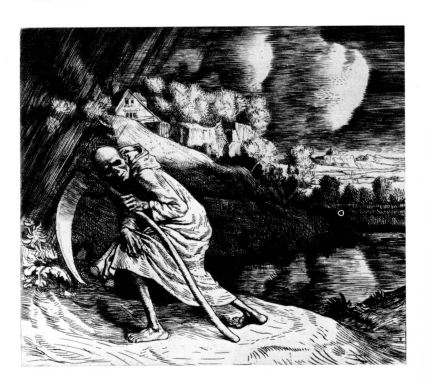

72. W. Strang. 'Death' in *Death and the Ploughman's Wife*, 1894

for the Endymion Series – Keats (1897), English Lyrics (1898) and Shelley (1902). Of each there were two editions, one being limited to 125 copies on jap vellum, in a special canvas binding. These have an undeniable attraction not always to be found in de luxe editions.

There was a short-lived vogue towards the turn of the century for etchings as book illustrations. One of the first of these was *The Earth Fiend* by William Strang (1892). He continued with *Death and the Ploughman's Wife* (1894), *The Pilgrim's Progress* (1895) and others. His *Thirty Etchings illustrating subjects from the Writings of Rudyard Kipling* (1901) is not a book, but a portfolio of plates; but it is very striking and now difficult to come by. All the etched books were issued in editions of between 100 and 200 copies. They are attractive curiosities.

D. Y. Cameron also etched illustrations for a few books, but the editions do not appear to have been limited. The best of them is John Buchan's *The Scholar Gipsies* (1896) which has seven original etchings.

In this period book illustration reached its peak, reckoned in terms of number,[37] and, although quantity was the commoner key-note, artists in this country were beginning to master the new techniques. Beardsley, Pissarro, Ricketts and Sullivan are its masters and must be in or near the front rank in the hierarchy of book illustration in the period we have been considering.

It is a long and varied history, beginning with Harvey and other pupils of Bewick, rising to astonishing peaks with Cruikshank, 'Phiz', Keene, Millais and du Maurier, then falling away with the disruption caused by increasing mechanisation, but finally emerging with the pioneers who had laid the foundations of the new renaissance still happily flourishing.

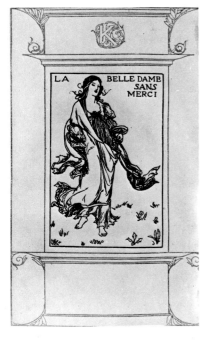

73. R. A. Bell. *La Belle Dame Sans Merci*. Keats, *Poems*, 1897

The torrent of ink that poured from the pens of illustrators at this time included much mediocre work and it cannot be expected that the general level should rise much above competence. One can hardly be thrilled by Cecil Aldin or Fred Barnard, Alfred Bryan or Granville Fell. Good workmanlike designers like these and innumerable others, with many more far below their level, were employed in the temporarily insatiable market. No peer of Cruikshank or Keene remains undiscovered among the rank and file.

Delicate illustrators such as R. Anning Bell and J. D. Batten, bold draughtsmen like R. A. Cleaver and Fred Pegram deserve better than the passing mention they can be given here. They can be followed by the indefatigable in the books suggested below for special consideration.

The end of the chapter is a sorry one. Throughout this survey of the period emphasis has been laid on the importance of the methods of reproduction and the degree of skill shown by those who used them, engravers and printers for the most part, although both of these were dependent to a vital degree on the quality of the paper with which they had to work. In all of these respects the nineties displays shortcomings as serious as almost any other period in our history, sometimes little superior to 'Catnachery'.

[37] R. E. D. Sketchley, *op. cit.*, 1903, lists 70 or more artists not mentioned here.

'Art editors' were the chief culprits, except when, rarely, they were artists themselves. Once it became possible to reproduce photographs, representational ability was the quality desired from an illustrator. How near could he get to imitating photographs? Magazine publishers turned to poor-quality glossy paper on which to print text and illustrations alike. The comparatively high standards of book publishing observed by such as John Lane and Osgood McIlvaine, Heinemann and Macmillan were swallowed up in the maelstrom of shoddy material based on the cut-throat competition that preceded the general observance of the net book agreement, which is now in danger of extinction.

One should not end this chapter on a sour note. Casting back over the period the outstanding impression is of its astounding fertility of illustration. In these days when the price of anything collectable has gone through the roof it is comforting to find so much referred to in these pages that has not yet attracted deserved attention. Patient and persistent searching can turn up agreeable bargains within the reach of modest purses. Even original drawings made for book illustration are comparatively despised, although latterly more attention has been paid to them. Possibly by the time these words are printed they too will be almost out of reach. But with books the range is so wide, the interest so varied, that supply is likely to exceed demand for a long time to come.

Books on the period in general

Holbrook Jackson, *The Eighteen Nineties*, 1913
Frequently reprinted. The standard work on the period, ranging far beyond *The Yellow Book* coterie.

Two catalogues of antiquarian booksellers, both compiled by the present writer will be found useful:
Books from the Library of John Lane and other books of the Eighteen-Nineties. Catalogue 165, Dulau, 1928
This consists mainly of association material from the archives of the Bodley Head, but with large additions from the collection of W. B. Dukes.
Books of the 'Nineties'. Catalogue 42, Elkin Mathews, 1932
The contents were from the collection of A. J. A. Symons.

James Thorpe, *English Illustration: The Nineties*, 1935
Takes a wider sweep even than Holbrook Jackson. He is especially good on the periodicals of the time.

R. E. D. Sketchley, *English Book Illustration of Today*, 1903
Extremely useful on the 'lesser lights'.

J. Pennell, *Pen Drawing and Pen Draughtsmanship*, 1889; *Modern Illustration*, 1895 and *The Illustration of Books*, 1896
All these are excellently illustrated.

C. G. Harper, *English Pen Artists of To-Day*, 1892
Modern Pen Drawings: European and American, edited by C. Holme, 1901

This is a *Studio* publication chiefly remarkable for the numerous reproductions of drawings by artists of the day. Many were specially drawn for this volume, or first published in it.

John Carter (editor), *New Paths in Book Collecting*, 1934, includes a chapter by T. Balston, 'English Book-Illustration 1880–1900' which deals extensively with the 'Cranford' Series and its derivatives. This essay appeared first in *The Book Collector's Quarterly*, Nos. XI and XIV, 1933–4, in which form the lists of series and artists were much more exhaustive.

Aubrey Beardsley Robert Ross, *Aubrey Beardsley*, 1909

The short text is still one of the best-balanced accounts of his work and the extensive iconography by Aymer Vallance is valuable.

Aubrey Beardsley. Catalogue of the Exhibition at the Victoria and Albert Museum, 1966

Invaluable for its wide range and authoritative and informative notes.

The Early Work of Aubrey Beardsley, 1899; *Later Work*, 1901, and *Uncollected Work*, 1925 contain a not quite exhaustive collection of reproductions of his work.

R. A. Walker, *Le Morte d'Arthur*, 1945

A detailed study of the changes in the various editions of Beardsley's version.

A. E. Gallatin, *Aubrey Beardsley: Catalogue of Drawings and Bibliography*, New York, 1945

The best straightforward list of the books and periodicals to which Beardsley contributed.

Charles Ricketts, *Self-Portrait, Letters and Journals*, 1939

T. Sturge Moore, *A Brief Account of the Origin of the Eragny Press*, 1903

This limited edition, printed at the Press, gives some account of Pissarro.

Check-lists of the publications of the Vale and Eragny Presses are in:

G. S. Tomkinson, *A Select Bibliography of the Principal Modern Presses*, 1928

W. Ransom, *Private Presses*, New York, 1929

Lilian Browse, *William Nicholson*, 1956 (has a catalogue raisonné)

M. H. Spielmann and W. Jerrold, *Hugh Thomson*, 1931

Well illustrated and with an exhaustive check-list.

James Thorpe, *Edmund Sullivan*, 1948

Well illustrated. Check-list of books.

Selected list of illustrated books

Aubrey Beardsley Sir Thomas Malory, *The Birth, Life and Acts of King Arthur*, 1893–4

Issued in 12 parts in an edition of 1,800 copies of which 500 were on hand-made paper and on completion in two volumes (ordinary paper) or three volumes (hand-made paper). The second edition, 1909 (in one volume) includes ten chapter headings not used in the first edition.

The Morte d'Arthur Portfolio, 1927
Has a note on omitted designs by R. A. Walker.

Oscar Wilde, *Salome*, 1894 (new ed. 1907 with the suppressed plates)
The so-called large-paper edition differs notably from the ordinary copies only in its binding of green silk. The material used is impermanent and its colour is usually ruined by the effect of the binder's paste.

Aristophanes, *Lysistrata*, privately printed 1896
Alexander Pope, *The Rape of the Lock*, 1896
The special edition printed on japon and bound in vellum is most handsome.

Charles Ricketts Longus, *Daphnis and Chloe*, 1892–3
C. Marlowe and G. Chapman, *Hero and Leander*, 1893–4
C. H. Shannon had a hand in both these books.

Oscar Wilde, *The Sphinx*, 1894
Many of the Vale Press books are sparingly but effectively decorated or illustrated by Ricketts.

Lucien Pissarro All his book illustrations of any consequence were wood-engravings for the books he printed at the Eragny Press. It is difficult to single out any for special mention, and, unfortunately, three of the prettiest books mentioned in the text fall outside our period. Two early ones that show promise are M. Rust, *The Quest of the Fishes*, 1894 and C. Perrault, *Deux Contes*, 1899.

William Nicholson *An Alphabet*, 1898
An Almanack of Twelve Sports, with verses by Rudyard Kipling, 1898
These two titles were published in October and December 1897, respectively, and post-dated on the title pages.
London Types, with quatrains by W. E. Henley, 1898
Twelve Portraits, 1899
The Square Book of Animals, 1899
Of *An Alphabet*, 1899, there was a special edition issued in portfolio form with the designs printed direct from the wood-blocks and hand coloured by the artist. In this form the subjects for the letters E and T are different from those in the ordinary edition.
Characters of Romance, 1900
This is not a book but a portfolio of plates. It includes designs equal to any of those in the books.

Laurence Housman Christina Rossetti, *Goblin Market*, 1893
Jane Barlow, *The End of Elfintown*, 1894

Hugh Thomson *Days with Sir Roger de Coverley*, 1886
W. O. Tristram, *Coaching Days and Coaching Ways*, 1888 (with Herbert Railton)
Oliver Goldsmith, *The Vicar of Wakefield*, 1890
Mrs Gaskell, *Cranford*, 1891

C. E. Brock	Thomas Hood, *Humorous Poems*, 1893
	J. Swift, *Gulliver's Travels*, 1894
H. M. Brock	W. M. Thackeray, *Ballads and Songs*, 1896
E. J. Sullivan	Thomas Hughes, *Tom Brown's Schooldays*, 1896
	Thomas Carlyle, *Sartor Resartus*, 1898
	Lord Tennyson, *A Dream of Fair Women*, 1900
	The Rubaiyat of Omar Khayyam, 1900(?)
	John Bunyan, *The Pilgrim's Progress*, 2 vols, 1901

Arthur Rackham S. J. Adair Fitzgerald, *The Zankiwank and the Bletherwitch*, 1896
R. H. Barham, *The Ingoldsby Legends*, 1898
Fairy Tales of the Brothers Grimm, 1900
Both of these last two titles were newly illustrated outside our period, with editions-de-luxe of each of them.

H. J. Ford He was the principal illustrator of the Andrew Lang series of Fairy Books from *The Blue Fairy Book*, 1888, to the *Lilac Fairy Book*, 1910, 11 titles in all. Uniform with these, and also largely illustrated by Ford, were other collections of stories and poems, beginning with *The Blue Poetry Book*, 1891.

F. D. Bedford E. V. Lucas, *The Book of Shops*, 1899 and *Four and Twenty Toilers*, 1900

H. R. Millar J. Morier, *The Adventures of Hajji Baba*, 1895
E. Nesbit, *The Book of Dragons*, 1900 (decorations by H. Granville Fell) and *Nine Unlikely Tales for Children*, 1901

Gordon Browne *Nonsense for Somebody . . . Written and Illustrated by A. Nobody*, 1895; *Some More Nonsense for the same Bodies as before*, 1896; *A. Nobody's Scrapbook*, 1900.
These three volumes written (in both senses – text and calligraphy) are capital fun and, for my money, incomparably the best things by this prolific artist.
Sketchley gives an extensive list of his other book work.

Leslie Brooke Edward Lear, *The Pelican Chorus*, 1900 and *The Jumblies*, 1900
Brooke's drawings are excellent in their way; but it is not Lear's way. His Owl and Pussy-Cat, his Duck and Kangaroo – are much more like the real animals than Lear's. This is just the trouble, they are too sophisticated – but they are very good.
Andrew Lang (editor), *The Nursery Rhyme Book*, 1897
One of his most extensively illustrated books and very representative of his work.
See also the list in Sketchley.

Charles Robinson R. L. Stevenson, *A Child's Garden of Verses*, 1896
Eugene Field, *Lullaby Land*, 1898

T. H. Robinson	W. M. Thackeray, *Henry Esmond*, 1896 Mrs Gaskell, *Cranford*, 1896
C., T. H. and W. H. Robinson	*Fairy Tales from Hans Andersen*, 1899 (Good lists of all three brothers are in Sketchley.)
R. Anning Bell	His three volumes in the Endymion Series are representative. John Keats, *Poems*, 1897; *English Lyrics from Spenser to Milton*, 1898; P. B. Shelley, *Poems*, 1902. His treatment of Shakespeare's *Midsummer Night's Dream*, 1895, is also noteworthy.
William Strang	The books that he illustrated with original etchings, printed direct from the copper-plates are: W. Strang, *The Earth Fiend*, 1892; *Death and the Plowman's Wife*, 1894 G. E. Lessing, *Nathan the Wise*, 1894 (translated by Strang) C. Monkhouse, *The Christ Upon the Hill*, 1895 John Milton, *Paradise Lost*, 1896 A. Sargant, *A Book of Ballads*, 1898 Laurence Binyon, *Western Flanders*, 1899 His own book of fairy-stories, which he illustrated with original coloured woodcuts, is handsome: *A Book of Giants*, 1898.
J. D. Batten	The series of fairy-tale collections edited by Joseph Jacobs and extensively illustrated by Batten includes: *English Fairy Tales*, 1890, 2nd series 1894; *Celtic Fairy Tales*, 1892, 2nd series 1894; *Indian Fairy Tales*, 1893.

Postscript on limited editions and publishers' terms

Useful and enlightening information on trade practice, production costs and selling prices has been gleaned from some records relating to a small but important publishing firm in the nineties.

The partnership between Elkin Mathews and John Lane was doomed from the beginning by the complete incompatibility of temperament between the two men. In 1894 they decided to part company and an inventory of the stock on hand was prepared to facilitate the division of assets. Of the titles on hand the following information is given, although there are gaps in some titles: date of publication (day, month, year), number of copies printed, subscription numbers, American sales, sales to date, cost per copy, published price, trade price, author's terms. One thing that is clear is that there was no cut-price problem with the publications of smaller firms. Mathews & Lane allowed only $16\frac{2}{3}$ per cent discount. This would be unacceptable to modern retailers as a general rate of discount, but must have been manna to booksellers who were used to about half that rate on most of their stock, for on a discount of one-sixth they could refuse discounts to the public.[1]

[1] It was customary with many books to invoice '13 as 12'.

For the rest the inventory table tells an interesting story. Unfortunately there are few illustrated books in the list, but there are enough to make the necessary points, and these are analysed in the following schedule.

Title	Date of publication	Number printed	Number subscribed	American sales	Subsequent sales	Published price	Cost price	Trade price	Stock on hand	Terms with author
Oscar Wilde *The Sphinx*	8 vi.94	303 S.P. 25 L.P.	—	50 S.P.	81 S.P. ? L.P.	£2 2s £5 5s	12s. 2d² ?	£1 15s	134 ?	10% on trade price
Oscar Wilde *Salome*	24 ii.94	755 S.P. 125 L.P.³	194	200 —	164 ?	15s £1 10s	3s 7½d 4s 3d³	12s 6d ?	abt. 150 abt. 10	Roy. S.P. 1s L.P. 3s
John Davidson *Plays*	12 ii.94	760 as 700	150	150	115	7s 6d	2s 9½d	6s 3d	271	Roy. 1s Eng. 6d U.S.
Kenneth Grahame⁴ *Pagan Papers*	30 xi.93	615	142	100	228	5s	1s 5d	4s 2d	68	Roy. 10%
George Egerton *Keynotes*⁵	? xii.93	6071	?	?	4007	3s 6d	9d	2s 11d	1444	Roy. 6d first 5000 then 8d
Florence Farr *The Dancing Faun*	? vi.94	1100	?	?	40	3s 6d	11¾d	2s 11d	404	Roy. 6d
F. Dostoievsky⁶ *Poor Folk*	? vi.94	1100	?	?	27	3s 6d	1s 10¾d	2s 11d	687	Paid translator £25, editor £10+ 10% gross returns

² This included 4s 2d as cost of the vellum binding.

³ The only difference between the S.P. and the L.P. copies apart from a fractionally larger page was the green silk binding of the latter, which cost the publishers an extra 7¾d, but cost the ultimate purchaser an extra 15s.

⁴ Aubrey Beardsley designed the title-page for this book. On the subject of invoicing '13 as 12' Grahame took exception to this on his royalty account. He obviously suspected Lane's integrity for he refused to sign the monstrous form of agreement presented to him – 'I admire its literary style immensely but I would not sign it for any publisher dead or alive . . . I used to come up in the dead of night and chalk Lane's door with "*Noe Thirtenes X Lord Have Mercie On Us.*" I have refused to wear "thirteen" collars (the only size that fit), and my only objection to sitting down 13 to dinner dates from the time I knew Lane. Seriously you will have to climb down about this.'

⁵ This and the two following titles form part of the Keynotes Series, for 22 volumes of which Beardsley designed the covers and title-pages. The figures for *Keynotes* itself relate to more than one edition. Of this astonishingly successful book Lane announced the sixth edition in 1895. Purists may like to note that the book was first published in wrappers, which suggests the possibility that the series may have been an afterthought.

⁶ The 'editor' – of this volume only – was George Moore.

It will be noted that the figures given do not always add up to the same total. This is due to lack of information in the record, and presentation and review copies are not accounted for. There is also a distinct suggestion of sharp practice in differences between the numbers announced by Lane and the size of the editions recorded in the inventory. He does not appear to have thought it necessary to disclose that in addition to copies printed for England there were 200 more of *Salomé* and 50 of *The Sphinx* for the United States and even this does not cover 25 surplus copies of the large-paper *Salomé* which was in itself something of a swindle.

The inventory sheets also give some enlightening information about the circulation of the first two volumes of *The Yellow Book*, all that had been issued down to the time of the split. Of the first volume 7,000 copies were printed costing 1s 7d a copy, published at 5s, discount 10d. Between April 1894 (publication date) and the following June 3, 609 had actually been sold, about 2,500 copies were out on sale or return and 633 copies were in stock. Of the second volume only 5,000 were printed, costing 2s 7d each. No definite sales figures for England are given, but 600 copies went to the United States and there were 1,030 copies in stock. Twelve months later Lane was advertising a fourth edition of the first and a third edition of the second and third volumes.

9 Foreign Influence

Ever since Latin ceased to be the universal lingua franca, language has been a hindrance to the international circulation of literature and translation has proved a poor helpmeet. As E. V. Rieu has written:[1] 'There is no patroness of translation among the Nine Muses, and if we invent a tenth for the purpose, I fear that we shall have to call her Cinderella.'

Pictures surmount national barriers with ease, and the earliest extant examples of book illustration in English history show evidence of this. Whether the monks who so brilliantly illuminated the Lindisfarne Gospels in the eighth century were foreigners or not their work shows a combination of Irish and Byzantine influence. A. W. Pollard, in *Old Picture Books* (1902), has shown how, in other and sometimes less scrupulous ways, the international nature of book illustration was exploited in early printed books. In the eighteenth century Gravelot spent several years in England working as a book illustrator and imparting some of his skill to Francis Hayman; and Bartolozzi and Schiavonetti both settled in England. Their book-work, like that of Fuseli, extended almost to the borderline of our period.

The enormously increased demand for illustrated books in the nineteenth century inevitably made its mark in this direction. Oddly enough it began the other way round, when Charles Thompson, a pupil of John Bewick and Robert Branston, settled in Paris in 1816 and introduced there the Bewick technique of engraving on the end-grain of the wood. When he died, in 1843, the French Government showed its traditional respect for the arts by granting a pension to his widow. Charles also introduced to French publishers the talent of his even more highly skilled brother, John. Much of John's work for the French market found its way back here in English translation of works illustrated by Grandville and others which he was wholly or partially responsible for engraving.[2] Orrin Smith, Linton, Landells and the Williams brothers were also commissioned by French publishers.

English wood-engravers also went to Germany. William Barnard, who was born in Dresden, learned engraving in St Petersburg with a goldsmith, then went to Paris, where he worked for Best, Regnier & Co., a partly English firm who engraved drawings for the Curmer edition of *Paul et Virginie* – of which there was almost certainly an English edition – the Doré edition of Balzac's *Contes drolatiques*, 1855 – English edition, 1860 – and many other famous French illustrated books of the romantic period. He finally settled in Leipzig, where he worked for over 20 years. John Alanson is mentioned on page 228 and A. H. Payne on page 231. There were several other English wood-engravers working in Germany at the time and it is possible that the German no less than the French romantic illustration owes a debt to the Bewick technique. The emigration of these artist-craftsmen

[1] *Cassell's Encyclopaedia of Literature*, 1953, art. 'Translation'. (A new edition is in preparation.)

[2] L. Carteret, *Le Trésor du Bibliophile*, 4 vols., 1924–8, attributes 14 works containing engravings by Thompson, but the list is incomplete.

helped to further the exploitation of the English market by continental publishers and, indeed, some of these engravers who set up on their own account produced books for sale in England, as will transpire later.

When J. F. Hoff was preparing the first comprehensive iconography of Ludwig Richter in 1876 many of the early wood-engravers were still alive. Hoff sought them out and took statements from them which include interesting details of the trade in Germany. Some of the trade practices, though not all, will have been common to Germany and England, especially as the craft was unquestionably introduced in Leipzig by Englishmen – Hoff lists no fewer than 22 English engravers at work there from about 1839 onwards. The total number of recorded wood-engravers at work during the Richter period reaches the surprising total of 110.

Ritschl von Hartenbach, perhaps the earliest of all the German school, claimed that he had taught himself, but Wilhelm Georgy, who became his assistant before 1840, is quite clear that his master was in touch with all the latest English techniques. Nevertheless, there is evidence that the English engravers were very secretive about the mystery of their craft, and one enthusiast who applied to be taken on by Alanson & Nicholls was turned away with an abrupt refusal even to let him see any stage of the work in progress. This correspondent told Hoff that he and others like him went to work all the same 'with enthusiasm and application', but admitted that much of the early work was, for that reason, not very high in quality. It is astonishing, throughout Hoff's record of his interviews, to see the frequency with which the engravers described themselves as self-taught (*Autodiktat*) and not less so to learn the backgrounds from which some of them were recruited. Rarely they came to wood-engraving from another branch of the printing or publishing trade. More often they were father feckless, casual labourers, who decided to get on the bandwagon. One had been a coachman, another a gardener's assistant, another had been a cobbler and yet another a boots in a small hotel. Neither did some of them stay long in the trade. As it became better organised regular apprenticeship became the rule and they were squeezed out.

Another feature in which the early German trade may be compared with England is that the artist himself seldom made his drawings directly on the wood. It was the work of the engraver to trace the drawing on to the wood-block before cutting it, and this was usually entrusted to assistants. It is probable that in England Rossetti's drawings were similarly treated and that Tenniel's drawings and those of some other artists were also handed over in little more than outline; but this was certainly the exception rather than the rule.

It became so in Germany, too, and Richter began to draw on wood in 1840. But as late as 1860 when Wigand produced an album of Richter's work, probably as a sales medium for clichés, von Hartenbach states that 75 of the 202 designs were drawn on the wood by himself, the remainder being distributed among the staff of his *atelier*.

Ateliers soon became as common in Germany as they were in

London and here Hoff's information sheds light on a practice that was probably common to both. It was quite common for assistants to confess inability to identify their work on Richter's drawings because they seldom knew the books for which their engravings were used. More than one added that he worked as a specialist on faces, or trees, or costume and that a single engraving might be passed from one to another according to a sharply delineated range of skills. Faces were usually done by the boss.

What is most remarkable in all this, however, is the fundamental difference between English and German practice. On the one hand is the apostolic succession from Bewick, the careful training of apprentices, the readiness of artists to submit to tutelage from craftsmen in acquiring the technique of drawing on wood; and on the other hand a complete lack of tradition and background among the German engravers, coupled with the jealous secrecy observed by the English, who also included in their number one or two mavericks, like William Barnard, whose apprenticeship was to a gold-engraver in St Petersburg. (Shades of Gutenberg!) It is small wonder that much of the early German work was poor in quality; but the Germans learned quickly and were quite soon able to work on a level footing with their London rivals, although they never produced a Dalziel.

An emigrant of a different kind who brought the work of German authors and artists to the notice of English publishers was Charles Boner, who was for many years the trusted companion and amanuensis of the Prince Thurn und Taxis. In the company of the Prince, a very cultured man and patron of the arts, Boner met authors and artists whose work he used in translations of foreign authors and in his own original writings. He was among the earliest translators of the *Fairy Tales* of Hans Christian Andersen, with two collections in 1846 and one in 1847, both illustrated by Count Pocci, a friend of Boner's employer, and other German artists. The drawings were beautifully executed for Cundall as wood-engravings and there were coloured versions of both. They compare very favourably with the illustrations for a German collection of Andersen's stories in 1851 to which Pocci contributed, which were ruined by botched engraving.

Pocci is an unusual figure in the history of book illustration. He was a scion of ancient Italian lineage whose father, like so many Italian noblemen of the time, became attached to the Bavarian Court. He fought with the Napoleonic army in Poland and achieved the rank of lieutenant-general. Brought up in the atmosphere of the Court at Munich and on his father's estate at Ammerland the young Pocci wrote poetry, composed music and toyed with the pencil and brush. He had no regular tuition in any of these pursuits and remained a dilettante all his life. His second recorded work, as a boy of 18 (1825), was a series of ten lithographs made from paper transfers, illustrating Scott's *Ivanhoe*, and he was always greatly preoccupied by the romantic aspects of history. Death was also much in his mind and his *Totentanz* (1862) is grim.

He had a strong sense of humour and a great partiality for children's stories. His illustrations for Charles Boner's English translations of

74. V. Pedersen. The Snow Queen from *Danish Fairy Legends and Stories*, 1853

Andersen were his first commissions for that market. He also illustrated Boner's *The Merry Wedding* (1847). The same drawings, with a new one for the title-page, were used for *Charles Boner's Book for those that are young* (1848). Boner's translation of *The Dream of Little Tuk* and of *The Ugly Duck*, both published in 1848 by Grant and Griffith, successors to John Harris and Newbery, seem to have completed his work for London publishers. All of these were originally intended for publication by Cundall, whose business failed after publishing the first three Andersen collections.

Caroline Peachey was also one of the first translators of the Andersen stories. Like Boner, she probably worked from a German text and she took very considerable liberties with it. Her first translation, in 1846, containing 14 stories, was without illustrations. In 1853, using the same title, *Danish Fairy Legends and Stories*, described as a Second Edition, Enlarged, she brought the number of tales up to 45. What is infinitely more interesting than the text is that the book contains 20 illustrations by Vilhelm Pedersen and this seems to have been their first appearance in England.

The history of these illustrations exemplifies the international traffic in book illustration at the time. The artist, a Danish army officer, was engaged to illustrate the Andersen stories by a Leipzig publisher for a German collection (1844–6). They were later issued with a Danish text in a part publication (1849), in which German clichés were used. There is some evidence that those used in the English edition of 1852 were printed in Germany. This edition was published by Addey, Cundall's short-lived successor, and is rather difficult to find. In 1861 Bohn published a third edition where the translator's name appeared for the first time, and the curious legend 'With 120 illustrations chiefly by foreign artists' – curious because they were nearly if not quite all by Pedersen. His illustrations of Andersen have never been surpassed.

International transactions of this kind were reasonably straightforward. Cundall seems to have availed himself of Boner's services

quite freely in canvassing the work of German artists for the English market and there were doubtless other English agents of the same kind, as there were unquestionably German agents in London. But there were very much more questionable transactions. Constantly, in looking through the cheaper publications, and especially the children's books of the forties and fifties, one recognises an unacknowledged Richter or Hosemann and the liberties taken with Speckter's drawings in the English version of Hey's *Fables* is shameful.

This free-and-easy attitude should be regarded in terms of general behaviour at the time; and, thanks to the painstaking investigations of bibliographers, it is possible to thread a course through enough of the publishing entanglements of the period to exemplify the fundamental changes that have come about in our own day. To us the freedom with which publishers used both texts and illustrations without entitlement is both astonishing and shocking. This practice was nowhere more in evidence than where a national barrier intervened, although such 'piracy' was by no means confined to international conditions. It is natural that we should find this surprising, because it is so largely alien to modern practice. It is mistaken to regard it as shocking.

Its existence and prevalence stem quite simply and completely from dimly formed conceptions of the notion of copyright. By the time our period is reached internal copyright, so far as authors were concerned, was fairly clearly defined. Some effort had also been made to protect the publisher, if not the artist, in relation to graphic material. The statutory requirement calling for the addition of the name of the publisher and the date of publication to every print was probably in part a political move. But it also undoubtedly afforded some protection against unauthorised reprinting.

The artist himself was less effectively protected. We have seen how Turner bought up the plates of his *England and Wales* expressly for his own protection; and we have seen also how wood-blocks, metal plates and, later, clichés were purchasable by all and sundry and reused with neither the intention nor the obligation to benefit the artist. It is clear that, generally speaking, when receiving payment for illustrating a book the artist forfeited all further rights in his work. Not only did the payment include the reproduction rights for the work immediately in hand but also the drawings themselves and the right to use them in any other project that took the publisher's fancy. Thus, in the sixties, drawings that were made to illustrate one set of texts in a periodical could be used in book form to illustrate quite different subjects. Thornbury's *Legendry Ballads* (see pp. 138–9) is a case in point.

We see also in the period artists becoming aware of the desirability of retaining some command over the future destiny of their work and of the emoluments arising from it. Turner has already been quoted in this connection, but we find Cruikshank setting up as his own publisher and Caldecott declining to sell his work outright. It also seems clear that Crane retained some measure of copyright in the Toy-Books, for the contract to reprint them at the end of the century

was between himself and Lane, the publisher. It is more than possible that the arrangement made by the Dalziels and others to partake in the publication of books for which they engraved the illustrations was prompted by a similar motive.

For the greater part of our period, however, international copyright in either text or pictures was non-existent. German publishers were astute on this score. They frequently prepared ready-made English editions of works by popular authors, usually simultaneous with the German edition and marketed them in London through a branch of the parent firm or a regular English agent. *Struwwelpeter*, although not simultaneously published here, is a ready example of this German practice. Another form of self-protection was to offer for general sale ready-made clichés of favourite subjects at prices lower than they could be made to special order. No strings seem to have been attached to the use of these clichés and it is questionable whether the artist derived any benefit from the sale of them.

The love-hate relationship between authors and artists on the one hand and publishers on the other is a commonplace. The creators may thank their stars that a halt has been called to the extreme laxity that was generally accepted on all sides in an earlier day. Examples of it have occurred frequently throughout these pages. Because it concerns an English book and because its ramifications are so tortuous and extensive I have traced the story of one such incident in all its deviousness.

In 1860, in the *Journal Pour Tous* there was a serial story by Gustave Aimard entitled *Balle-Franche*. It later appeared in volume form in a series called *Romans Américains Illustrés*.[3] In volume form only three of the drawings used for the serialisation were used, four more had been used for other purposes, including one for another serialised story, *Le Coureur des Bois*, by Gabriel Ferry (see below), and two new ones were also included.

Gabriel Ferry's story, as serialised in the same journal, had 150 illustrations by Doré, some of which, however, were 'borrowed' from a story by Mayne Reid, *L'Habitation du Désert*, which had appeared in Hachette's *Bibliothèque des Chemins de fer* in 1856.[4] When Ferry's story appeared in volume form in 1878 it included 40 of the drawings used to illustrate it in the *Journal Pours Tous* and six others which had been originally used to illustrate Aimard's *Balle-Franche*.

To complete this devious history it must be added that Hachette, the publishers of the *Journal Pour Tous*, ran another periodical, roughly concurrent with it, called *La Semaine des Enfants* in which, in 1860–1, they serialised the Mayne Reid story that they had already published in volume form in 1856. To illustrate it they raided the clichés which they had used in the *Journal* to illustrate the Aimard and Ferry stories, along with those from the book edition of 1856, thus increasing the number of illustrations from 24 to 50. How barefaced the transaction was may be gauged from the fact that an illustration used to illustrate Ferry on 3 November was used for Mayne Reid

[3] Several of the series were illustrated by Doré and some were translations.
[4] Nelson published an English edition of this at about the same time.

three weeks later and another that appeared in the *Journal* on 28 November was transferred to the *Semaine* on 8 December. In all these instances of chopping and changing the underlines had to be changed to suit the text, and some occasional re-engraving was called for.[5]

Doré was a constant victim of unscrupulous publishers. The adjective is surely justified if we think of moral as opposed to legal obligation. He also achieved world-wide fame as an illustrator, even in Russia, and we shall return to him at some length at a later stage.

The influence of English wood-engravers in Paris has already been mentioned and some reference has been made to English editions of books that they helped to illustrate in France. The *Gil Blas*, profusely illustrated by Jean Gigoux in 1835, and often characterised as a key book in the romantic revival, reached London as early as 1836, and although it was published at the high price of £1 12s it was a great success and was frequently reprinted. Oddly enough it bore the imprint of Dubochet, a Paris firm which did not produce an edition in France until 1838, the original having been published by Paulin and far superior to all the later editions. The Grandville *Gulliver* of 1835 reached London by 1840 and his *La Fontaine* of 1838 came out here in 1843. These were less successful and were remaindered at a fraction of the original published prices. Daumier and Gavarni had little attraction for English publishers. I have found no English editions of Daumier except his minor contribution to Janin's *Winter in Paris*, and the only popular work illustrated by Gavarni is a rather unrepresentative collection entitled *Gavarni in London* (1849) with a text by Albert Smith, the mountaineer-poetaster. The vignettes were cut on wood by Vizetelly and printed in two tints. In his more characteristic vein as a lithographer he is recorded as having contributed three illustrations to *An Artist's Ramble in Scotland*, by M. Bouquet, of which Ackermann published plain and coloured editions in 1849; and Rowney, in 1854, issued six lithographs by him with the title *Rustic Groups*, but neither of these has come my way.

There is, however, one publication associated with Gavarni that is too good a joke to pass without comment. In 1839 Curmer, the Paris publisher of many famous illustrated books, began the publication in parts of *Les Anglais Peints par Eux-Mêmes*, running *pari passu* with his magnificent *Les Français Peints par Eux-Mêmes*. The former work was announced as containing designs by 'M. Kenny Meadous'. This work is none other than a translation of *Heads of the People* and one cannot help wondering what the French public made of 'Le Cokney', 'L'Exciseman' and 'Le Sporting gentleman'. Kenny Meadows's drawings were used as full pages and Gavarni added a great number of text vignettes. Among '*les Somittes littéraires*' from whom the text was translated was Thackeray. An amusing example of the two-way traffic in illustration.

That Tony Johannot was known in England we have seen from his tentative engagement to illustrate Ainsworth's *Tower of London* (see p. 44). Very little of his work appeared in English, most notably his

[5] Leblanc reproduces one example of the merciless liberties taken with these blocks, and a list of others.

illustrations for *Don Quixote*. He supplied 800 vignettes for the French edition of 1836–7, but when Bohn used them to illustrate Jarvis's translation in 1842 he thought it advisable to add others by Armstrong of whom the present chronicler can find no other record. Unfortunately the Molière of 1835–6, the famous twin of the elegant Cervantes, failed to find an English publisher. More to London taste was, Guinot's *Summer at Baden-Baden* (1853). One other of Johannot's better works, Sterne's *Sentimental Journey*, came out in London in 1851.

Generally speaking, however, considering the great volume of book illustration poured out by the French romantics, the London market was comparatively little affected by it. But just coming over the horizon was a young Frenchman who was to take London by storm and to achieve a reputation in this country that equalled and possibly surpassed his native fame – Gustave Doré.

Doré was born in Strasbourg in 1832, the son of a civil engineer employed in the Ponts et Chaussées Ministry. In 1847 he was taken by his parents to Paris on a visit. One day, according to his own account, he was sufficiently impressed by the display of caricatures in the shop-window of Aubert & Philipon to show them one of his own sketch-books. This was brought to the attention of Philipon himself, the originator of the famous journals, *La Caricature* and *Le Charivari*, and Daumier's collaborator in the creation of *Robert-Macaire*. He was about to start publication of another illustrated periodical, *Le Journal Pour Rire*, and promised Doré regular employment on it. Here the boy was to find himself in the company of Daumier, Gavarni and other leading illustrators of the period and he was soon recognised as worthy of the distinction. Indeed, even before the new journal was started Philipon's partner Aubert published a volume with 104 lithographs by Doré, *Les Traveaux d'Hercule*, announcing it as the work of a boy of 15 and promising a second volume, which never appeared. Derivative though these drawings unquestionably are they are very good fun and they show a spontaneity and economy of line which is lamentably and progressively absent from much of his later work.

In the first issue of the *Journal Pour Rire* there are 14 drawings by Doré and in the first two years about 1400. In 1848 Aubert published an album of selections from the *Journal* with 410 drawings by Doré and from this point he never looked back. In 1851 his book commissions began and he illustrated seven books with about 500 drawings while contributing a further 150 to the *Journal Pour Rire*.

By 1854 he had captured the attention of English periodical publishers and drawings by him appeared in the *Pictorial Times*. In 1855 he also appeared in the *Comic Times*. Although both of these journals were probably borrowers he received his first direct commission from England in 1855 when, at the suggestion of Blanchard Jerrold, he was engaged by *The Illustrated London News* to illustrate Queen Victoria's visit to the Exposition in Paris which was directly inspired by our own Great Exhibition of 1851, which in turn owed so much to its sponsorship by Prince Albert. Doré here showed almost for the first time his gift for depicting multitudes of people.

In 1857, Addey, the one-time partner of Joseph Cundall and his

short-lived successor, purchased from the French publisher sets of Doré's engravings to a version of the Wandering Jew legend and issued them with an English text. It was Doré's first appearance between covers in this country: but, as so often happened with the publications of Cundall and Addey, one admires their courage more than their judgement. This massive folio, by a comparatively unknown artist, who had not yet found his feet in this field, and despite the publicity comparing Doré to Blake, was almost certainly doomed to failure. It was later taken over by Cassell and eventually remaindered.[6]

Nevertheless it soon became clear that he was attracting the notice of English publishers, and in 1858, when James Blackwood published W. F. Peacock's *The Adventures of St. George* and as a sequel G. F. Pardon's *Boldheart the Warrior*, both were illustrated by Doré. It is extremely doubtful whether he received any benefit from this, for the illustrations to both books were re-engraved, and very badly so, from J.-B. Lafon's *Les Aventures du Chevalier Jaufre* (Paris, 1856), to which the English texts were by no means free of indebtedness.

We have already seen the freedom with which Doré's illustrations were bandied about by his own publisher, Hachette (p. 220). Evidence of it occurs throughout Leblanc's bibliography. His note on the irrelevant use of a Doré illustration in an edition of *Uncle Tom's Cabin* of 1923 exemplifies the situation. '*Nous avons déjà rencontré cette gravure dans une des nombreuses publications à bon marché illustrées par Doré entre 1855 et 1860.*'

It is very doubtful whether Camden Hotten's editions of the Rabelais or the Balzac were authorised. In both the illustrations were newly engraved in London. At least for the former work he made a better job of them than Bry, the publisher of the original edition, in which the engravings are botched and the paper deplorable. Garnier made handsome amends in his excellent folio edition of the Rabelais of 1873 for which the Bible published by Mame of Tours, of which a further account will shortly be given, was to be the model. The contract between Doré and Garnier is reproduced in facsimile by Leblanc. It is an interesting document calling for some comment.

Doré was to receive 80,000 francs for the illustrations; a large sum, but there were to be some 650 of them, 31 being full-page in large folio format. Moreover, this sum was to include the cost of engraving the drawings on wood and the acquisition of the copyright as well as the actual drawings. This last condition is expressly stated in the contract – '*la propriété materielle et artistique des dessins et de la gravure*'. The rights in them were absolute and included the use of them according to the '*fantaisie*' of the publisher. They were also permitted to include among the Rabelais illustrations seven from the *Contes Drolatiques*, which they had taken over from the original publisher in 1861. Such a contract makes it very doubtful whether Doré reaped much, if any, benefit from editions of his works published outside the country of their origin. No English publication of this gigantic edition in two folio volumes has been traced.

[6] Willis & Sotheran offered it in 1862, bound in half morocco, at 12s 6d. The published price, in cloth, was £1 1s.

We come now to the great Bible of 1866, perhaps the most important landmark in Doré's career. Whereas he had had to hawk round to publishers his drawings for the Rabelais, only to see them ruined by the cheap-jack who eventually took them on, the Bible was enthusiastically sponsored by one of the greatest French publishers of illustrated books of the day, Mame of Tours, who spent £20,000 on its preparation and sold 3,000 copies of the first edition at £3 each within a month of publication. He printed one copy on vellum for his own library and 24 copies for sale on special paper at £12 each.

Looking through these illustrations today it is impossible to recapture the positive furore of enthusiasm with which they were received on their first appearance. The major impression created by them is that Doré was entirely the wrong man for the job. His weakness for melodrama is especially disturbing in the New Testament where, as Jerrold puts it, one is constantly reminded of 'blue-fire and stage carpentry'. They are, in short, frequently vulgar in the extreme, and whereas vulgarity can be accepted in connection with the earthiness of Rabelais and Balzac it becomes insufferable in a biblical context. For this reason the Doré Bible has largely failed to retain a high place in the affections of all but the most undiscriminating of Doré enthusiasts.

Nevertheless its original reception was truly remarkable. Whereas it was six years before the Balzac was reprinted, a second edition of the Bible, with numerous changes in the illustrations, was called for almost at once. Editions appeared in almost every Europen country, including Russia. One of the first off the mark was an English edition from Cassell, Petter & Galpin, 1867. This caused an even greater sensation than the French edition, and the demand among collectors for any and everything by Doré was clamorous.

It gave particular pleasure to the artist that his paintings found a ready market in England. He had long thought of himself as a painter rather than a mere book illustrator and had taken it bitterly to heart that his pictures were either rejected or skied by the Salon. These same rejected paintings, as a direct sequel to the success of the Bible, found purchasers in London at up to £5,000 or £6,000 each. This also is extraordinary from a present standpoint, especially when the vast dimensions of his canvases are recalled.[7]

Blanchard Jerrold, who had gone to Paris for *The Illustrated London News* in 1855 to report on the Exposition, spent much time in the company of Doré, who illustrated his text, and he seems to have played a major part in spreading the artist's reputation here and in bringing him to London in 1868. The visit was a triumphal procession. He dined with the Prince and Princess of Wales *en famille*, a grand reception was held at the Mansion House, and the Archbishop of Canterbury entertained him at Lambeth Palace. But perhaps what pleased him most in the whole of this round of festivities was the arrangement he made, with Jerrold as intermediary, for the setting up of the Doré Gallery at 35 New Bond Street where the firm of Fairless & Beeforth conducted a permanent and exclusive exhibition of his

[7] 'Christ leaving the Praetorium' covered 600 square feet.

work that was to last until his death and beyond. Some idea of what it looked like can be obtained from a photograph of the exterior in Leblanc's bibliography and Doré's own drawing of part of the interior reproduced in Jerrold. It is, fortunately, no business of mine to comment on Doré's oils in detail: but it does seem extraordinary that such a gallery could be supported for nearly 20 years by the work of such a shockingly bad painter. The premises of the Gallery are now occupied by Sotheby's and the arched entrance has been retained.

There was one feature of the Gallery that was less fortunate for Doré. Plagued, like so many other creative artists before and since, by the thought of the disproportionate share of the products of his labours taken by distributors, in 1875, using the Gallery as imprint, he set up as his own publisher of an illustrated edition of Coleridge's *Ancient Mariner*. It cost him £3,500 to produce and in 1876 he bemoaned its complete failure. After his death most of the unbound sheets were found in his *atelier*.

This has carried us ahead of chronology. He was enchanted with London, where he considered himself better esteemed than in Paris, and he now made plans with Jerrold for a joint work on London. This he envisaged as the most ambitious of all his undertakings and he laid out a scheme for it vastly greater than any publisher was prepared to consider.[8] Author and artist went to work together with great enthusiasm and Jerrold's account of the explorations they made in its preparation is worth quoting.

'We spent many days and nights visiting and carefully examining the most striking scenes and phases of London life. We had one or two nights in Whitechapel, duly attended by police in plain clothes; we visited the night refuges; we journeyed up and down the river; we traversed Westminster, and had a morning or two in Drury Lane, and were betimes at the opening of Covent Garden market; we spent a morning in Newgate; we attended the boat-race, and went in a char-a-banc to the Derby, and made acquaintance with all the riotous incidents of a day on the racecourse; we dined with the Oxford and Cambridge crews; we spent an afternoon at one of the Primate's gatherings at Lambeth Palace; we entered thieves' public-houses; in short, I led Doré through the shadows and the sunlight of the great world of London.'

Jerrold also reproduces a number of the hundreds of rough sketches that were all that Doré took back with him to Paris and when Jerrold suggested their inadequacy Doré replied, '*J'ai beaucoup de collodion dans la tête*'.

This was in 1869. When he returned to Paris the long and difficult negotiations with the publisher began. The chip which Doré had begun to wear on his shoulder since what he regarded as the undue delay in granting him the insignia of the Legion of Honour[9] had now assumed alarming proportions and he did not take kindly to the

[8] Jerrold gives a transcript of this in an appendix.

[9] When it came in 1861 he valued it only as an 'official answer to the men who have tried to put me down and crush me'.

75. G. Doré. Opium Smoking in
London, Jerrold and Doré, 1872

publisher's niggling insistence on specifying the exact proportions of
each drawing, or on his charging up the cost of the clichés. Several
months elapsed in chaffering of this nature and the outbreak of the
war of 1870 intervened before work could be started on it.

Doré served throughout the war and the siege of Paris as a member
of the National Guard. France's defeat had a profound effect on him,
most especially in the loss of Strasbourg to which he had long planned
to return. When he came back to London, towards the end of 1871,
his misanthropy had taken a greater hold on him; but his energy was
revived by the visit and he set to work on the drawings for the London
book, the first part of which was published in January 1872. He
stayed until July to complete the published drawings; but he made
many that were not published. He kept them all together in what he
called his 'London Album' hoping, in vain, to sell the entire series
for £1,000.

As will be seen from Jerrold's account of their exploration of the
terrain – partially quoted on p. 225 – this was never intended to be a
topographical work, but rather a study of life in London at all social

levels. It contains some of his finest drawings and, although one is constantly reminded of a non-English outlook, and despite many evidences of the faulty register of Doré's mental camera, like the Norman arches on his London Bridge, the total effect is impressive. He is best in his low-life scenes, whether in lively mood depicting the road to Epsom on Derby Day or in sober mood depicting the misery of the thieves' kitchens or the relief-centres and doss-houses of the down-and-outs. Carlyle said that his 'London Docks have the aspect of Nineveh' and his drawing of the Lascars' Room in *Edwin Drood* is legitimately melodramatic.

76. G. Doré. Monseigneur Hugon de Sennecterre. *Life of Gustave Doré*, 1891

Most of the other English editions illustrated by Doré are described in the appendix to this chapter. None of them, nor any of the French editions that did not find a way to London, is quite the peer of this one great *tour de force*. Indeed, the more one examines his work in detail the more one is driven to the conclusion that his reputation as an illustrator has been overrated. His greatest fault was that he did too much. This applies not only to his vast output but to the fact that he could seldom leave well alone. The unfortunate tendency to over-elaboration is evident as early as 1855 in the architectural quiddities of the Balzac. As time went on he came to demand more and more of his engravers, using wash effects freely, a disastrous technique for wood-engraving.

That he usually suffered from atrocious inking on bad paper is clear from the excellent reproductions in Jerrold's *Life*, and these show also how greatly superior his sketches often were to his finished work. But the Victorians loved him – which made him, alas, a very bad influence on other artists. To keep up with the incessant demand he was often hasty. In his unfortunate steel-engravings for Tennyson's *Idylls of the King* the smoothly sawn tree-trunks and the use of the modern British coat of arms are pointers to a general disregard of drawing techniques and of the heedless speed that drove him to the observance of relentless date-lines.

No other foreign illustrator and few native ones of the period so completely captured the English fancy. The German invasion of the English market was quite different in kind. First of all it was not so concentrated on a single personality. Secondly it was based more generally on the enterprise of the German publishers, although there were notable exceptions to this, especially in Cundall and in Addey, his partner and successor. Thirdly it is most in evidence in children's books.

Among the earliest and most consistently successful of the German invaders was Ludwig Richter. He worked almost exclusively in black and white yet it is no injustice to either artist to think of him as a kind of German Kate Greenaway. There is the same sweet improbability in his characters, the same continual teetering on the borders of sentimentality – frequently overstepped – and the same nostalgia for a never-never land of an enchanted simplicity.

Richter was the son of a professor at the Dresden School of Art who supplemented his income by designing *Gelegenheit-Graphik*-calendars, greeting-cards and the like. As a boy he already took a

77. L. Richter. From *The Vicar of Wakefield*, 1841

share in his father's work, which had a lasting and artistically unfortunate effect. His painstaking and scrupulous bibliographer credits him with designs in his father's calendars at the age of 13, and these not only in Dresden, but in Pirna, Freiberg, Meissen and Stolpen. In his sixteenth year (1818–19), he contributed for the first time to the illustration of a book, a Robinsonade, by J. C. Grote, *Neuer norddeutsche Robinson*, published in Meissen.

His first appearance on the English scene seems to have been in 1841 when, in the third year of his long and fruitful association with the publishing firm of Wigand in Leipzig, Richter produced his most extensively illustrated book to date, with 63 drawings for a German edition of *The Vicar of Wakefield*, an established favourite with German audiences. Wigand decided to produce an English version simultaneously which, like the German text, was printed by Breitkopf & Härtel. For this venture into a new publishing field the printers were clearly instructed to give special attention to quality, and in ink, paper and impression the English edition is superior to the German. Indeed, it stands out very markedly among Wigand's publications which were generally aimed at the cheapest market, miserably printed on wretched paper. The book was a great success in both countries and was reprinted several times in both languages, the English editions always with a German imprint until 1857. Then Williams & Norgate, who had set up as London agents for several German publishers, began to import sheets with their imprint on the title-page. It is a pleasant enough book although the illustrations are neither markedly English nor eighteenth century in tone.

A very much prettier book in which Richter had a large hand was less satisfactorily treated in England. This was Musäus, *Volksmärchen der Deutschen* (1842). Richter made 151 drawings for this book most of which were engraved on wood by John Alanson, a pupil of Bewick, who was working in Leipzig in the 1840s, but later went to Canada where he died in 1859. In 1845 the German publisher reissued the book with the addition of 12 full-page lithographs by Richter. Joseph Cundall published a selection in the same year with the title *Legends of Rubezahl and other tales. From the German of Musäus.* There were only four illustrations, two of them by Richter, these being lithographed on toned backgrounds by Day & Haghe from woodengravings in the German edition.

Cundall was also engaged in a very curious way with the next Richter book to achieve English publication. This was *Die schwarze Tante* (1848), a children's story-book, also published by Wigand who issued a simultaneous English edition entitled *The Black Aunt*. In spite of this Cundall imported sheets in 1849 adding a cancel title with his imprint and that of R. Yorke Clarke & Co. Cundall certainly chose a better title, *Nut-Cracker and Sugar-Dolly*, but it must surely have been yet another instance of the enterprise of this excellent publisher taking preference over his business acumen. But it is a very seductive book.

The Book of German Songs (1856) had a chequered and interesting career. It was originally projected by Ingram & Cooke in 1853 for inclusion in their National Illustrated Library. Charles Keene was

already doing reportage for *The Illustrated London News* under the aegis of the same publishers, and he was commissioned to illustrate this book. Before it was completed Ingram & Cooke gave up book publishing and their manager, H. W. Dulcken, found himself out of a job. Dalziels were already at work on engraving the drawings and the newly formed house of Ward & Lock were in the market for illustrated books. Whether they assumed financial responsibility for the book, or whether it was an early instance of Dalziels' own enterprise is one of the numerous uncertainties associated with this work.[10] It contains 40 illustrations and Forrest Reid hazards a guess that almost half of them are by Keene. Four of them are actually signed by him and were the first to bear the familiar initials. Dulcken's statement to Layard[11] infers that those not by Keene were by Richter, but the latter's bibliographer identifies only two of the drawings as his and these were originally made for an edition of J. P. Hebel published in 1851. Dulcken says that at least one of the Richters was for a poem by Uhland. One would have thought that nothing could be easier than distinguishing Keene's work from Richter's, but in fact the book shows quite another facet of the German influence.

At about this time Keene was much impressed by the drawings of Adolf von Menzel, one of the greatest of German book illustrators, whose subjects, however, were not tempting to English publishers. Keene studied Menzel's illustrations very closely, especially those for Kugler's *Frederick the Great* (1840). Thus he was at this time very susceptible to German influence, and in the illustrations to *German Songs* that are certainly his this emerges very clearly, and very properly.

The expert may possibly find some help in identifying the German drawings in this book from the fact that they are printed from electros.[12] This process provided an entirely new source of income for publishers, though not for artists. Among Richter's publishers alone no fewer than six of them issued catalogues of clichés for sale made from his drawings. With supplements issued from time to time these catalogues were in circulation well into the 1890s, and many must have found their way to England, for Richter's drawings are frequently found in works for which they were certainly not originally designed. But this sort of thing was by no means confined to England; it was common in Germany also. In 1842 Wigand, Richter's most prolific publisher, cobbled up chapbooks with illustrations from a dozen or more other books illustrated by Richter, apparently without protest from the artist; and one can find 100 or more titles with Richter's name on the title-page, for not one of which he originally put pencil to paper. Many of them have London imprints.

One of the most sympathetic of German book illustrators and

[10] In the *Record*, p. 226, they state that their financial interest in Ward & Lock publications began only in 1863, but they are very unreliable on dates.

[11] G. S. Layard, *The Life and Letters of Charles Keene*, 1892, p. 56.

[12] This process was first used in *Phototyp nach der Erfindung des Professor Berres in Wien*, 1840. Cf. Gernsheim, *The History of Photography*, 1955, p. 355. But a similar process had been described by Jacobi in St Petersburg and others in 1839.

almost as beloved as Richter in his native land was Otto Speckter, the Hamburger. Only two other illustrators of note in this period were Hamburgers, P. O. Runge (d. 1810), who had a great influence on Speckter, and J. P. Lyser, who was Speckter's senior by three years. Neither Runge nor Lyser seems to have been known in England. The latter's strange and rather sinister humour, both as author and artist, appealed only to a very restricted circle even in his own country and was certainly not exportable.

But Speckter's appeal was international, and made its mark both in England and in France. Hans Andersen wrote to him on the occasion of his illustrations of a selection of his stories in 1845–6 that he had never seen his work better illustrated.

Speckter reached a high-water mark in the first editions of two volumes of fables by Wilhelm Hey published by Perthes in Hamburg (1833–7). His illustrations were so popular in Germany that they were constantly reprinted and the stories were generally known as Speckter's rather than as Hey's *Fables*. In 1844 Longmans published a selection of these translated by Mary Howitt with the title *The Child's Picture and Verse Book*; but all the stuffing was removed from Speckter's drawings. In the original German edition they are lithographed but in the London edition they are wood-engravings. In addition to the English translation the original German text and a French translation are given. It seems likely that the illustrations were taken from a French edition of 1840 in which wood-engravings were used; but I have been unable to examine a copy of it. There is no reference to Hey on the title-page; the sub-titles read 'commonly known as Otto Speckter's Fable book'.

In 1858 H. W. Dulcken produced a translation, in which the author is given as F. Hey and, although the text is reduced to doggerel, the illustrations are competently treated by the Dalziels. There were other editions in English, including one of the second series of *Fables* issued by the German publisher, but neither these nor any of the German reprints recaptured the gaiety and freshness of the originals.

The long fable, 'Reynard the Fox', seems to have originated in the early folklore of the Low Countries.[13] The adventures of Reynard make excellent reading, reminding one of *Uncle Remus* but with Reynard in the place of Brer Rabbit. Goethe's version of the stories (1794)[14] is well known, most especially, perhaps, for the edition illustrated by Wilhelm Kaulbach in 1846. This splendid edition, first issued in parts and then in a handsome calf binding designed by the artist, has 36 fine steel plates. Cundall imported sets of these and published them in 1847 (perhaps post-dated), with an English trans-

[13] The first printed edition is *Hystorie van Reynaerdt de Vos*, Gouda, 1479. The first English edition to be printed was Caxton's of 1481, translated from the Gouda edition. Its early popularity in both countries is evident from another edition at Delft in 1485 and a reprint of Caxton's edition in 1489.

[14] As was Goethe's custom at the time this piece was first printed in a collected edition – *Neue Schriften*, 1794–1800. As was also his custom each work was available in separate form. In my experience *Reineke Fuchs* in this form is incomparably more rare than *Faust, ein Fragment*, which was treated in the same way in a 1790 collected edition.

78. O. Speckter. The Kite. On the left is the English woodcut, on the right the original German lithograph from Hey's *Fables*

lation, at a published price of £2 2s. It is a noble book in both its German and English forms.[15] In 1857 the drawings were reduced and cut on wood and this edition also appeared in English. This is a pleasant enough book to those who do not know the original. It has a very pretty binding.

It is typical of Cundall's extravagance that he had already published, in 1843, a version of the story with plates by Everdingen, at £1 11s 6d. It seems to have been cheaply remaindered by Bohn.

In 1852 one J. W. Hartmann produced another rhymed version for which engravings were made from drawings by Heinrich Leutemann, a specialist in animal studies. The publisher, in Dresden and Leipzig, was A. H. Payne,[16] an English wood-engraver who had settled in Leipzig.[17] He prepared the plates with German and English underlines and the book was marketed in London by W. French in 1852. The drawings compare by no means unfavourably with Kaulbach's and where both have illustrated the same scene the honours may be said to be divided.

It is worth noting for comparison that Griset illustrated an English version of the story in 1872.

Cundall also published in 1848 *The Heroic Life and Exploits of Siegfried the Dragon Slayer* by Guido Görres. Only six of the 13

[15] The German edition is a common, but not an inexpensive book. I have seen only one copy of the first English edition. Even rarer – I have never set eyes on it – is a reputed English edition published in Munich simultaneously with the German edition.

[16] He also issued several publications of the 'gallery' type with steel-engravings, and an *Orbis Pictus*, all with London imprints, but produced in Leipzig. He is later to be found as an engraver of illustrations by Ludwig Richter, both as A. H. Payne and as Payne and Gray.

[17] Rümann gives the date of the German edition as 1855. The London edition is not dated on the title-page, but the preface is dated 1852 and it is registered as published in that year in the *English Catalogue*.

79. W. Kaulbach. Frontispiece for
*The Heroic Life and Exploits of
Siegfried the Dragon Slayer*, 1848

lithographs in the original German edition of 1843 were used, but a
very pretty book resulted, especially with the illustrations in coloured
form. It was handsomely printed at the Chiswick Press with an
attractive binding of pale green cloth bearing a truly fabulous expiring
dragon in gold on the front cover. Like most Cundall books it was
on the expensive side – 7s plain, 13s 6d coloured.

One German book stands out far beyond any other for its immediate
and continued popularity in England – *Struwwelpeter* – for even with
this unpromising title, which was not changed to *Shock-Headed Peter*
until considerably later, it made an impression in England almost
equal to its popularity at home. Heinrich Hoffman, a general prac-
titioner and mental specialist in Frankfurt, wrote and illustrated the
book as a Christmas present for his three-year-old son without
thought of publication; but, in his own words, he was 'forced into it
almost against my will'.

The style of the book – which includes the work of the author-

artist and its presentation by the publisher – is delightful and turning its pages still awakens admiration for its aptitude. But the text and the drawings arouse the reflection that parents may have had a larger share than their children in its original success. Later it became and has remained a part of German folklore to the extent that the original publisher recently commissioned Fritz Kredel to revise Hoffmann's original drawings for a new edition. Even that delightful artist, however, could not improve on Hoffmann.

Despite light-hearted, tripping verses and gay, brightly coloured pictures the severe and sometimes savage moral tone of the book is not disguised. The central figure of each story is usually a child who is punished for some misdemeanour. A little girl is reduced to a pile of ashes through playing with matches; a little boy disappears for ever because he goes out when it is raining, despite, even because of his forethought in taking an umbrella. Worst of all a thumb-sucker has these digits snipped off by a demon-tailor. The English text of this incident is the more uncompromising for, whereas the German mother returns to find the sad fate of her son the English mother adds 'I told you so!' The vividness of the pictures leaves nothing to the imagination.

Other offences are reprimanded less severely and more sympathetically: his antipathy to cruelty to animals and colour prejudice strike more sympathetic chords; fidgeting and not looking where you are going are rather venial sins.

Such wide popularity could not hope to escape imitations. Even Hoffmann's own publisher issued one in 1847, with an English edition entitled *The Funny Picture Book* and Nelson, in 1857, copied Hoffmann even more closely, though less successfully, with *Evil Deeds and Evil Consequences*, the characters in which included Wild Harry (= Shock-Headed Peter), Cruel Jack (= Cruel Frederick) and Careless Mary (= Careless Harriet).

There is, perhaps, some significance in the fact that it was the parents in Hoffmann's circle who urged him to publish the book. There is considerable evidence that a vindictive attitude of parents to the peccadilloes of their children was not uncommon. One may recall John Ruskin's mother inciting him to scald his fingers on a boiling coffee-pot, to teach him a lesson.

Such criticism may appear heavy-handed and there is certainly no denying the charm of the book, however perverse its message. A later book of his, *King Nutcracker and Poor Reynold*, said to have been the author's own favourite, is much more care-free: but it had not a particle of the success of *Struwwelpeter*. It was issued simultaneously in Frankfurt and London by his regular publisher.

According to Rümann, Oscar Pletsch left Berlin for Dresden in the late 1850s to work for a publisher of religious books. He produced illustrations for books on 'Christian Gifts for Eastertide' and 'Stories of Angels from Holy Writ'; but it was from a Hamburg publisher that he received, in 1860, his first commission to illustrate a book for children, *Die Kinderstube*. Like most illustrators of his time he was strongly influenced by Richter; but, unlike his master, he took very

easily to colour work and his drawings were greatly enlivened by it.

Pletsch's work was well liked and usually well treated in England. In one of his prettiest books, *Schnick-Schnack*, the coloured plates are excellently reproduced by Leighton Brothers, Baxter licencees whose work was not always worthy of their master. Another very charming English publication with illustrations by Pletsch and Richter is *Little Folks*, which is a book and not the familiar annual publication. It has a frontispiece and 19 text illustrations, all coloured by hand and printed on one side of the paper only. It was published in 1884, although undated, is elusive and a book to look out for.

Wilhelm Busch was almost certainly the most outstanding German book illustrator of his generation. The frequency with which his work appeared in English suggests that he was popular here but without attaining anything like his astonishing success in his own country. Astonishing is, perhaps, the wrong word, for his humour, with both pen and pencil, was exactly attuned to the taste of his countrymen of all ages. Indeed it is the very sign of greatness that his children's books were – still are – a source of pleasure to grown-ups: and yet he could draw and write equally well for adults. Indeed, his position in Germany is somewhat the equivalent of Lewis Carroll's in England. But the persistence with which his work was published in England appears to have been a triumph of hope over experience. Busch seemed to the publishers to be a natural for the English market; and it is interesting and enlightening to see where they went wrong. The lamentable quality of the English texts with which his drawings were provided has a lot to do with it, but the failure goes deeper than that and it bears on the whole question of what did and what did not succeed in the English market. Considering the stream of German toys and games that flowed into Britain the comparatively small trickle of illustrated books from the same source is puzzling.

Book illustrations are, by definition, inseparable from the text that they help to interpret and may be properly used only to illustrate that text. There are plenty of examples to the contrary from the fifteenth to the nineteenth century, where unscrupulous publishers have not hesitated, without a by-your-leave, to apply the work of artists to texts that they had never seen. At once the most grotesque and least excusable example is cited by Mr Henry Pitz[18] where Adolf Menzel's superb drawings for Kugler's *Frederick the Great* were maltreated to illustrate a *Pictorial History of the United States* (1843–4).

In some investigations that I recently made relating to the use of foreign book illustrations by English publishers in the nineteenth century it emerged very clearly that the choice of artists and the degree of success with which they met were quite strikingly connected with the suitability of the text for the English market. No foreign illustrator was ever more beloved in England than Gustave Doré, but only a fraction of his vast output was published there, some of it for texts quite different from those for which they were designed.

Wilhelm Busch, with whose books and illustrations we are here concerned, never attracted, in England, a hundredth part of the

[18] *The Brandywine Tradition*, Boston, 1968.

popularity achieved by Doré, although a much greater proportion of his work was translated and published in Britain. The answer to this apparently paradoxical situation is not a simple one. Basically it is because Busch's type of humour did not survive translation into an English idiom. This was undoubtedly due partly to the extreme difficulty of translating humorous verse and perhaps even more to the fact that most of the translators were hacks like Thomas Westmacott and H. W. Dulcken. It is doubtful whether the latter was English: there is no doubt whatever of his shortcomings in the writing of it.

Busch was not a *Reichsdeutscher*. He was born, and remained all his life, a provincial. His birthplace was a tiny village in the kingdom of Hanover, near the Westphalian border. When he was born, in 1832, the King of Hanover was William IV of England; and in the war of 1866 Hanover fought on the side of Austria against Prussia.

This has a distinct relevance to our purpose in the reminder that throughout the earlier part of our period, down to 1871, in fact, Germany, as a nation, did not exist. The chequered course of its history favoured the parochialism of small kingdoms and princedoms and local patriotism was fostered by dialect poetry, the authors of which found publishers and readers who staunchly supported the opposition to Prussian supremacy.

Artists found these texts greatly to their taste, as may be seen in the frequent illustrated editions of such dialect writings as those of Fritz Reuter and Klaus Groth and the low German fable of the Hare and the Hedgehog – equivalent of our Hare and Tortoise. Partiality for such dialect writings persists in modern Germany. Like some local wines, local dialects do not travel well. Try to imagine translating 'Blaydon Races' into German!

There is another aspect of this question that affects the English market. Local vernaculars are the vocabulary of the man in the street and, especially in rural areas, where they flourish and persist most strongly, have an earthy, not to say vulgar element that is not unacceptable to illustrators. Echoes of this are found in the brutality of Hoffmann and in the coarseness of Busch where, for example, the barber's clever dog sits awaiting snippets hacked from the faces of clients, or the two naughty boys of Corinth are rolled into pancakes by the tub of Diogenes.

This element of coarseness does not occur, for example, in Richter's work, which is all sweetness and light, and therefore, despite the unmistakably German characters of his scenes and figures, he was much more popular in England than Busch.

In broad generalisation, and recognising the dangers inherent in such a questionable procedure, one may say that German illustrators were at home with provincial and rural types whereas their English contemporaries preferred more sophisticated subjects. Richter's children could play ring-a-ring-a-roses with Kate Greenaway's: but Busch's rustics could not be given house-room with Caldecott's.

Busch was a staunch Lutheran. He thought Luther the greatest of all Germans and there is a strong flavour of robust Lutheranism in his irreverent satire on St Anthony of Padua. Superficially a light-hearted

lampoon, its scurrility brought the publisher before the court. He escaped with a caution, but thought it wise to suppress the final scene where the Blessed Virgin welcomes the saint's pet pig to the heavenly realm with the words, 'After all we have admitted some sort of sheep, why not a hog?'

Busch himself seems to have hesitated before submitting the work to a publisher. Fifteen drawings and verses for the delicious temptation scene with a saucy ballerina as the temptress were completed seven years before the work was published. It was never published in England, which is a pity, for, irreverence notwithstanding, it is among his very best works.

His earliest appearance in print ensued from his membership of a bohemian club in Munich called *Jung-München*, where his caricatures attracted the attention of Kaspar Braun, founder and editor of the *Fliegende Blätter*, who published Busch's first drawings in 1859 and, oddly enough, a set of light verses by him illustrated by Wilhelm Dietz.

In 1864, as a sequel to a serenade by Busch and his friends to Ludwig Richter, the older artist accepted for publication by his son in Dresden four Jest Books – *Bilder Possen*. The four little booklets, each of some 16 pages, were Busch's first appearance between covers. Alas! they were a complete and utter failure; and even when reissued in one volume, in 1880, they made no mark. Nevertheless they formed part of the book in which he made his first bow to the British public – *A Bushel of Merry Thoughts* (1868), which also contained a selection from his comic strips that had been collected into a volume in 1866. It is remarkable that this should have been the first choice of an English publisher, for *Max und Moritz* had been published in 1865 without attracting attention in England, and was to appear in the United States three years before its London publication. The fact is that neither this collection nor its successor made much play with the name of Busch, indeed the book was marketed with W. H. Rogers as its author, and the pungent spontaneity of Busch's couplets is dribbled away in doggerel that frequently does not even scan.

The failure of the Jest Books in Germany was so abject that when Busch sent Richter a more elaborate piece he returned it on the grounds that another such failure would ruin him. This was *Max und Moritz*, which Busch then sent to his old friend Kaspar Braun, expressing the hope that it might entertain him sufficiently to warrant the risk of publication. Braun responded enthusiastically, prophesying a great success. He printed a first edition of 4,000 copies and could hardly keep pace with the reprints.[19] The adventures of the two young rascals are almost as much a part of German folklore as the Grimm *Fairy-tales*.

It was not until 1872 that Braun decided to try Busch in the English market and then not with *Max und Moritz* but with an utterly charming book based on the behaviour of bees and called, in German, *Schnurrdibur, oder die Bien* (1869). The English edition, *Buzz-a-Buzz, or the Bees*, was printed in Munich in an edition of 3,000 copies and

At early dawn 'tis quite a treat
To see them work, they are so neat;
Some clean their house with brooms and mops,
And others empty out the slops.

The egg she lays; the nurses hatch
That egg, and in the cradle watch.
The babe to swaddle, and prepare
The pap-boat, is their constant care.

80. W. Busch. *Buzz-a-Buzz*, 1872, (above) 'The architects rule'; (below) 'The egg she lays'

[19] In 1916 the book was in its sixty-sixth impression.

81. W. Busch. *Max and Moritz*, 1874

marketed in London by Griffith & Farran, whose imprint included the legend 'successors to Newbery and Harris'.

The pictures are a mixture of Grandville and Beatrix Potter. Completely anthropomorphic in character they illustrate every phase of life in the hive – the workers using plumb-lines in building the cells and refreshing themselves from steins, the larvae rocked in cradles and fed with nectar from baby's bottles, the drones asleep in a half-tester bed and the queen waited on hand and foot, each picture with its lively couplet of verse. The two series depicting the swarm and the queen bee's nuptials are delightful, and all show the knowledge derived from a close study of these creatures when staying as a boy with his naturalist uncle in the country near Göttingen. There is a counter-plot which concerns the bee-master and the courting of his pretty daughter, the whole comprising 136 wood-engravings and 415 lines of verse.

Here again the possibility of success was jeopardised by the text, which was the work of a Cheshire parson called W. A. Cotton. He had picked the book up on a Cologne railway bookstall and found it so entertaining that he decided to produce an English version, not, as he wrote in the Preface, a translation, but 'written up to the pictures'. He is described on the title-page as 'the author of *My Bee Book*' and he was a leading apiarist, one of the founders and the first secretary of the Apiarist Society. He approached a bookseller in Chester with a view to publication and they interested a London firm.[20]

Cotton's text is painstakingly accurate in its bee-lore, unfortunately at the expense of the fun, and, despite his prefatory remarks, he followed Busch's text rather literally and with all too heavy a hand. The edition of 3,000 copies appears to have been a failure. So much so that when Braun and Schneider offered an edition of only 1,000 copies of *Max and Moritz* a new London publisher had to be found.

The London edition of *Max and Moritz* was, however, anticipated by an American translation by C. T. Brooks published in Boston in 1871. This I have not seen, but the English version (1874) is a great improvement in textual quality on either of the preceding books. Unfortunately the London agent, A. Myers, was only on the very fringe of the publishing world, as is indicated by his Hounsditch address. He seems to have been a wholesale warehouseman specialising in picture-books, toys and games and much patronised by street vendors.

The strange story of Busch's appearances in English continues with the publication of *Die Fromme Helene* in 1872, of which an English translation was put out in the same year by W. P. Nimmo, an Edinburgh publisher who was shortly to open a London branch. It was called *Pious Jemima*, and seems to have been authorised, although it, too, seems to have failed to catch on, for a year or two later, with a cancel title, as *Naughty Jemima*, it appeared over the imprint of Ward, Lock & Tyler.

Busch was pleased with the English edition, although he found that some of the rhymes did not come quite so trippingly off the tongue

[20] For further details see p. 248.

as he would have liked. It was his favourite among all his books, and the most successful of all those intended for adult reading. In Germany it sold in hundreds of thousands, although at one time police interference was threatened, for in Munich Catholic piety was not considered a proper subject for robust humour. Busch fussed over it more than usual. He criticised the wood-engraving, complained that to announce on the title-page 'with 180 illustrations' was like offering a house to one who bought the front-door key, and thought it a mistake to send out review copies, for reviewers would not make head or tail of it.

Hookeybeak the Raven (1878) is an example of how difficult it is to capture the true flavour of Busch's verse in English. H. W. Dulcken, who was the translator, was a Fleet Street poetaster of the period who had made some rather leaden-footed translations of Hans Andersen. A specimen of his Busch translations will show that while he does pretty well with the sense of Busch's text its sparkle completely escapes him.

Busch

Hier sieht man Fritz, den muntern Knaben
Nebst Huckebein, dem jungen Raben
Und dieser Fritz, wie allen Knaben,
Will einen Raben gerne haben.
Schon ruscht er auf dem Ast daher,
Der Vogel, der misstraut ihm Sehr.

Dulcken

Here's Tommy Tit, who's gathering the berries in the wood;
Here's Hookeybeak the raven – that raven wasn't good.
Says Tommy, 'Here's a raven sure – that's just the bird for me!
I'll have him – won't I have him!' and so he climbs the tree.

This preoccupation with texts may appear irrelevant in a book concerned with illustrations: but it is relevant to the influx of foreign illustrated books in England because it helps to explain why good work missed its mark. Busch himself originally preferred to make comic strips which he regarded as self-explanatory, but when these were reprinted he added text to them, saying, 'You can't quote pictures.'

There is one more of Busch's English publications that should be mentioned in some detail both for its brilliance and its curious publishing history. In its English dress it is called *The Power of Sound* (1879). The title-page gives more prominence to the 'translator', one Thomas Westmacott, than to the author. It is, in my experience, extremely difficult to come across. It started life in 1865 as a comic strip in the *Fliegende Blätter* as 'Ein Neujahrs Konzert'. In 1868 it first attracted the attention that it never subsequently lost when it appeared as No. 465 of the *Münchener Bilderbogen* with the title 'Der Virtuos'. In this form alone it had run through 35 reprintings by 1912, and had been translated into Danish, Dutch, English, French, Hun-

garian, Portuguese and Russian. In 1873 it was included in a collection of Busch's periodical appearances called *Kunterbunt*.

One is reluctant to take leave of this strange but sympathetic man. His three nephews draw an affectionate portrait of him[21] from which he emerges as a simple backwoodsman, fleeing the sophistication and bustle of city life to the peace and solitude of a remote countryside. This view is not without foundation, but there are undertones that suggest a more complex personality.

He was 27 years old before he sold his first drawings for publication. He had made no effort to find a publisher, not because he did not need the money, but because he genuinely believed there was something morally wrong in being paid for what one enjoyed doing.

He never lost his repugnance for working for the Press and the reason he gave for this is characteristic. The Press, he wrote,

'is like a greedy monster that must be constantly and regularly fed. One begins by providing the choicest, most nourishing delicacies; gradually the creature's appetite becomes unappeasable and one is compelled to supply it with scraps with ever decreasing discrimination. Finally one is reduced to stinking flesh and empty sausage skins. The books I can produce only when it pleases me and when I have something to say.'

It is a fact that after 1871 he contributed no more to his two regular stand-bys, the *Fliegende Blätter* and the *Münchener Bilderbogen*. By that date his books were already successful and he could see his way to an assured, if modest, future from them. Indeed it becomes increasingly obvious that, as time went by, he found the books themselves irksome. It was only with the greatest reluctance that he would consent to draw direct on to wood-blocks, and then he complained, with some justice, that those entrusted with the cutting of them often executed it inadequately. 'My muse does not dance lightly enough when wooden shod', he complained. Although all of his *Bilderbogen* and several of the books appeared in coloured form, with the exception of *Max und Moritz*, and possibly one other book, he took no part in the colouring, protesting, again with justice, that he preferred the pictures in black and white. It is significant that after his death not a single copy of any of his books was found among his *Nachlass*.

Between 1865 and 1872 Busch produced 11 books, including nearly all his best – *Max und Moritz*, *Schnurrdibur*, *Der heiliger Antonius* and *Die fromme Helene* – all but one of which appeared in English translations. From 1873 until his death in 1908 there were 13 others, one of which was a gathering from previous periodical publications, and only one of which, *Fipps der Affe*, can be included in the first rank. Only once did he illustrate a text not of his own writing – the eighteenth-century prep-school jingle of Kortum's *Die Jobsiade*.

'I have been called a bookworm and a misanthrope', he wrote in an autobiographical sketch.[22] 'The former is without foundation, the

[21] In the *Neues Wilhelm Busch Album*, 1912 (see p. 247).

[22] First published in the *Frankfurter Zeitung*, 1886, later, in revised form in the 'Jubilee' edition of *Die fromme Helene*, 1893.

latter not entirely so.' In 1876, while in Munich for an exhibition, he wrote to a friend: 'The crowds, the festivities, the noise and the smoke drive me silly; and then never in bed before two in the morning.' He was spending more and more time in Wiedensahl, his village birthplace, and in 1878 he set up house with his married sister there.

Secure in the knowledge that the proceeds from his books would continue to supply his modest personal needs, he gradually abandoned city life almost completely and began to paint. This pursuit eventually absorbed him completely, but as a pastime only. As long as he lived he never sold or exhibited a picture, although he occasionally gave one to a friend. Possibly for this reason he has never been given his due as a painter, a distinct blind-spot on the part of connoisseurs, who seem to have regarded his work in this field as a comedian's aspiration to play Hamlet. His genre studies, in particular, are very striking.

But with that we are not concerned. His book illustrations undoubtedly suffered in reproduction. The nervous and sensitive character of the original drawings, evidently produced with great speed and facility, may be studied with profit in the excellent Album produced by his nephews, in which his bubbling sense of humour is displayed to the full. Two of the best things in the Album were never published – *Der Privatier* and *Die Spinne*. Both appear to have been sketched in about 1895, and both show him in unrivalled form.

Lothar Meggendorfer made almost as many *Münchener Bilderbogen* as Busch and, although not in the same class with him, could be lively and amusing. It is not for these that he concerns us here but for the highly ingenious movable books that he devised, several of which reached the London market. These do not rank very high as works of art, but the degree of movement effected by the pulling of a single tab at the foot of each page is truly remarkable.

Work by other German illustrators, such as Konewka and Hosemann is occasionally found in English books, others, like Ille and Oberländer, seem regrettably to have failed to catch a publisher's eye. The German impact on the English market is remarkable for its erratic and uncertain course. There was no single German artist whom the British took to their hearts as they did Doré: neither was their success here such as to encourage much competition for their services, or much direct imitation, with the possible exceptions of Hoffmann and Richter. It is possible that if Cundall had succeeded as a publisher London might have seen more of the work of the like of Pocci. In point of fact, in such successes as there were, notably Hoffmann, Busch and Meggendorfer, the initiative was taken by the German publishers, who themselves produced English editions and found agents to handle them in England.

On the more serious side little enough German work found its way here. Kugler's *History of Frederick the Great*, which is Adolf Menzel's masterpiece in book illustration, achieved English translation in 1843, only three years after the first German edition. It was remaindered and I have found nothing else by Menzel in English form. As for the brave pioneers of *Pan*, *Jugend* and *Ver Sacrum*, although they sat at the

feet of Morris, Burne-Jones and Beardsley, they made no impression on English publishers.

Fairly extensive use of foreign, and especially of German book illustration was made in England throughout the second half of the century, much of it unauthorised, or divorced from the original subjects. Lack of information, and possibly of persistence, is responsible for the gaps.

Books applicable to this chapter

There is no general treatise on the influx into the English market of book illustration from abroad, and what there is, is not in English. The information must be hunted down in all kinds of odd corners; hence the regrettable inadequacy of this chapter. Some of the sources are listed below in relation to the particular artists.

I believe that most of the relevant information contained in them has been included here.

Gustave Doré R. Delorme, *Gustave Doré*, Paris, 1879

The first extensive study of the artist's work. Still valuable for its documentation and illustration. The author takes issue with Doré's critics as an enthusiastic partisan.

Blanche Roosevelt, *Life and Reminiscences of Gustave Doré*, New York, 1885

This Cassell publication is important for reviving interest in Doré, even in France – there was a French edition in 1887. There are 66 unpublished designs among the 100 or more illustrations. It is exceedingly fallible in its bibliographical information.

Catalogue des dessins, aquarelles et estampes de Gustave Doré exposés dans les Salons du Cercle de la Librairie, avec une notice bibliographique par M. G. Duplessis, Paris, 1885

Although incomplete and to some degree inaccurate, this is a valuable compilation. It cites several works unknown to Leblanc, but it is probable that some, at any rate, are 'ghosts'.

B. Jerrold, *Life of Gustave Doré*, 1891

Especially useful for the London visits and for the illustrations. These, however, are inadequately captioned and there is no list of them, neither is there any index.

J. Valmy-Baysse and L. Dézé, *Gustave Doré*, 2 vols., 1930

Bibliographically this is largely superseded by Leblanc, but it is valuable for its illustrations. It cites 67 works not described by Leblanc, but many are certainly 'ghosts'.

H. Leblanc, *Catalogue de l'Œuvre Complet de Gustave Doré*, Paris, 1931

Indispensable to every student of the artist's work, whether in book illustration or elsewhere. He lists 500 publications, and signalises those that were not directly commissioned. His book is crammed with information. He is not altogether at home in his English transliterations but one is seldom led astray.

Books in English illustrated by Doré

(N.B. All published by Cassell, unless otherwise noted.)

The Arabian Nights, 1868
An English version of *Les Mille et Une Nuits*, Paris, 1865, in which the 20 illustrations to 'Sindbad' were by Doré, originally contributed to *La Semaine des Enfants*, 1857–8, the other stories being illustrated by hacks. In 1880 J. & R. Maxwell published a version of three of the stories including the Sindbad, the text 'revised by M. E. Braddon', the wife of John Maxwell and the author of *Lady Audley's Secret*.

H. de Balzac, *Droll Stories*, Hotten, 1860, repr. 1874
The original French edition of 1855 was the fifth edition of this book, the first edition of which – not illustrated – appeared in three volumes, 1832–7.

The Doré Bible, 2 vols., 1867
French original 1866. This was among his most popular productions. There were editions in most European countries and a particularly unattractive one in Chicago with the vast designs compressed into one octavo volume.

H. Blackburn, *The Pyrenees*, Sampson Low, 1867
This contains 115 illustrations 'borrowed' from the 341 in H. Taine, *Voyage aux Pyrénées*, Paris, 1860, which were also levied upon by S. O. Beeton for J. G. Edgar, *Cressy and Poictiers*, 1865. (But see p. 244.)

Cervantes, *The History of Don Quixote*, 1866
A very inferior version of the French edition of 1863. It was published in parts and in volume form on completion.

S. T. Coleridge, *The Rime of the Ancient Mariner*, Doré Gallery, 1875 (later printing dated 1876)
A work much favoured by Doré buffs. It is not a translation: on the contrary, the first French edition appeared in 1877. Leblanc notes the curious fact about the English edition that 450 copies of it in sheets were found in Doré's *atelier* after his death. It was the only book illustrated by him that was found there. This may account for the notable rarity of the book in original cloth. There was an American edition in 1877.

Dante, *The Inferno*, 1865; *The Purgatory and the Paradise*, 1868
One of Doré's most elaborate undertakings, well suited by his macabre inventions. The original French edition of 1861 does not appear to have been published in parts, but the English edition probably was.

The Doré Gallery, 2 vols, 1870
Comprises a selection from previously published work, both English and French. An elaborate folio, it was published at £5 5s. There was a part issue in 1883 but the impressions in it are poor.

Fairy Realm, a collection of favourite old tales told in verse by Tom Hood, 1865
Reprinted in 1872 as *Fairy Tales Told Again*, a much inferior rehash of the original. No French edition is recorded.

Historical Cartoons, Hotten, 1865
A wretched edition of *Folies Gauloises* (1859) which, in the original,

has the attraction of being one of the few lithographic suites by Doré.

Victor Hugo, *Toilers of the Sea*, Sampson, Low, 1867

There are only two illustrations by Doré, but, as the book is extremely scarce, and as there was no French edition it is noted here as a curiosity.

B. Jerrold, *London, a pilgrimage*, Grant, 1872

For some, including myself, this is Doré's *chef-d'œuvre*. Originally published in parts and in volume form on completion. A French edition, with a text by Louis Enault, was issued in Paris in 1876, omitting six of the drawings (see text pp. 225–6).

H. Knatchbull-Hugessen, *River Legends*, Daldy, Isbister, 1875

All the illustrations are 'borrowed' from X. B. Saintine, *La Mythologie du Rhin*, 1862.

La Fontaine, *Fables*, 1868

Original French edition, 1867, is immensely superior.

The Legend of the Wandering Jew, Addey, 1857

Later taken over by Cassell, this edition bears comparison with the French original of 1856, the blocks having been printed in Paris by the same printer.

John Milton, *Paradise Lost*, Cassell, 1866

The earliest printing gives the addresses of the publisher in London and New York. It is superior to the later ones which do not.

Thomas Moore, *The Epicurean*, 1865

An English edition has not been traced, but was certainly issued. The date given above is of the French edition.

G. F. Pardon, *Boldheart and the Warrior*, and W. F. Peacock, *The Adventures of St. George*, Blackwood, both 1858

The illustrations in both are 'borrowed' from Mary Lafon, *Les Aventures du Chevalier Jaufre*, Paris, 1856. Jerrold says that Mary (actually Jean-Bernard) Lafon's book was published in London in 1869 as *Sir Geoffrey the Knight*, but no other record of it has been found. However, an edition with the title *Vaufry the Knight* was published by Addey in 1856, which was almost certainly Doré's first appearance in England in book form.

Charles Perrault, *Fairy Tales*, Beeton, 1865; Cassell, 1866

French original, 1862. The two English editions may be compared with *The Arabian Nights*, noting that J. & R. Maxwell had, in the meantime, taken over the firm of Beeton. They were themselves later absorbed by Ward & Lock.

Edgar Allan Poe, *The Raven*, Sampson Low, 1883

A subject very suitable for Doré both this and the American edition of 1884 have suffered in the hands of the engravers and printers. Posthumous – the last work illustrated by Doré.

Rabelais, *Works*, Hotten, n.d.

The 50 illustrations are selected from the 100 or more of the French edition of 1854. They are all full-page, whereas in the French edition some are text illustrations. Surprisingly, Hotten had the designs newly engraved for his edition which, for this reason and because of better printing and paper, is superior. If one cares for Doré in this vein, however, both editions are surpassed by a French edition of 1873 which includes seven cuts from the *Contes Drolatiques*.

(Raspe) *The Adventures of Baron Munchhausen*, 1866; French edition, 1862

The English edition omits one full-page engraving, but has one more vignette. There were also Dutch and German editions. The French text was translated by Gautier.

Shakespeare, *The Tempest*, London, 1860?
Mentioned by Leblanc, but not traced.

C. Graves, *The Story of Puss in Boots told in rhyme*, Theatre Royal, Drury Lane, 1888

The word-book of a Drury Lane pantomime with four illustrations 'borrowed' from the Perrault *Contes* (Paris, 1862; London, 1865).

H. A. Taine, *A Tour Through the Pyrenees*, New York, 1875

This is especially noted because many of the drawings were 'borrowed' for Blackburn's book on the subject (1865). The American edition of Taine – I have traced no English edition – and the Blackburn edition were from a French edition of 1860. Doré had in fact never been to the Pyrenees and his drawings for Taine were made from photographs.

It would appear at first sight that Tennyson and his publisher Moxon greatly favoured Doré as an illustrator and although these volumes are interesting for a variety of reasons one does not invariably, or even frequently, share their enthusiasm.

In point of fact Moxon made exceedingly good use of the 37 drawings that he commissioned from Doré for *The Idylls of the King*. The illustrations are line-engravings from steel plates and where the engravers' names are given they include some that are familiar in other quarters – Finden, Brandard, Greatbach, Barlow and others.

He appears to have issued them first in two forms, one as The Doré Gift Book of illustrations to Tennyson's *Idylls of the King*, 1868. This was without text except for an introduction on the Arthurian Legends. Simultaneously came an edition of *The Idylls of the King*, 1868, with the plates printed on india paper and laid down. From the descriptions given by Leblanc this would appear to be a second printing from the plates in which, for example, the arrangement of the marginal lettering is changed. It is, nevertheless, markedly superior in quality.

Moxon then proceeded to issue at least five of the poems separately with the apposite plates, some of them more than once. There were also French editions of the complete work and of some of the *separata*, but none of these various English and French editions compare with the india proofs of 1868.

Two Hundred Sketches, Humorous and Grotesque, Warne, 1867

This is valuable because it gathers together in book form much of Doré's early work for *Le Journal Pour Rire* (1848 onwards). There are, in fact, 300 drawings.

In 1930 Fernand Vandérem selected 13 of the 220 works illustrated by Doré as outstanding. Of these, two – *London*, 1872 and *The Raven*, 1884 – originated in London and of five others there were English editions – Rabelais, Balzac, *The Wandering Jew*, Münchausen.

Tony Johannot Cervantes, *Don Quixote*, 1842
Sterne, *Sentimental Journey*, 1851
Guinot, *Summer at Baden-Baden*, 1853

Vilhelm Pedersen His still unsurpassed illustrations to the fairy stories and tales of Hans Andersen were first used in England for Caroline Peachey's translations:

Danish Fairy Legends, Addey, 1853

Most of the 20 illustrations are full-page and those that are not are printed two to a page. This, and the fact that all of them are printed separately from the text and inserted, also that one bears the signature of Kretzschmar, the German wood-engraver, combine to suggest that they were printed in Germany.

In 1861 Bohn issued an enlarged edition containing 12 further stories that had been published in two Danish collections in 1852 and 1853. None of these made their first English appearance in this volume and as Pedersen had not illustrated any of them they were provided with nondescript clichés from Bohn's extensive anonymous collection. More agreeably, not only were the vignettes restored to their proper places in the text, but many more of them were used. Some are rather worn, but this edition contains the widest selection of Pedersen's drawings in any English edition.

Otto Speckter F. H. Ehmcke, *Otto Speckter*, Berlin, 1920

Extensively illustrated and with a bibliographical check-list by K. Obrecher. The text is by the famous typographer and designer. Produced at a bad time, the paper is of distressingly poor quality. The information on English editions needs checking.

Books in English illustrated by Speckter

Puss in Boots, and the Marquis of Carabas (1843) 1844

From the German *Das Märchen vom gestiefelten Kater*, Leipzig, 1843, which was illustrated with engravings. In the English edition these were made into lithographs by Louis Haghe and it is possible that some copies were hand-coloured. The published price was reduced from 7s 6d to 1s 6d in 1855.

The Charmed Roe; or the little brother and little sister. A fairy tale, 1844
This is dated 1847 by Ehmcke and Rümann but, like *Puss in Boots*, it was entered by Murray in the *English Catalogue* in 1843 and post-dated 1844 on the title-page. Neither authority mentions a German original. Neither records the earlier title.

The Child's Picture Book and Verse Book, commonly known as Otto Speckter's Fable Book, translated into English by Mary Howitt, 1846; *Picture Fables*, drawn by Otto Speckter, with rhymes translated from the German of F. [*sic*] Hey, by Henry W. Dulcken, 1858; W. Hey, *Other Fifty Fables for Children*, Gotha, 1869
All these are selected from Wilhelm Hey, *Fünzig Fabeln für Kinder*, 1833, and *Noch Fünfzig Fabeln*, 1837, both of which were anonymous. This may account for the lack of Hey's name in the first title but not for the blunder in the second.

Hans Andersen, *The Shoes of Fortune*, 1847

One of the earlier translations of Andersen into English. It was made by Charles Boner and contained ten stories translated for the first time into English and one by Boner himself. The translation – rather mediocre – and the illustrations are from two German selections of 1845–6. Not all the English illustrations are by Speckter. Indeed he contributed only four, whereas 20 of them are by Pocci.

Later Tales, 1869; *Fairy Tales and Sketches*, 1870

These two late collections of Andersen stories included illustrations by Speckter and others, nearly all of them from clichés.

Wilhelm Kaulbach	*Reynard the Fox*, 1847

The Heroic Life and Exploits of Siegfried the Dragon Slayer, 1848

(Both books are dealt with in the text, pp. 230–2.)

Oscar Pletsch	*Nursery Carols*, 1862

Illustrations by Pletsch and Richter taken from various sources including *Christenfreude* (1855) and *Engel-Geschichten*, 1859.

Mrs. C. Heaton, *Happy Child Life in Pictures*, c. 1865

A very pretty book with charming coloured illustrations which, however, were probably made for a different original.

Schnick-Schnack, 1867

An English version of *Allerlei Schnik Schnak*, 1866, in which the coloured plates, produced by Leighton Brothers, are greatly superior to the German ones.

Little Folks. Twenty Characteristic Pictures, 1884

This rather belated version of *Kleines Volk* (1865) is also superior to the original. The illustrations are hand-coloured.

Child-Land, c. 1875

There are nearly 200 illustrations by Pletsch and Richter all from clichés.

Franz Pocci	F. Pocci, *Das Werk des Künstlers Franz Pocci*, Munich, 1926

The standard iconography of Pocci's work, compiled by his grandson. It is good, though not exhaustive, on the English translations.

Books in English illustrated by Pocci

Hans Andersen, *A Danish Story-Book*, 1846; *The Nightingale and other Tales*, 1846; *Tales from Denmark*, 1847; *The Dream of Little Tuk and other Tales*, 1848

These four collections of Andersen's stories were translated from the German by Charles Boner, who lived in Germany and commissioned the drawings from Pocci. The first three were published by Cundall, each with three or four full-page lithographs on a toned background and a number of text cuts. The fourth title was published by Grant and Griffith after Cundall's failure. It had no text cuts. There were plain and coloured editions of all of them. Pocci also contributed 20 drawings to an Andersen volume issued by Chapman

& Hall, most of them new, but one or two from elsewhere. This was: *The Shoes of Fortune*, 1847. There were no coloured copies of this.

From the same publisher, in the same year, but undated, came Charles Boner, *The Merry Wedding*. With lithographed and printed vignette titles and 28 text cuts. It is possible that some copies had the lithograph title coloured. This was reissued, without the title-vignette, as *Charles Boner's Book for those who are young*, 1848.

Viola Tricolor in Pictures and Verses, New York, 1876
This I have not seen, but from the bibliographical description it would appear to be a splendid folio, with eight coloured lithographs. Published simultaneously with the German edition, no London edition is recorded.

Ludwig Richter The iconography of Richter's work by J. F. Hoff was published in 1877 and greatly enlarged by K. Budde. It gives details of some of the English editions and has much fascinating detail on the production techniques of the time. This is:

Adrian Ludwig Richter, *Vezeichniss seines gesamten graphischen Werkes*, Freiburg im Breisgau, 1922

Books in English illustrated by Richter

Oliver Goldsmith, *The Vicar of Wakefield*, Leipzig, 1841
This translation was published simultaneously with the edition in German. The earliest edition with a London imprint seems to have been in 1857.

Legends of Rubezahl and other tales from the German of Musäeus, 1845. (See text p. 228.)

The Black Aunt, Leipzig, 1848
This translation was published simultaneously with the edition in German. In 1849 Cundall imported sheets of the Leipzig edition which he issued with his own title-page as *Nut-Cracker and Sugar-Dolly*. (See text p. 228.)

The Book of German Songs, 1856. (See text p. 228.)

Mother Goose from Germany, Philadelphia, 1864
There is no German original of this. It is recorded by Hoff-Budde as having 20 wood-engravings after Richter from various sources. Pocci is said to have contributed to it also, but his bibliographer was unable to locate a copy of it.

J. & M. E. Lehmann, *Spelling-Book, or first English Book for little learners*, Mannheim and Strasbourg, 1876
Illustrations by Richter, Doré, Bertall and others, from clichés.

The Lord's Prayer, Dresden, 1856
This is an English version of *Vater Unser in Bildern*, a suite of nine wood-engravings published simultaneously in German and English, both issued in Dresden by Gaber and Richter – the former engraved the blocks, the latter was Richter's son. The two editions were printed by different Dresden printers.

Wilhelm Busch E. Daclen, *Ueber Wilhelm Busch und seine Bedeutung*, Dusseldorf, 1886

Many early drawings but not always true to originals. Text rather uncritical. Not approved by W.B.

H., A. and O. Noldeke, *Wilhelm Busch*, Munich, 1909. This was later incorporated in *Neues Wilhelm Busch Album*, Berlin, 1912.
Even those who cannot read the affectionate, albeit revealing, account of their uncle by his three nephews will profit by the wealth of illustrations, especially the sketch-books, the oil paintings, and, above all, the groundwork material for his books.

A. Vanselow, *Die Erstdrucke und Erstausgaben der Werke von Wilhelm Busch*, Leipzig, 1913
The standard bibliography. Excellent on the original editions, largely uninformed on the translations.

F. Bohne, *Wilhelm Busch*, Zurich, 1958
The most extensive and authoritative biography of Busch.

Books in English illustrated by Busch

A Bushel of Merry Thoughts, verses by W. Harry Rogers, pictures by Wilhelm Busch, Sampson, Low, 1868
This volume of 64 pages was Busch's first English publication. It contains four pieces, Ice-Peter, Cat and Mouse, Sugar-Bread, Hansel & Gretel, The Naughty Boys of Corinth. The first two are based on the *Bilder-Possen* (1864), the second two are from *Schnaken & Schnurren* (1866). The last had previously appeared as *Bilderbogen*.

Max and Moritz, Boston, 1871
This translation of *Max and Moritz* (1865) by C. T. Brooks preceded the first London edition by three years.

Max and Moritz. A Story in Seven Tricks, Myers, 1874.
The English edition was printed in Munich.

Two Naughty Boys.
A musical fairy play founded on the Picture Books of Wilhelm Busch and Palmer Cox by George Grossmith, Jr. Produced at the Gaiety Theatre, 1905. A German dramatisation by Leopold Günther had been produced, with Busch's approval, in 1878.

Buzz-A-Buzz or the Bees
Done freely into English from the German of Wilhelm Busch. By the author of *My Bee Book*. London, Griffith & Farran; Chester, Phillipson & Golder, 1872.

It will be observed that in order of English publication this translation of *Schnurrdibur* (1869) precedes *Max and Moritz*. Its bibliographical history is somewhat entangled. The translator was W. T. Cotton of Frodsham in Cheshire, hence the appearance of Chester in the imprint.

Braun and Schneider, who published the original German edition, have recorded in their ledgers the production in 1872 of 3,000 sheets for an English edition. The most likely interpretation of this is that Cotton approached Phillipson & Golder with the idea of an English edition, they interested Griffith & Farran who got Braun & Schneider to supply them with sheets.

Pious Jemima, Edinburgh: William P. Nimmo, 1872

Translation of *Die fromme Helene*, Bassermann, 1872. The English edition was printed in Munich. It was later taken over by Ward, Lock & Tyler and given a new title – *Naughty Jemima*, 1874. The translator's name was Van Laun, a Dutch member of the faculty of Edinburgh University, under the pseudonym James MacLeish.

Hookeybeak the Raven, and other tales, Routledge, 1878
This translation, by H. W. Dulcken, coincides in part with the contents of *Hans Huckebein, der Unglücksrabe*, Stuttgart, 1870, and includes the second story in that volume, *Das Pusterohr* ('The Pea-Shooter'). It does not include the third story, *Das Bad am Samstag Abend*, possibly because it had already appeared separately as *Fun in a Bath, the Brothers Magrath*, published without date with the unfamiliar imprint of George Harrison. It does include six pieces that are not in the German volume, but are taken from *Bilderbogen*.

Diogenes and the two Naughty Young Corinthians, 1879
Translation of *Diogenes und die bösen Buben von Korinth*, which appeared first as a comic strip in *Fliegende Blätter* (1862) and was included in the collection *Schnaken und Schnurren* (1866). This English version was preceded by one in *A Bushel of Merry Thoughts* (see above).

Cousin Freddy's first and last donkey ride, 1879.
This had a similar history to *Diogenes*.

The Power of Sound; or the Effect of Music, 1879.
The publishing history of this piece is given in the text (see p. 238).

The Siege of Troy, 1879
Like *Diogenes*, *Cousin Freddy* and *The Power of Sound*, the text of this was by T. Westmacott. The German original was *Monsieur Jacques à Paris* in *Fliegende Blätter*, 1870.

The Fool's Paradise, with many wonderful adventures there, as seen in the strange, surpassing Peep-Show of Professor Wolley Goble, Griffith & Farran, 1883. Translation of *Balduin Bählamm*, 1883.

Plish and Plum, Boston (Mass.), 1883
Translation by C. T. Brooks of *Plisch und Plum*, 1882. No English edition has been traced but there was another Boston edition in 1899.

'Until now', wrote Fenimore Cooper in 1828, 'the Americans have been tracing the outline of their great national picture. The work of filling up has just commenced.'[1] He referred to his country's history but the graphic nature of the simile is very apposite to the national history of art, and especially to book illustration.

It is not until the very eve of the nineteenth century that American book illustration can be at all seriously considered and even then it was largely derivative. This is not surprising when it is remembered that the date of the Declaration of Independence is 1776; that in 1812 the British burned Washington and that Cooperstown, in the State of New York, where Cooper was brought up and where he wrote his earliest novels on his father's still unsettled estates, was incorporated only in 1809. When *The Spy* (1821) appeared, laid in the 'neutral country' of Westchester County, the entire and largely scattered population of the United States was under 10,000,000. Within 50 years of the burning of Washington came the appalling Civil War and the ruin of the cultured South.

During the Colonial period reading matter was largely imported from England and, although the Bay Psalm Book was printed in Cambridge, Massachusetts in 1640, and several small publishing firms sprang up in the eighteenth century it was with Washington Irving and Fenimore Cooper that native literature found a voice of its own.

Book illustration followed a similar course; and as reproductions from the seventeenth and eighteenth centuries in Mr Hamilton's *American Book Illustrators* amply demonstrate, it was crude and lacking in either inspiration or technical ability.

Alexander Anderson 'the father of wood-engraving' was born in 1775, two days after the battle of Lexington, and probably made his earliest engravings, on metal, in 1792. These were of little account artistically. As will shortly emerge, his first significant mark on the history of American illustration was made in 1795; but in the form of copies from an English publication.

When, towards the end of the 1860s, W. J. Linton decided to settle in the United States one of his prime reasons was an intention to rescue American wood-engraving from what he regarded as its appalling fate in England. In *The Masters of Wood Engraving* (1894)[2] he constantly bewails the degeneration of English wood-engraving, which had become a mechanical process serving only to reproduce the work of artists unable to practise the craft themselves and expressly succeeding in the imitation of metal-engraving.

He was baying the moon and in 1882, when his pioneer *History of American Wood Engraving* was published, he found that the 'New School' had caught up with him there. He bemoaned, once more, 'the departure from artistic conscientiousness', the insistence on 'fidelity to the painter'. The essence of his creed is expressed in one phrase: 'The engraver should also be an artist, not less than a translator, something more than a copying machine.' Nevertheless Linton's own

[1] Quoted in the *Cambridge History of American Literature*, vol. I, p. 308.
[2] He had previously printed three copies of it at his private press in Connecticut.

account of the American engravers begins with Alexander Anderson, who was mainly a copyist of other men's work and seldom designed his own cuts.

This is generally true of all the early nineteenth-century America illustrators who, in the words of Mr Sinclair Hamilton, 'were employed principally in copying from English sources or in reproducing the work of feeble and inarticulate designers'. In consequence in these early years 'the engraver was the significant figure, with the illustrator secondary in importance'.[3]

Returning now to Anderson, the earliest recorded book to contain illustrations by him is an edition of Josephus published in New York in 1792 in which seven of the 60 copper engravings after Stothard, Corbould and others were engraved by Anderson. He later experimented with engraving on type metal, but in 1795 he set the future course of American reproduction methods for the better part of 100 years by the introduction of wood-engraving as a method of book illustration. The book in which this innovation occurred was *The Looking Glass for the Mind*, an English translation of a selection from Berquin's *L'Ami des Enfants* published in London in 1792 by E. Newbery with engravings by John Bewick. Anderson copied the Bewick cuts and the Bewick technique. Linton himself, even though kindly disposed to Anderson, admits that 'no appreciator of Bewick could speak of them as worthy of comparison with the originals'; and Linton was never a Bewick enthusiast.

In 1804 Anderson copied Thomas Bewick's engravings for *A General History of Quadrupeds*; in 1803 produced four original (?) illustrations for the first American illustrated edition of Goldsmith's *The Vicar of Wakefield* and in 1807 a title-page illustration of Charlotte and her family for a translation of *Werther*.

Anderson illustrated a great many more books but their interest is more antiquarian than artistic. He took pupils, Garret Lansing, John H. Hall and William P. Morgan. Hall was the most prolific and the best of these, better than Anderson according to Linton, who praises especially his illustrations for Thomas Nuttall's *Manual of the Ornithology of the United States and of Canada* (1832–4).

It would be neither profitable nor possible to pursue in detail the early years of the period, but one book that cannot be overlooked is *The Illuminated Bible* published by Harper in 1846. This has many remarkable features. It has well been called 'the first notable American effort to produce a richly illustrated book'.[4] It contained 1,600 wood-engravings of which more than 1,400 were specially drawn by J. G. Chapman. It is one of the comparatively rare American examples of a book produced in a workshop on Dalziel lines. J. A. Adams, whom Linton thought the best engraver of his time, and to whom he extended the rare compliment of being 'worthy to rank beside the best of the great old timers in England', was in charge, and 16 craftsmen are named as working under him. But although some engravers,

[3] Sinclair Hamilton, *Early American Book Illustrators and Wood Engravers, 1670–1870*, 1958.

[4] Weitenkampf quoted by Hamilton, *op. cit.*

like William Croome, were also designers, artists in general were junior in importance to craftsmen. The position so far as artists were concerned was bedevilled in a similar way and to a similar extent as for authors, by the lack of copyright protection. When European texts and drawings could be used with impunity and without payment by American publishers there was little encouragement for native writers and artists. Later it was precisely this discouragement of native talent that produced a more liberal attitude, but in the meantime the penalties were even more severe on American authors and artists than on the transatlantic sufferers whose work was mortifyingly broadcast without recompense.

The ludicrous lengths to which publishers would go in this direction are well shown in the illustrations to John Frost's *Pictorial History of the United States of America* (1843–4) where many of the illustrations were adapted from Menzel's designs for Kugler's *Geschichte Friedrichs des Grossen* (1840) – a book, incidentally, which can still be bought at a price disproportionate to its wealth of magnificent engravings. The adaptations are grotesquely inadequate, with Prussian grenadiers made to do duty as Indian braves. It was, as Mr Henry Pitz cogently remarks,[5] 'an indication of the low state of illustrative art in the country at the time'.

This very book, however, was in another way the herald of a new era, for it contained three illustrations by a young artist who was soon to make such a distinct mark that for the first time in the history of American book production the name of an artist would be considered a sufficient selling-point to warrant inclusion on a title-page. This was F. O. C. Darley, a self-taught draughtsman, born in Philadelphia in 1822, whose first book illustrations appeared in 1843 as a series of 14 lithographs for an anonymous five-part monthly publication called *Scenes in Indian Life*. He had already been spotted by Poe and had made a few drawings for the *Saturday Museum* in 1842 and two for *The Gold Bug* as it appeared in Graham's *Dollar Newspaper* (1843). But *Scenes in Indian Life* struck the note in which he was to excel, as a native American artist depicting the American scene of his own day. European artists affected his work greatly, the sixties group in England, and Menzel in Germany, for example. He would illustrate books by Dickens, Scott, Tennyson and Maria Edgeworth. But he was always at his best with typically American writers on whose work he continued to be engaged from the very beginning. Thus in 1844 he illustrated J. C. Neal's *Peter Ploddy*, W. T. Thompson's *Major Jones's Courtship* and other 'cracker barrel' humorists; sporting sketches like W. T. Porter's *The Big Bear of Arkansas* (1845); a muckraking novel by George Lippard, *The Quaker City* (1845), laid in Philadelphia, the metropolis near which he was born; the writings of pioneers from Parkman's *The California and Oregon Trail* (1849) to Mrs Kirkland's *A New Home?* (1856) and several of the romantic novels of W. G. Simms, including *The Yemassee* (1853) which has been described as being an even more authentic study of the Indian than Fenimore Cooper's.

[5] *The Brandywine Tradition*, Boston, 1968.

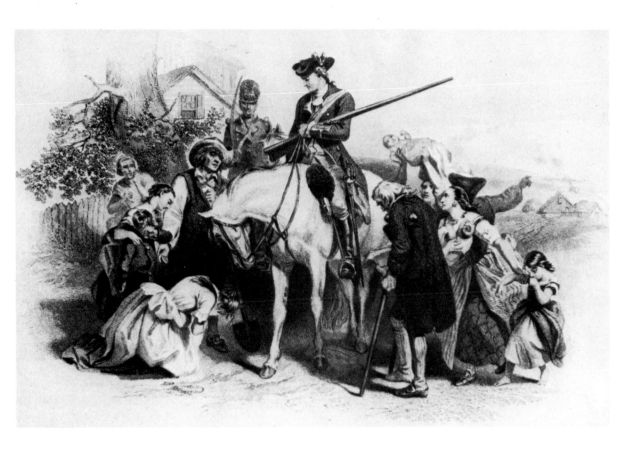

82. F. O. C. Darley. *Life of Washington*

So, for the first time, Americans were provided with an artist of stature who brought into the study and the drawing-room authentic pictures of the lives and habits of the humble, everyday folk who were building the great new society that was growing up around them.

He was soon to be engaged in the interpretation of a part of their heritage still familiar to their elders, but hitherto lacking the pencil of the artist to fill out the text of one of the first two native writers of international stature. His illustrations for various books by Washington Irving between 1848 and 1850,[6] and, above all, his illustrations for the 32 volumes of a collected edition of Fenimore Cooper (1859–61) are his most lasting monument.

It is worth noting here that no book by Cooper and only one by Irving was illustrated on its first appearance and the Irving book was almost the last to appear in his lifetime, his *Life of George Washington* (1855–9). The second edition of his first book, *Salmagundi* (1814), a collaboration with two other authors, had half a dozen illustrations by Anderson, but there was little of any consequence before Darley. Darley's illustrations of Irving began with two series of designs made for members of the American Art-Union. These were for *Rip Van Winkle* (1848) and *The Legend of Sleepy Hollow* (1849). These were

[6] It is interesting that whereas Linton reproduces two of these, his purpose is to exemplify the engraver rather than the artist.

83. F. O. C. Darley. Ichabod
Crane in his schoolhouse in *The
Legend of Sleepy Hollow*, 1849

prints unaccompanied by printed text, although described as 'among
the best things of the sort that the century produced anywhere'.[7]
They are indeed handsomely produced in oblong folio format and
the drawings are of the utmost delicacy in the manner of Flaxman,
but with infinitely more life and charm.

The *Rip Van Winkle* illustrations were revamped as wood-
engravings in a smaller size for an 'Artist's Edition' of the *Sketch Book*
in 1864. Most of the illustrations for this edition are by lesser artists –
Charles Parsons, John McLenan and William Hunt among others –
but it is a pleasant book and is still one of the most popular of the
American productions in the sixties idiom.

Three books of Irving's were illustrated by Darley for Putnam,
The Sketch Book of Geoffrey Crayon (1848), *A History of New York*
(1848), of which Irving remarked to his nephew that Darley was the
only artist who had hit off the figure of Diedrich Knickerbocker, the
putative author, and *Tales of a Traveller* (1850).

Comparison of Darley's illustrations of Irving's stories with Calde-

[7] F. J. Mather, Jr in *The Pageant of America*, Yale, 1927, Chap. 12. Cited by
Hamilton, *op. cit.*

cott's is informative if not pressed too far. Caldecott was two years old when Darley's *Rip Van Winkle* suite appeared. Moreover, although Darley was nearly 40 years Irving's junior, they knew one another and certainly conferred on the illustrations. Irving died 17 years before Caldecott's edition of *Old Christmas* appeared, and although this formed part of the *Sketch Book* which Darley also illustrated, both it and *Bracebridge Hall* are laid in English backgrounds familiar to Caldecott but unknown to Darley personally, although both his parents were English born. Caldecott was probably the more gifted artist but, especially in the Catskill legends, Darley's drawing has a bite and a touch of that eeriness so frequent and so telling in Cruikshank that was entirely foreign to the good-humoured Caldecott.

The delay on the part of American publishers in grasping the graphic opportunities offered by the novels of Fenimore Cooper is surprising. The 'Leather-Stocking' novels were naturals for illustration and it should not be forgotten that Cooper was a pioneer in the writing of sea-stories – *The Pilot* (1824) and *The Red Rover* (1828). Yet he was twice illustrated in France – 1827–30 by the Johannot brothers and 1848–55 by Bertall – before the Darley edition of 1859–61. The earlier of the two French editions preceded the first American collected edition (1835–6), which is a wretched reprint from the stereotype plates of the first editions. Cooper died in 1851, eight years before the first volumes of the Darley edition appeared, but Darley may have known him. The illustrations received a full measure of esteem at the time and in 1861–2 were issued in separate form, much more carefully reproduced than in the original volumes.

Darley seems to have been the first illustrator of Clement C. Moore's *A Visit from St. Nicholas*, the publishing history of which is a curiosity worthy of more extended record than can be given here. Moore, a professor of theology, wrote the poem for his own children. It was first published anonymously, and, it would seem, without his knowledge, in the *Troy Sentinel* in 1823 and was included in his *Poems* (1844), by which time it was already well known, although not generally associated with his name. Considering its universal fame in the English-speaking world this is remarkable.

The publisher of the edition illustrated by Darley, J. G. Gregory (1862), used the original title, as did McLaughlin, for the better-known edition illustrated by Thomas Nast (1869). Latterly the title has been changed to the first four words of the opening couplet:

> The night before Christmas, when all through the house,
> Not a creature was stirring, not even a mouse.

Darley was considered by Kitton[8] to be the best of the American illustrators of Charles Dickens in a series of frontispieces made in 1860 for a collected edition published by Townsend in New York and called the *Household Edition*.[9] These illustrations were in the form of steel engravings. In 1888 a selection of them was issued as *Character Sketches from the Works of Charles Dickens*.

[8] *Dickens and his illustrators*, 1899.
[9] Chapman & Hall's *Household Edition* began publication only in 1871.

Despite his caustic comments on Americans, both spoken and written, Dickens was almost as widely read in the United States as in Britain and several American artists were commissioned by American publishers to illustrate his novels. Among these, besides Darley, were Thomas Nast, C. S. Reinhart, E. A. Abbey, A. B. Frost, Sol Eytinge and Hammat Billings, most of whom will be treated at greater length.

Darley 'became nationally famous for his American themes' and 'without a peer in his own field'.[10] Later he fell into oblivion and it is only quite recently that the encomiums of such collectors as Mr Sinclair Hamilton and such writers as Mr Henry Pitz have recalled the fact that even before Winslow Homer there was an artist 'whose art was indigenous to the soil and most at home when standing firmly on it'.[11]

Darley was born in 1822 and lived until 1888, by which time Howard Pyle, whom some of us think of as a modern artist, was already a well-known illustrator. Also close to our own day was Winslow Homer, the great American genre painter. Born in 1836, his prentice work appeared in book form in 1856. He died only in 1910. His book illustrations are inadequately charted. Mr Hamilton, who knows more about them than anybody else, surmises that he illustrated several books in Boston before he went to New York in 1859. Only one such book has been identified – *The Eventful History of Three Little Mice and how they became Blind* (copyrighted in 1858). Only the frontispiece is signed by Homer but he is thought to have drawn the other 16 illustrations. No other of his books contains half that number of illustrations. Most have only one or two and these often in the company of other artists. Thus in W. C. Bryant's *The Story of the Fountain* (1872), Homer is only one of eight artists and in E. J. Hall's *Lyrics of Homeland* at least four other artists are associated with him.

Most of Homer's best work was in periodicals, notably his reportage of the Civil War for *Harper's Weekly*. Some of his most attractive and characteristic book illustrations are in an edition of William Barnes's *Rural Poems* published in Boston in 1869 for which he and Hammatt Billings each provided six drawings.

Billings is an interesting figure. His most prolific and fruitful period as an illustrator was between 1851 and 1853 when he illustrated the first editions of three books by Hawthorne – *True Stories from History and Biography* (1851), *A Wonder-Book* (1852) and *Tanglewood Tales* (1853), and two editions of *Uncle Tom's Cabin*, the first (1852) in which there were only six illustrations, and a special illustrated edition, dated 1853, but published before the end of 1852, with 116 illustrations, which include the finest of all his illustrations, able to stand up even to Cruikshank's. One of the delightful quirks that frequently reward the inquisitive is that Billings was the first to illustrate a story by Dickens that had appeared in *Household Words, A Child's Dream of a Star*. The drawings were engraved by Linton. This was published in Boston in 1859. It is not, as is frequently stated,

CHAPTER IV.

AN EVENING IN UNCLE TOM'S CABIN.

THE cabin of Uncle Tom was a small log building, close adjoining to "the house," as the negro *par excellence* designates his master's dwelling. In front it had a neat garden patch, where, every summer, strawberries, raspberries, and a variety of fruits and vegetables, flourished under careful tending. The whole front of it was covered by a large scarlet bignonia and a native multiflora rose, which, entwisting and interlacing, left scarce a vestige of the rough logs to be seen. Here, also, in summer, various brilliant annuals, such as marigolds, petunias, four-o'clocks, found an indulgent corner in which to unfold their splendors, and were the delight and pride of Aunt Chloe's heart.

Let us enter the dwelling. The evening meal at the house

84. H. Billings. *Uncle Tom's Cabin*, 1853

[10] Pitz, *op. cit.*

[11] F. Weitenkampf, 'Illustrated by Darley' in *International Studio*, 1925.

its first appearance in book form. As those who know their Brussel[12] will appreciate, the story was included in *Reprinted Pieces* (1858).

Billings is mentioned only in passing by Kitton. He is more generous to another American illustrator of the period, Sol Eytinge, and actually uses his portrait of Dickens as a frontispiece. Eytinge illustrated six volumes of the Diamond edition of Dickens's works in 1867 for Ticknor and Fields in Boston, providing 16 drawings for each work. He also illustrated[13] the first edition of Thomas Bailey Aldrich's *The Story of a Bad Boy* (1870) which was considered by John T. Winterich to be 'the first realistic American juvenile'. None of the three Bret Harte's that he illustrated was the first edition: but his illustrations were approved by the author who was sometimes outspoken on his publisher's choice of artists. The three Harte volumes are *Condensed Novels* (1871), *The Heathen Chinee* (1871) and *The Luck of Roaring Camp* (1872), which has been described as 'the most influential short story ever written in America'.

Thomas Nast, who at the age of six was taken to America by his German parents, was greatly helped by Eytinge. He was a colleague of Winslow Homer's on *Harper's Weekly* and for his Civil War cartoons Lincoln called him the North's 'best recruiting sergeant'. He introduced the donkey to represent the Democratic Party and the elephant to typify the Republican Party. His place in history is secured by his implacable series of cartoons on the Tammany Hall scandal by means of which almost singlehanded he destroyed Boss Tweed and his gang.

His book illustrations are much milder in tone and many of the best of them are for children's books, notably the 'Dotty Dimple' and 'Little Prudy' stories by Rebecca Clarke. A surer passport to immortality is provided by his three illustrations to Mary Mapes Dodge's *Hans Brinker* (1866), which was honoured by the French Academy, and retains a place in American affections close to *Little Women*. Darley provided the frontispiece for this book. Mrs Dodge has a further claim to fame as the editor, from its onset in 1873 almost until her death in 1905, of *St. Nicholas*, one of the finest of children's magazines anywhere at any time and a rich source of illustration frequently raided by book publishers.

Nast was often commissioned as a Dickens illustrator – *Pickwick*, *American Notes* and *Pictures From Italy* for Harper, 86 drawings in all. He also illustrated an American edition of *The Fight at Dame Europa's School* (1871) and the very different military commentaries of D. R. Locke's creation, Petroleum V. Nasby, a series of horse-laughs which, although much favoured by Lincoln, have hardly survived him.

Nast fell on evil days towards the end of his life and was appointed by Theodore Roosevelt American Consul in Ecuador, where he died in 1902.

Illustrators now come thick and fast. There was D. C. Johnson, 'the American Cruikshank', who illustrated Seba Smith's *Life and Writings of Major Jack Downing* (1833) and J. C. Neal's *Charcoal*

[12] I. R. Brussel, *Anglo-American First Editions*, 1935.
[13] The illustrations appeared in the serial version in *Our Young Folks*.

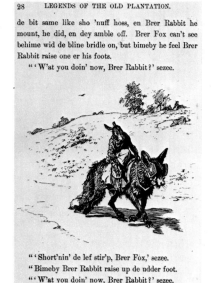

28 LEGENDS OF THE OLD PLANTATION.

de bit same like sho 'nuff hoss, en Brer Rabbit he
mount, he did, en dey amble off. Brer Fox can't see
behime wid de bline bridle on, but bimeby he feel Brer
Rabbit raise one er his foots.

" 'W'at you doin' now, Brer Rabbit ?' sezee.

" 'Short'nin' de lef stir'p, Brer Fox,' sezee.
" Bimeby Brer Rabbit raise up de udder foot.
" 'W'at you doin' now, Brer Rabbit ?' sezee.
" 'Pullin' down my pants, Brer Fox,' sezee.
" All de time, bless grashus, honey, Brer Rabbit
wer puttin' on his spurrers, en w'en dey got close to
Miss Meadows's, whar Brer Rabbit wuz to git off, en

85. A. B. Frost. 'Short'nin de lef
stir'p'. *Uncle Remus*, 1895

Sketches (1838); John McLenan, formerly a pork packer, who illustrated J. G. Baldwin's *The Flush Times of Alabama and Mississippi* (1853), a hair-raising and amusing account of roguery in the South, *Rollo in Paris* by J. Abbot (1854), and one of the goriest books in American literature, *The Life and Adventures of James P. Beckwourth* (1856). Frances Miram Whitcher's *Widow Bedott* (1855), illustrated by J. A. Dallas, and B. P. Shillaber's *Mrs. Partington* (1854), illustrated by F. M. Coffin and Nathan Brown, were fun while they lasted but have not lasted very well.

In strong contrast are the 'Uncle Remus' stories by Joel Chandler Harris, who, although he belonged to the Deep South – he was born in Georgia in 1848 and wrote the stories while on the staff of the *Atlanta Constitution* – had to seek a publisher in the North. This is not surprising when the record states that in 1880 the assessed value of guns, dirks and pistols in Alabama, for example, was nearly twice that of libraries, a situation due to the acuteness of the race problem where in some districts the blacks outnumbered the whites by two, three or four to one.

Harris knew far more about the Negro than any other author of his time. Uncle Remus was not a propaganda figure like Uncle Tom,[14] but an old-time Negro steeped in the mysticism, humour, music and above all, the folklore of his race. Harris made no bones of the high esteem in which he held Uncle Remus or the affection that he felt for him, which would not have gone down well in the South in 1881, when the first 'Uncle Remus' book was published. It is fair to add that in any case publishing resources were virtually non-existent there at the time.

Harris's New York publisher, Appleton, served him well with illustrations by F. S. Church and J. H. Moser, although I can find nothing else by either of great significance. Moser, in fact, was dropped for the second 'Uncle Remus' book (1883) in which Church's collaborator was W. H. Beard. Younger generations will be more familiar with the composite volumes illustrated by A. B. Frost and E. W. Kemble, illustrator of *Huckleberry Finn*. In fact Frost was the original illustrator of the third book, *Uncle Remus and His Friends*, when it appeared in 1892.

All the early illustrators of the series have a claim to a share of the credit apportioned to Harris by C. A. Smith that 'he has done more than add a new figure to literature; he has typified a race and thus perpetuated a vanishing civilisation'.[15]

Another great humorist from the South had leapt into fame some ten years before Uncle Remus made his bow. This was Mark Twain with his *Innocents Abroad* (1869). His publisher farmed out the illustrations to the wood-engravers Fay & Cox who commissioned the drawings from a totally unknown artist called True Williams. More than 200 drawings were used, mostly as text cuts. Although

[14] Irwin Russell remarked that *Uncle Tom's Cabin* gave no more idea of true Negro life and character than the *Nautical Almanac*. (Cited in *The Literary History of the United States*, 1948, vol. II, p. 853.)

[15] *Cambridge History of American Literature*, vol. II, p. 347.

they display little inspiration they suited the text and Williams was engaged to illustrate Twain's next three books, the last of which was *Tom Sawyer* (1876)[16] with which he was less successful than with the travel books. Twain's biographer more than hints at Williams's tippling habits which may have been a contributory cause of his being replaced as the illustrator of *Huckleberry Finn* (1884), by another young artist, E. W. Kemble, for whom the association was a bonanza: deservedly, for few artists have captured more successfully the author's atmosphere, or more unerringly brought his characters to graphic life.

He never did anything better than the *Huckleberry Finn* illustrations. Mark Twain dropped him in later books in favour of Dan Beard and others. Kemble, however, had a long and successful career as an illustrator and, as already noted, was associated with some of the later titles and editions of the 'Uncle Remus' series.

A. B. Frost, like Kemble, with whom he was notably associated in more than one of the 'Uncle Remus' volumes, is pure American homespun. Both men had more humour than Darley, and Frost, especially, shows a very deft comic touch somewhat in the *Fliegende Blätter* manner, in his strip cartoons. Frank Stockton's *Rudder Grange* (1885), a humorous story of life on a canal boat on the Harlem River, suited him well, and his illustrations are among the best and most characteristic in Thomas Nelson Page's *In Ole Virginia* (1896). With Frost, however, we are in the heyday of the American illustrated magazine and much of his best work will be found in *Harper's*, *Scribner's* and *St. Nicholas*.

Frost was among the first American artists to be recognised in England, not only in the simultaneous London publication of the books of Joel Chandler Harris and Mark Twain but in direct commissions from English publishers. Dickens, of course, was in the forefront and Frost was commissioned by Chapman & Hall to illustrate *American Notes* for the *Household Edition*. This edition was published simultaneously in London and New York, the English illustrations being placed at the disposal of Harper's. Strangely enough they commissioned American drawings for several of the books. Frost, for instance, was preferred to Barnard for *Sketches by Boz*, Reinhart for *Nicholas Nickleby* (Barnard), *The Uncommercial Traveller* (E. G. Dalziel) and Nast for *Pickwick* ('Phiz') and *American Notes* which had surely been much better suited to Frost than the very particularly London atmosphere of the *Sketches*, although it must be admitted that Barnard's drawings fall far short of the Cruikshanks of the original edition. On the other hand, Frost's drawings for *American Notes*, to an English eye, strike exactly the right note, especially in the railway dialogue scene in Chapter V, the canal boat cabin in Chapter X and the village scene at the halting of the coach in Chapter XIV. These surely depict America exactly as Dickens saw

[16] Hamilton points out that the figure of Aunt Polly used for the frontispiece was first used to represent the 'heroine' of B. P. Shillaber's *Life and Sayings of Mrs. Partington* (1854). The only hard fact about the figure is that it was not the work of Williams.

86. A. B. Frost. 'As the coach stops'. *American Notes*, Household Edition

it in 1842. Ward, Lock also published a *Pickwick* with Frost's illustrations in 1881, but this was an American importation.

Much more surprising is to find Frost commissioned by Lewis Carroll to illustrate two of his nonsense books, *Rhyme? and Reason?* (1883) and *A Tangled Tale* (1885). The drawings in both books are immensely superior to the text, but Frost did not find his author any more sympathetic to work with than did Tenniel.

A Popular History of the United States in which W. C. Bryant collaborated with H. Gay, four volumes (1876–81), is not a major literary work, and its illustrations are more remarkable for quantity than quality. A very large number of illustrators were employed on this work, which was originally issued in parts, and an even larger number of engravers, nearly 40 of whom are named in the first volume alone, including W. J. Linton. The artists include Winslow Homer, with one totally uninspired drawing, both A. R. and W. Wand, W. L. Sheppard, S. Eytinge and A. Fredericks. All of these compare very unfavourably with the facsimiles taken from the seventeenth-century *General History of Virginia* by John Smith. The comparison emphasises not only the pedestrian nature of much American book illustration of the time, but also the prevalent lack of knowledge of the limits of wood-engraving. There is ground for suspicion also that, Linton's efforts and asseverations notwithstanding, the level of engraving in the United States was far below English craftsmanship. The large number of engravers used in this *History of the United States* and in other works of the period shows that the English system of massing groups of engravers under one roof, as with Dalziel and Swain, was not followed in America, and this was also disadvantageous.

E. A. Abbey's name appears with some frequency among the

87. (above) H. Holliday. *The Hunting of the Snark*, 1876
88. (below) E. A. Abbey. *Selections from Herrick*, 1882

illustrators and this must have been one of his earliest book commissions. There is hardly a trace of his later sparkle. Possibly the engravers or the printers served him ill, certainly the quality of the paper on which the English edition is printed is vile. One would like, for example, to have seen the original of the 'Deposition of Wingfield' as Governor of the English Colony at Jamestown. This shows distinct imagination though surely the smirk on Wingfield's face was not put there by Abbey. The later volumes of the work are occasionally more rewarding when the artists were engaged on what was contemporary history to some of them – the opening up of the West, the Civil War and the Indian troubles.

E. A. Abbey might well have been considered in another part of this book with the artists of the Hugh Thomson school, for, although born in America in 1852, from about 1878 onwards he made his home in England and is included in our *Dictionary of National Biography*. He came to England originally as a staff artist of Harper's and the first fruits of his visit were illustrations for a selection of Herrick's poems, which was published in 1882 by Harper and Sampson, Low. He soon settled in England permanently, became a successful painter, and a highly favoured book illustrator – one of the earliest to develop what is often called the 'Hugh Thomson school'.

The two men were roughly contemporaries, Abbey born in 1852 and Thomson in 1860. Abbey's first characteristic work, the Herrick, appeared in 1882 and Thomson's, the Roger de Coverley, in 1886. There is little doubt that Thomson was influenced by Abbey. J. R. Carey, Thomson's early friend, records in his diary that he knew and admired Abbey's fine line in *Harper's Magazine* and comparison between the illustrations by the two artists for Goldsmith's works – Abbey in *She Stoops to Conquer* (1887) and *The Good-Natured Man* (1889), and Thomson in *The Vicar of Wakefield* (1890)[17] – is enlightening. Abbey, less prolific than Thomson, was unquestionably the better artist, and whether one favours the 'Cranford' style or not his influence on his contemporaries can hardly be questioned. Unfortunately in his major work, *The Comedies of Shakespeare* (1896), *Harper's* succumbed to the facile opulence of photogravure, a medium entirely unsuited to Abbey's style. The drawings must have been quite splendid and were exhibited at the Société Nationale des Beaux Arts in the year of their publication.

There is, however, nothing distinctively American in his work. For that one must turn to his contemporary, Howard Pyle, born in 1853. Abbey was a native of Pennsylvania. Pyle was born in the neighbouring state of Delaware. Unlike Abbey, who was the son of a Philadelphia merchant, Pyle was born in the small country town of Wilmington, and the influence of his rural background remained with him all his life, although at the age of 16 he travelled daily to Philadelphia for art lessons.

On the strength of the acceptance of an illustrated article by Scribner's on a visit to the Atlantic coast in 1876 and of direct encouragement from Roswell Smith, a partner in the firm, Pyle's father

[17] He also illustrated *She Stoops to Conquer*, but only in 1912 and in colour.

sent his son to New York where, after free-lancing for Scribner's and for *St. Nicholas*, he obtained fairly regular work for Harper's, where he met Abbey for the first time and A. B. Frost, with both of whom he developed a close friendship.

Within three years he had established himself with magazine editors as both a writer and an illustrator, his principal connection being always with Harper's. But he was slowly feeling his way towards the field in which he was eventually to make his mark – the romantic world where legend and history overlap, where knights were bold and pirates were not so black as they are painted – a never-never land, as unreal and sentimental as *The Dream of John Ball*, but somehow more attractive.

In 1879 he returned to Wilmington with the assurance of work from Harper's but with the immediate purpose of writing and illustrating a version of the 'Robin Hood' stories for children. But that was not yet. Pyle's decision to move out of New York was probably partly influenced by the announcement of a new magazine for children, *Harper's Young People*, in almost every number of which he appeared as author-artist. In 1881 he tried his hand with Dodd Mead at toy-books on the lines of the Crane series printed by Edmund Evans for Routledge. 'Pyle's two books, *Yankee Doodle* and *The Lady of Shalott*, were not in the same class.'[18]

Despite his continued regular and close association with Harper for magazine work he now turned for a while to Scribner for the publication of his books. *The Merry Adventures of Robin Hood*, which he wrote and illustrated, was published by Scribner in 1883. It got off to a slow start because its lavish and careful production made it expensive. It was, for example, bound in full leather tooled to an elaborate overall design by Pyle, who kept a jealous eye on its production throughout.[19] General acclaim for the book, not least from Pyle's fellow artists, ensured a steady and increasing sale which still continues. His illustrations for James Baldwin's *The Story of Siegfried* (1882) also began to attract notice.

In 1880 he began to publish, in *Harper's Young People*, a series of jingles in which the lettering of the text was devised by him to accord with the pictorial decoration, so that the page formed a complete and harmonious unit. In 1886 Harper brought out a collection of these with the title *Pepper and Salt or Seasoning for Young Folk*.[20] The result was a book which has no counterpart in its day, at least in the United States, and is delightful.

Pyle had also started a series of children's stories in the magazine

"I HAVE TO GO TO ENGLAND AND BE A LORD APPLEWOMAN."

89. R. B. Birch. *Little Lord Fauntleroy*, 1886

[18] Pitz, *op. cit.*

[19] The English edition is much rarer than the American. The entire printing comprised 3,000 copies of which 510 copies were sent in sheets to Sampson, Low for the English market. (Blanck, *Peter Parley to Penrod*, p. 74.) It is a striking indication of the affection and esteem accorded to Howard Pyle in his own country that over the period of 100 years covered by Mr Blanck he has the unique distinction of four entries, his nearest rivals being Louisa Alcott and Mark Twain, each with three.

[20] Of this book and the two Baldwins (the second one was *A Story of the Golden Age*, 1887) Low also took sheets for the London market.

and in 1888 Harper brought this out in book form, titled *The Wonder Clock*. It is generally beyond the province of a work on a book concerned with illustrations to comment on the text, but here such comment is relevant. The same technique is used for the illustrations as in *Pepper and Salt* but here it does not succeed for a variety of reasons. The drawings themselves are well enough, but they are ill matched by the poor typography of the letterpress. For this Pyle can hardly be blamed, but whereas the stories themselves are phrased with an admirable lack of 'prithees' and 'quothas' in a way wonderfully suited to their audience, the titling of the illustrations is in a heavy black letter and is generally in an antiquarian cast completely at odds with the text.

Scribner got from him in the same year a very much better book, one of his best, possibly the best of all, *Otto of the Silver Hand*. The story, in contrast to the jolly mood of *The Wonder Clock*, is one of gloom and despair, but the illustrations, to quote Mr Pitz once more, 'are bold and monumental'.

The development of the half-tone process and its further ramifications into colour printing were the undoing of Pyle as a book illustrator, although they affected his immediate popularity only favourably. This will be found a harsh saying by many of Pyle's admirers, and perhaps its bluntness requires a little more critical sharpening. Pyle's facility in black and white came to a peak at a time when photography had almost completely replaced wood-engraving as a process medium. Pyle quickly grasped the potentialities of the new technique and thus was able to produce ideal material for the purpose, while at the same time using the new medium to produce results hitherto rarely, if ever, achieved. Comparison of Pyle's reproduction on pp. 263 and 4 with those of Thomson and Abbey on pp. 197 and 8 and 261 shows at once the economy and lack of fuss of the spare and powerful Pyle technique and his keen eye for unity.

Caldecott in England, who produced his first major work in 1876, the year that Pyle's first drawings were accepted in New York, was equally successful with black and white. When he went on to colour in 1878 with the first of his toy-books, he had the inestimable advantage of co-operating with Edmund Evans, a printer with 20 years' experience of colour printing, already on the eve of producing *Under the Window*, a technical masterpiece in this field. Evans's colour process, moreover, was based on wood-blocks, printed with the letterpress, on the same paper as the text. Thus the originals of the Caldecott illustrations are in essence pencil drawings coloured by hand.

It was just inside our period, in 1900 in fact, that Pyle produced his first notable colour work in the form of decorations for six pages of the Christmas issue of *Harper's Monthly*. They were printed by the four-colour process, inevitably on glossy paper, and thereafter Pyle remained steadfast to this process, producing, among other things, a series of rather lamentable illustrations for stories by James Branch Cabell. But, already in 1893, the demand for more verisimilitude in book illustration had caused Pyle to exchange the pen for the brush in illustrating Holmes's *Autocrat*. The results, though not unpleasing,

90. H. Pyle. *Pepper and Salt*, 1886

91. H. Pyle. *The Wonder Clock*,
1888

seem prentice work when compared with *Pepper and Salt* or *The Wonder Clock*. It is not without significance that all four of Mr Blanck's Pyle choices are from the black-and-white period. Pennell, with typical hyperbole, roundly declares him a better draughtsman than Dürer. Mr Pitz puts this in perspective when he says that Pyle's 'pictures reflected the influence of Albrecht Dürer as it had been transformed by Howard Pyle'.[21]

Signs are not wanting that Pyle knew that he was overdoing it – his break with Cabell is one of them. He knew also what he could do best and that this was seldom possible unless he supplied his own texts. His writings for children are especially good, and above all they show a visual imagination abounding in opportunities for graphic depiction. It is in this sphere that he captured and has retained the affection and regard of his countrymen as a nonpareil among book illustrators.

There is little more to detain us in nineteenth-century book illustration. The bold individuality of Charles Dana Gibson, creator of the 'Gibson Girl', was displayed largely in magazines, although collections of them were issued in rather unwieldy book form. The

[21] *Op. cit.*

work of Will Bradley, a worthy exponent of the *Art Nouveau* style is best seen in his posters. Joseph Pennell, who lived mostly in England, was chiefly successful in topographical illustrations. Our debt to him is much greater for his generous tributes to his contemporaries. He lectured at the Slade on book illustration and in 1889 (revised in 1894) he produced a remarkable survey of black-and-white work of the period. This was *Pen Drawing and Pen Draughtsmen*, in which the British insular viewpoint is given a broader perspective by the inclusion of continental artists. He is concerned almost exclusively with the second half of the nineteenth century. Some of his critical comments do not stand up well today and his unstinted praise of mechanical reproduction processes is sometimes dubious, but the 366 illustrations are invaluable.

Perspective in the present survey of book illustration is nowhere more important than when considering American book illustration. Until almost halfway through our period it is not surprising to find little that is of more than antiquarian interest, and most of it derivative. Darley is the first outstanding figure, not least because he expressed the native idiom. But there is no Millais, Rossetti, Keene, Pinwell, Hughes or Sandys in the United States. In the days of Abbey, Frost and Pyle there is no Beardsley, Caldecott, Crane or Greenaway.

There are a variety of reasons for this. A young civilisation, puritanically based, preoccupied with the westward extension of its perimeter, the bloody catastrophe of the Civil War and the ostentatious brigandry of the big barons of the new industrial revolution created a climate unfavourable to the flowering of the arts. (It may be noted in passing that the first American composer of mark was Macdowell, born in 1861.)

The lack of copyright protection greatly hindered the advance of American book illustration. So long as American publishers had free range of the wealth of English book illustration at no greater cost than the cutting of new blocks they were reluctant to incur the expense of commissioning original work from native artists. Thus, in the Hamilton Collection at Princeton, and in such pioneer studies as W. J. Linton's, the early emphasis is on the engraver as opposed to the draughtsman.

There is an outstanding exception to this line of argument. Despite the stream of unauthorised and unpaid-for English books that flooded the American market, a great new school of American authors arose. Cooper, Irving, Emerson, Longfellow, Whitman, Melville, Holmes, Poe and the young Henry James flourished in despite of undercutting by transatlantic competition.[22]

Why, then, was there no comparable rise in the number and

[22] Yet one of the main reasons for the passing of the American Copyright Act of 1891 was the need to protect American authors. Mr Graham Pollard, in his introduction to Mr I. R. Brussel's *Anglo-American First Editions, East to West*, Constable, 1935, writes: 'It had become almost impossible for an unknown author to get a first novel published in America, because the author had to be paid and the book sold, in competition with English books for which the author need not be paid.'

competence of book illustrators? The answer must surely lie in the lack of illustrated periodicals. Cruikshank contributed to a dozen or more periodicals and if the part issues of Dickens, Ainsworth and others are included the range was enormously widened. In 1841 *Punch* was founded and in 1842 *The Illustrated London News*. Both brought in their wake a host of imitators and rivals and, though many were short-lived, the illustrated periodical had come to stay. Gleeson White devotes three chapters to the illustrated magazines of the sixties, beginning with *Once A Week* in 1859.

In the United States in the earlier period there is nothing comparable. The first significant illustrated periodical was *Frank Leslie's Illustrated Newspaper* started in 1854 by a wood-engraver, who recruited the 14-year-old German immigrant Thomas Nast in the same year and six years later sent him to England to sketch the brutal prize-fight between Tom Sayers and J. C. Heenan, the 'Benicia Boy'. In 1856 *Harper's Weekly* began publication. The graphic reporting of the Civil War in this journal by Nast and Winslow Homer gave a fillip to pictorial journalism. But it was the seventies and eighties that saw the heyday of the American illustrated magazine. It was the encouragement of Roswell Smith of *Scribner's Monthly* that brought young Pyle to New York in 1876 and Charles Parsons who first gave him regular work for *Harper's Monthly* where he found Rinehart, Abbey, Frost and A. R. Wand in the art room.

Of inestimable importance for supplying the regular flow of commissions without which the illustrator must languish were the children's magazines. *Our Young Folks*, founded in 1865, was taken over by the incomparable *St. Nicholas* on its foundation in 1873. Only one other periodical for young people can be mentioned in the same breath with it, *Boy's Own Paper*. Started six years later and with more limited terms of reference the palm must be yielded to its American rival, especially in the quality of its illustrations which both artistically and technically are of very high quality.

Despite its limitations, one might almost say because of them, the field of nineteenth-century book illustration in the United States is fascinating. We shall know much more about it when the new edition of Mr Sinclair Hamilton's catalogue is completed.

Books applicable to this chapter

The best general survey is the catalogue of the collection formed by Mr Hamilton, now in the Library of Princeton University, of which an extensive supplementary volume appeared in 1968.

Sinclair Hamilton, *Early American Book Illustrators and Wood Engravers, 1670–1870*, Princeton University Press, 1958, vol. II, 1968

Much contemporary information is contained in W. J. Linton, *The History of Wood Engraving in America*, Boston, 1882.

B. E. Mahony, L. P. Latimer and B. Folinsbee, *Illustrators of Children's Books*, Boston, 1947. Contains a deal of information and illustration, but is not always to be relied on bibliographically.

Frank Weitenkenkampf, *American Graphic Art*, new and enlarged edition, New York, 1924. Includes much on book illustration.

On Howard Pyle there is a bibliography in C. D. Abbot, *Howard Pyle*, New York, 1925.

Henry C. Pitz, *The Brandywine Tradition*, Boston, 1968, deals extensively with Pyle and his pupils and has a chapter on Darley.

Much other relevant material is cited by Hamilton.

Selected list of illustrated books

Alexander Anderson He is of great importance as a pioneer and a wood-engraver. He rarely appears as an original designer, and his work as such is of little significance. He lived until 1870, and was active until the early 1850s. The best list of his known work is in Hamilton.

J. Adams Also notable as an early wood-engraver, like Anderson, self-taught, is J. Adams. His *chef-d'œuvre* is:
Harper's illuminated Bible, 1846
This was engraved in his workshop and contains 1,600 vignettes and borders of which more than 1,400 were drawn by J. G. Chapman, many showing little appreciation of the limits of the engraver's craft. Others were copied or adapted from cuts by Harvey, Martin and other English artists.

It is an outstanding book not only because it is the most extensively illustrated American book of its time, but also because of its technical innovations. According to Berry and Poole[23]

'this was the first large-scale work published in America for which overlays and underlays were systematically made . . . [and] is also famous as containing the first impressions from electrotypes made from some of the wood engravings'.

There is some confusion about the date of publication. Linton says 1843, Berry and Poole, 1842. In the Hamilton Collection (*Catalogue*, p. 46) is J. G. Chapman's own set of india proofs of the engravings with his note that they were 'taken by hand by the engravers thereof, in course of execution for "Harper's Family Bible" – New York, 1843–44–45. . . .' This may indicate part publication or the long period of preparation needed by the engravers. Hamilton's date for the book, 1846, seems correct.

F. O. C. Darley The first notable American book illustrator. His earliest work recorded in Hamilton is: *Scenes in Indian Life*, Boston, 1843.

His best work is to be sought in his illustrations of Washington Irving, notably in: *Illustrations of Rip Van Winkle*, New York, 1848; and *Illustrations of the Legend of Sleepy Hollow*, New York, 1849.
A History of New York by Diedrich Knickerbocker, New York, 1850
Tales of a Traveller by Geoffrey Crayon, New York, 1850 and an edition in 32 volumes sold separately, of the novels of J. Fenimore

[23] *Annals of Printing*, 1966, p. 231.

Cooper, New York, 1859–61, several times reprinted.

Winslow Homer Made no great mark as a book illustrator and is mostly found contributing an occasional drawing or two in conjunction with other artists. His best work is in *Harper's Weekly* (see the book list in Hamilton and the greatly extended entry in his second volume).

Hammat Billings H. B. Stowe, *Uncle Tom's Cabin*, Boston, 1853

Billings contributed six drawings to the first edition (1852), but these are outclassed by the 116 illustrations in the above edition published for the Christmas season of 1852, but post-dated. His work also figures well in three books by Hawthorne: *True Stories from History and Biography*, 1851; *A Wonder-Book for Girls and Boys*, 1852; *Tanglewood Tales for Boys and Girls*, 1853. Unfortunately all three books are Hawthorne first editions and therefore expensive. All were published in Boston.

Hamilton gives some interesting figures of the respective payments made to the artist and the engraver for these three books. For *True Stories*, Billings received $40 and Roberts, the engraver, $80. For *A Wonder Book* the figures were $42 and $98, and for *Tanglewood Tales* $42 and $185.

S. Eytinge Charles Dickens, *Oliver Twist*; *Barnaby Rudge and Hard Times*; *Dombey and Son*; *Martin Chuzzlewit*; *The Old Curiosity Shop and Reprinted Pieces*; and *Our Mutual Friend*

These six volumes form part of the Diamond Edition published in Boston in 1867.

Bret Harte, *Condensed Novels*, Boston, 1871; *The Heathen Chinee*, Boston, 1871; and *The Luck of Roaring Camp*, 1872

T. Nast (Clement C. Moore) *Visit from St. Nicholas*, New York (1864 and 1879. The latter with more pictures.)

The poem had been illustrated by Darley in 1862 but Nast's illustrations are much more generally favoured.

M. E. Dodge, *Hans Brinker*, New York, 1866

The frontispiece is by Darley, the other three illustrations are by Nast.

Charles Dickens, *Pickwick Papers*, New York, 1873 and *Pictures from Italy and American Notes*, New York, 1877

The latter volume also includes *Sketches by Boz*, illustrated by A. B. Frost.

A. B. Frost J. C. Harris, *Uncle Remus and His Friends*, Boston, 1892 and *Uncle Remus, his Songs and Sayings*, New York, 1895

Frost also made drawings for collections of the Uncle Remus stories in the early 1900s, sometimes in collaboration with E. W. Kemble and other artists. The first two volumes in the series were illustrated by other artists: *Uncle Remus, His Songs and His Sayings*, New York, 1881 – illustrated by F. S. Church and J. H. Moser; *Nights With Uncle Remus*, Boston, 1883 – illustrated by F. S. Church and W. H. Beard.

In amendment of the reference to Church in the text (p. 258) one may add that he illustrated an edition of Hawthorne's *Wonder Book*, Boston, 1884, which suffers by comparison with Billings's drawings for the first edition, 1852. Returning now to Frost we have: Frank Stockton, *Rudder Grange*, New York, 1885.

Charles Dickens, *The Household Edition* of his collected works, edited by his biographer and friend John Forster, was published simultaneously in London and New York in 30 volumes between 1871 and 1880. They differ widely in the illustrations for some of the volumes. We have already seen that Nast illustrated three of the works for this edition (see p. 257). Oddly enough one of these is *American Notes*, for which the London publisher used drawings by A. B. Frost. The American publishers, however, commissioned Frost's drawings for *Sketches by Boz*.

Frost also illustrated: Lewis Carroll, *Rhyme? and Reason?*, 1883 and *A Tangled Tale*, 1885.

E. A. Abbey	Robert Herrick, *Selection from the Poetry of*, 1882
	R. B. Sheridan, *The Rivals* and *The School for Scandal*, 1885
	Oliver Goldsmith, *She Stoops to Conquer*, 1887

Howard Pyle	*The Merry Adventures of Robin Hood*, 1883
	Pepper and Salt, 1885
	The Wonder Clock, 1887
	Otto of the Silver Hand, 1888

These were all published in New York. Sampson, Low took a small number of sheets for the London market for all but *The Wonder Clock*. The same is true for the two books by James Baldwin that Pyle illustrated: *The Story of Siegfried*, 1882 and *A Story of the Golden Age*, 1887.

Index

Figures in italics refer to
illustration numbers